ART AND LIFE
IN POLYNESIA

T. BARROW Ph.D.

CHARLES E. TUTTLE COMPANY
Rutland, Vermont & Tokyo, Japan

DEDICATION

To the Craftsmen of old Polynesia

Thread it from the inside, it comes outside,
Thread it from the outside, it goes inside.
Tie it firmly! Bind it fast!

(Tahitian canoe-builders' chant)

This Tuttle edition is the only edition authorized for sale in
North America, South America, Canada, the Middle East, and Asia

Published by the Charles E. Tuttle Company, Inc.
of Rutland, Vermont and Tokyo, Japan
with editorial offices at Suido 1-chome, 2-6, Bunkyo-ku, Tokyo, Japan
by special arrangement with A. H. & A. W. Reed, Sydney, Melbourne
Wellington, and Auckland

Copyright in Japan, 1972 by Charles E. Tuttle Co., Inc.

Library of Congress Catalog Card No. 72-77509

International Standard Book No. 0-8048-1059-1

First Tuttle edition, 1973

PRINTED IN JAPAN

CONTENTS

ACKNOWLEDGMENTS

FIRST, ACKNOWLEDGMENT is due to the long-departed Polynesian craftsmen. Without them there would be no book. The things they made are timeless and speak eloquently for themselves.

This book was born, like a baby elephant, after long gestation. It embodies much experience gained in daily and direct handling of Polynesian artifacts, long contact with Polynesians since earliest boyhood in New Zealand, youthful visits to isolated islands, and the reflections of middle age in cosmopolitan Hawaii. My wife, Hisako, helped in every way, particularly through her encouragement and typing. Miss Deborah Allen of the University of Hawaii read the manuscript and suggested changes here and there.

The virtues of the book, such as they are, emerge not from any special personal talent, but rather from the rare opportunities I have had to study material at first hand.

My chance to gain intimate familiarity with Polynesian art came in two decades of professional work as an appointed ethnologist to two great Pacific collections (the Dominion Museum, Wellington, New Zealand, and the Bernice P. Bishop Museum, Hawaii), and many opportunities through these appointments to travel and meet enthusiastic students. In 1950, as a green undergraduate, I worked under Dr H. D. Skinner of Otago Museum, Dunedin, New Zealand, the patriarch of modern Polynesian anthropology and archaeology.

In 1955 I had the good fortune to enrol at Cambridge University, England, for postgraduate study under the supervision of Dr G. H. S. Bushnell, and with the help of Professor

Grahame Clark was there admitted to Peterhouse, a college founded in 1284 A.D. Study trips to continental European collections followed, and many lasting friendships were formed with collectors and museum colleagues. The generous help of Adrian Digby (then Keeper) and B. A. L. Cranstone opened to me the Polynesian treasures at the British Museum, London. Professor Paul Wingert, doyen of South Sea art studies, visited New Zealand at an early stage of my museum career, and I attribute much of my interest in the aesthetics of Oceanic arts to my friendly association with him.

In 1960 a research fellowship enabled me to work at the Bishop Museum for several months, and the Director, Dr Alexander Spoehr, permitted me to make extensive photographic and written records, many of which I have used in this book. I am grateful to the Board of Trustees and the present Director, Dr R. W. Force, for past access to Bishop Museum collections and for interest in my work. Many friends to whom I am indebted are now dead. I think that in relation to this book I should recall to memory Sir Peter Buck (Te Rangi Hiroa), Captain A. W. F. Fuller, Mr W. J. Phillipps, Mr K. A. Webster, and Dr Carl Schuster. These men, whom it has been my pleasure to know, expressed in their work a scholarly humanism that is rarely to be found today. Computer-minded anthropologists of the new generation are more efficient with data than were these pioneers but they do not surpass them in understanding.

A substantial part of this book is illustration. Where known I have named photographers or museum archives. I have documented existing photographic records because I regard them as important and deplore underrating them. For this reason I note my own photographs, which were made from necessity and not from any desire merely to "take photographs".

The plan to create this book was a by-product of a tour of mainland American museums made late in 1969 by means of a travel grant-in-aid from the Wenner-Gren Foundation for Anthropological Research (New York). The experience precipitated my thinking. Renewed acquaintance with discerning friends and the fresh illustrative material made available encouraged me to organise my enriched resources for the benefit of others. The special helpers I refer to are Allen Wardwell of the Art Institute, Chicago, Raymond Wielgus of the Field Museum of Natural History, Chicago, and Ernest Dodge of the Peabody Museum, Salem, Massachusetts.

The directors of A.H. and A.W. Reed approved my proposal for a book, and I proceeded to put my materials together. I am grateful to all concerned. In fact, this work has involved so many people at one time or another that I cannot hope to give adequate acknowledgment. Friends and family were encouraging at all times. However, the main burden fell on museum colleagues and collectors, so a special word of thanks must be given to them, including of course the boards and directors who allowed access to collections. With two exceptions the following collections were visited—they are listed here roughly in order of first appearance in the text:

Auckland War Memorial Museum, Auckland
Alexander Turnbull Library, Wellington
National Art Gallery, Wellington
Otago Museum, Dunedin
Bernice P. Bishop Museum, Honolulu
Kon-Tiki Museum, Oslo
United States National Parks Service, Hawaii

National Maritime Museum, Greenwich
The National Museum of Ireland, Dublin
Pitt Rivers Museum, Oxford
Field Museum of Natural History, Chicago
Auckland City Art Gallery, Auckland
Dominion Museum, Wellington
Mr and Mrs Leo Fortess Collection, Oahu
Honolulu Academy of Arts, Honolulu
British Museum, London
Peabody Museum, Salem
Art Institute of Chicago, Chicago
Ethnographical Museum of Sweden, Stockholm
Cambridge University Museum of Archaeology and Ethnology, Cambridge
Hunterian Museum of the University of Glasgow, Glasgow
Institute of History and Philology, Academia Sinica, Taiwan
Fogg Art Museum, Harvard University, Cambridge, Massachusetts
Tokyo National Museum, Tokyo
Marischal College Anthropological Museum, Aberdeen
Museum of Primitive Art, New York
Tropical Institute, Amsterdam
Smithsonian Institution, United States National Museum, Museum of Natural History, Washington DC
Musée de l'Homme, Paris
Mr and Mrs Raymond Wielgus Collection, Chicago
Musée de Pape'ete, Tahiti
Royal Scottish Museum, Edinburgh
James Hooper Collection, Sussex
Hawaii Volcanoes, National Park Museum
Peabody Museum of Archaeology and Ethnology, Harvard University, Cambridge, Massachusetts
Canterbury Museum, Christchurch
Taranaki Museum, New Plymouth
Ethnographical Museum, Basel
Hawke's Bay Museum, Napier

Lastly I note the names of individuals (excluding those already mentioned) who have, over the years, contributed in some way to making this book possible.

Rigby Allen, R. Apple, G. Archey, G. Bacon, M. Badner, T. Bayliss, J. C. Beaglehole, Beatrice Blackwood, Dr and Mrs R. Browne, A. Bühler, G. Bull, C. Burland, J. Charlot, J. H. Cox, B. Danielsson, Janet Davidson, R. K. Dell, E. Dodd, R. S. Duff, K. P. Emory, W. B. Fagg, R. A. Falla, J. Feher, R. Firth, V. F. Fisher, Mr and Mrs L. Fortess, R. R. Foster, D. Fraser, J. D. Freeman, P. W. Gathercole, A. A. Gerbrands, J. Golson, R. C. Green, R. Halbert, O. Hachiro, T. Heyerdahl, J. Hooper, Helena Hull, Christina Jefferson, S. Kooijman, K. E. Larsson, Betty McFadgen, D. S. Marshall, Margaret Mead, S. M. Mead, J. Melser, T. Moreland, J. S. B. Munroe, Imgard Moscher, R. K. de nan Kivell, Aurora Natua, W. R. Neill, D. Newton, W. T. Ngata, A. Murray-Oliver, D. L. Oliver, J. B. Palmer, P. Piddington, S. H. Riesenberg, Sir Robert and Lady Sainsbury, S. D. Scott, H. L. Shapiro, A. Sharp, F. W. Shawcross, D. R. Simmons, Y. H. Sinoto, M. Smart, W. G. Solheim II, P. Taiapa, C. R. H. Taylor, H. Tischner, C. I. Tuarau, E. G. Turbott, Olwyn Turbott, G. Walters, W. Watson, G. White, W. Y. Willetts, C. L. Bailey, J. Guiart.

My heartfelt thanks to all concerned.

The making of this book was greatly aided by a travel grant awarded the author by the Wenner-Gren Foundation for Anthropological Research, New York.

FOREWORD

TERENCE BARROW provides in this book, *Art and Life in Polynesia*, an impressive collection of Polynesian art illustrated in colour and black and white. The positive achievement of this study is all the more remarkable in following so closely the author's notable *Maori Wood Sculpture of New Zealand*. Students and the general public will welcome this new book with the enthusiasm they gave to the last.

To secure the materials for *Art and Life in Polynesia* Dr Barrow investigated public museums and galleries in every country where there are major Polynesian collections—literally from New Zealand in the South Pacific to Britain and Europe. It should be noticed in passing that the New Zealand collections contain treasures as notable as those of other countries and in numbers probably no fewer than all the other collections put together. Private collections were also searched for appropriate illustrative material.

This imposing array of material culture is presented by Dr Barrow against a background of Polynesian religion and social organisation. The text takes the form of general introduction, and informative captions to plates. The collections used by the author are listed in the acknowledgments and noted in the captions themselves.

Twenty years ago Sir Peter Buck (Te Rangi Hiroa) indicated the close cultural relationships that exist between the Marquesas Group and Easter Island. Dr Barrow confirms not only this particular relationship but also demonstrates similar cultural links between the Chathams and New Zealand, and the Cook Islands, the Australs, the Society group, and the Hawaiian Islands.

Terence Barrow joined my anthropology class at Otago University, Dunedin, in 1950. He came fresh from the Dominion Museum where he had been busy unpacking the great W. O. Oldman Collection of Polynesian artifacts. He soon showed himself to be a student of unusual capacity and industry, taking first place in the class of his year, and making the highest score in the practical examination. Barrow's enthusiasm was intense: in addition to required class studies he did a large amount of voluntary work on the Otago Museum archaeological and ethnographical collections. His subsequent studies at Auckland University and Cambridge University, as well as wide travels and two decades of work in museums with Pacific collections, have given him an unrivalled knowledge of the ethnology of Oceania.

This book is an expression of a prolonged direct experience with Polynesian art, and with Polynesians. He now shares his experience with us.

For all anthropologists, archaeologists and taxonomists working on Pacific cultures these are indeed great days of discovery and new knowledge. *Art and Life in Polynesia* is a timely book which should prove to be pre-eminent in its own class, and an important contribution to furthering our knowledge of Polynesian art.

Dunedin,
New Zealand, 1971

H. D. SKINNER,
Director Emeritus, Otago Museum, Dunedin.

PREFACE

THE AIM of this book is to provide a new perspective on Polynesian art by viewing it directly in relation to life, and by presenting with caption and comment an extensive range of illustrations. The objects selected as illustrations were chosen with the utmost care. Every photograph, colour or black and white, is a choice from many alternatives. No book with this scope of illustration has appeared previously. It is, however, stylistically a close relation to the recent exhibition catalogues by Duff and Wardwell; also it is a companion to the author's *Maori Wood Sculpture of New Zealand*.

An attempt is made here to get away from the disconnected manner commonly encountered in scholarly publications on the Pacific, in which photographs are regarded as inferior adjuncts to the text and detached from accompanying documentation, if any exists. Here illustrations are presented with adjoining captions, to be looked at and thought about. Descriptive material, known history, measurement, and comment appear with the illustrations.

The work aims at no particular class of reader. In the subject of Polynesian art and life we are all learners in varying degrees of ignorance. However, intuitive responses, for which science has little place, are recommended as vitally important to the appreciation of this art material. Generally the book should be useful to art students, sculptors, architects, and designers, as well as to ethnologists and archaeologists. Also it is hoped that the reference librarian, college student, layman, and those without aim other than relaxation, will find the book useful and enjoyable.

The work is divided into two sections. Part I provides background material with a general selection of plates, while Part II contains plates and captions arranged for specific island groups. Part I is subdivided according to subject. Sequential numbers are assigned to all plates. Cross-reference to plates is made by noting (with or without brackets) the numbers of the plates to be compared.

The Bibliography shows the name of author and year of publication of a particular book or paper. It gives details of all works referred to, and other reading helpful in the study of Polynesian art and life. The writer has, however, restricted textual references to literature to a few essential books or papers, in the hope that easier reading will result. Acknowledgments and Bibliography note all sources of help. Measurements, in both inches and centimetres, are provided as an aid to scale, although slight inconsistency has arisen in some conversions.

The dispersal of Polynesian artifacts in Western museums and private collections, particularly those of Britain, France, Germany and North America, is readily explained by the connection of these countries with Pacific exploration, political intervention, or colonisation, over the last two or three centuries. Some collections have returned to Polynesia, namely to the museums of New Zealand and to Hawaii (Bernice P. Bishop Museum, Honolulu). Today the "supply" of old Polynesian artifactual material is virtually exhausted and cannot be revived regardless of demand.

The greatest private collections of Polynesian art were formed in Britain by persistent hunters at salerooms, failing museums, antique shops, and stately homes in their decline. In Britain there arose a remarkable breed of collectors of Polynesian objects who were most patient in their search. W. O. Oldman, A. W. F. Fuller, K. A. Webster, H. Beasley, and J. Hooper formed magnificent collections in the decades before 1950. Then the "supply" dried up. The James Hooper collection is the last big Polynesian collection to remain in private hands (at time of writing). The other great private collections have long since been dispersed or found permanent homes in institutional museums. As museum assemblages generally owe their origin to private collectors, it does not become museum professionals, as is often the case, to regard private collectors with condescension and disdain.

The current monetary evaluations of Polynesian objects reflect the present world interest; for example, the commerical value of the artifacts illustrated in this book would amount to many millions of dollars. Current auction-room prices are many times the pre-World War II rate, and some hundreds or thousands of times the value of the original exchange. This does not make all old items extremely valuable. Money values can vary from a dollar for a battered adze to a million or more dollars for some rare image. The intrinsic worth, however, is in the Polynesian cultural heritage.

By 1850 Polynesia was denuded of most of its old art, except for that hidden in archaeological sites or caves, or objects too massive to be carried away, such as stone images. However, this European "trophy" and "curio hunting" worked greatly to the advantage of cultural preservation, since little that remained in Polynesia of wood, fibre, or feather material survived the century. New Zealand,

and to a lesser extent Hawaii, retained and preserved much at home.

This volume should serve present-day Polynesia as a source book to help those wishing to revive Polynesian craft tradition. These old objects should inspire the artist of today, whether he is Polynesian or not, and I hope will discourage the slavish imitation or devotion to the tourist dollar. Respect for the past and good taste in modern adaptations is the key to the right use of this magnificent art. Close study of its spirit and forms must precede any application to present-day use. It is not material to remain in a sort of hothouse museum of barbaric curiosities.

Unfortunately, there were not trained field-workers present in the eighteenth or early nineteenth centuries asking old-time craftsmen about their art. Little information comes from the days when it could have been directly obtained. It is now too late to rely on living informants. The carving tradition survived in New Zealand, but the actual meaning of decorative art motifs was not placed on record at a time sufficiently early to be reliable. For example the *manaia* motif, second only to the *tiki* in frequency of occurrence, remains a mystery. This is not to say that we cannot get to its meaning, as the careful review and assembly of all available data, the comparative study of related areas, and assessment from all types of records, can yield answers.

Part I provides a review of Polynesia, while Part II is concerned primarily with the magnificence of Polynesian achievement in the past, particularly as it can inform and inspire the present. Generally the book aims at fostering appreciation of the courageous, fascinating Polynesians who have, as if by some miracle, survived the impact of the alien culture that swept away their gods, customs, crafts, and tools. What remains in Polynesia is a vestige of what was.

Archaeological work undertaken in the decades succeeding World War II, particularly in New Zealand, Hawaii, and Easter Island, is providing us with a clearer picture of Polynesian prehistory. Unfortunately, little sculptural material is found in excavation, so museum material, usually inadequate in documentation, must remain the basis of Polynesian art studies. Let us face this hard fact at the outset. The bulk of extant Polynesian art material is poorly documented. Names of collectors, dates of collection, makers, tribe of origin, precise identity or function, and other crucial information are rarely to be found. We are alone with a few facts and the objects themselves.

Readers should bear in mind that the many generalisations made about Polynesia in the text that follows are rarely applicable to all islands. This is true also of the division of the Pacific into culture areas—it is a generalisation of convenience. In fact, there are no clear-cut customs that are invariably the same from island to island, and there are certainly no lines drawn on the Pacific Ocean. Finally, Polynesian names of artifacts are for the most part omitted from text and caption because of the present inconsistency in usage. True names have not always been preserved, and the many literal descriptive names attached to artifacts are not always reliable. For present purposes the specialists know and assess names well enough, but they remain a confusion to general readers.

Lastly, the comments made about the devastating impact of Christianity on traditional Polynesian culture and the lack of missionary awareness are in no sense anti-Christian or anti-missionary. Christianity brought to Polynesia a new civilisation, while the missionaries for their part did a wonderful job. When some individuals threw out the baby with the bath water it was with the best of intentions.

Honolulu,
Hawaii. T.B.

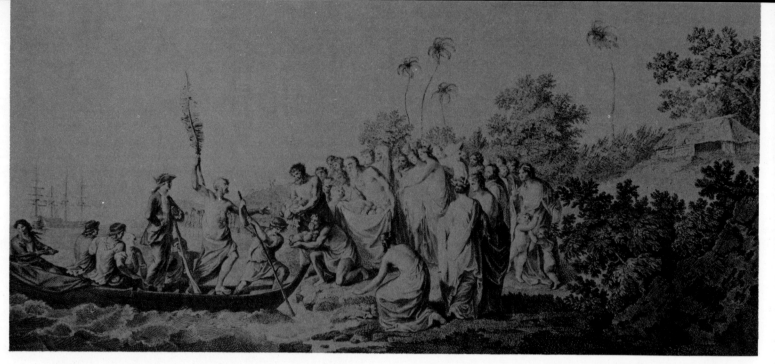

I

This engraving (after a painting by Hodges, artist on Captain Cook's second Pacific voyage) is entitled "The Landing at Middleburgh (Eua) one of the Friendly Islands", and it appears in *A Voyage towards the South Pole, and round the world . . . in the years 1772-1775*, published in London, 1777. *Collection and photo*: Alexander Turnbull Library, Wellington, New Zealand.

Captain Cook is seen standing in the ship's boat next to a chief who waves a banana leaf in a gesture of peace. These Polynesians are drawn to look like classical Greeks because of prevailing Western ideals of art, and the publisher's aim to satisfy eighteenth-century readers who wished to see South Sea islanders as a gentle and idyllic people. In reality, Polynesia had two faces, one civilised, the other savage.

INTRODUCTION

POLYNESIAN ART, when broadly viewed, expresses the character of an oceanic people—men who courageously shipped out on unknown seas with their women, children, plants, animals, and tools, to find and settle new islands.

The story of the Polynesians has many chapters, and none is more meaningful to modern man than that concerning the arts. It reveals a way of life, remote from modern man yet pregnant with ideas and a new aesthetic that have contributed much to modern art via Paul Gauguin, Matisse, Picasso, and other artists. The popular discovery of Polynesian art belongs to the twentieth century and the accompanying rise of interest in anthropology and related fields of knowledge.

Before the end of the nineteenth century a true evaluation of Polynesian art was hampered by the dogmatic belief in Western racial superiority, the cultural dominance of Greek and Renaissance ideals, revealed religion with its belief in Lucifer, distrust of sexual symbols, and the conviction that the images of other cultures were idols of devil worship. Now it is generally accepted that no group of mankind is inherently superior to any other and that all traditions have something unique to offer. Human consciousness is really the surface phenomenon of a deep unconscious, rich in psychic potential.

In view of the integrated character of Polynesian culture, we must consider aspects of religious belief and economic life if we are to understand its art. Polynesian priests, when acting as media between gods and men, sincerely believed that the spirits possessed them. Likewise, when a family regarded some particular animal, such as a shark or owl, as their totem, they firmly believed it was a spiritual relative. Polynesian art was true to its own cultural beliefs.

The sources of study of Polynesian art are public and private collections, journals of voyagers, ethnographical monographs, and archaeological reports. All have bearing on the interpretation of Polynesian art. We must ask ourselves when we look at an object: when was it made? why was it made? what socio-religious concepts inspired it? who was the carver? how was he paid? what tools and materials did he use? what significance is to be found in the art motifs? how does the object relate to similar objects from the same island or other islands?

We must realise that we are looking at a giant jigsaw puzzle with most of its pieces missing, and that if we can perceive the subject of the picture blank areas can be sketched in.

10

The demi-god Maui hauling up the North Island of New Zealand (Te-Ika-Roa-a-Maui: The Long Fish of Maui) from the bottom of the South Pacific Ocean. *Collection and photo*: author.

For centuries Pacific peoples have related stories of the culture hero "Maui-of-a-Thousand-Tricks", who fished up new islands, snared the sun, and eventually died trying to grasp immortality for his fellow mankind. The Tahitian interpreter Tupaia, who sailed with Captain Cook, is recorded as having told stories about Maui. Wharton, the editor of an account of the *Endeavour's* first voyage, published in London 1893, noted that Captain Cook regarded the many tales of Maui as too absurd to write about in his journal. The illustration is from Dittmer's *Te Tohunga* (1907).

The grand impersonal quality of Polynesian art grew from insecurity, a struggle for survival, and problems in adapting to new island environments. Old-time Polynesian life was both beautiful and ugly. It is useless to view Polynesia with over-romantic eyes or to bewail Western guns and diseases as its destroyer. Old Polynesia was bloody and unsafe. Its art expresses social tension and aggressiveness; yet the mood is calm.

THE WESTERN DISCOVERY OF POLYNESIA.

The Western discovery of Polynesia was made on 21 July 1595, when Alvaro de Mendana sighted the island of Fatu-Hiva in the Marquesas. Contact with the Marquesans was at first amicable, but soon turned into bloody fracas in a sequence of events often repeated thereafter when European and Polynesian had misunderstandings.

The saga of the exploration of Polynesia by an expanding Europe has been told many times, and never better than in J. C. Beaglehole's *The Exploration of the Pacific*. From the early eighteenth century onwards, Polynesians faced buccaneers, explorers, whalers, blackbirders, traders, missionaries, and others claiming the Pacific as their own according to their calling. Many of these men contributed in one way or another to completing the map of the Pacific. From the extensive discoveries of Captain James Cook came the most valued collections of early-contact artifacts.

The term "South Seas", until the nineteenth century used to define the area of all Pacific islands and Australia, originated in 1513 with the Spanish conquistador Vasco Nunez de Balboa, the first European to see the east Pacific. (Marco Polo had seen its western side late in the thirteenth century.) After gazing at a new horizon to the west from a hill of Panama, Balboa named the sea Mare del Sur, or South Sea, then promptly claimed it all for the crown of Spain. Seven years later Ferdinand Magellan, a Portuguese in the service of Spain, became the world's first trans-Pacific navigator, and named the sea he had crossed Mare Pacifico, or Pacific Ocean.

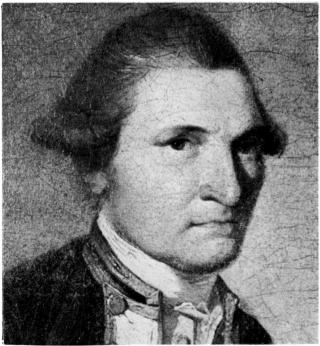

3 △

Captain James Cook, RN. This head is from a large oil portrait by John Webber (17), draftsman on the *Resolution* from 1776 to 1780. This fine picture, now a treasure of the New Zealand National Art Gallery in Wellington, was painted at Cape Town about three years before Cook met his death at the hands of the Hawaiians at Kealakekua Bay in 1779. According to tradition, the portrait was painted for Mrs Cook. *Photo*: author.

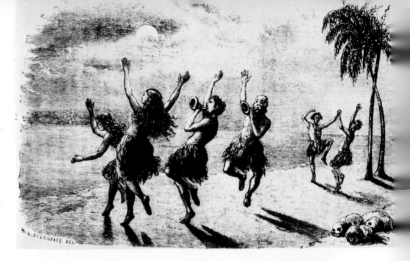

▷4

The nineteenth-century view of Polynesians turned away from the eighteenth-century romanticism, which regarded Polynesians as children of nature living in an innocent golden age. They next became in the Western view benighted pagans and ardent worshippers of devilish idols. This engraving, after a work by the artist W. H. Sterndale, was published in 1894 by the London Missionary Society in *The Story of the South Seas Written for Young People*. (See 213 also.) Polynesians in grass skirts (which Polynesians never used) are shown cavorting to blasts of trumpets. The picture is captioned "Heathen ceremonies on the return of the Pleiades"; the rising of the consellation Pleiades had special meaning for the Polynesians, as on many islands it heralded the new year and a season of plenty. (See page 40.) *Collection and photo*: author.

The term "Polynesia" was used in 1756 by the Frenchman de Brosses in his *History of Navigation*. However, the word appears to have been coined at an earlier time. De Brosses used it in a collective way to indicate Pacific islands, but it became more specific as cultural boundaries for the area were determined. The word was originally derived from the Greek *polus* (many) and *nesos* (island).

The Pacific islands were a bitter disappointment to the early Spanish goldseekers. Those who followed looking for substantial trade at first found nothing other than vegetables, coconuts, sweet potatoes, yams, and hogs. They viewed artifacts as fascinating curios to take home, but as having little negotiable value. Harbours were poor, and port facilities non-existent.

Most Pacific islands vary in fertility and lack fruitfulness unless plants are introduced by man and carefully cultivated. The settlement of Polynesia was in fact made possible by the Polynesians' ability to introduce food, plants, and domestic animals. Without cultivation island environments could support no more than small groups. New Zealand, with its rich resources of coast, bush, river, and lake, provided an exception to this general rule. Polynesian art flourished only on islands that had passed the subsistence level. Where food and leisure were superabundant the creative arts and their practitioners rose in achievement and social eminence.

The European dream of Polynesia as an idyllic world of free love where food was obtained without labour and where men lived in peace is a myth that has persisted into the twentieth century, aided by eighteenth-century engravings and Jean Jacques Rousseau's doctrine of the noble savage. Polynesia was, and is today, one of the most romantic parts of the earth, the natural scene being singularly beautiful and the people most charming. But old Polynesia had two faces, one of them ghastly. Warfare, overpopulation, infanticide, starvation, oppressive taboos, heavy obligation to chiefs,

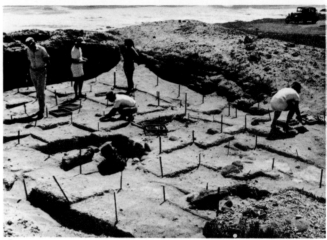

5△
Archaeologists of the Bishop Museum, Honolulu, and the University of Hawaii at work on a fisherman's camp site at South Point, Hawaii, in 1955. *Photo*: Bernice P. Bishop Museum, Honolulu, Hawaii.

The scientific story of Polynesian dispersion, the chronology of island settlement, and factual information bearing upon Polynesian life, are being steadily revealed by archaeological research. Few of the thousands of known sites have been excavated systematically; however, archaeological activity within Polynesia has expanded steadily over the last two decades.

human sacrifice, cannibalism, and slavery decimated society, and natural disasters of hurricane and/or *tsunami* periodically devastated the islands.

CULTURE AREAS AND GEOGRAPHIC BOUNDARIES

By the end of the eighteenth century the racial and geographic character of the Pacific islands was more or less described. Island clusters had by that time appeared on maps of the vast ocean which covers over one-third of the earth's surface. It soon became evident that islands tended to become smaller and their groupings more scattered with wider stretches of dividing water from west to east.

In the western Pacific lay torrid malarial islands occupied by dark-skinned and aggressive Melanesian tribes. To the north and west lay dangerous atolls settled by brown-yellow Malay-like Micronesians. To the east, from Hawaii to New Zealand and from Tonga to Easter Island, lived another people, the

Polynesians, whom the voyagers found nearest themselves in physical type, humour, and predisposition to open fighting.

Scientific anthropology, with its sub-discipline of archaeology, is a development of the nineteenth-century and in part a product of those eighteenth-century philosophers who saw man as a social animal. Applied anthropology is a twentieth-century phenomenon. Unfortunately, when Polynesia was being discovered and initially settled by foreigners, the techniques of modern anthropology were not available for application, and professional anthropologists (or archaeologists) did not exist. In fact, as far as ideal study conditions are concerned, Polynesia was discovered over a century too soon. The records we have of classical Polynesian life are a remnant, with the ethnographic picture often a thing of shreds and patches. (In contrast, for example, the stone age tribes of mountain New Guinea have been studied since World War II by every anthropological technique used by trained professionals.) Without such acute observers as Captain James Cook our knowledge of traditional Polynesian life would be very scanty indeed.

From the maze of observations, journals, collections of "curios", artists' sketches, and so on, fact and fiction were slowly separated. Much remains to be discovered, but broad generalisations can be made as a basis of a review of Polynesian art.

Oceania and west Asia are conveniently divided into six culture areas, five of which bear relationship to Polynesian culture (the sixth area is Australia):

(i) Austroasia: the coastal and near coastal lands of south China, Vietnam, Korea, Cambodia, Thailand, Malay Peninsula;

(ii) Austronesia: the island world of South East Asia including the Philippines, Formosa, and Japan;

(iii) Micronesia: the atolls and high islands north of Melanesia;

(iv) Melanesia: the island chain between Micronesia and Australia (New Guinea is shared by Austronesia and Melanesia);

(v) Polynesia: a vast triangle about 5,000 miles along each side with corners at New Zealand, Hawaii, and Easter Island.

Tahiti in the Society Islands conveniently marks the geographic hub of Polynesia. A circle drawn on a map with the centre point at Tahiti and with Easter Island, Hawaii and New Zealand on the periphery gives an encompassing view of Polynesia. There are, however, Polynesian communities within Melanesia and Micronesia on islands classified as "Polynesian outliers". Well-known outliers in Melanesia are: Rennell, Bellona, and Ontong Java. Nukuoro, a Polynesian-settled island in the Caroline group, is a good example of an outlier within Micronesian boundaries. Culture boundaries are useful for reference, but it must be remembered that all areas overlap and are interlinked. To understand one area it is essential to look to its neighbours. The interpretation of art requires a broad view of the Pacific as one vast area of interrelated styles.

Polynesia is conveniently divided into four sub-areas comprising island clusters or groups of islands. This subdivision describes the basic art areas which are here listed in the same order as the illustrative plates of Part II:

West Polynesia: Tonga, Samoa and Fiji;

East Polynesia: Marquesas and Society Islands;

Sub-Marginal Polynesia: Austral, Gambier and Cook Islands conventionally;

Marginal Polynesia: Easter Island, Hawaii, New Zealand and the Chatham Islands.

The division of Polynesia into West, East, Sub-Marginal, and Marginal areas is based mainly on facts of geography and culture. Men, social forms, and artifacts alike disperse, evolve, transmit themselves, and change with time. When contacts cease between parent and offspring, a society's development proceeds without parental influence, although other influences appear. This process is markedly evident in Polynesia. Linguistic and other studies indicate that West and East Polynesia developed separately after the settlement of the East from the West about the sixth century AD. It would appear from present evidence that there was virtually no migrating eastern movement from West Polynesia after this time, although some back-tracking to western homelands seems probable.

The East Polynesia inventory of artifacts includes many items absent in West Polynesia, and vice versa. Pottery, headrests, and hook-hangers are present in the West alone, while East Polynesian cultures exhibit distinctive pestle pounders, rectangular-sectioned tanged adzes, drums with sharkskin membranes, temples with stone platforms, sprit sails, squared barkcloth beaters, *tapa* printing stamps, and elaborate wood carving. Notable absences from Polynesia in general are the weaving loom, fighting bow, and festival masks, all of which are important in neighbouring Melanesia.

GEOGRAPHICAL CLASSIFICATION OF ISLANDS

The geographical classification of the Polynesian islands is by island forms. Each island type is associated with certain environmental features, some of which favoured settlement, others not.

Island environments correlate with and determine the direction of social and art development.

The basic island types are as follows:

(i) High islands formed by basaltic peaks projecting above the sea. Such islands are usually elevated sufficiently to cause regular precipitation of rain from moisture-laden prevailing winds and are fertile in their valleys and coasts. Examples are Oahu, Hawaii, and Tahiti. Typically the valleys act as watersheds, feeding fresh streams running down to bays which may terminate in sheltered canoe havens. Fringing or encircling coral reefs accompany high islands within tropic zones. The development of classical Polynesian culture is centred on high islands, and from them has come most extant sculpture.

(ii) Atolls or low islands formed by coral polyps. The small marine invertebrates that have formed coral for millions of years always leave their limy skeletons as a foundation for succeeding generations. As suggested by the brilliant hypothesis of Charles Darwin, typical atolls and coral reefs are built on submerged peaks that have steadily subsided. Regions of the sea floor of the Pacific have been lowering steadily. The earth is not stable. Borings taken in 1952 at Eniwetok atoll revealed solid coral down to basalt base rock at about 5,000 feet below present sea level, which is thought to represent a coral build-up of over 40 million years. Atolls have sparse vegetation and low rainfall. They were the "coconuts and fish" subsistence South Sea habitats of the comic strips. Virtually no sculpture was made on atolls. (The Taumotu Archipelago of French Oceania is the most famous chain of atolls in the Pacific.)

(iii) Coral islands of the *makatea* type. These are formed by the raising of atolls or reefs by subterranean uplift. Islands of this type were built as atolls on basaltic peaks in the usual manner until there began a reverse movement of the sea floor from subsidence to vertical lift. Some *makatea* islands are now 300 or 400 feet above sea level and retain at their centres evidence of old lagoons. Their depressed centres act as rain catchments and as basins to hold decaying vegetable or animal matter. Consequently, they are fertile and responsive to cultivation. Seacliffs with eroded coastal shelves having living coral polyps at the edges are typical of this type of island also. Art activity is sometimes notable on *makatea* islands, a good illustration being Mangaia in the Southern Cook Islands.

(iv) Islands formed from geologically ancient rocks of sedimentary, volcanic, and metamorphic origin which were thrust up millions of years ago, and since have been eroded or added to by volcanic action. The New Zealand group, comprising three large as well as numerous offshore islands, is geographically (like Fiji) an extension of the Melanesian chain. In Polynesia it represents this island type which by nature exceeds others in general size, natural resources, and potential for cultivation, fowling and fishing. New Zealand was the group in Polynesia where future cultural and art development was least restricted by environment. It would appear that classical Maori culture could have evolved for centuries if it had not been cut short by the impact of a foreign culture.

POLYNESIAN ORIGINS

There are four basic theories of Polynesian origins (excluding Polynesian mythological explanations):

(i) That a Proto-Polynesian people of Austroasia and Austronesia had become boatbuilders and navigators of sufficient skill to reach out over the Pacific on deliberate voyages of exploration, and that they found islands and settled them with their domestic plants, animals, women and children. The chief exponent of this theory was Sir Peter Buck, who presented it to the Pacific at large through his classic work *Vikings of the Sunrise* (1938). The general theory had been postulated by Captain James Cook almost two centuries before Buck.

(ii) The second theory, a modification of (i), is that ancient coastal mariners were for the most part carried from Austronesia to new islands as involuntary castaways who so lacked navigational ability that they could not return to home islands. This theory of settlement, also speculated on by Captain Cook, has its modern formulator and proponent in Andrew Sharp (*Ancient Voyagers in the Pacific*, 1956).

(iii) That the original settlement of Polynesia was from America, via Peru and the northwest coast of North America. Captain Cook could not persuade himself that the Polynesians were of American origin, although he considered this possibility. The theory gained much popular credence when Captain Thor Heyerdahl drifted his *Kon-Tiki* raft in a 100-day voyage from Peru to Raroia in the Tuamotu Archipelago. The fascinating story of his venturesome voyage and a statement on its relationship to Poly-

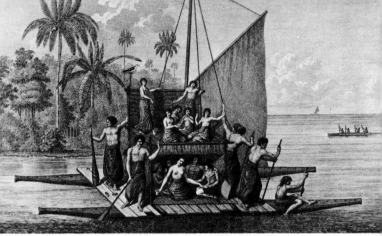

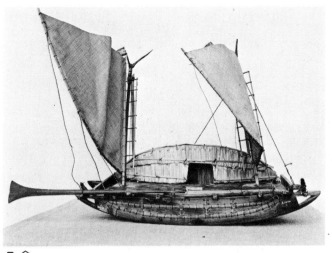

7 △
A model of a double-masted voyaging canoe of Fangatau, Tuamotu Archipelago, made about 1854. *Collection and photo*: Bernice P. Bishop Museum, Honolulu, Hawaii.

This vessel type, traditionally about sixty feet long, was capable of carrying about one person for each foot of length. It has two hulls, a deck cabin, lateen sails of fine matting, a massive steering oar, and hulls made from planks sewn together with coir cordage. Tuamotuan atolls lacked an impressive decorative art, but the canoe-building craftsmanship was masterly.

6 △
A small double canoe of the Tongan Islands with crew and passengers (including a European amourist within the cabin). As the hulls of many canoes were virtually sealed, they remained buoyant and seaworthy even when waves washed over them. The engraving, after the artist Piron, is from Jacques Labillardière's *Atlas du voyage à la recherche de La Pérouse ... 1791, 1792* (Paris, 1800). *Collection*: Alexander Turnbull Library, Wellington, New Zealand. *Photo*: author.

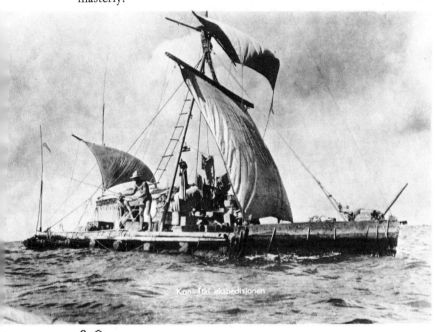

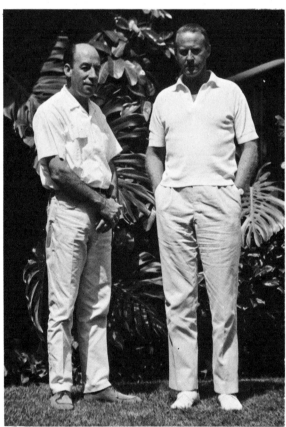

8 △
The *Kon-Tiki* raft, sailing along the south equatorial current in 1947 on its 4,000-mile epic voyage from Callao, Peru, to Polynesia. *Photo*: *Kon-Tiki* Museum, Oslo, Norway.

The story of the venturesome *Kon-Tiki* voyage, which ended in a crash landing on a reef at Raroia in the Taumotu Archipelago, has been retold many times in many languages since Captain Thor Heyerdahl's official Norwegian account, which was published in 1948. For notes on Polynesian origin theories see pages 14–20.

9 ▽
The author (left) with his friend Thor Heyerdahl at Waikiki, Honolulu, Hawaii. *Collection*: author.

The author does not support the *Kon-Tiki* theory of primary Polynesian origins in the American continent, but he has immense regard for the courage and enthusiasm of Captain Heyerdahl. Heyerdahl has aroused world-wide interest in Polynesian origins. No one in the history of Polynesian studies has been more bitterly attacked and criticised. That scientists become emotionally involved in theories that should be regarded impersonally is simply a fact of life, and evidence that scientists are usually as human and fallible as other people.

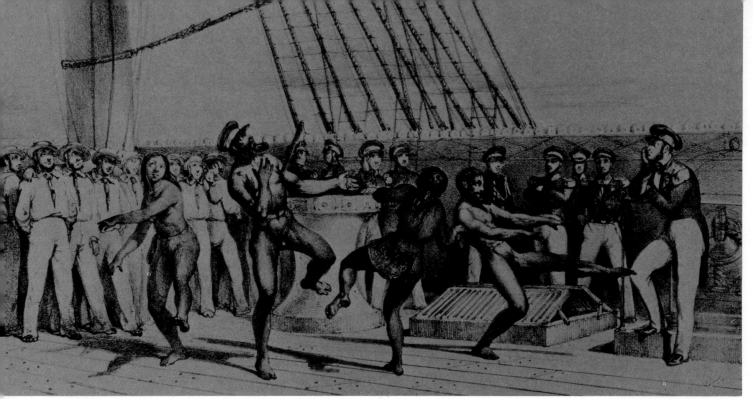

In this scene Easter Islanders provide an impromptu dance for the entertainment of officers and men of the French frigate *Venus* which called at the island in 1838. The illustration, after the artist Masselot, is from Abel du Petit-Thouars' *Voyage autour de monde sur la frégate La Venus* (Paris, 1840-45). *Collection*: Alexander Turnbull Library, Wellington, New Zealand. *Photo*: author.

Two views of the monolithic stone images of Easter Island, photographed in 1969 by Y. H. Sinoto of the Bernice P. Bishop Museum, Honolulu. The upper illustration (11) shows half-buried images inside the volcanic crater of Rano-Raraku. Some of the oldest and finest images are found at this site; many of them stand almost buried by soil erosion (the tallest are almost forty feet high). Conical hats made from red *tufa*, a siliceous volcanic rock, were placed on the heads of temple images, such as the restored *ahu* (See the engraving 224). These "hats" were much damaged during the wars. Hats in Oceania related to the status of the wearer. (See page 55.)

nesian settlement is presented by Heyerdahl in *The Kon-Tiki Expedition* (1950). The Mormon Church favours this route on the grounds of their religious scripture which states that the Polynesians are one of the lost tribes of Israel. (iv) The fourth theory, stated here because thousands believe it, is that the Polynesians are survivors on mountain tops of a now submerged continent called Mu (or Lemuria). Advocates say that Mu formerly occupied most of the central Pacific, just as they claim that Atlantis, a counterpart, covered much of the Atlantic. A description of Lemurian culture and its relationship to Polynesians is to be found in Madame Blavatsky's *The Secret Doctrine* (1888).

It would be inappropriate to review the pros and cons of these theories here. In the author's opinion overwhelming evidence supports purposeful voyaging by Polynesians, and the emergence of a Proto-Polynesian people out of South East Asia. The Philippines appear to have served as a major source of emigrants, who slowly but surely settled islands in an order more or less from west to east. Wide

gulfs of landless seas, sometimes termed water barriers, between Melanesia and West Polynesia required well-provisioned seagoing vessels and navigational skills before each could be crossed. As shipbuilders' or sailors' skills declined, voyaging over the great water barriers dwindled.

Moderately good weather conditions greatly aided stone age voyages of long distance. There is reason to believe that the great Polynesian voyaging eras, notably those of about the eighth century, took place during a cycle of warmer weather, when calmer seas prevailed.

Regarding the so-called drift theory, there is abundant evidence that castaway canoes often reached islands after months of drifting. There are, however, major objections to accepting lost canoes as a principal source of island settlement. First, Polynesians did not carry women, animals or domestic plants on offshore fishing canoes, which were no doubt the vessels most often blown away. Second, if drift "voyages" had a primary role in Pacific island settlement, we should find Polynesians, Micronesians and Melanesians thoroughly mixed up, since all areas have canoe traffic and occasional

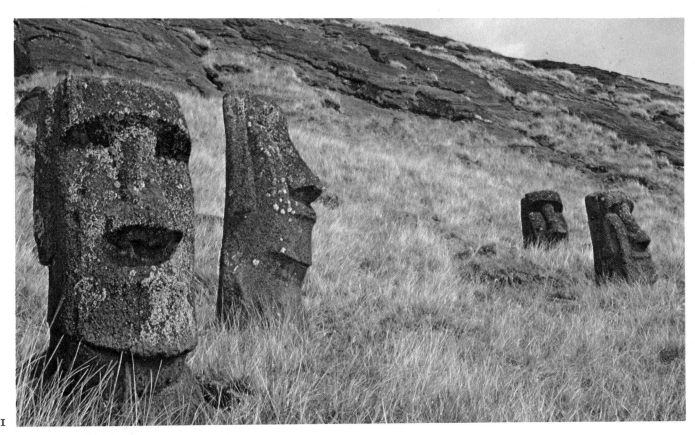

11

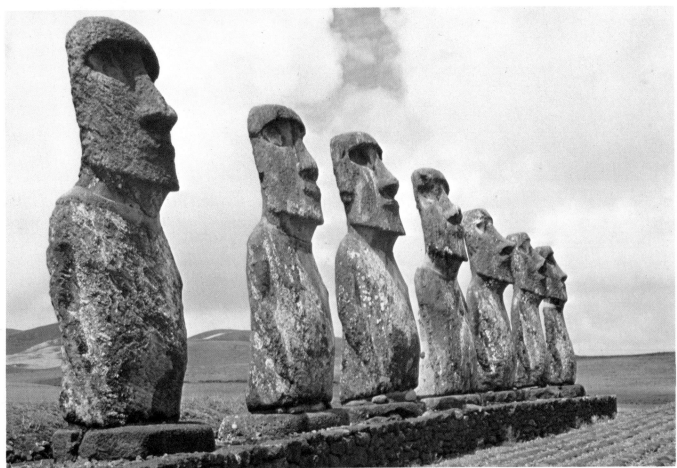

12

17

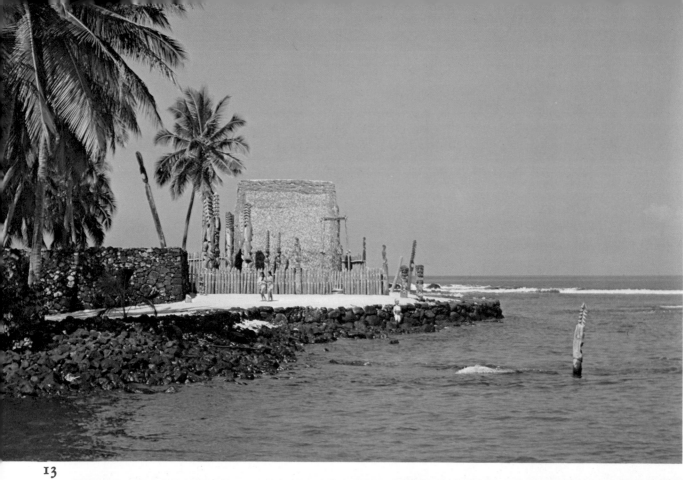

13

14

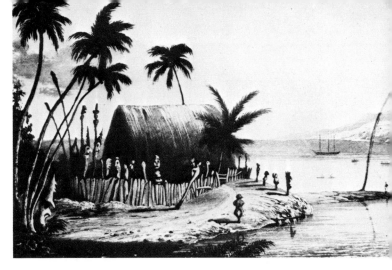

13 ◊ **14** ◊
Two scenes at Honaunau Bay, Hawaii, photographed by the author in 1969. The upper view is of the restored Hale-o-Keawe site, which is especially notable among Hawaiian temples because of its role in Hawaiian life in the eighteenth-century, its yield of extant images (including 75 and 286), and the connection with the adjoining City of Refuge (page 19), the great wall of which is seen in the lower picture (14). Honaunau Bay is situated a few miles south of Kealakekua Bay, where Captain Cook was killed. Men from the *Resolution* and *Discovery* visited the area, but the best recorded visit to the site is that of Captain George Anson Byron in HMS *Blonde* in 1825.

storms. But actually, each culture is distinctive.

The west-to-east migratory movement against contrary winds is significant. Adventurous sailors always prefer to explore into the wind, usually by taking advantage of a seasonal wind blowing against the prevailing quarter, then coming back when the prevalent wind returns. This is a common sense manipulation of winds and offers a better chance of successful exploration.

Also, Polynesians introduced plants and animals of Asian origin to Polynesia. The sweet potato (*kumara*) alone appears to have originated in the Americas. The Polynesian language itself is a branch of the Austronesia-based Malayo-Polynesian family of languages. Specific cultural features such as art forms, canoe types, myths, religions, harpoons and adzes are traceable to Asian ancestors. The souls of the Polynesian dead were believed to return to the far home called Hawaiki in the far west. There need be no doubt about general Asian origins of Polynesian culture, but this does not exclude prehistoric *Kon-Tiki* rafts from entering Polynesia and bringing South American influences to some islands. It would be equally unreasonable to deny that Polynesian canoes reached the coasts of the Americas.

The problem of routes taken into Polynesia by the Proto-Polynesians will be resolved by archaeological excavation in Micronesia and Melanesia. Sir Peter Buck favoured a Micronesian island route; however, a northern Melanesian route is now regarded as being more feasible. Probably both routes were used. Polynesians occupying outliers on the borders of Melanesia are both way-station settlers and back-tracking migrants, usually the latter. It would appear that the Melanesian islands were never permanently settled by Polynesians because of the hostility of the aboriginal inhabitants and Polynesian suscepti-bility to malaria. A "malaria line", medically speaking, separated Polynesian and Micronesian islands from the Melanesian islands.

The determinations of archaeology, linguistics, and systematic artifact typology indicate Asian affinities to Polynesian culture. For example,

15 ⌂
The Hale-o-Keawe (13) as it was at the time of the visit of HMS *Blonde* in 1825. This old view (after the artist Robert Dampier), on which modern restorations of the temple are partly based, appears in Captain George Anson Byron's *Voyage of HMS Blonde to the Sandwich Islands* ... (London, 1826). The abundant wooden images surrounding the sacred temple house were soon to be destroyed. (See page 56.) *Photo*: Bernice P. Bishop Museum, Honolulu.

A temple of the island of Kauai (259) was recorded by Webber (17).

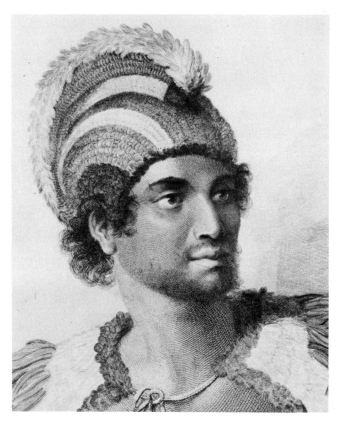

16 ⌂
An engraving entitled "A Man of the Sandwich Islands, with his Helmet", from a drawing by John Webber (17), draftsman on Cook's third voyage. (Published in *A Voyage to the Pacific Ocean ... in the Years 1776-1780*, London, 1784).

This chief is wearing a feather-covered helmet and feather cape. (Compare 260-61.) *Collection*: Alexander Turnbull Library, Wellington, New Zealand. *Photo*: author.

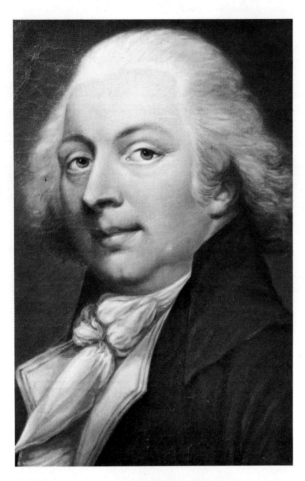

A self-portrait by John Webber, RA (*c.* 1750-93), artist on Captain Cook's third Pacific voyage of discovery (1776-80). *Photo*: author.

Webber was commissioned by the British Admiralty to the *Resolution* as ship's draftsman, and he became one of the most productive artists ever sent on a South Sea expedition. His paintings, drawings, and engravings provide an unusual wealth of detail, useful today in the study of Polynesian life and art. John Webber's personal collection of "curios", and this portrait, are kept in the Historical Museum of Bern, in his native Switzerland. Among his paintings are several portraits of Captain Cook (e.g. see 3). Webber sometimes signed himself William, and is occasionally misnamed "James", presumably in confusion with his captain. However, the native spelling of his name is Johan Weber.

◊ **18**

An engraving after Webber (17) entitled "An offering before Capt. Cook, in the Sandwich Islands". *Collection*: Alexander Turnbull Library, Wellington. *Photo*: author.

The Hawaiians, for reasons logical to their way of thinking, identified Captain Cook with the great god Lono and treated him accordingly, until they became disillusioned by time and circumstance, then they killed him in a skirmish. In this temple scene of 1779 a sacrificial pig is being offered to Cook in the presence of three officers of the expedition, all seated with the Hawaiian chiefs before two wooden images and the temple house.

◊ **19**

An engraving after Webber (17) entitled "A Human Sacrifice, in a Morai (*marae*) in Otaheiti (Tahiti)" depicts Captain Cook and some of the ships' officers being shown the interior of a Tahitian temple, Society Islands, in September 1777. *Collection*: Alexander Turnbull Library, Wellington, New Zealand. *Photo*: author.

This scene is one of the most vivid depictions of Tahitian religious custom. In it a newly-killed human sacrifice lies lashed to a pole, numerous skulls of former sacrificial victims rest on the stone platform at the back, while two boys singe a dog on a fire before adding it to the pigs already on the elevated platform. The high drums on the left are similar in type to those of Raivavae. (Compare 187.) The essential features of Polynesian religion are summarised on pages 43-4.

neolithic stone adzes of the Pacific, which have been studied intensively by Duff (1962, 1970) and others, show clearly that Polynesian adzes relate to a common dispersal which includes the adzes of India, Malaya, Thailand, Burma, Cambodia, Vietnam, south east coastal China (from the Bay of Canton to the Yangtze River), Formosa, and the Philippines. In view of all the known facts it is not surprising that maps plotting adze dispersals correlate with the spread of the Malayo-Polynesian language.

Within Polynesia itself adze differences in East and West Polynesia correlate with the diverged Polynesian languages of the two areas. The tanged-butt adze is absent from most of West Polynesia yet universal in East Polynesia. Similarly, fish-hook modifications are of significant help in determining a chronology and pattern of dispersal. Differences in early and late Hawaiian hooks, and their resemblance to Marquesan and Tahitian forms, enabled Sinoto (1968) to present well-supported theories on the origins of the Hawaiians and the sequence of their settlement of Hawaii from the Marquesan and Society groups.

The harpoon point is a sophisticated technological item that has circum-Pacific dispersal. Similar harpoons are found in the Arctic, New Zealand, the Chatham Islands and the Marquesas. Such evidence of dispersal of basic artifacts has great interpretive significance when we come to consider the origins and relationships of Polynesian art.

RACIAL ORIGINS, PHYSICAL AND MENTAL QUALITIES

Events on the Asian mainland and on the islands of Austronesia more than four or five thousand years before Christ are of great significance in the formation of the Polynesian type. South East Asia has seen each of the three races of mankind dominate, then decline, or merge in complex admixtures to form the new intermediate racial groups.

Pressures on the Asian coastal rim and island peoples, among whom were numbered the Proto-Polynesians, usually came from the north and from sophisticated civilisations. Early Chinese history has an important place in the sequence of events

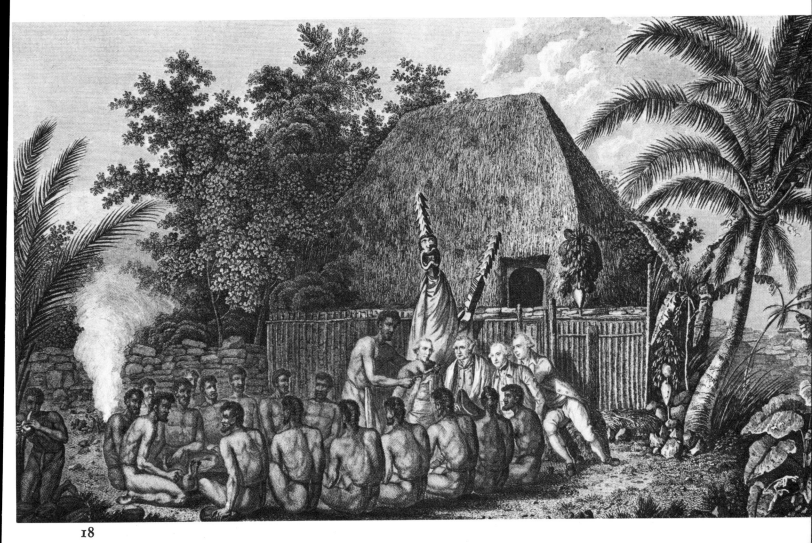

18

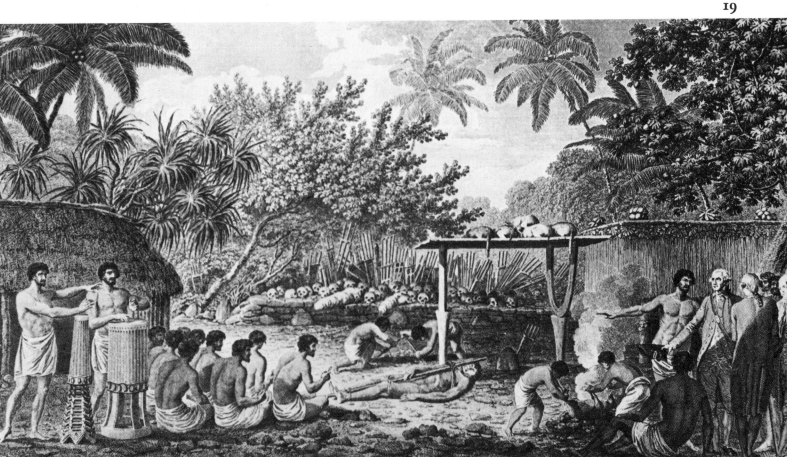

19

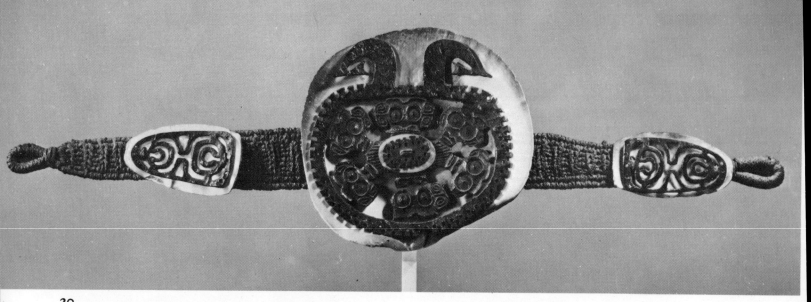

that stimulated or impelled the Proto-Polynesians and neighbours of the old Malayo-Polynesian stock to seek less populated parts or to flee from antagonistic intruders. The picture is complex and as yet not clearly defined.

The catalyst of Proto-Polynesian migration, it would seem, was the appearance of a bronze age culture in the central plain of China and its subsequent aggressive expansion. Weapons of stone and wood are never a match for metal, and the rule would appear invariable that nations with a superior technology can overwhelm those with an inferior technology. The bronze age in China emerged with the Shang dynasty (referred to as Shang, Yin, or Shang-Yin, orthodox dating c. 1766-1122 BC, or by revised chronology, c. 1500-1027 BC—chronological references in this text follow the former dating). Shang warriors used chariots, swords, armour and battleaxes with ruthless ferocity. They had little concern for the neolithic gardeners and farmers who then occupied vast tracts of the Asian mainland. Whenever the Shangs pushed out their elbows, or their successors in the Chou and Han dynasties decided to expand their domains, neolithic peoples living near or far felt the effect, in proportion to their distance.

Proto-Polynesian groups probably never confronted Shang warriors, but they felt the pressures generated by Shang expansion as well as the influence of Shang culture on the eastern and southern coasts of China and on the islands of South East Asia. Primitive Oceanic cultures were extremely sensitive to change in environment or population increase. The migratory movements of the Proto-Polynesians were undoubtedly stimulated by pressures coming out of mainland Asia, particularly at the onset of the bronze age, and by their own population increases. Overpopulation makes men restless and migratory.

Proto-Polynesian movements must have been sporadic however, and without any dramatic fleeing before an imminent enemy. From time to time, a bay too crowded for fishing in a delicately-balanced ecology would have caused a fisherman to seek another ground; a village too crowded would have sent small families to seek space with kinsfolk who lived in a less crowded village. Multiplied thousands of times over hundreds of years, such small events determined the migratory patterns, which were in due time to include the islands of Polynesia in their scope.

A stimulating new view of South East Asian prehistory is stated by Professor W. H. Solheim (1970) of the University of Hawaii. Solheim proposes that South East Asia generated much of cultural importance which found its way to China including, it would appear, bronze-working technique. This idea does not necessarily lessen the subsequent influence of Chinese bronze culture on South East Asia in the Chinese expansions that followed, (no technical skill in bronze work anywhere in Asia surpassed that of Shang or Chou); however Solheim's hypothesis does deprive China of its primary role in the development of South East Asian art (as proposed for example by Heine-Geldern, 1937, and more recently in 1966). Solheim summarises his position as follows: "The most obvious difference between my reconstruction and the traditional reconstructions based on that of Heine-Geldern is that in mine South East Asians are innovators, contributing much to world culture and in particular contributing to the foundation of north Chinese culture and its later expansion, as opposed to seeing South East Asia as a *cul de sac* with innovations and progress coming from the outside, and in particular owing much of its progress to migrations from the north, China in particular." Elsewhere Solheim (1968) indicated that bronze work is evident in north eastern Thailand as early as 2300 BC, with the chance of an earlier date quite

20 ◊

A warrior's ornamental headband. *Width*: 19¾" (49.3 cm).
Collection: Mr and Mrs Raymond Wielgus, Chicago, Illinois,
USA. *Photo*: Raymond Wielgus.

Headbands of this type were worn in the jaunty manner seen
in the portrait 21. This type of head ornament was formed by
attaching pearlshell plates of various shapes to a woven coir
base, then overmounting the plates with turtleshell fretwork.
Similar ornaments termed *kap-kap* found in Melanesia, es-
pecially in the Solomon Islands, appear to relate directly to
those of the Marquesas Islands.

21 ▽

A late nineteenth-century studio photograph (photographer
unknown) of a tattooed Marquesas Islands man, shown wear-
ing a decorative headband (20), and postured with his right hand
resting on a club of a late type (160). *Collection*: author.

The human hair ornament on this man's shoulders is old,
but the cockfeather ornaments on his wrist and ankles appear
to be a late innovation. (Compare the life-size model of a fully-
dressed warrior, 144.)

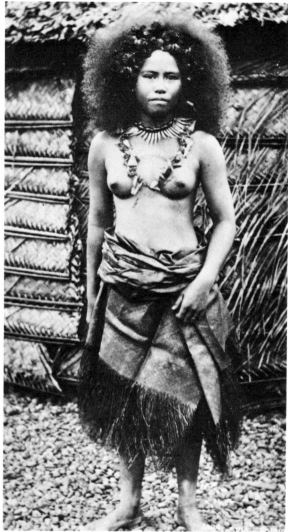

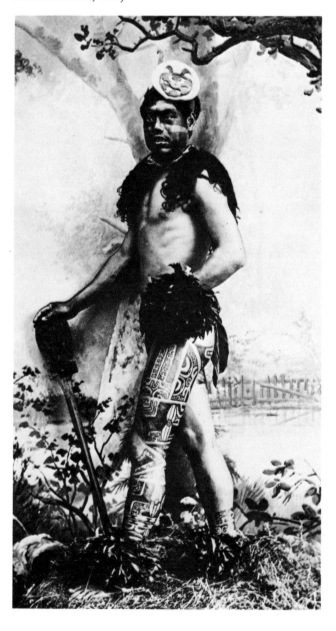

22 △

The daughter of a high chief. Western Samoa. From a photo-
graph taken in Samoa over seventy years ago by the Burton
Brothers of Dunedin, New Zealand. *Collection*: author.

This handsome girl is wearing a finely-plaited mat of a kind
that has great ceremonial significance in the Samoan islands
(see page 38), and a necklace formed from split and ground
tooth ivory of the sperm whale. In Samoa sacred maidens
called *taupou* are selected to represent the prestige of their
villages and to make appearances as dance leaders and makers of
kava on all occasions of importance.

feasible. This concept of Austronesian prehistory is
impressive to those who know the Oceanic cultures
of both South East Asia and the broader Pacific.
By the fourth millenium BC people were evidently
on the move in all directions, especially by water,
ending long isolation in many places. Malayo-
Polynesian culture expanded east and west, in the
latter extension reaching to Madagascar, while in
the former, to distant Easter Island.

For thousands of years the south Asian region
from which the Polynesians derive has been a
mixing pot of the three major racial groups of man-

23

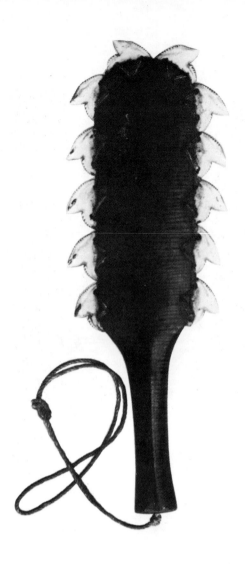

A cutting implement formed from wood, with individually attached shark teeth and a wrist thong. Hawaiian Islands. *Length*: 10″ (25.3 cm). *Collection*: National Museum of Ireland (Trinity College Collection), Dublin. *Photo*: museum archives.

A wide variety of implements and weapons with mounted shark teeth was collected from Hawaii. Related forms have been collected in New Zealand and other Pacific islands (notably weapons of the Gilbert Islands). Some of the small hand cutters of Hawaii were used in war, while others are said to have been used domestically. In the author's opinion, such implements were in some instances associated with the ritualistic dissection of human bodies. Death is referred to on page 48. Freeman (1949) notes that this specimen in the Dublin Cook Collection bears an old script label which reads: "A knife of the Sandwich Islands; with a knife of this kind Capt. Cook was cut to pieces".

◁ **25** ▷ **24**

Woven sennit casket alleged to hold the bones of King Liloa. (25, enlarged detail of five-ply coir.) Oahu, Hawaiian Islands. *Length*: 35″ (89 cm). A pearlshell disc representing the umbilicus remains attached, but the shell inlay of both eyes has been lost. *Collection*: Bernice P. Bishop Museum, Honolulu. *Photo*: author.

This remarkable casket was uplifted from the mausoleum of royalty near Iolani Palace in Honolulu when the site was transferred to Nu'uanu Valley. Buck (1957) provides the history of this casket and of a second that is similar to it in most respects. He describes the weaving technique as "vertical warps radiating from the commencement centre and single horizontal weft which makes continuous spiral turns over and under alternate warps in a check weave." Post-contact cloth and iron were found with the bones when the caskets were opened at the Bishop Museum. An impressive feature is the tight plaiting over the skull. Burial canoes and chests are known from other parts of Polynesia. The mood of many New Zealand wooden burial chests is akin to this Hawaiian coir casket. The subject of burial is discussed on page 48.

kind—Caucasian, Mongoloid, and Negroid. The stock of the Proto-Polynesians was composed of many admixtures of the three stocks before the settlement of Polynesia. Classical Polynesia had some groups possessing traits stronger in one race type than another. For example, West Polynesians received a strong Negroid strain which appears to have drived from contact with adjacent Melanesia. There is good reason to believe that the Fijians owe their basic physical inheritance to Melanesia.

The marginal islands of Polynesia present strong Caucasian strains, presumably because the earliest Proto-Polynesian migrants out of Austronesia had less contact with invading Mongoloids than did their rearguard. A study of East Polynesian skulls reveals that the early Polynesians were predominantly long-headed (dolichocephalic), a trait strong in Caucasians, while later groups showed much roundheadedness (brachycephalic), which is the head form dominant in Mongoloids. Roundheadedness is predominant in West Polynesia today, as it is in Micronesia. The picture is one of strong Caucasian traits in early groups with Mongoloid elements increasing in areas that continued to receive settlers from the west. Negroid strains are always present, being most pronounced where Melanesian islands are adjacent.

Particular physical features found in the populations of some islands may be explained by microevolution with gene mutation. It is a biological rule that any isolated group of creatures that inbreeds for centuries within one environment is liable to acquire shared characteristics within a relatively short period of time. Selective breeding was practised by Polynesians. Chiefly persons, male or female, were considered ideal when tall, stout, and of light skin. The intermarriage of nobles tended to reproduce the preferred physical type.

The Polynesian physical type is well known from novels, photographs, and depictions in art, especially in the masterly work of Paul Gauguin. Yellowbrown to dark-brown skin colour, well-structured body, brown to black straight or wavy hair, constitute a physical type attractive to Westerners. Young Polynesian women were regarded as great beauties by early visitors and were highly praised for personal charm.

The personal qualities of the Polynesians were such that they met Europeans on their own level, thus developing a mutual respect. This contrasted

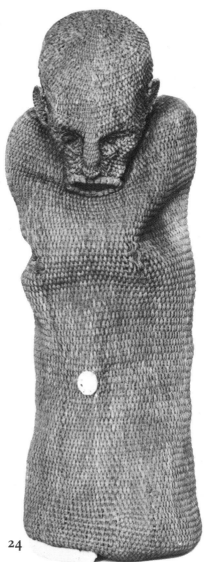

24

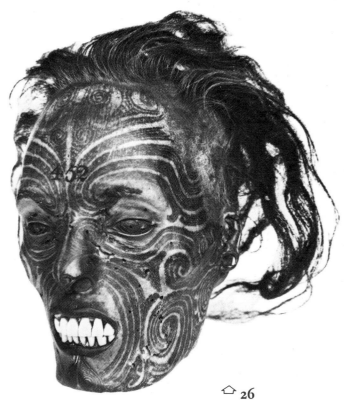

⇧ 26

The mummified head of a Maori chief. New Zealand. Life size with skull intact. *Collection*: Pitt Rivers Museum, Oxford, England. *Photo*: author.

The Maori custom of preserving the heads of both friends and enemies of consequence was rooted in ancient beliefs relating to the magical power of the head. The New Zealand technique of mummification by steaming, smoking, and oiling, after the removal of the brain, was extremely effective in retaining individual identity. Throughout Polynesia the skull was awarded reverential treatment if the deceased was of sufficient social status. (See page 50.)

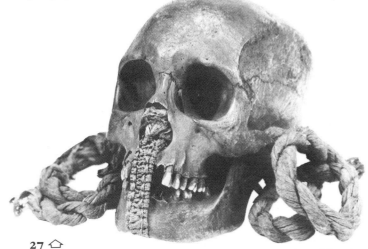

27 ⇧

A skull with coir plait holding lower jaw to cranium and fitted with twisted barkcloth carrying cords. Marquesas Islands. *Collection and photo*: Field Museum of Natural History (A. W. F. Fuller Collection), Chicago, Illinois, USA.

The Marquesans shared with the New Zealand Maori an extreme indulgence in the ferocious arts of war and cannibalism. The reverential preservation of family heads and the scornful hoarding of the heads and skulls of enemies were praiseworthy and right in parts of Polynesia.

25

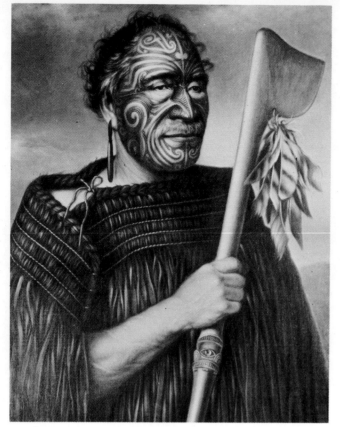

28 ⇧

An oil portrait of Tamati Waka Nene, by Gottfried Lindauer.
Collection and photo: Auckland City Art Gallery, New Zealand.

Tamati Waka Nene, distinguished chief of the Ngapuhi
of North Auckland, was one of the most renowned of all
Maori leaders in the nineteenth century. He is shown here with
his fine facial tattoo, wearing a jade ear pendant and rain cloak,
and carrying a long club of the *tewhatewha* form. This type has
spatulate blade weighted by a projecting end-lobe set opposite
its striking edge. A bundle of split hawk feathers attached below
the lobe was used to help to distract the opponent when open-
ing feints were made in fencing. A Janus mask is cut on the
shaft.

with eighteenth and nineteenth century contacts
with the Melanesians and Australian Aborigines,
who could not communicate easily with Europeans.

To the Westerners, the Polynesian mental quali-
ties included quick intelligence, ready grasp of
social relationships, a code of honour compre-
hensible to them, a sense of obligation, great
curiosity, polite manners, and confidence in them-
selves. Their unattractive side included habitual
thievery, treacherous scheming, merciless treatment
of captives, and an insatiable thirst for revenge.
These negative attributes they shared with the worst
of the hard-bitten European seafarers with whom
they had to deal, so in general Polynesians were
well-fitted to deal with all comers. Unfortunately,
they were not prepared to fight introduced diseases
and rum, nor to handle firearms wisely. Their own
codes obliged them to bloody slaughter, which they
could not control when they acquired firearms.
Such objects, events, and new ideas, both good and

bad, contributed to the end of traditional Polynesian
craftsmanship.

A CHRONOLOGY OF SETTLEMENT

As almost all extant Polynesian artifacts were
collected directly from Polynesians within the
historic period, so extant collections represent a
period limited in time. Apart from objects excavated
from archaelogical sites which date well before the
contact period, we are concerned primarily with
artifacts from either the classical contact phase or
the following post-contact period.

Study resources are the artifacts themselves,
travellers, journals, museum records, ethnographical
bulletins, comparative studies, and archaeological
determinations in chronology and artifactual
sequences. As noted above, certain basic artifacts,
such as the adze and fish-hook, provide reliable
evidence of cultural dispersal and local evolution.
Changes in form suggest newcomers to an island,
local developments brought about by environ-
mental needs, or both.

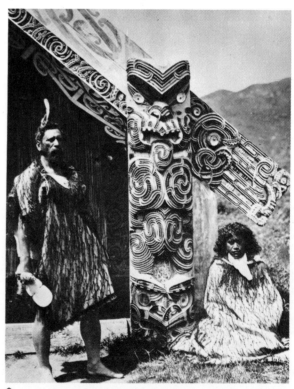

29 ⇧

A chief (with his wife) holding a whalebone short club at the
front of a tribal meeting house. New Zealand. *Photo*: Dominion
Museum, Wellington, New Zealand.

Maori life was in most respects conditioned by the stress of
constant tribal conflict and the need to plan for survival either
by attack or by effective defence. Muskets caused mass slaughter
in post-contact times and ended traditional concepts of warfare.
In New Zealand, entire carving schools of great accomplish-
ments ended in territories where the musket wars terminated the
old way of life.

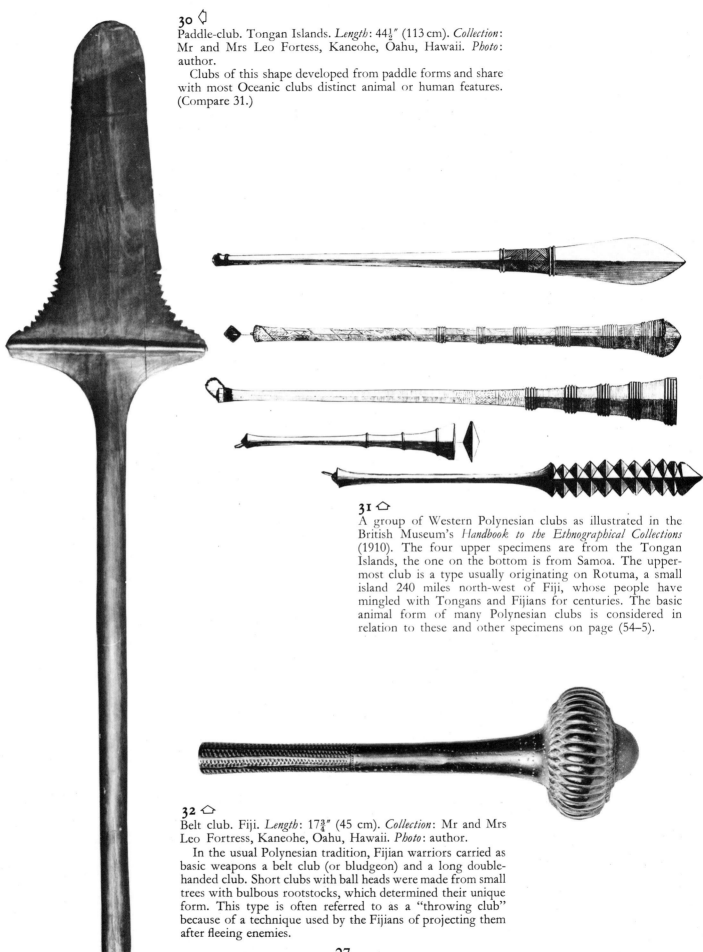

30 ◁
Paddle-club. Tongan Islands. *Length*: 44½″ (113 cm). *Collection*:
Mr and Mrs Leo Fortess, Kaneohe, Oahu, Hawaii. *Photo*:
author.

Clubs of this shape developed from paddle forms and share
with most Oceanic clubs distinct animal or human features.
(Compare 31.)

31 ⬆
A group of Western Polynesian clubs as illustrated in the
British Museum's *Handbook to the Ethnographical Collections*
(1910). The four upper specimens are from the Tongan
Islands, the one on the bottom is from Samoa. The upper-
most club is a type usually originating on Rotuma, a small
island 240 miles north-west of Fiji, whose people have
mingled with Tongans and Fijians for centuries. The basic
animal form of many Polynesian clubs is considered in
relation to these and other specimens on page (54–5).

32 ⬆
Belt club. Fiji. *Length*: 17¾″ (45 cm). *Collection*: Mr and Mrs
Leo Fortress, Kaneohe, Oahu, Hawaii. *Photo*: author.

In the usual Polynesian tradition, Fijian warriors carried as
basic weapons a belt club (or bludgeon) and a long double-
handed club. Short clubs with ball heads were made from small
trees with bulbous rootstocks, which determined their unique
form. This type is often referred to as a "throwing club"
because of a technique used by the Fijians of projecting them
after fleeing enemies.

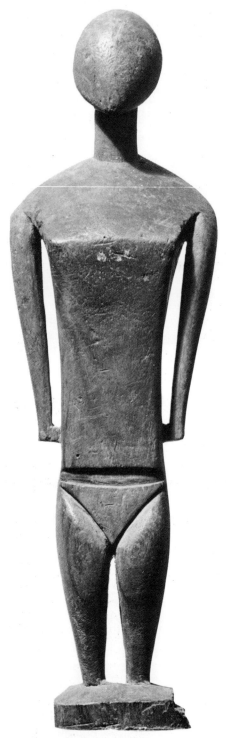

33 ⌂

A highly conventionalised human image from Nukuoro, Caroline Islands. *Height*: 15½″ (39.4 cm). *Collection*: Honolulu Academy of Arts, Hawaii. *Photo*: author.

The austere abstraction of this figure is typical of the sculptured images of this atoll. Nukuoro is one of a series of islands outside the Polynesian triangle inhabited by a people whose physical type, language, and culture are clearly Polynesian. These "outliers" are considered on page 13. Nukuoro atoll is a reef with some forty islets clustered on all except its western side. The making of these beautiful images was restricted to a certain area, and the sizes range from twelve inches to about seven feet in height. They are presumed to represent ancestors but they may be symbols of gods.

Detailed discussion regarding Polynesian dispersal is beyond the scope of this study; however, a general chronology should be determined. Scientific progress in recent decades has made it possible to give the settlement of Polynesia a general time scale which can be related to various arts.

The establishment of a scientifically reliable chronology for Polynesia was made possible by the discovery of the Carbon 14 technique of measuring the degree of radioactive carbon in organic matter. Since disintegration proceeds at a known rate, the relative age of a specimen is determined by the measurement of remaining activity, which is then compared with the absolute scale. This revolutionary discovery has been applied in Polynesian archaelogy over the past two decades with much success. When its dates are related to typological studies, glottochronology, traditional accounts of origins, and generations in island genealogies, a clear picture of Polynesian settlement develops. However, the final picture, specifically detailed, cannot be expected for two more decades. Other methods of scientific dating should help provide a very accurate chronology in due time.

Two modern presentations of a Polynesian chronology based on careful research are presented below. The first, by Roger Duff (1969), is most conveniently found in the handbook entitled *No Sort of Iron*. The second, by Bishop Museum anthropologists, was secured for use here through personal communications with Drs Emory and Sinoto (see also Sinoto, 1968). Both Duff and the Bishop Museum are in fundamental agreement.

Duff defines five phases in Polynesian cultural evolution:

(i) Proto West Polynesia, 500 BC–100 AD. Sites go back to perhaps 500 BC in Tongatapu, 100 BC in Samoa. (Duff omits consideration of Fiji in terms of dating.)

(ii) Early East Polynesia, 500–1100 AD. Following the settlement of West Polynesia there emerges a distinctive Eastern sub-culture with the Marquesas serving first, yet briefly, as a point of canoe dispersal to Hawaii, Mangareva, and Easter Island. Later the Society Islands served as the primary point of dispersal for marginal Polynesian settlement.

(iii) Resettlement Phase, 1100–1400 AD. Following a population build-up as a result of successful horticulture and a probable first introduction of the *kumara* further migrations from the Society Islands occurred. This included second-phase settlements of certain groups already located, thus introducing late Polynesian intrusions.

(iv) Classical Phase, 1400–1770 AD. This phase is characterised by local cultural developments within groups, progressive isolation owing to loss of deep-sea navigation skills, and the emergence of the distinctive characteristic features of particular groups. For example, the nephrite ornaments, perpetual tribal warfare, the great war canoes, and elaborate wood-carving styles of the New Zealand group.

(v) European Contact Phase, 1770–1820 AD. The last period is the era of foreign offshore contacts which preceded mass religious conversion and the intrusion of Western commercial and political influences and new ideas. This caused the Polynesians to set a new course in art and in life. The period saw a brief flowering of carving art, when metal tools gave a technical freedom which remained restrained for a time by traditional craftsmanship and Polynesian religious ideas.

The Bishop Museum chronology for settlements is primarily based on Carbon 14 samples, the study of artifact typology, and other data. Carbon samples are from the oldest known sites. However, it is probable that new discoveries will push all dates back a century or two. The Bishop Museum anthropologists suggest the following sequence:

(i) Fiji, 1500 BC.
(ii) Tonga, 500 BC.
(iii) Samoa, 300 BC.
(iv) Marquesas (from Samoa) 300 AD.
(v) Hawaii (from Marquesas) 750 AD; second migration (from Society Islands) 1250 AD.
(vi) Easter Island (from Marquesas) 800 AD.
(vii) Society Islands (from Marquesas) 850 AD.
(viii) New Zealand (from Society Islands) 900 AD; second migration (from Marquesas) 1000 AD.
(ix) Mangareva (from Marquesas) 1200 AD.

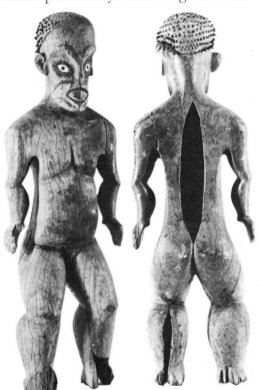

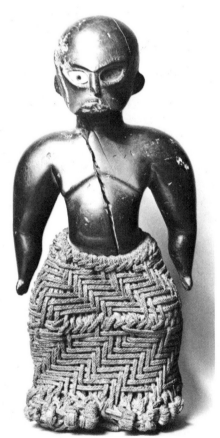

34 △ △ 35
Front and back views of an image believed to represent the poison god, Kalaipahoa. Oahu, Hawaiian Islands. *Height*: 36" (91.4 cm). *Collection*: Bernice P. Bishop Museum, Honolulu. *Photos*: author.

 The long elliptical cavity in the back, designed to accommodate substances used in sorcery, and six black lizards painted on the face, help to confirm the identification of this sinister figure. The holes around the out-thrust tongue indicate that the mouth formerly held human incisor teeth, while the numerous wooden plugs and remnants of hair on the scalp show that this figure formerly had abundant hair (probably in the style of 75).

36 ▷
An image with a unique coir sennit skirt. Hawaiian Islands. *Height*: 15½" (39.4 cm.) *Collection*: Bernice P. Bishop Museum, Honolulu, Hawaii. *Photo*: author.

This image of highly-polished hardwood has an eye inlay (one inset missing) and an out-thrust tongue. The coir sennit skirt covering the lower parts has plaited knobs, representing toes. The Hawaiians excelled in doing heavy braid work, as may be seen elsewhere (24, 25). The symbolism relating gods with coir sennit is considered regarding Polynesian religion on page 55.

Polynesians are classified by anthropologists as neolithic fishermen and gardeners. Micronesians and Melanesians share this description. Oceanic people were also primitive farmers, as they kept domesticated pigs, dogs, and fowls. The rat went along as a stowaway on canoe voyages and was added to the food list as a welcome addition to a limited diet. Animal protein was always in short supply. An occasional stranded whale, an odd seal, porpoise, or flying fox (in West Polynesia), or human flesh (in some islands) supplemented pig and dog meat.

The failure to introduce the pig to any group, as happened in New Zealand and Easter Island, was a great loss, as the pig was to Oceanic peoples the king of beasts for many good reasons. It flourished on virtually anything, loved coconuts, and was fertile even in hard environments. Also, roast piglets were important ceremonial gift items.

The basic food-plants and otherwise economically useful plants that were carried on settlement expeditions included the coconut, breadfruit, banana, sugarcane, sweet potato (*kumara*), yam, arrowroot, cordyline (*ti*), Lagenaria gourd, *kava* pepper, and *tumeric*. Indigenous plants were exploited too, a good illustration being the New Zealand flax, which became indispensable to classical Maori culture.

Both the ultimate origin of the sweet potato and the extent of natural groves of coconut palms at the first settlement of Polynesia remain under speculation by ethno-botanists. The flora and fauna of Polynesia, both indigenous and introduced, are conspicuously of Asian origin.

CANOES, SEAFARING, AND FINDING ISLANDS

The islands of Polynesia were found and settled in a comparatively short span of time after voyaging canoes, techniques of seamanship, and skill in transporting plants and animals had been adequately developed by the Proto-Polynesians. The outrigger float, which gave stability to dugouts, played an important role in the development of oceangoing canoes. In fact it dispersed with the Malayo-Polynesians as far west as Madagascar and to the eastern extremity of Polynesia, namely Easter Island.

The double canoe or catamaran, which may have developed from the outrigger, or vice versa, served as the Polynesian workhorse of deep sea voyaging. These vessels were massive in size and capable of outsailing any European vessels of the eighteenth century both in speed and in sailing to windward. Some changed tack quickly by having the crew carry the lower point of the lateen sail from one end of the hull to the other—thus converting, at each change of tack, bow to stern.

Early visitors to Polynesia were much impressed by the sailing ability of canoes. Accurate models convey their seaworthy qualities to anyone familiar with practical sailing. In fact, the term "canoe" is something of a misnomer. It evokes ideas of a narrow, flimsy craft, when actually the largest vessels were true ships. The great sailing canoes of Fiji could exceed 100 feet in length, sail at fifteen knots before a strong wind, and carry 200 warriors, or heavy cargo with passengers.

Polynesian canoes were capable of sailing anywhere, given provisions, crew, and skilled navigators. The basic problem of Polynesian voyaging is found in the question: How did seafarers get to predetermined points without compass or chronometer? Latitude could be more or less fixed without instruments, but longitude required either chronometer or elaborate astronomical observations by sextant. The truth is that we do not know exactly how Polynesians navigated, only how they could have navigated. We know they watched movements of sun, moon, and stars, and knew of the existence of numerous islands.

Tupaia, the pilot-priest Cook shipped from Tahiti in 1769 during the first voyage in the *Endeavour*, named 130 islands that he had visited or of which he had knowledge, and helped to compile a chart of them. Most of the islands that he named may be identified, in spite of the inconsistent orthography used for Polynesian names at that time. The island noted farthest west is Samoa. Also, Tupaia described the characteristics of the inhabitants of many islands, saying, for example, that the Marquesans were cannibals and had "canoes longer than the British", thus making his knowledge all the more remarkable.

Tupaia did not name New Zealand, Hawaii, or Easter Island in his list of islands. Therefore we must reason that contact with those groups had ceased many hundreds of years before the eighteenth century, and either that knowledge of them had been erased by time or, less likely, that they were never reported in Tahiti. We can, however, attribute the skill of Tupaia to the training of the priestly cult of navigator chiefs who had, it would appear, the ability to guide canoes over trackless seas. On the voyage of the *Endeavour* across the Pacific to Batavia this Tahitian, when asked, pointed in the direction of his home. Quick compass checks always confirmed Tupaia's indication.

Stars and sun, wind direction, swell movement, currents, flight patterns of migrating or land-based birds, drifting debris, cloud pillars, under-cloud

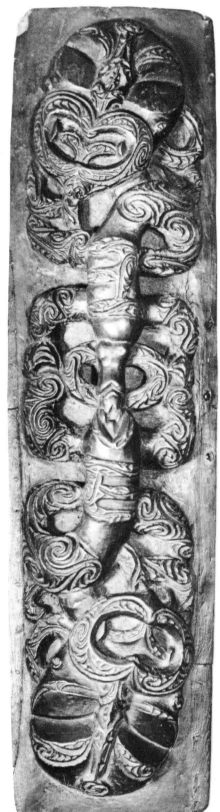

38 ⬦
An oval stone with incised human vulvae. Easter Island. *Length of stone*: 10⅝″ (27 cm). *Collection*: Bernice P. Bishop Museum, Honolulu. *Photo*: author.

The vulva was used in abundance as an art motif on Easter Island, in relation to fertility magic. Stones such as this and skulls with incised foreheads (some with the vulva symbol) were placed in chicken runs to aid and protect egg production. Petroglyphs and certain wooden images of Easter Island are liberally decorated with vulvae, and the vulva symbol appears as a character on the talking boards (256-58).

37 ⬦
The lid of the treasure box 295. New Zealand. *Length of box*: 15⅜″ (39 cm). *Collection*: Peabody Museum, Salem, Massachusetts, USA. *Photo*: author.

Sexual themes pervade Maori carving to an extent found nowhere else in Polynesia. Male and female figures are often shown in sexual union, as on this box lid. Similar figures occur on the base of the same box (295). The subject of sexual symbolism in Polynesian art is reviewed on page 57.

39 ⬦
Stone flax pounder. New Zealand. *Height*: 9½″ (24 cm). *Collection*: Mr and Mrs Leo Fortess, Kaneohe, Oahu, Hawaii. *Photo*: author.

Polynesian stone pounders are frequently of phallic form, those of New Zealand and the Marquesas Islands (150) being notably so. A general note on the significance of the phallus in Polynesian art is on page 57.

reflections, water colour, land smell and the pointing of pigs and dogs, the sound of distant surf and ground swell motion, all provided clues to finding or relocating islands. Most islands are in fact encircled for about fifty miles seaward by evidence of land presence. The peaks of elevated islands are in some instances visible for 100 miles in clear weather.

The pathfinding skills of primitive man were studied intensively by Harold Gatty (1958), who was a pioneer navigator of the trans-Pacific air route when air navigation was elemental. It is not unreasonable to admit the possibility that prehistoric man shared with his fellow mammals some of the directional sense that has baffled scientific analysis; nevertheless, Gatty did not attribute the so-called "homing instinct" or "sense of direction" to a sixth sense, but believed in the remarkable effectiveness of trained observation.

The old-time Polynesians had no instruments of navigation, but they knew exactly where and when particular stars would lift above the horizon and under which stars particular islands were to be found. The sidereal, or star compass, was remembered by the use of rhythmical chant. Obscured skies, however, left no option but to rely on wind and swell direction until skies cleared. Thousands of canoes must have been lost during the epic settlement of Polynesia, and thus hundreds of thousands of men, women, and children must have perished.

SOCIAL STRUCTURE

Polynesian social structure varied in form from group to group but was basically one of chiefs, commoners, and slaves. Tribal kinsfolk grouped in villages under hereditary chiefs. Blood ties with other clans obligated friendship unless there was a real cause for enmity. Tribes without genealogical connection to one's own tribe were regarded with suspicion and unworthy of mercy in time of war.

Marriage took several forms. Monogamy was regarded as undesirable, polygamy being the rule in the form of multiple wives (polygyny), or rarely, as in the Marquesas, multiple husbands (polyandry).

Sexual rights usually extended to one's brother's wife. Brother and sister marriage took place in some areas to conserve and multiply chiefly mana. The young were encouraged to experiment sexually with their friends, both for pleasure and for sorting out compatible and fertile partners. Chiefs enjoyed any woman they fancied, but commoners kept to their peers.

Democratic feeling was at a low ebb in old Polynesia. A man was what he was born, be it aristocrat, commoner, or slave. High chiefs held the power of

40 △
A pair of reptilian monsters (*taniwha*) drawn in charcoal on the ceiling of a natural limestone shelter. *In situ*, Tengawai Gorge, South Canterbury, New Zealand. *Length*: 16′ (4.88 m). This drawing is reproduced by courtesy of H. D. Skinner (1964).

The relationship of lizard and crocodilian forms to Polynesian art is a fascinating subject in which speculation and reasonable assumption are vital to any true view of the motif. (See page 54.)

44 △
A sheet of barkcloth. Western Samoa. *Collection and photo*: United States National Museum, Washington, DC.

The design of this *tapa* is based on rectangular compartments, with two different patterns used repeatedly in chequerboard fashion. The light base pattern is block-printed, then a secondary pattern is overlaid by hand, using dark pigments. (See page 37 for a general note on *tapa*, and compare styles of other areas: Hawaii, 48 and 288; and Marquesas, 148-49.)

The underside of a decorated gourd bowl. New Zealand. *Length*: 15″ (38 cm). *Collection*: Dominion Museum, Wellington, New Zealand. *Photo*: author.

An effective Maori technique of gourd decoration was that of scratching through the rind of a fresh gourd, then adding black pigment later to accentuate the incised lines. As this technique was a form of free drawing, and because the gourd surface is convex, the curvilinear patterns of Maori art (seen illustrated as a rafter pattern, 88) were favoured in gourd decoration.

▽ 45

41 △
A flute with lizard design, made from a human thighbone. New Zealand. *Length*: 5¾″ (14.5 cm). *Collection*: British Museum, London. *Photo*: Dominion Museum, Wellington, New Zealand.

△ 42

Lizard resembling a crocodile, from the handle of a ceremonial adze (similar to the adze 296). New Zealand. *Length*: 5¼″ (13.3 cm).

This reproduction is from a crayon rubbing taken by the author from an adze in the collection of James Hooper, Sussex, England.

◊ 43
Detail of a feather cloak. New Zealand. *Collection*: Alexander Turnbull Library, Wellington, New Zealand. *Photo*: author.

The mixed feathers of this cloak include native pigeon (*kereru*), ground parrot (*kaka*), *tui* and exotic peacock. The pattern is an arrangement of triangles set on a base of flax fibre. New Zealand featherwork is technically much simpler than that of Hawaii; however, when viewed in terms of aesthetics, at its best it equals Hawaiian work. (Compare 260-65.)

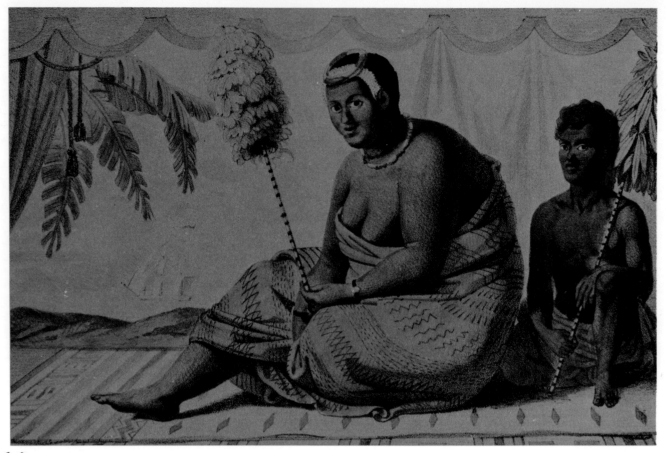

46 ⌂
Queen Kaahumanu, the favourite wife of the famous Hawaiian king, Kamehameha I. From a painting by Louis Choris, who visited the Hawaiian Islands with the Russian imperial navy (1816–17). *Collection*: Honolulu Academy of Arts, Hawaii. *Photo*: museum archives.

Queen Kaahumanu and her attendant hold sacred feather wands called *kahili*. Kaahumanu wears *lei*-type feather head ornaments, a necklace of ivory beads mixed with trade beads, and a dress of decorated barkcloth.

life or death over the people. If a great chief became too tyrannical the lesser chiefs, aided by the power of popular opinion, could bring about his humiliation by one means or another. Slaves were born slaves within the tribe or were prisoners-of-war. Regardless of rank, if a man or woman was taken into slavery all mana departed from that person. There was no greater disgrace than capture and slavery, so even one's own tribal doors closed without pity on the unfortunate captive. Death in battle was accounted glorious and, considering the alternatives, to be preferred.

Captives accepted their new social role with stoic indifference, and few attempted to escape. The majority yielded with a strange unconcern to death as human sacrifice or to supply human flesh for the chief. It was considered extremely improper for a slave to attempt to escape, and if captured sudden death was his or her reward.

Chieftainship was hereditary in most island societies; however, there was no firm rule of succession. Transmission of power through the male line was usual, although not necessarily from father to eldest son. Some islands favoured a matrilineal inheritance. In Samoa the usual heir was the eldest surviving brother of the deceased. In the absence of a male heir a daughter might receive all the prerogatives of chieftainship. A dying chief could choose to nominate a successor. In troubled times when society was in flux commoners sometimes assumed the power of nobles through fighting prowess or political shrewdness, but this was rare.

Genealogical chants were memorised and were as valid as legal documents in questions of ancestral rights. In making a claim a well-born chief might repeat unfalteringly fifty generations of his ancestors, the most distant being the gods themselves. Recitation of genealogical succession was aided by notched staves in New Zealand, and by knotted strings or *quipu* in the Marquesas. The chants were often rhythmical, as the words of a song or metred poetry are remembered readily.

Position on the genealogical tree determined not only the status of a chief but his kin and his claims on other tribes. Those who could demonstrate the least distance between himself and the primal ancestors could claim the most mana. "Good" blood ties were vital in politics and war; there

▽ 48
Detail from a sheet of barkcloth, the decorative motif of which is derived from human legs. *Collection*: Bernice P. Bishop Museum, Honolulu. *Photo*: author.

The sophistication and complexity of the superb art of Hawaiian *tapa*-manufacturing techniques are exemplified in the classic work of Brigham (1911), who lists 207 terms relating to the craft. The limb pattern is cleverly obtained by the use of a single small stamp and by colour washed on alternate rows. Several plants were used as a source of fibre, the papermulberry being favoured over others: it had been carefully introduced by the Polynesian settlers of Hawaii. (See page 37 for a note on *tapa* craft.)

47 △
Finely-plaited ornamental fan. Hawaiian Islands. *Collection*: Peabody Museum, Salem, Massachusetts. *Photo*: author.

Hawaii has in common with many other islands two types of fans: the ordinary coconut leaf fan which was quickly made, and the finely-plaited pandanus leaf fan the making of which called for highly-skilled craftsmanship. (Compare 157 and 214.) The ceremonial use of fans as symbols of prestige and power is considered on page 55.

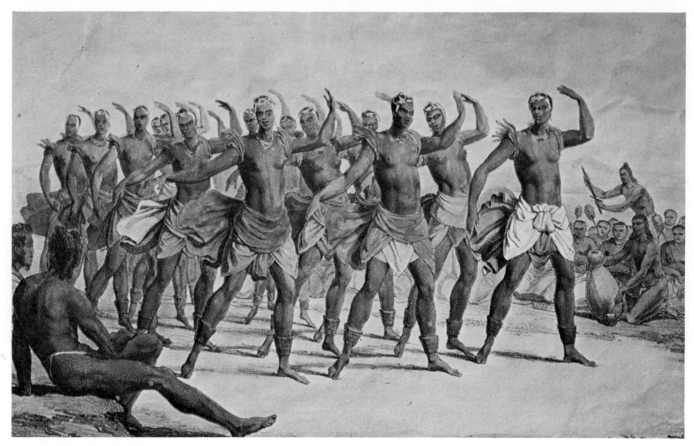

49

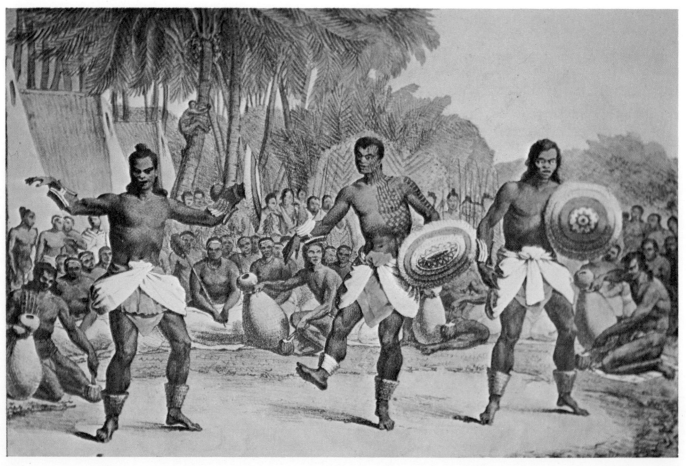

50

could be advantage even with enemies if a blood link could be cited.

Revenge obligation determined much Polynesian behaviour. Blood-letting was the only balance for blood lost by a kinsman, and any victim served, provided he was tribally related to the offender. Not to take revenge was weakness. Words in themselves were regarded as having magical power. A spoken threat was thought to be the same as the deed, so revenge was obligatory on the mere hearing of a threat or insult. No insult was greater than to have one's body compared to food, especially to cooked food cast out as unfit to eat. To have a relative eaten or his head taken caused terrible unrest until the blood account was balanced. Unfortunately, the balancing of one side upset the accounting of the other, so tribal feuding was perpetual.

DAILY LIFE IN POLYNESIA

The everyday life of Polynesia was apparently idyllic. The absence of clocks, vehicles, banks, books, iron, alcohol, guns, and virtually everything else that make up modern urban life allowed a natural rhythm to prevail. If the times were peaceful and food in good supply, Polynesian life looked ideal. Rousseau's followers, who held that primitive man was naturally innocent and well-behaved, found support for their theories in the more romantic journal descriptions of the South Seas and in the graceful engravings that illustrated them. This was one side of the coin.

Affectionate relationships existed between near kin, while communal effort was the rule in work and in play. Leisure-time activities included kite-flying, top-spinning, ball-tossing, knucklebones, swinging

49 ▷ 50 ◁

A group of female dancers (upper study), and a trio of male dancers (lower study) are portrayed in lively *hulas* at the court of Kamehameha I, Hawaiian Islands. *Collection*: Honolulu Academy of Arts, Hawaii. *Photos*: author.

These two coloured lithographs after Louis Choris appear in an account of the Russian imperial navy's visit to the Hawaiian Islands (1816–17), *Voyage pittoresque autour du monde, avec des portraits de sauvages* ... (Paris, 1822). The statuesque women wear abundant ornaments. The men are tattooed and wear anklets made from thousands of dog incisor teeth. (See page 40 for general observations on Polynesian dance and music.)

▷ 51

A group of girls dancing before a noblewoman. Tongan Islands. From a work by Piron in Labillardière's *An Account of a Voyage in search of La Pérouse* (London, 1800). *Collection*: Alexander Turnbull Library, Wellington. *Photo*: author.

This idyllic scene, with girls who look more like classical Greeks than classical Polynesians, illustrates the romantic mood of the times and the visionary notions of Polynesia held by Europeans of the age. The interesting view of Europeans in the exotic South Sea is discussed on page 12.

the bullroarer, dancing, story-telling, surfing, archery, boxing, wrestling, stilt-walking, playing instruments, making string-figures, sliding or tobogganing, playing draughts, swimming, sitting and chatting, or just gazing out to sea.

Certain trees and plants had great labour-saving value. The coconut palm provided almost everything necessary to sustain life; on coral atolls it was indispensable. It is the Pacific's tree of life. Its trunk provided wood, its fronds thatch, and its nut yielded oil, flesh, and refreshing liquid. From coconut husk fibre was made rope for hauling, cordage for canoes, fine sennit to lash adzes and even to represent the gods. The coconut was so treasured that its fruit was usually made taboo to women. Where the coconut palm did not grow its memory was often preserved in a name, as in the New Zealand nikau palm and in an Easter Island amulet. According to Samoan belief the first palm grew from the severed head of Tuna, the eel lover of Sina, who still shows his face at the end of a husked nut. Also, the pandanus tree had a special place in primitive Polynesian economy, as it provided materials for thatch, baskets, mats, and canoe sails.

The papermulberry yielded fibrous parts which after soaking were beaten into sheets of barkcloth. This *tapa* was made throughout Polynesia in various grades, the inferior kind being of breadfruit or wild fig. Beaters and related implements varied in form from place to place, as did the skill of the women who practised the craft. Notable skill in this art was developed in the Society Islands and Hawaii. Texture, weight, colour, and decoration were planned according to the use of the cloth.

HOUSES AND FURNITURE

The houses of Polynesia varied from group to group and were typically formed by posts, rafters and ridge set up in a rectangular plan. Size and

style of structure were adapted to the needs of local climate and society. Stone bases were usual in tropical islands, while closed low houses were typical of the subtropical islands. In temperate New Zealand some dwelling houses had their floors below ground level.

Houses indicated the status of the owner by base and ridge height and decoration. Parts were tied together, often with elaborate lashings. Houses were planned and situated according to function, to house men, women, guests, the sick, priests, gods, bones, canoes, fishing tackle, foods, or chickens. Late New Zealand carved tribal meeting houses are the most spectacular in Polynesia because of their size, carved work, and painted rafters. (The relationship of the elaborately carved nineteenth century Maori meeting house to its austere progenitor is not yet determined.)

Every house of importance had a name and was respected as a living organism. In New Zealand where the tribal meeting house is symbolic of a primal ancestor, the ridge beam represents the ancestor's backbone, the rafters his ribs, the barge boards of the facade his outstretched arms, and a pinnacle mask his face.

Domestic utensils and house furnishings varied in kind and quality according to the rank of the occupants. Seats and head pillows were reserved for the use of chiefs, height and size again being significant. Mats and *tapa* of various grades provided bedding. Wooden bowls, platters, coconut cups, leaf baskets and blinds, pounding boards, breadfruit splitters, stone and obsidian flakes, carrying poles, hangers, shell vegetable peelers, spittoons, and similar items make up the principal domestic utensil list.

Fire was generated by wooden fire plough. However, fire made for one purpose could not be used for another; for example, fire made for cooking could not be carried to a chief's house for light. Cooking fires were separated on the basis of sex and rank,

thus causing irksome multiplication in daily domestic tasks. Men performed the heavy tasks of cooking.

Taboo imposed many inconveniences in domestic life, the objective always being to avoid the pollution of mana. In Hawaii domestic taboos were so strict that a commoner or slave was killed if his shadow fell on the house of the high-born. Even an inadvertent crossing into unmarked ground belonging to a chief's house might bring death to the offender, as could the touching of anything that was personal to the chief.

EXCHANGE OF GOODS

Polynesian society functioned without money. Payments were made by gift, or the receiver assumed obligation to repay. Certain items were traded by exchange from place to place, such as the nephrite of southern New Zealand for products of its more fertile North Island; but systematic exchange was rare. In Samoa and Tonga fine mats fringed with red feathers and sometimes honoured by personal names changed hands on all occasions of importance. Particular mats became family heirlooms and if parted with could pass through many hands before returning to the family.

The *tambua* of Fiji were vital to social transactions. They were used primarily in asking favours of chiefs in matters relating to marriage, war, and peace, or in the installation of new chiefs. A *tambua* was presented to the petitioned person, whose acceptance of it implied assent to what had been proposed. The usual *tambua* is made of a spermwhale tooth; however, old grave specimens indicate that wooden *tambua* in the form of cachalot teeth were in use in prehistoric times.

FOOD SUPPLIES

Village supplies were maintained by horticulture, fishing, fowling, the foraging of land and coasts, and slaughter of the three domesticated animals,

52 ⌂
An unfinished stone adze of the triangular cross-section "hogback" type. Cape Palliser, New Zealand. *Length*: 13" (33 cm). *Collection*: Dominion Museum, Wellington, New Zealand. *Photo*: author.

This adze has reached the stage of secondary flaking and

hammer dressing and is ready for the final grinding of the surfaces. In this unfinished stage it illustrates the mastery of Maori adze manufacture far better than if it were a finished, polished specimen. (See page 59 for notes on the stone tool culture of the Polynesians.)

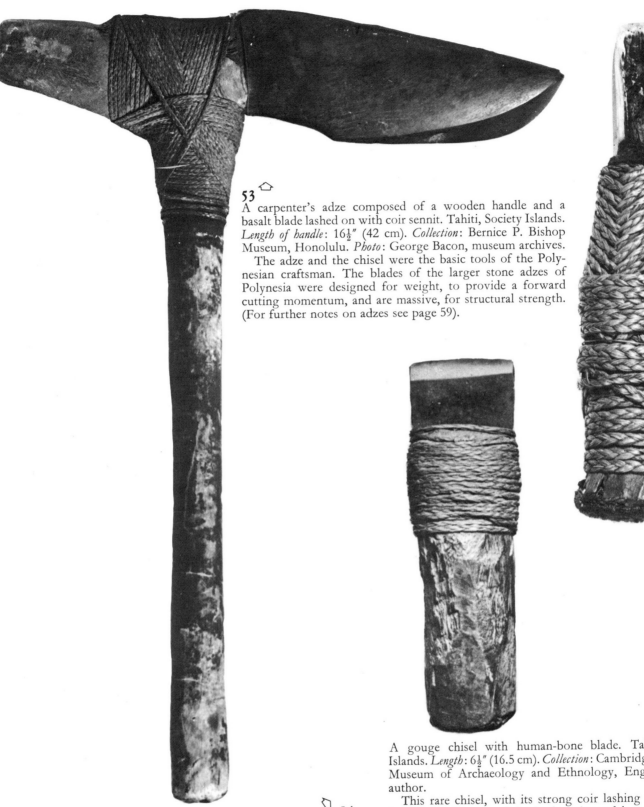

53

A carpenter's adze composed of a wooden handle and a basalt blade lashed on with coir sennit. Tahiti, Society Islands. *Length of handle*: 16½″ (42 cm). *Collection*: Bernice P. Bishop Museum, Honolulu. *Photo*: George Bacon, museum archives.

The adze and the chisel were the basic tools of the Polynesian craftsman. The blades of the larger stone adzes of Polynesia were designed for weight, to provide a forward cutting momentum, and are massive, for structural strength. (For further notes on adzes see page 59).

55

A gouge chisel with human-bone blade. Tahiti, Society Islands. *Length*: 6½″ (16.5 cm). *Collection*: Cambridge University Museum of Archaeology and Ethnology, England. *Photo*: author.

This rare chisel, with its strong coir lashing and wooden handle, has been much bruised at the end by mallet blows. It provides an all-too-rare instructive example of complete stone age tool structure with evidence of actual use. Such specimens impart an impression of effectiveness and remove the incredulous attitude common in steel age man, who often feels that bone and stone must have been ineffectual as materials of cutting tools. (See page 59.)

54

A stone-headed chisel of the Tongan Islands collected by Anders Sparrman, physician and naturalist on James Cook's second expedition (1772–75). *Length*: 5″ (12.7 cm).

This rare specimen is illustrated by Söderström (1939) in his description of the Sparrman Collection, Ethnographical Museum of Sweden, Stockholm. *Photo*: museum archives.

pig, dog, and chicken. Provision against famine was made in some areas by the storage of fermented root mash (*poi*), dried fruits, fernroot, or fish.

Each activity had its artifacts, many of which are sculptural and decorative. Today they evoke degrees of aesthetic response because of their form and patina, but to the owners they were merely useful tools. All objects have an aesthetic value, but chances are a god-image will have a greater sculptural dynamism than a digging stick, while the latter may give more information about the economy. It is an error to place one above the other in absolute terms.

Fishing had a very important place in all Pacific island cultures. In Polynesia it became a highly-developed specialisation governed by taboos, seasons, and rights to particular fishing areas, and aided by chants, talisman, and omens. Some Polynesian fishing equipment was superior to that used by the Europeans of the time. The New Zealanders laughed at the seine net used by Captain Cook's men.

Nets required gauges, needles, menders, floats, and sinkers. Hooks were made in forms suitable for trolling, line-fishing, or pole angling. Spears, lures, gorges, weir traps, nooses, harpoons, plant drugs, dredge rakes, holding ponds, and other fishing means were employed according to the conditions of reef, lagoon, river, lake, or deep sea fishing. Chiefs took at liberty what they wished from the hard-won catch before shares were given to the families related to the fishermen.

Horticulture required digging sticks, planting stakes, grubbers, and a knowledge of when to plant and when to harvest. Gardeners and fishermen alike looked to the moon when timing seasonal activity. Phases of the moon were especially important in planting or fishing.

Garden magic was used to protect growing crops from unfavourable weather or destructive pests. Failure, in Polynesian belief, was caused not by nature but by malignant spirits, so protection could come only from supernatural power. Ritual was adopted and skulls, bones, and images placed in gardens in both protective and fertility magic.

New Zealand exhibits a wide range of crop deities that are thought to represent Rongo, the god who presided over growing crops. The Maori "*kumara* gods" are extremely varied in form and are impressive as sculpture.

Stone pounders, although of humble domestic use, rank high as works of art. Designed to pound and mash starch pudding (*poi*) from breadfuit, banana, or *taro*, vertical stone pounders are found in East Polynesia alone, namely in the Society, Marquesan, Hawaiian, and Cook Islands. New Zealand horizontal stone pounders were used to dress flax fibre by pounding away the soft parts of the leaf, thereby freeing the strong fibre for cloak-making or other use.

SEASONS AND CELEBRATIONS

Polynesian domestic life, labour, and ceremony were based on a lunar calendar and lunar months. In East and Marginal Polynesia, the month was divided into thirty phases of the moon with a name for each phase, while in the West a simple numerical count of days was made. The New Year of Polynesia was heralded by the appearance of that delightful small constellation, Pleiades, also known as "Orion's Dagger" or "Seven Sisters". The return of the Pleiades was celebrated by dance and song. In Hawaii its appearance in the middle of October initiated the *makahiki*, a four-month festival of sports, secular and religious festivities, and truce between enemies. In New Zealand a New Year festival was initiated by the heliacal rising of the Pleiades, but it followed the harvest festival, which was in March. Crops were already stored when the Pleiades made its appearance; however, the old Asian and northern hemisphere association of the constellation with the planting and gathering cycle remained with the Maori despite the change in seasonal relationships. The tropical islands experience little seasonal fluctuation. The Pleiades marked the new season on most islands, but in some places the first new moon following the appearance of the Pleiades marked the New Year, thus exactly fixing the first month of a lunar calendar.

Dance and song, for which the Polynesians are renowned, took many forms, depending on intent and occasion. Ritualistic, secular, comic, or sensual, they always had an appreciative audience. Men performed most of the religious dances, often using dance batons, such as paddles or clubs, of a special design. The principal musical instruments were flutes, trumpets, conches, slit drums, and drums with sharkskin membranes. Wooden slit drums were important in West Polynesia. Sharkskin drums were restricted to East Polynesia and Hawaii. The tall Raivavaean drums are among the most remarkable creations of Polynesian art.

DRINK AND KAVA

Water served as daily drink. Beverages were limited to coconut milk and *kava* made from the dried root of the pepper plant (*Piper methysticum*). The Maori of New Zealand used water exclusively. Condiments and relishes were few, being merely salt, seaweed, plant products such as nuts, and in some islands certain jellyfish.

In West Polynesia *kava* was served at social events with great ceremony and etiquette, the order of

56 ⇧

A common dwelling of the Hawaiian Islands of the late nineteenth century. *Photo*: Bernice P. Bishop Museum archives, Honolulu.

The immigrant Polynesians found the climate of Hawaii sufficiently cold, in winters particularly, to require enclosed, well-thatched structures. The standard house of Polynesia is a rectangular floor layout with corner posts and a high ridge. (See the references to house types and their uses on page 37.) Interior furnishings were limited to mats, sleeping covers, bowls, and the simplest necessities of domestic life.

58 ⇧

A variety of plaited designs from sleeping mats of the island of Aitutaki, Cook Islands, recorded by Buck (1944). *Photo*: author.

All patterns have names such as "turtle", "coconut leaf", and so on, some of which appear to resemble the thing named, while others seem to be fanciful associations. They are representative of the wide variety of mat patterns found throughout Polynesia.

57 ⇧

A selection of Polynesian stone pounders. The illustration is from the British Museum's *Handbook to the Ethnographical Collections* (1910). Provenience for the pounders shown is as follows:

(a, b, c) There are three basic Hawaiian forms: the ring type "a" and stirrup type "c" are specialised forms from the island of Kauai, while the knobbed form "b" was made throughout the Hawaiian Islands; (d, e, f) Society Islands (compare the Tahitian pounders 179–80); (g, h) Marquesas Islands (compare "h" with 150); and (i) Cook Islands; this specimen is from Mangaia and is a type made from stalactite or stalagmite calcite found in caves on the island.

A stone age kitchen. Western Samoa. This photograph, taken by the author in 1964, provides a glimpse of old-style Polynesian life. Excluding the iron pots, pans, and cotton clothes, the scene could be one of a thousand years ago. However, very few modern Polynesians live as close to nature as this village group. The heavy work of cookery is usually assigned to men. (See page 38.) **59** ⇩

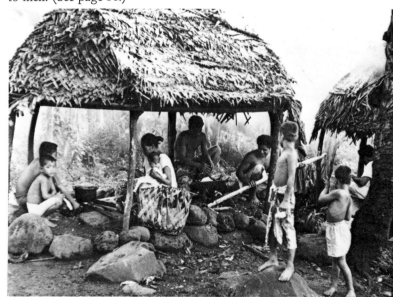

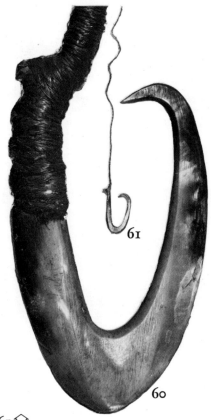

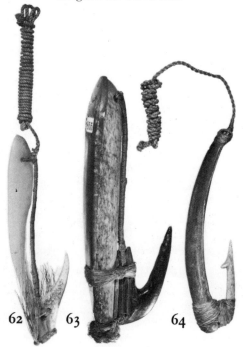

60 ⌂ 61 ⌂

A pair of pearlshell fish-hooks used in hand-line fishing.
Tahiti, Society Islands. These hooks are of similar form but
show the great size difference found in some types of Poly-
nesian hook. *Height of large hook*: 6⅛" (15.5 cm). *Height of
small hook*: ¾" (2 cm). Both hooks were collected in Tahiti
on the first voyage of Captain Cook (1768–71). *Collection*:
Cambridge University Museum of Archaeology and Ethno-
logy, England. *Photo*: author.

Polynesian hooks are of three basic types: for hand-line
fishing, for trolling, and for hand-rod threshing. Form is
determined by function and by the materials used in manu-
facture. Relative size is important as one cannot take a large
shark on a hook designed for a 2 lb fish.

62 63 64 ◁

Three trolling hooks. On the left is a Tahitian hook with pearl-
shell shank and point, attached line, and fringed lure. The
Tongan hook in the centre has a whalebone shank, a turtle-
shell point, and a pearlshell back. The hook on the right is
from New Zealand where pearlshell was not to be found
(in order to obtain the flashing effect of a fish when trolled
the wooden shank is lined on the inner face with iridescent
abalone shell). The point is of bone.

This trio of hooks is in the collection of the Field Museum,
Chicago. *Photo*: museum archives.

serving being always from highest to least-ranking
chief. In East or Marginal Polynesia, where *kava*
was used, it was regarded more as a refreshing
drink than an elaborate ritual. In West Polynesia
custom inspired the making of exceptionally fine
kava bowls, round in form, with a suspension lug;
however, the number of legs multiplied with the
decline of craftsmanship to a point in Western
Samoa where bowls with as many as sixteen legs
were made for tourists.

The *kava* ceremony is officiated over by a chief-
tainess of good birth. In former times the *kava*
root was chewed by young men and women, spat
into a bowl, then mixed with water before serving.
This mastication method suggests that there must
have been "clean" health in old-time Polynesia.
However, it caused terrible cross-infection of
tuberculosis and other introduced diseases in post-
contact times and has since been abandoned for
stone pounding of the root. *Kava* drinking as a
custom has survived in Samoa, Tonga and Fiji.

PERSONAL ORNAMENT AND TATTOO

In Polynesia it was the male who was lavishly
decorated. The impressive appearance of chiefs as
warriors and diplomats was a matter of tribal pride.
Decorative combs, necklaces, amulets, earplugs,
leis, feathers, girdles, cloaks, capes, and hand
weapons were used by chiefs according to local
custom and personal status. Women were decorated,
too, but with less splendour.

Bodily modifications were made by the tattoo,
the pigments being placed under the skin with small
combs or chisels of bone or shell. Men were usually
heavily tattooed in thighs and buttocks while
women had delicate marks on thighs and arms in
most groups. Master tattooists were held in high
esteem. New Zealand facial tattoo of both men and
women assumed a form of flesh carving which left
deep grooves in the skin. Easter Island, Cook Island,
and Marquesan tattoo covered large areas of the
body. Men and women of sufficient social standing
were tattooed upon attaining maturity and were
thereafter regarded as fully responsible tribal
members.

Ornaments made from the natural teeth of sharks,

42

dogs, or sea mammals were often worn unchanged except for drilled holes. Some teeth, such as those of the heavy sperm-whale, were modified into a hooked form or split into tusk-like necklace units. Hybridized fish-hook and tooth-form breast ornaments are found in several areas. Ornaments made close body contact and consequently were regarded as being highly charged with mana, especially those that had passed as family heirlooms from generation to generation.

ENVIRONMENT AND ART

Polynesian art is remarkably homogeneous in its main features and reflects sensitive responses to differing island environments. Sculptural arts especially are influenced by material resources. New Zealand wood art was largely a product of environment, as was the stone art of Easter Island.

Food supply, population, and social stratification directly reflect the natural resources of islands. Where food is plentiful, population increases, intertribal rivalry is stimulated, and high specialisation of occupation occurs. Polynesian art flourished best in the most productive groups. In general, Polynesians exploited island resources to the limit of their neolithic technology.

In some groups the sophistication of sociopolitical life relegated the plastic arts to a minor role; for example, in the classical cultures of Samoa, Tonga, and Tahiti. In these cultures the importance of gods and ancestors did not change, but their symbols grew less formal. Diversion of social energy to political interests, as in the Samoan Islands, where they absorbed both commoners and and chiefs, left little interest in decorative art.

Certain animals, indigenous or introduced, influenced particular arts. The breeding of dogs for food in Hawaii allowed, as a by-product, the manufacture of dancers' leggings, which required the canine teeth of as many as 700 animals in the making of a single pair. Teeming bird life made possible the feather cloaks of Hawaii and New Zealand, just as the abundance of cocks provided for the Marquesan warriors' great headdresses.

POLYNESIAN RELIGION

Polynesian religion inspired much Polynesian art. Its sophisticated concepts suggest that it was derived from old sources existing long before Polynesia was settled. South East Asian and southern Chinese ideas are evident in its composition; for example, ideas of polarity in nature. Polynesian ideas on sexual differentiation in nature relate to the Chinese *yang*, or male active positive principle, and *yin*, or female inactive negative principle.

Women were regarded by Polynesians as inferior

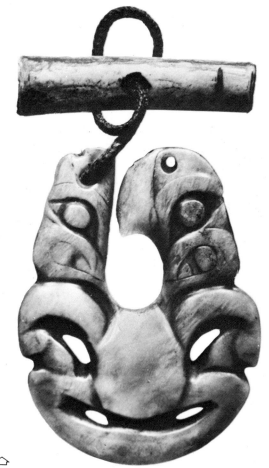

65 ⌂

A nephrite pendant of New Zealand which combines a fish-hook shape with conventional *hei-tiki* human form. (Compare 307 and 309.) Its neck cord is attached to the toggle of bird wing bone. *Height of hook*: 3¼″ (8.4 cm). *Collection*: British Museum, London. *Photo*: museum archives.

Nephrite hook-form amulets are relatively common in New Zealand but not of this hybrid composition. Until the discovery of a similar specimen at Waikanae (see Barrow, 1961), the only known example of this type of ornament was this specimen, collected by Saddler of HMS *Buffalo* in the mid-1830s. Elaborate hook forms used in fishing rites to promote good catches are known from many parts of Polynesia (the Mangaian hook 220 is an example).

to men unless some notable heredity placed them in positions of power. It was believed that by their negative nature women were dischargers of positively-charged mana. Consequently women were taboo at any activity that involved male mana, such as religious ceremonies, craft-work concerned with gods, and canoe- and house-making. They were a deprived sex and could not eat with men, use canoes unless for special travel, or eat foods such as shark, bananas, or human flesh. Their hair was usually cropped, while that of men was worn long. Their ornamentation and dress were inferior.

As the highest chiefs had gods at the top of their

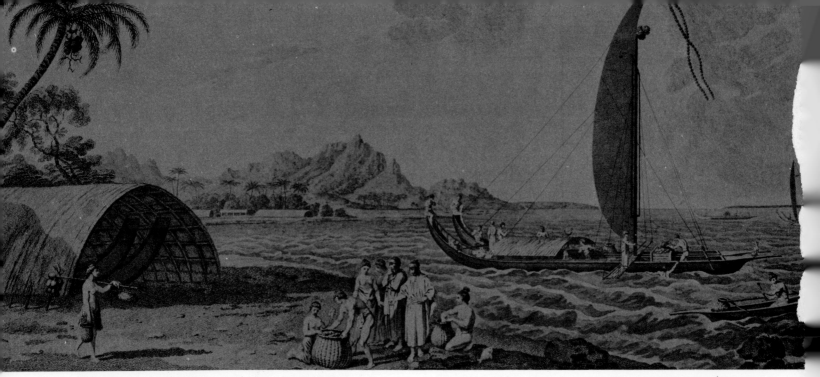

Canoes of the Society Islands as seen in 1769 by Sydney Parkinson, natural history draftsman aboard Captain Cook's *Endeavour* (first Pacific voyage, 1768–71). *Collection and photo:* author.

The trim double-hulled craft in the foreground, with deck-house and well-stayed mast, is obviously a fast sailer. Early visitors often noted the superior sailing qualities of Polynesian canoes over lumbering European vessels. (See page 30.) A canoe house with canoe is shown on the left of the engraving.

A small fishing canoe about to be beached, and a fisherman repairing his nets. Both photographs were taken by the author on Upolu, Western Samoa. Western Samoa is one of the few places in Polynesia where old modes of life and traditional ways of doing things have persisted (other present-day Samoan subjects are depicted, 69–72). Change is steadily increasing in pace in Samoa as elsewhere in the Pacific. Each generation moves further from the colourful past of tradition to the less picturesque but more convenient ways of modern life.

genealogy, they shared the mana of the gods and so had little reason to be humble. Human ancestors could become demi-gods.

Generally speaking, the higher the gods the more remote they were from human affairs and from human interest. Priests and commoners usually called on lower gods and ancestral or minor spirits to aid the affairs of daily life. The spiritual beings of Polynesia can be classified into three groups:

(i) Cosmic deities representing nature's elements and power. Tangaroa, the sea god, was widely regarded as the principal creator, and Tane as the promoter of fertility and protector of forests. Rongo presided over peace and horticulture. Tane became the god of craftsmen and was important to makers of canoes and such things.

(ii) Patron gods, who served as benefactors to tribal activities and to a large extent governed man's activities on land and sea, including certain crafts.

(iii) Family protectors, comprising local godlets, tribal ancestral spirits, culture heroes, sprites, and fairies. This supernatural legion was appealed to on all common occasions and its omens heeded. The spirits of this class appeared everywhere and were used in sorcerers' magic.

Creation myths vary greatly. Tangaroa usually assumes the role of creator of man and other gods. In Tahitian stories man was moulded from the earth by Tangaroa with the aid of the war god Tu. The Polynesian Adam is called Tiki. In some legends man made his female partner from earth and breathed life into her earthen image. In other stories Tane, the fertility god, creates a woman from the earth and has sexual intercourse with her in order to create mankind. The introduction of Christianity to Polynesia caused the early admixing of Hebrew biblical stories with local legends, to the confusion of folklorists.

Polynesian art relied on classes of craftsmen-priests called *tohunga* in New Zealand, *kahuna* in Hawaii, *tufunga* in Samoa, and so on. The name implies professional skill with high social rank. *Tohunga* were specialists in sacred crafts, temple ritual, oral widsom, and formula chants to secure the aid of gods and spirit mediums. They regarded words as living forces which could, if incorrectly used, backlash on the perpetrator. The ommission of a word from a chant could be fatal. Polynesian priests knew their profession well and were careful.

67

68

69

70

69 ◇ 70 ◇ 71 ◇ 72 ◇
Four photographs taken by the author in Western Samoa. Houses by the sea, coastal villages, inland rivers, and the friendliness of the people are typical of these islands. Through their art Polynesians expressed a harmony with life and death and a sense of unity with their environment.

There was little sham or insincerity in chiefly priesthood.

TEMPLES AND SHRINES

Temples of many forms, from wayside shrines to massive stone structures, were in use throughout Polynesia. The most spectacular temples are located in East Polynesia, Easter Island, and Hawaii. They were appropriately used as mausoleums and places where priests could call on the gods with ritual sacrifice in the presence of ancestral spirits. Temple furnishings included images, oracle towers, temple houses, offering stands, and pits for the disposal of taboo refuse.

The most celebrated of all Polynesian temples is that of Taputapu-atea, at Opoa, Ra'iatea, which was visited by Captain Cook in 1769. The priests at Opoa had created 'Oro as a son of Ta'aroa and had gone so far as to elevate him above Tane, to the great consternation of Tane's loyal followers. The 'Oro cult, which resembles in some respects the secret societies of Melanesia, had as one of its arms the famous Arioi Society. War ensued, and many of the faithful followers of Tane left for other islands. 'Oro is usually represented by an image of plaited coconut-husk sennit decorated with red feathers.

Small shrines, sometimes no more than a few rocks, were erected to meet the daily needs of fishermen, craftsmen, and wayfarers. Simple offerings were placed on these shrines to placate spirits and to help secure their active aid in everyday activities.

MANA AND TABOO

Polynesian social and religious behaviour, as well as specific individual and group interaction, are often best studied in relation to mana and taboo. Art work is intimately linked to both concepts.

Taboo means "forbidden" or "restricted", both in the social and religious sense: taboo could be imposed on people, things, and places. Mana was a subtle power that could be possessed by people and things: its presence was awarded with prestige within the community in proportion to the amount possessed. Taboo protected mana.

We should think of mana as the positive and active principle of Polynesian life and of taboo as the negative and protective aspect. People acquired mana through inheritance and accumulated successes, while objects acquired it through effectiveness. To be taken into slavery or killed was to forfeit one's mana to the victor. Mana was lost by failure or by breach of any taboo that brought one into contact with pollution of one sort or another. Food, especially cooked food, was high on the list of things that were *noa*, or common, and liable to lessen mana. Cooked food was kept away from sacred places.

All things possessed a degree of mana. An adze, canoe, or fish-hook gained mana from ownership, and from repeated success in use. Some chiefs were so highly charged with mana that taboos surrounding them were potentially dangerous to ordinary members of the community. A few nobles were of such extreme mana that they were carried when going abroad as the very ground they touched became taboo if they walked on it. Anything a chief owned or touched or used became charged with something that can be compared to high tension electricity; it was safe enough if not touched. Some shortcircuits were disastrous, as we know from the classic case of a slave who ate scraps of food and later died in convulsions on learning that the food

73 ▷

This engraving, after a sketch by artist Webber (17), depicts a graceful Tahitian girl bringing gifts of barkcloth to Captain Cook in 1777. The pair of gorgets attached to the front of her costume (also valuable gifts) are made from coir sennit, with added trimmings of feathers, shark teeth, and dog hair. *Collection:* Alexander Turnbull Library, Wellington, New Zealand. *Photo:* author.
One of the gorgets is now in the Dominion Museum, Wellington.

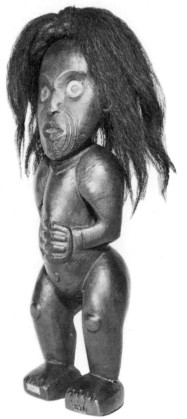

A free-standing image, presumably used at the foot of a house post to represent a tribal ancestor. New Zealand. *Height*: 15¾″ (40 cm). *Collection*: Hunterian Museum, University of Glasgow, Scotland. *Photo*: author.

This type of image, which relates closely to certain Hawaiian images (75), was established as a type from extant examples found by the author in British collections (Barrow, 1959).

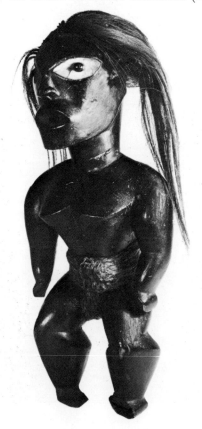

had been left by a chief. Such incidents were reported by reliable observers.

Both mana and taboo were impersonal in operation. It would appear that neither was connected in Polynesian belief with the direct action of gods or spirits. Polynesians regarded the operations of mana and taboo in much the same way as modern man sees the workings of mathematics or gravity. The effect of mana and taboo on the attitude of craftsmen making things and on community attitude to things made was fundamental in both Polynesian art and life.

DEATH AND BURIAL

The division of society into aristocrats, commoners, and slaves was carried over to the Polynesian afterworld. The souls of chiefs were favoured over those of commoners, and it was doubted whether slaves had souls. The living were fearful of the spirits of the dead, who were thought to wander about in discontent before passing on to their dismal underworld. The underworld, called Po by the Maori, literally means "night", or "place of departed spirits". Priests often claimed control of the dead, so their power was both feared and respected. At Pukapuka in the Cook Islands rings of twisted coconut fibre were used by priests to catch souls and let it be known to the community that so-and-so had his soul "caught". The family was then obliged to persuade the priest with gifts of food or property to release the ensnared soul.

To Polynesians there was no such thing as a natural death. They believed all died from external causes, such as black magic, the blow of a warclub, or drowning at sea. The gods themselves sometimes ate human spirits, thus causing death, and this too was an external cause.

The arts associated with death and burial include head mummification and manufacture of burial caskets, bone boxes, or memorial poles. As enemies ever watched for an opportunity to humiliate the dead and to insult the remains of their bodies, for example by converting bones into fish-hooks, burials were kept secret. Caves, rock ledges, and chasms were favoured hiding places. Sometimes special canoes were made to hold the body, as the

A god or goddess with attached human hair and *tapa* loincloth. Honaunau Bay, Hawaiian Islands. Taken from the Hale-o-Keawe temple (13, 15) by Midshipman J. N. Knowles during the visit of HMS *Blonde* in 1825. *Height*: 16½″ (42 cm). *Collection*: British Museum, London. *Photo*: author.

A pearlshell eye and the fitted tongue are missing. In general appearance this image compares closely with certain New Zealand images of similar size which also have human hair attached to the head (74).

76

77

78

76⇧ 77⇧

A ridge carving, believed to be from a bone house. Localised to Raivavae, Austral Islands, on the basis of style. *Width*: 20½″ (52 cm). The line additions to the lower photograph (77) represent the author's reconstruction of the missing parts. *Collection*: Cambridge University Museum of Archaeology and Ethnology, England. *Photo*: author.

Figures appear on both sides of this ridge piece. It is recorded as having been collected on Captain Cook's first voyage (1768–71); however, no specific record of island provenience exists. Its Austral Island attributes are sufficiently distinct to allow localisation of style. This carving obviously relates closely to the New Zealand carving 78.

The "Kaitaia carving", so named from its place of recovery ⇧
during a drainage operation at Kaitaia, Northland, New78
Zealand. *Width*: 7′ 5″ (226 cm). *Collection*: Auckland War Memorial Museum, New Zealand. *Photo*: museum archives.

Some scholars have persistently identified this remarkable carving, which is so unlike classical Maori wood styles (compare the classical styles 83 and 289–95), as a door lintel. On the evidence of structure and resemblance to the Raivavaean carving 76–77, and for the several convincing reasons proposed by Skinner (1964), it seems reasonable to accept the Kaitaia specimen as a ridge carving rather than a door lintel. Its decorative arrangement resembles classical door lintels, which have as a rule a central figure and outward-turned *manaia* (see page 54), and it could well be argued that Maori door lintels are in fact adaptations of ridge decorative carvings that were widely used in South East Asia. The outward-turned beaked monsters of the Kaitaia carving (78) are hybrids, basically avian with human and reptilian features added. These *manaia*-like creatures replace the outward dogs of the Raivavaean carving 76–77.

soul was thought to journey to the ancient homeland in the west called Hawaiki. The use of such "soul boats" is widespread in South East Asia and was probably a burial custom of the Proto-Polynesians.

WARFARE AND CANNIBALISM

Polynesian warfare was usually a periodic activity. Its main objective was the slaughter of any member of the enemy group whether man, woman or child. Its basic causes were population pressure and the tribal blood feuding initiated by insults and killings. The thirst for revenge was never satisfied. In the days of spear and club battle casualties remained modest; however, when Western firearms were acquired the picture changed from one of lively skirmishes which all enjoyed to one of horrible slaughter. Territory invaded in times of war was rarely occupied permanently, although spoils were taken and captured inhabitants either killed or carried away as slaves.

The earliest Polynesian settlements offer little archaeological evidence of warfare, but in classical times it existed on all but the smallest islands. Polynesian fortifications and weaponry reached a primitive perfection. Weapons used included long and short clubs, spears, daggers, toothed cutters, slings, stone-headed clubs, throwing and tripping devices, and strangling cords. Ironwood long clubs and the jadeite short clubs of New Zealand are often things of great beauty.

Cannibalism appears to have been practised at one time or another throughout Polynesia, although at the time of European contact it was habitual only in some areas. The most notorious places were Fiji, the Marquesas, and New Zealand. Acquisition of mana by the ritual swallowing of an eye of the slain enemy, or the eating of some part of his body, gave religious meaning to some South Sea cannibalism. However, the delicious taste of human flesh was proclaimed a good enough defence by some hardened old warriors remonstrated with by visitors. Women were forbidden this flesh.

As archaelogical excavation of early Polynesian sites rarely turns up evidence of cannibalism or warfare, we must assume that the earliest settlers lived in peace and either developed these traits within their society or received them as customs from new migrants. War and cannibalism became a way of life in some places. In classical times bones of the slain were used freely in making fish-hooks, flutes, fan handles, and other useful items. The Fijians refined the eating of human flesh by inventing a pronged wooden fork to help effect the taboo that human flesh must not touch the lips of the eater.

HEAD CULTS

Throughout Oceania and South East Asia a man's head was regarded as the most taboo part of his body. Headhunting has been a feature of South East Asia and Melanesia for thousands of years, and until recent times pockets of Asian headhunters, such as the Wa of upper Burma, the Naga of north east India, and the mountain tribes of northern Luzon, were very active. Polynesian interest in heads and the collecting of them belongs to this ancient Asian tradition. Headhunting was closely associated with ideas of sexual fertility, and many Asian primitive tribes thought it essential to survivial.

Polynesians are not ordinarily classified as head-hunters, yet in some areas they took and preserved heads as trophies or otherwise used heads in ritual. Captain Cook reported seeing long strings of jaw-bones hanging in the great temple at Opoa, Ra'iatea, and skulls of sacrificial victims were abundant in Tahitian temples. Polynesians evidently shared in the widespread Pacific head cult ideas, such as the head being the focal point of personal mana. The heads of carved images are sometimes rendered as large as the body, and they are almost always to some degree outsized because of the relative importance of the head in Polynesian belief.

Anything associated with the head of a Poly-nesian aristocrat was extremely taboo. Hair combs were considered highly potent with mana. To touch the head of a noble or to pass food over it was a sure death warrant to slave or commoner. A shadow falling on the head of a sacred chief was a sacrilege sufficient to bring death if the shadow's owner was not of equal mana.

Chiefs visiting European ships for the first time appeared to behave irrationally by refusing to go into certain areas. Now we can understand why: if they visited the lower decks, others would be standing above them. The prospect of walking under strings of onions or bags of potatoes swinging from a deckhead horrified them, since food was particularly harmful to mana.

After death the head of a chief was treated with veneration. In New Zealand it was often mummi-fied so that it could be kept affectionately at home. The heads of enemies were similarly preserved but as objects to be insulted. Skulls were sometimes kept in boxes or bowls, in either sacred or secret places. Red ochre was often applied to skulls and bones, as well as to sacred burial objects, as an indication of respect.

Mummified heads or skulls were believed power-ful talisman in promoting fertility.In New Zealand bones and dried heads or skulls were placed near

80 △ **79** ◁

Motifs of early bronze age China, of the Shang period (probable dating of dynasty: 1766–1122 BC), are here reproduced for general comparative purposes. 79 is a typical bronze vessel face mask (*t'ao t'ieh*), while 80 is the typical profile dragon (*k'uei*), two of which can meet together to form a mask (as with this *t'ao t'ieh*). The parts of the *k'uei* dragon are analysed in illustration 81, while a New Zealand *manaia* (82) is placed below as a suggestive comparison. *Photos*: author.

The curvilinear surface decoration of bronze age China and the fabulous creatures within its decoration have been proposed as ancestral to many South East Asian, Melanesian, and Polynesian art forms. The author believes that this general principle of relationship is reasonable and worthy of serious investigation; however, it must be remembered that South East Asian art also had its influence on Chinese forms. (See page 22.)

Tail · Bottle-shaped horn · Eye · Crest · Beaked jaw

Forward-hooked quill · Backward-hooked quill · Leg

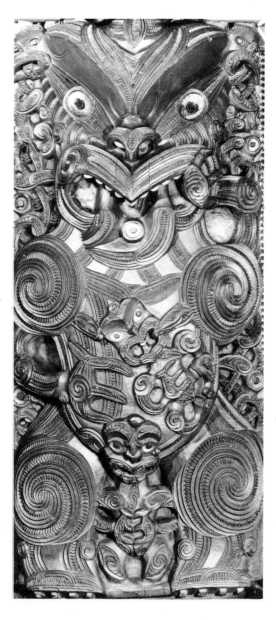

81 △ **82** △

A New Zealand *manaia* creature (see page 54), presented in isolation from the panel of which it is part. *Photo*: author.

The presence of the spur or crest on the beak and other features of *manaia* suggests an affinity with the *k'uei* creature 80–81.

◁ **83**

A panel from the same source as 82, the Gisborne, New Zealand, house Te Hau-ki-Turanga (see also 289–90), depicting a female ancestor with a child at her breast. *Photo*: author.

This panel is an appropriate representative of classical Maori wood sculpture, which bears ready comparison with ancient Chinese bronze forms (79). (See the discussion on page 000.)

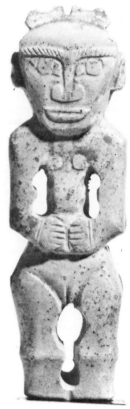

growing crops. On Easter Island skulls, some with a vulva symbol engraved on the forehead, were put into chicken runs to promote egg production. When one knows the importance of crops or chickens in the Polynesian religious and social context, these acts become reasonable and lose their absurdity.

TOTEMS AND METEMPSYCHOSIS

Fundamental to Polynesian art symbolism was the belief in the power both of ancestral spirits and their totems. Strictly speaking, totems are plants, animals, or minerals towards which a human kinship group has mystical feelings of relationship and dependence. In Polynesia birds, fish, turtles, water snakes, sea urchins, cockles, coconuts, and lizards were favoured totems; sharks, turtles, and owls were especially popular.

The identification of these totems with ancestral spirits constituted much of the everyday religion of Polynesia. Since the totem was regarded as personal kin the eating of it was disallowed. Oddly enough it was permissible to help others catch one's own totem animal provided it was not harmed or eaten by members of one's totem group; also, in some instances only certain parts of the body of the totem were forbidden as food.

The root of the totem custom was the belief in metempsychosis, or the entering of a man's spirit into an animal at the time of the man's death. Transmigration of the soul with accompanying transfer of mana could also occur with plant or mineral totems. An outcrop of rocks or banana plant might serve in this way.

The Samoans were regarded by their fellow Polynesians in the early years of evangelism as being particularly godless, because they lacked the usual religious paraphernalia of images and temple trappings. In fact they had numerous deities and totems and lived under their guidance. Sometimes proof of sincerity of Samoan conversion to Christianity was to have a man kill and publicly eat his family totem. The great chief Malietoa of Western Samoa, on his renunciation of paganism, had totems

84 ⬆

A female figurine of jade of the Shang dynasty, China (c. 1766–1122 BC), believed to have been found in a tomb. *Height*: 4⅜″ (11 cm). *Collection*: Fogg Art Museum, Harvard University, Cambridge, Massachusetts. *Photo*: museum archives.

This ancient Chinese figurine, the jade of which has been calcified by time, has a sculptural style that is strikingly similar to several Polynesian image styles. The facial features, especially the eyes, and the form and stance of the body, are readily paralleled in Polynesian art.

85 ◁

Detail from a ritual bronze bell of *dotaku*, illustrated in the Tokyo National Museum's catalogue of the Olympic Games exhibition of Japanese treasures, 1964 (collection of Ohashi Hachiro, Tokyo).

Bells of this type are associated with the Yayoi culture of Japan (c. second century BC to c. second century AD). The zoomorphic designs set in compartments are reminiscent of the ideographs found on Western Polynesian clubs (111–14). The close resemblance of many Polynesian styles to ancient styles of Asian islands and coastal cultures suggests that many Polynesian art forms were diffused into Polynesia and are not exclusively the result of local development. This subject is discussed in the text. (See page 20-22.)

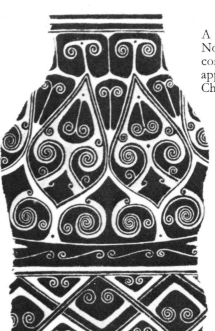

88 ▷

A New Zealand painted rafter pattern typical of eastern North Island Maori culture, from the time of European contact. *Photo*: author. This and many other rafter designs appear in Hamilton (1896), and may be compared with ancient Chinese patterns 86–87.

86 △

A bronze pole motif formed by gold and silver inlay, of the Chou Dynasty of China (1122–256 BC). After Badner (1966), in his paper relating New Zealand and ancient Chinese art motifs. *Photo*: author.

The likeness of this design to Maori patterns used in New Zealand rafters (for example, 88) is immediately apparent.

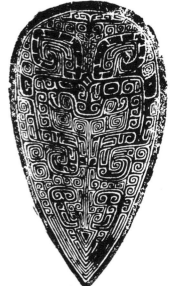

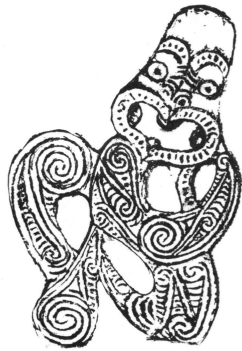

87 △

An ink impression from a bronze harness trapping from Anyang, China, of the Shang Dynasty (1766–1122 BC). *Collection*: Institute of History and Philology, Academia Sinica, Taiwan.

This design, which contains a horned *t'ao t'ieh*, relates in character and mood to many patterns of New Zealand (for example, 82–83, and 289–97), and to the Marquesas Islands patterns in general. (Compare 159–65.) Such resemblances are not coincidental nor superficial, as the members of the respective cultures were in contact during a period relatively recent in the chronology of man in the Pacific. (See pages 28-9.)

89 △

A crayon rubbing by the author from a figure on a treasure box from North Auckland, New Zealand. This figure is on the base of the box numbered 223 in the author's *Maori Wood Sculpture of New Zealand* (1969). The use of spiral forms in Polynesia, China and South East Asia is considered on page 58.

caught and eaten. His sons had as their totem a fish called *anae* which they ate, according to missionary John Williams, "with trembling hearts", then hastily retired from view to vomit the fish they had eaten because they feared it might eat their innards. Traditionally, if a man ate his totem it was said to grow within the body until it killed him.

The shark was a popular totem, and those who claimed its kinship were said to swim safely among them. In Hawaii when priests imagined the shark totem wanted sustenance, some luckless commoner was caught with a running noose, strangled, then fed to sharks. It was thought that the soul of the victim would animate the totem to the benefit of society.

Fishermen sometimes fed their own dead to sharks in the belief that this would give them protection from attack during any further mishap at sea. Even spirits of stillborn babies, which were thought to be spiteful and dangerous, were transmitted by feeding the body to sharks. The appearance of the shark in Polynesian art is limited to West Polynesian club decoration.

ANIMAL AND FABULOUS SYMBOLS

The animal symbolism of Polynesian art is quite limited except in Tonga, where a very wide range of creatures is depicted in the surface decoration of clubs. In most areas the human figure, as either god or ancestor, dominates as the basic theme of art.

Next to man, birds, bird-men, and lizards take precedence as art themes. Considering the widespread importance of animal totems one would expect animals to appear in abundance, but they do not. In this respect Polynesian art contrasts greatly with Melanesian art, which is rich in animal totems.

The mammals of Polynesia were restricted to an inconspicuous native bat, the sea mammals, and introduced pigs, dogs, and rats. None makes regular appearance as art motifs. Birds, which were abundant and greatly respected as totems, omen makers, and spirit vehicles, are likewise neglected as literal art motifs; but the fabulous use of bird elements is, in the author's opinion, important. Mankind has favoured the use of birds in art and mystical symbolism, as is well documented in E. A. Armstrong's *The Folklore of Birds* (1958).

Throughout Oceanic carving there was a strong tendency to either humanise birds or to avianise humans. This has resulted in the development of motifs that are bird-man hybrids. The present author surveyed the Polynesian forms in a paper entitled "Material Evidence of the Bird-man Concept in Polynesia" (1967). Of carved bird-men the Easter Island examples are the most notable for variety and association with a recorded bird-man cult. Elsewhere we have bird-men but no evidence of specific relationship. Generally, precise meanings have been lost.

The *manaia* of New Zealand, which appears abundantly in classical carving, is the subject of much controversy. Some observers insist it is a profile rendering of the human form which serves also as a device of surface decoration and space-closing. After studying *manaia* over many years on hundreds of carvings, this writer is of the opinion that *manaia* is a member of the bird-man family of Polynesia, its reptilian traits being combined with human and avian traits. The old carvers who might have told us what *manaia* is if they had been asked have long since departed. Modern carvers seem not to know more than do academic observers, and they too disagree among themselves. We can expect to get to the truth of *manaia* by comparative study, although solutions may take decades of research.

The most fruitful approach seems to be that of first accepting *manaia* as a motif with antecedents in ancient China and South East Asia. Observable relationship appears to be found in the dragonlike *naga* creatures of Austronesia and in Chinese bronzes of Shang and Chou. The decorative themes of classical Maori and Marquesan art exhibit distinct resemblance to the arts of South East Asia and bronze age China. *Manaia* often appear on door lintels grasping a snake, a creature absent from Polynesian land fauna but present as a sea snake. Parallel uses of the *manaia* and "snake" of New Zealand are found in Melanesia and throughout South East Asia in obvious bird-snake versions.

Lizards make rare yet regular appearances in Polynesian decorative art. Polynesians generally regarded lizards with fear, for they symbolised death; for example, New Zealand lizards represented Whiro, the malevolent god who personified all that was evil. Many of the demons and monsters described in Polynesian myths resemble giant lizards or crocodiles, the latter being quite absent from Polynesia.

One of the most fascinating discoveries in Polynesian studies was made by H. D. Skinner and described in his paper "Crocodile and Lizard in New Zealand Myth and Material Culture" (1964). He demonstrated that folk memory of crocodiles is preserved in Maori culture and other Polynesian arts, and that analysis of club forms is especially revealing of this element.

The Proto-Polynesians must have known the crocodile. Recorded traditions of Melanesia, Borneo, the Philippines, and other Austronesian places where the crocodile is a common art motif reveal that it was powerful as a totem creature and vehicle

of soul transmigration. In Timor and thereabouts virgin girls were ritually sacrificed to crocodiles in a manner surpassing in terror the best Hollywood versions.

Melanesian artifacts often have crocodile head terminals, some depicting the animal in the act of swallowing a human. In Polynesia the crocodile theme is rarely obvious, although some New Zealand versions are distinctive. Also, the clubs of West Polynesia illustrate well this persistent crocodilian motif. Cook Island pole clubs have eyes set below a long blade of serrated teeth, toothed Samoan clubs appear to represent toothed jaws, and the broadhead Marquesan or Tongan clubs exhibit eyes and snout.

The widespread dispersal of Asian or South East Asian elements in South Sea art has been ably studied in relation to particular features of Polynesian culture and art. As early as 1924 Skinner published evidence of material connections between New Zealand and Austronesian art.

In his paper 'Joint Marks: a Possible Index of Cultural Contact between America Oceania and the Far East' (1951), Schuster traced the Pan-Pacific dispersal of faces or parts of faces that occur at joints of images. Elsewhere (1952) he examined the widespread use of V-shaped chest marking on Pacific images. Skinner (1967) examined the dispersal of cylindrical headdresses in Pacific cultures from the points of view of their artistic form and prestigious use in society. Such studies are increasing in number and represent a matter-of-fact approach to diffusion in Pacific cultures.

SYMBOLS OF THE GODS AND OF SOCIAL RANK

Man-made items and natural forms served as symbols of the gods and of chiefly mana until traditional ideas were abolished. At the introduction of Christianity the Polynesian gods were rejected and their images destroyed, carried away as curios, or left in neglect. Also, symbols of chiefly status were abandoned in all but a few islands.

Manufactured symbols of the gods consisted, for the most part, of coir-sennit or *tapa* rolls, red feathers, adzes, or images of wood, stone, bone or ivory. Unworked stone, living trees, feathers, shells, and natural phenomena played a singificant role as god symbols and were in no way considered inferior to manufactured things; however, they are not art objects. Sennit plaited from coconut husk fibre and red feathers were specially esteemed as appropriate vehicles for the spirits of the gods.

In small island communities the relationship of one man to another was predetermined by birth, and exact status was understood by all, so authority was acknowledged without marked external trappings. There were certain symbols to proclaim a chief, but they were usually inconspicuous, such as the fly-flap and staff in West Polynesia, and seat and baton in East Polynesia. Feather wands were used in Hawaii to symbolise authority, while adzes with long jadeite blades were seen in New Zealand. The quality of a man's weapons, dress, and tattoo marked his personal dignity, as did the size and height of his house. Women had less need for status symbols, although certain fans and ornaments proclaimed their aristocratic standing. Men used fans in some islands as symbols of peace, but there is evidence that fans were used in war also, as may be seen in the war dances of Fiji, which have been retained as entertainment.

White was the colour of *tapu*, red of mana. Red was a colour known to stimulate excitement in men and animals alike. Therefore, it was regarded as the chosen colour of the gods, especially of Tu, god of war, and of chiefs of the highest rank. Cook's men discovered that the red feathers and red barkcloth that they had collected in Tahiti found a brisk market in New Zealand and elsewhere, so they laid in good stocks as opportunity offered.

Iron-bearing clays, oxidised to red, were used widely in powder or paint form to rub on the bones of ancestors and on objects of special value. This custom prevailed in New Zealand, where red ochre mixed with shark oil was applied regularly to wood carvings, rubbed on precious ornaments, and applied to the bodies of the living and the dead. Red, white, and black are the three basic colours of Oceanic art, but except in Maori rafter paintings are rarely found used concurrently in Polynesian art.

ANTHROPOMORPHIC IMAGES

Human images representing gods or ancestors were made of wood, stone, bone, shell, ivory, *tapa*, feathers, or coir sennit. Two or more materials could be used in combination. Surfaces were inlaid, engraved in low relief, or lightly painted, according to local usage and style. The stance of images was usually rigid, the joints sometimes being marked by knobs or faces. Spirals mark joints in many New Zealand carvings.

Images are typically placed in one of two basic postures: standing with arms pendant and knees flexed, or sitting with elbows on knees. The latter position, although common throughout Melanesia and of ancient Austronesian antecedence, is rare in Polynesia. Out-thrust tongues, erect phalli and enlarged female vulvae, such as are seen so abundantly in New Zealand carving, express involved notions of protective magic, as well as aggressiveness in the case of tongue and phallus. Such

symbolism is readily paralleled elsewhere in Oceanic, South East Asian and ancient Chinese iconography.

Aberrant forms, such as double-headed images or figures in usual positions, are rare in extant collections, but they do exist. There are no absolute rules in Polynesian iconography, although general rules prevail. Janus heads are common in some areas.

The Polynesian image-maker could carve naturalistic forms but favoured them conventionalised. Possibly this was because he was representing gods and spirits, not the external appearance of particular people. In assessing Polynesian sculptural values we must lay aside the artistic perspective and ideals of the Greek or Renaissance art and educate our eyes to see in a Pacific way.

Some areas exhibit their own unique image qualities. The dynamic forms of Hawaiian wood sculpture are distinctive to those islands, and Easter Island wooden images have a perfection of finish, while for abstract beauty Nukuoro figures are unequalled. The achievement of New Zealand wood sculpture is unrivalled diversity.

Although human images served only part of the need for material symbols of gods and ancestors they are, from the aspect of art study today, the focal point of style definition. Much of the modern response to the aesthetics of old Polynesia is a response to carved images. To Polynesians, however, they were vehicles of no value unless first made sacred in rituals that caused spirits to enliven them. If they were not inhabited by a spirit, or if for some reason mana had departed from them, they were treated with indifference, contempt, or even scorn, depending on circumstance.

In Polynesian religion a bundle of sennit or roll of *tapa* could possess greater mana than the finest man-made image, or an unworked rock might serve as the abode of a powerful god. In the Society Islands wooden images were demoted in religious status at the elevation of the god 'Oro, whose special symbol was a coir-sennit and feather figure of small size and abstracted form. Thereafter wooden images more often served sorcerers than priests.

It is well to bear in mind that modern estimates of the worth of Polynesian art derive not so much from Polynesian value as from contemporary Western aesthetic responses, exotic appeal, and commercial demand. Just over a century ago human images from native cultures were regarded as the curious relics of heathenism and were used as missionary propaganda to illustrate theories concerning the debased nature of savages. Since the turn of the century, however, anthropology, and more recently art history, have provided new perspectives. The significant values of Polynesian sculpture, as well as the many achievements of Polynesian craftsman-ship in all branches of art, are now widely appreciated.

The advent of Christianity in the Pacific inspired a wave of "idol" and temple destruction. In view of the intolerant Christian ethic of the early nineteenth century the suppression of native culture is understandable, but is not less deplorable. The systematic suppression of dance and song along with the destruction of sculptures of the gods were insisted upon by some missionaries. Wooden figures fed many bonfires or were cast out to rot. Converted Polynesians were often as anxious as the missionaries to dispose of evidence of their paganism, and they destroyed enthusiastically what their forefathers had venerated.

Hawaii provides an example of Polynesian zeal in breaking from the past. In 1819, before the New England missionary party arrived in Hawaii (1820), Kamehameha II (Liholiho) abolished the taboo system. Temples and their fittings were burnt, women were permitted to eat all foods with their menfolk, and the lowest classes were uplifted. Few Hawaiian temple images escaped the general conflagration inspired by the abolition of taboo. Images surviving today were either carried away as curiosities before the great orgy of wrecking or have been recovered subsequently from caves or swamps.

Polynesian images have suffered mutilation at the hands of Westerners in a variety of ways. Early voyagers are known to have used them for musket practice, and as firewood. The author saw a large Maori image that had been in use as a chopping block. Incidents of vandalism are not hard to find in modern times, even in the very museums established for conservation.

Paradoxically, the Western invaders of Polynesia who helped to destroy Polynesian culture turned to saving some traditional items. By 1900 Britain had become a remarkable storehouse of Polynesian artifacts, many of which have since dispersed to New Zealand or the United States of America through either sale or donation of private collections.

However, preservation was not always easy, even in quiet Britain. The circumstances of entry of a Rarotongan staff god collected with several others in the 1830s is well worth noting. The missionary John Williams, when apologising for the untidy appearance of one of the gods, said: "It is not, however, so respectable in appearance as when in its own country; for his Britannic Majesty's officers, fearing lest the god should be made a vehicle for defrauding the king, very unceremoniously took it to pieces; and not being so well skilled in making gods as in protecting the revenue, they have not made it so handsome as when it was

an object of veneration to the deluded Rarotongans."

Rarotongan staff gods were subject to missionary mutiliation, since they terminated in a penis, then referred to as "an obscene figure". These "offensive" ends were simply hacked off. The removal of sexual organs from Pacific carvings was a propriety of many nineteenth-century private acquirers and a few museums, not out of character in an era that put pants on the legs of pianos. The idea of indecency was a projection of their minds. There is nothing pornographic in Polynesian wood carving. It expresses at times a vigorous sexuality and mystical notions of the power of sex in nature, but the mode of expression is never crude or insensitive.

SEXUAL SYMBOLISM

Polynesians approved of wholehearted sexual pleasure for all. Provided that their code of propriety and social rules—as to when and with whom—were observed, there were few restraints on free indulgence. The Western correlation of sex with sin mystified Polynesians even after their conversion to Christianity. The association of virginity with moral purity was a deep mystery which missionaries had difficulty in clarifying for their flocks, and they were obliged, on some islands, to add a word for virginity to the language. Polynesians had occasional public exhibitions of sexual intercourse as either ritual or entertainment. According to Captain Cook, who saw one of the latter demonstrations in Tahiti, there was no sign of shame on the part of performers or spectators. Polynesian life was licentious but in no way dissolute until the influence of Western grog, firearms, and sailors' morals. Sailors with the early expeditions first debased the innocence of old Polynesian sexual pleasure and introduced venereal disease as well.

Phallic terminations on weapons and staff gods, fishing sinkers and necklace units of testicle form, vulva and related fertility symbols, are found in abundance from East to Marginal Polynesia. Sexual symbolism in art is weak in West Polynesia, although the buxom female figures of Tongan art are strong in secondary sexual features.

Most sexual motifs in Polynesian art are readily paralleled elsewhere in Oceania and South East Asia. Priapism cults of the Roman or Hindu variety are absent, although the Arioi cult of the Society Islands exalted sexual pleasure. Female members were admitted only on condition that they disposed of any children born to them and that they shared in sexual activities with fellow Arioi members.

It is not surprising to find sexual symbols abundant in iconographic art, as sexual virility was one of the chief attributes of god and ancestor. The word *tiki* refers to the first man created, the phallus, or a human-phallic form in a symbolical byplay. This fundamental aspect of Polynesian art has been little more than touched on. Writers appear to have preferred silence to endangering their reputations as respectable citizens. If we face what is before our eyes without prudishness, the important place of sexual symbols in much Polynesian art is evident enough. The place of sex in Polynesian life is widely known.

AESTHETIC VALUES AND FUNCTION

The aesthetic aspects of Polynesian art are of primary interest to modern artists and connoisseurs. However, the makers of images were largely unaware of aesthetics as something to be talked about. If an image was to be made for a temple, it was made in the way the forefathers prescribed. Style change was slow, probably never deliberate. Each man knew exactly what he was to do. Nothing was signed with a maker's name. Individual skill was recognized and rewarded but it was attributed to the working of mana rather than to any personal ability.

The choice of hard materials was responsible, in part, for the uncluttered and monumental quality of much Polynesian sculpture. Some artifacts only a few inches high, such as a small Marquesan *tiki*, would allow enlargement to ten feet without loss of sculptural impact. Craftsmen exploited many materials, but wood is the most important. Polynesian art is basically a wood art with gods and deceased ancestors constituting its primary subject matter. Figures have a rigid stance but are nevertheless vigorous in style.

Many figure postures and forms are infantile in the sense that proportions, stance, and flexion of limbs are suggestive of those of young children. This is a curious impression that seems to have validity, although the aim of Polynesian art is not the portrayal of children. The smaller Easter Island wooden images especially support this theory of infantilism in the forms of some Polynesian sculptural work.

It may be safely generalised that in Polynesian art the form of an object was determined by the function for which it was intended. Any decoration was adapted to the form, be the object a canoe, house, bailer or whatever. The ingenious adaptation of images to New Zealand panels and pots by flattening, stretching, or compressing them illustrates a remarkably flexible use of the human figure in architecture.

REGIONAL ACHIEVEMENTS AND LOCAL STYLES

Some areas of Polynesia are famous for achievement in particular crafts. Notable areas of specialisation are the following: Hawaii and New Zealand

for wood carving; Easter, Necker and Raivavae islands for stonework; Fiji for canoe-building; Tonga for ivory work; the Marquesas, Easter Island, New Zealand and the Cook Islands for tattoo; the Chatham Islands for dendroglyphs; New Zealand for rock painting and jadeite working; and Hawaii and Tahiti for barkcloth manufacture.

This general statement does not mean that the best work in a particular medium is found in its geographic area of greatest specialisation. Easter Island specialised in stonework, yet the best stone sculpture in Polynesia is probably Marquesan. The small wooden images of Easter Island are technically speaking the most precise and finished, surpassing Maori work in this respect.

Areas of style types usually match the major cultural divisions and island groupings. Variations of local styles are found within island groups or even within individual islands. At least a dozen discernible regional wood carving styles existed in New Zealand, and some survived into the twentieth century on the East Coast and Bay of Plenty areas of the North Island.

SURFACE PATTERNS AND THE SPIRAL

Polynesian surface patterns consist of *bas-relief*, *intaglio* or painted designs that are rectilinear, curvilinear, or a combination. Spiral forms reached an unexcelled vigour and variety in New Zealand wood sculpture and tattoo. Comparatively speaking, only the Marquesan craftsmen equalled the Maori in the skilful decoration of surfaces, whether of wood or human skin.

The Polynesian designer preferred to incise his patterns if the material could be readily worked that way. When decorating flat surfaces craftsmen often divided the area to be decorated into quadrangles and then manipulated the pattern within the available space of each division. This predisposition to design compartments is exemplified in the surface decoration of Tongan clubs, Samoan barkcloth patterns, Marquesan blocked motifs, and Maori wood sculpture and rafter motifs.

The Polynesian spiral, presumably derived from an assemblage of artistic motifs carried by the Proto-Polynesians, has comparable forms in northern Melanesia, South East Asia, and ancient Asia. Marquesan and Maori spirals and surface decorations generally resemble those of bronze age China. R. Heine-Geldern, Carl Schuster, Douglas Fraser, Mino Badner (see Bibliography), and other scholars have postulated actual design relationships between the art of Polynesia and ancient China.

Spirals are not limited in Polynesia to New Zealand, as is popularly supposed. Fretted spirals predominate in Marquesan art, and some rounded spirals are found there. Spirals in wood appear in New Zealand, the Chatham Islands, the Marquesas, and Easter Island. The pattern of their dispersal suggests a common ancestor and association at the earliest settlement of Polynesia.

THE ROLE OF THE CRAFTSMAN

Craftsmanship functioned on many levels in Polynesian life. Most men could swing an adze or make a net, but few were qualified priestly specialists bearing the title of *tohunga*. The community rewarded them well for their services.

Qualifications for entry into apprenticeship required one to be born a male and to possess appropriate lineage and natural talent for the particular craft. Tribes or individual families developed fame as hereditary practitioners of one craft or another, as was customary in Far Eastern countries.

Esoteric trade guilds functioned on some islands under a patron god, rules of conduct, and an agreed code of behaviour. Payment was made by gifts of goods and food, money being a late importation. Unscrupulous craftsmen were not above the extortion of clients with tricks such as stretching out a job until the employer's resources were exhausted. Samoan carpenters and canoe-builders were extremely touchy on matters of protocol and had to be handled diplomatically at all times. They would readily down tools and would not touch the unfinished work of another.

Crafts were conducted with respect for the traditional taboos. Ritual chants for every phase of work from the first picking up of an adze to the lifting of taboo safeguarded any interference from malignant spirits. Women had their own crafts of barkcloth manufacture and weaving, but the important hard-media crafts were the preserve of men. Women did not go near craftsmen at work, nor approach anything unfinished.

The craft of the tattooist was the most taboo of all because of the direct handling of the bodies of persons of rank. The touching of a chief's head or the drawing of his blood was about the most frightening personal act possible in Polynesian life. For these reasons the tattooist needed to protect himself by ritual and professional immunity. The delicacy of Polynesian tattoo reveals the great attention given to this sacred art.

Tane was regarded by craftsmen as their presiding deity. In Tahiti adzes were "put to sleep" each night in the god's temple. A remarkable artifact reflecting the occult regard for craftsmanship is the ceremonial adze of Mangaia. These non-functional adzes represented Tane as Tane-Mata-Ariki, that is, Tane-of-the-royal-face. A particular feature of these

Hawaii. Ingenious "finger weaving" techniques originally developed in the manufacture of fish-traps and baskets were applied to garment-making in New Zealand, while netting techniques were used in making base fabric for Hawaiian garments and in featherwork. Flat plaiting of various gauges was applied in making many things, including mats, baskets, and fans. Plaited decoration is often exquisite.

IRON EFFLORESCENCE AND DECADENCE

Before Western intervention Polynesians lived and worked at the polished stone tool or neolithic level of human culture. The Hawaiians had received odd fragments of metal embedded in driftwood carried from Asia or North America by the Northern Pacific and Californian currents—the same currents that brought the giant logs welcomed by canoe makers. Captain Cook was surprised to find that the Hawaiians called iron by a specific name, *hao*, and showed interest in acquiring it. Polynesians encountering ships for the first time usually ignored iron until they learnt its properties; then they became so passionately fond of it they would trade or steal for it at every opportunity. In time ships' nails became a standard unit of trade, the value of which was saved from uncontrolled inflation on Cook's ships by orders to crew members that iron be used in buying supplies and not curiosities or trifles. Almost any woman would give her favours for a ship's nail, so the rule was hard to enforce.

Hoop iron from barrels made excellent blades, so it, too, was always in demand. With such blades craftsmen could do more ambitious carving. The simple fact is that a very large part of extant Polynesian sculpture belongs to that era of early carving that had a virtuosity made possible by metal tools. The drum bases and the trade paddles of Raivavae and the large ancestral panels of New Zealand wood carving illustrate the efflorescence of style following the introduction of sharp-bladed tools. Carvings grew bigger and more elaborate as tools became more efficient.

The efflorescent effect on art was spectacular as long as old restraints prevailed, but a general decline followed until a point of decadence was reached. Traditional carving had ceased in most areas by the mid-nineteenth century. Traditional sculptural arts terminated first. This brief flowering of carving art in some parts, notably in New Zealand and the Marquesas and the Austral Islands, was in conflict with the ideals of the newly-acquired Christianity, which forbade interest in "heathen" culture or its products.

Trade with visiting ships kept certain crafts alive in their decadent forms, but the incentive of money or goods was a poor substitute for the former stimulus of belief in the old gods and the spirits of ancestors. Imported sawn timbers and other short-cuts to work did make for lifeless products, but the real cause of decadence was the loss of culture. Change of tools or materials does not automatically cause decadence in art. In Polynesia the reasons were simply loss of stimulus from traditional beliefs and the fact that there was no longer a place for the old-time craftsman.

RELATIONSHIP AND ORIGINS IN ART

Polynesian art did not grow without seed or transplantation. Its antecedent traditions and ancestral forms were carried into Polynesia by the earliest settlers, who had an inheritance of ancient art. The persistence of art motifs, often rendered unrecognisable in local idiom, is one of the most remarkable facts of human culture. It is no great wonder, however, that Polynesian culture with its short isolated life of a couple of thousand years should have retained so much of the distant past. Within Polynesia, the Hawaii and New Zealand groups, although severed in time and space, nevertheless exhibit iconographies that are remarkably similar in their main features. Fragments of early New Zealand wood art, such as the Kaitaia carving, share styles closely with the Austral Islands, Easter Island with the Chatham Islands, and so on, in a marvellous artistic homogeneity.

The perspective of Polynesian art is one of at least 3,000 years, its vanishing point being the world of southern Asia. There neolithic fishermen and gardeners, among whom were the Polynesian ancestors, met in trade or conflict with bronze age agricultural peoples of mainland Asia. We have already discussed the early dynastic cultures of China which began their southern expansions within the second millennium before Christ, bringing pressures to bear on the Malayo-Polynesian aborigines of the south.

However pioneering present-day studies may be in their attempt to relate the Polynesian to the primitive ethnic and proto-historical cultures of Northern China and South East Asia, there is good reason to press for more comparative study of Austronesia-Austroasia and Polynesia.

In 1968 Columbia University of New York prepared and toured a large photographic exhibition illustrating the visual relationships of the arts of Pacific cultures. The catalogue to this exhibition, entitled "Early Chinese Art and the Pacific Basin", offers a significant collection of parallels between the arts of ancient China, Polynesia, Borneo, Sumatra, the north west coast of North America, Mexico and western South America; parallels that support the thesis of pan-Pacific dispersal of Asian culture.

adzes is a surface decoration formed from multiple headless human figures set in rows with elbows on knees. This motif, often referred to as the K-figure, is of a form better likened to two capital Ws, one of which is inverted, looking like this:

This figure motif is found also on artifacts from Mangaia and the Austral Islands.

Non-functional adzes with carved helves are found in New Zealand where they served as batons of authoritative rank. Mangaian and New Zealand forms originated from carpenters' tools and not from battleaxes, and they illustrate the symbolical importance of the adze. There is a persistent world-wide fallacy that stone blades are weapons of war. Polynesia never had a battleaxe in its inventory of weapons.

TOOLS AND STONEWORK

The tools of Polynesian craftsmen were made from wood, stone, bone, shell, shark or rat teeth, and fish skin. The adze and the chisel were basic tools of work, but axe, awl, flake knife, wedges, drill, and rasps were included in the carpenter's kit. Various adzes met different needs, and they were of many forms. Basalt was the standard blade material, but in New Zealand many fine-grained rocks, including nephrite of steel-like hardness, were used. The Maori tool kit reached a summit of neolithic variety of adze types probably unsurpassed at any previous time in human prehistory. Many New Zealand adzes abandoned at the pre-polished stage show mastery of the flaking technique.

The relationship of wood to tool and vice versa was felt by craftsmen. Sometimes the small or large facets caused by blade cuts were left as becoming surface patterns. They reveal great virtuosity with adze and chisel.

Stonecutting was achieved by direct picking or adzing, as on Easter Island. New Zealand nephrite was cut with sandstone saws and with sand and water abrasive. Pecking and flaking were wide-spread, done with hammerstones weighing from a few ounces to many pounds. The neolithic tra-dition of Polynesia includes stone temples, massive images rooted in the ground, and portable stone objects such as small *tiki* of the Marquesas or *poi* pounders of the Society Islands. Each object called for different technical procedures.

The absence on coral islands of fine-grained rock, such as basalt, required inhabitants to seek stone where they could find it, by trade or expedition. If none was available they substituted shell or bone blades. The island of Pitcairn formerly served atoll-dwelling Tuamotuans as a quarry site and was journeyed to over many miles of sea.

The introduction of metal by Western ships began in the late eighteenth century. Iron tools were in general use by 1830. Stone, shell, and bone blades were cast aside in favour of metal whenever and wherever it became available, and this had a pro-found effect on Polynesian art of the post-contact period.

RAW MATERIALS

Wood was the chosen material of the Polynesian craftsman. A favoured hardwood was the *Casuarina* or ironwood. The Easter Islanders suffered from the absence of large trees, although a small tree, *Sophora toromiro*, provided a dense hardwood suitable for precise carving. The Maori of New Zealand, the most blessed with raw materials of all Poly-nesians, found trees ideal to the carver. *Podocarpus totara*, which was readily split into slabs, was relatively soft, yet durable. This tree above all others allowed spectacular development of classical Maori wood art with its massive war canoes and decorated houses. Every island produced some kinds of usable wood, the coconut itself providng a hard trunk timber indispensable to atoll life.

Incidentally, attempts to identify woods patinated by long handling or artificial staining or blackening can be frustrating. Artifact surfaces cannot be scraped or sections cut to obtain expert opinion. Even experienced carpenters seem unable to help with identifications in difficult cases where help is most needed. The typical woods are, for the most part, readily identified.

For the purpose of art study, however, degree of hardness is a primary factor. The intractability of hardwoods tended to discourage elaboration of form or surface decoration, while soft or relatively soft woods encouraged these things. The New Zealand wood style, which is so reminiscent of certain rococo oriental and Melanesian carving, was technically feasible because of the abundance of relatively soft woods and a good supply of hard and fine-grained rocks.

Stone, ivory, and bone followed wood as the favoured materials for sculpture. Other materials were used either alone or in combination with primary or secondary materials. Secondary materials were coral, pumice, bulrush, pith, obsidian, teeth (whale, dog, shark, or human), feathers, hair (human or dog), clay (as pottery in West Poly-nesia and as ochrous pigments generally), shell, sharkskin, tutleshell, coconut-coir as sennit, miscel-laneous plant fibres, and barkcloth. Pigments of considerable variety were of both vegetable and mineral origin and were applied in a variety of ways.

Fibres worked by techniques of plaiting and netting were in a few places adapted to sculpture, notably in the god images and sennit caskets of

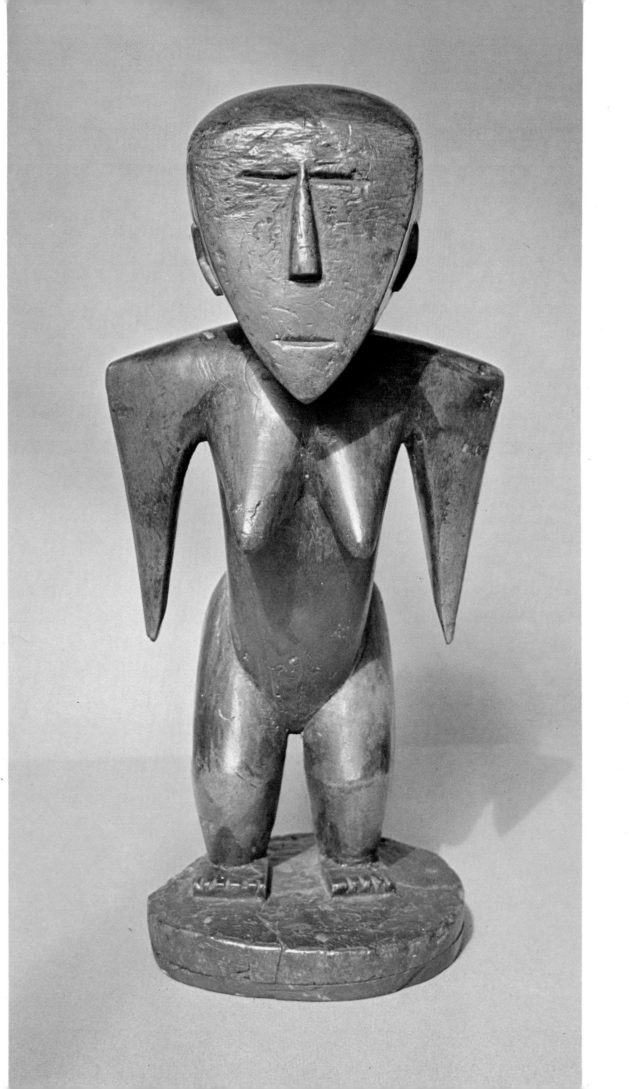

Today we can claim to know only the general drift of events. Advanced archaeological work in all areas, the study of adze forms and other basic cultural items, and the use of modern techniques of dating sites, should, by the end of the century, yield a well-focused picture. At this time we have some facts and the pleasure of speculation. The best service we can render the study of Polynesian art and life is to keep our minds open by shedding the prejudices of our own culture wherever we can, and by letting the objects of old Polynesia speak for themselves.

On page 191 will be found a map of the major Polynesian island groups indicating the geographical relationship of islands of special significance.

In this book the plates are presented under the headings of the principal island clusters, and Easter Island.

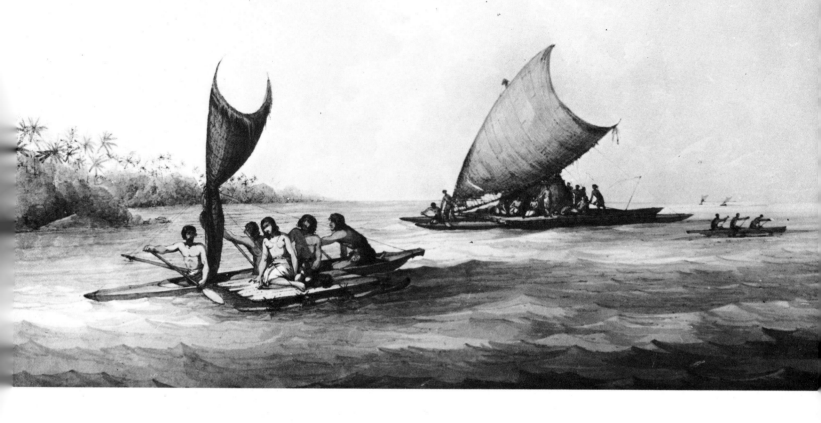

TONGA, WESTERN POLYNESIA

91 ⌂
A view of canoes of the Tongan Islands. From a collection of lithographs (London, 1808) after Webber, draftsman on board the *Resolution*, published in connection with the great last voyage of Captain James Cook. *Collection*: Alexander Turnbull Library, Wellington, New Zealand. *Photo*: New Zealand Tourist and Publicity Dept, Wellington.

Three distinct types of canoes are to be seen, namely, a small paddling canoe (right), a substantial outrigger canoe with sail (left), and a massive interisland sailing canoe with double hulls and a deckhouse (centre). The big sailing canoes of Tonga were secured from Fiji, where large trees had allowed the building of heavy hulls, and where special canoe-building skills had been developed over many centuries.

90 ◁
Image of a goddess. Lifuka, Ha'apai Group, Tonga. Wood. *Height*: 13″ (33 cm). *Collection*: Auckland War Memorial Museum (W. O. Oldman Collection), New Zealand. *Photo*: author.

This beautiful, free-standing image appears in the frontispiece plate with a second wooden goddess (94–96). They share a common history of rejection as gods. (See 94–6.) Tongan wooden images of this style represent one of the peaks of achievement in the impressive tradition of Polynesian wood sculpture. This superb example of extant image stands unrivalled for aesthetic power.

The Tongan Islands consist of about 150 islands and islets in the four groups of Tongatapu, Nomuka, Ha'apai, and Vava'u. The proportion of dry land to sea is approximately 269 to 20,000 square miles respectively. Individual islands are typically of the low coral type, although volcanic and upraised coral islands are present. In former times young warriors of Tonga were active in Fiji, Samoa, Rotuma, and the Ellice Islands. The Tongans relied on military services in Fiji to pay for the great seagoing canoes which they could not make at home because of relatively poor timber resources. Tongan sculpture in wood and ivory, as well as the material culture in general, is distinguished by sensitive craftsmanship and refinement of feeling. A notable feature of the area is the art of surface decoration of war clubs, an art that was exercised also on the clubs of Fiji and Samoa. The modern Kingdom of Tonga emerged from a noble line of chiefs and rulers and today is a constitutional monarchy.

63

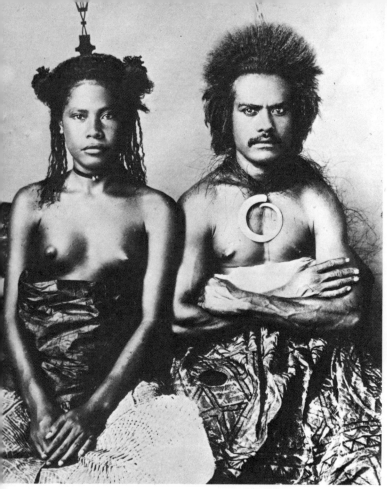

⌂ 92 A young man and a girl, both of chiefly rank, photographed in the Tongan Islands by the touring Burton Brothers, who established a studio at Dunedin, New Zealand, in 1859. *Collection*: author.

This charming study was made about 1890. Both Tongans have waist garments of barkcloth and wear decorative combs thrust into their hair. In addition the girl holds a plaited fan, and the young chief has a boar-tusk neck pendant suspended by braided human hair.

⬦ 93

Decorative comb. Tonga. Coconut leaf-ribs and human hair lashing. *Length*: 15⅜″ (39 cm). *Collection*: Dominion Museum (W. O. Oldman Collection), Wellington, New Zealand. *Photo*: author.

Polynesian combs were regarded as particularly charged with mana because of their contact with the head. (See page 50.) In Polynesian combs were made either of wood or bone, in one piece, or by binding together individual teeth, as this comb demonstrates. They served as personal ornaments, lice-scratchers, and as hair combs.

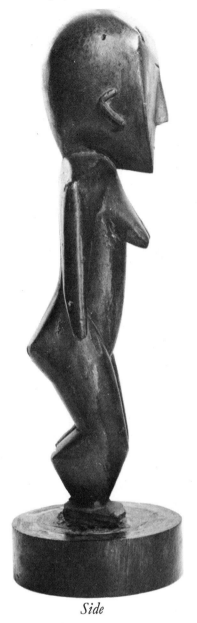

Side

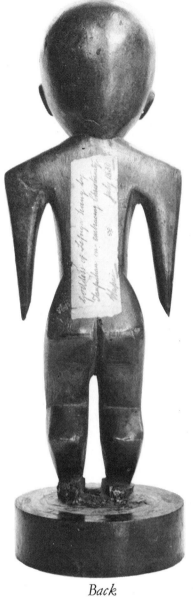

Back

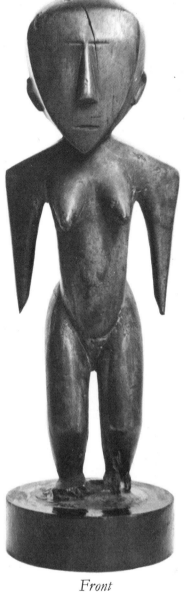

Front

⌂
94
Image of a goddess represented by three views. Lifuka, Ha'apai Group, Tonga. Wood. *Height*: 14¾″ (37.5 cm). *Collection*: Auckland War Memorial Museum (W. O. Oldman Collection), New Zealand. *Photo*: author.

An old script label of the sort dear to the heart of ethnologists is stuck on the back of this figure. It reads as follows (old spellings retained): "Goddess of Lefuga hung by Tafaahau on embracing Christianity—Hapai—July 1830".

This dignified goddess, number 90 (with which it appears in the frontispiece plate), and the seated image (97–9), belong to a distinguished group of Tongan images which have been

⌂
95

⌂
96
discussed and illustrated by Buck (1937), Oldman (1943), Larsson (1960), and Duff (1969). In 1837 the Rev. John Williams illustrated this goddess (94–6), hanging by the neck, in his book *A Narrative of Missionary Enterprises in the South Seas* (London, 1837), so its history is clear. However, the collectors of 90 and 97–9 are less distinguishable. The Rev. John Thomas, a Wesleyan missionary, collected four images at Lifuka in 1830, some direct from King Taufa'ahau (subsequently King George Tupou I) as did John Williams. The King, Thomas reports, hung several images in his house and " . . . laughed heartily at these Idols now fallen into disgrace".

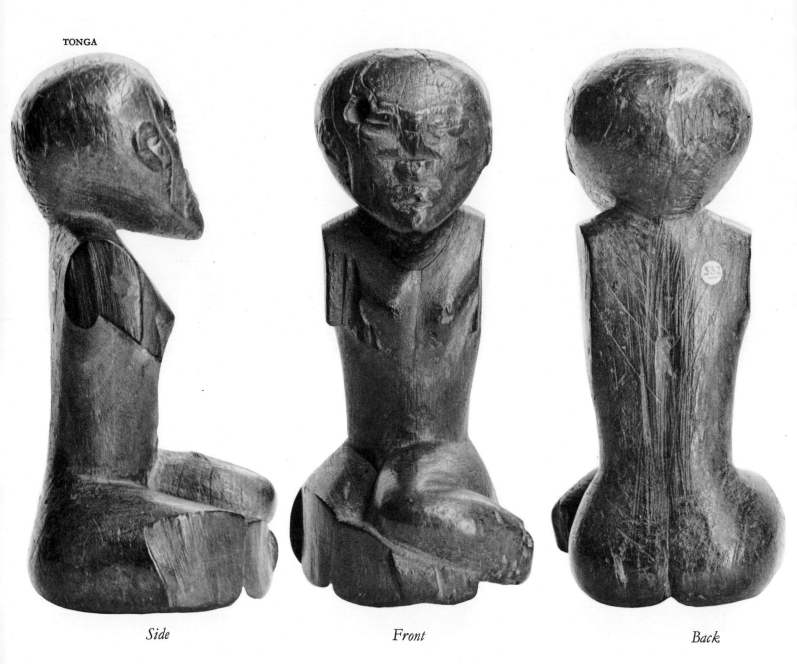

Side *Front* *Back*

97

Image of a sitting goddess. Lifuka, Ha'apai Group, Tonga. Wood. *Height*: 7½″ (19 cm). *Collection*: Auckland War Memorial Museum (W. O. Oldman Collection), New Zealand. *Photo*: author.

A piece of white barkcloth, which accompanies this figure, has with it an old script label which reads (old spellings retained): "Household Goddefs of the Emperor of Tongu and part of the drefs worn by him when he worshiped the Devil".

Polynesian iconography is characterised by standing sym-

98

metrical images with arms pendant, so the sitting posture of this goddess with her legs drawn to her left side is notable. In fact, in Polynesian sculpture this is one of the very few departures from the rigid symmetrical stance to free posture. Arms tend to change position in Polynesian figures, but the legs are typically rigid, and only slight flexing at the knees.

The severe damage to head and lower limbs, and the loss of arms, may be attributed to the beating the goddess received from her former devotees on her fall from power. Similar facial damage on another goddess (90) was in all probability received from thrashing "punishment".

99

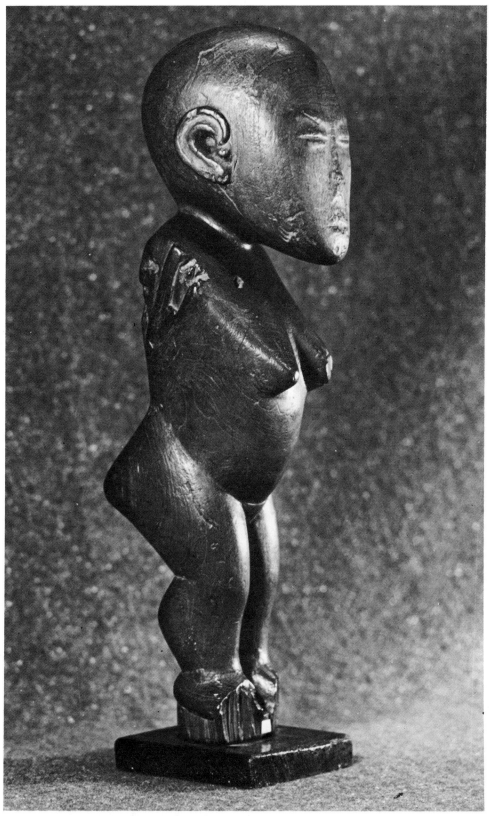

100 ⇩

Image of a goddess. Tonga. Wood. *Height*: 14½″ (36.8 cm). *Collection*: Marischal College Anthropological Museum, Aberdeen, Scotland. *Photo*: Art Institute of Chicago, USA.

A curious old label pasted to the back of this figure purports that it is "Sakunu a great Tongan Goddess". The name "Sakunu" cannot be Tongan as there is no "s" in the Tongan language; however, it could be a Fijian god or an ancestral name. The style of this figure is unquestionably Tongan, probably of the Ha'apai image school of craftsmen. Torso and head are in good condition, but the arms are missing. The wear and patination of the fractured surfaces indicate that the arms were lost long ago, possibly well before the figure was carried away from Tonga.

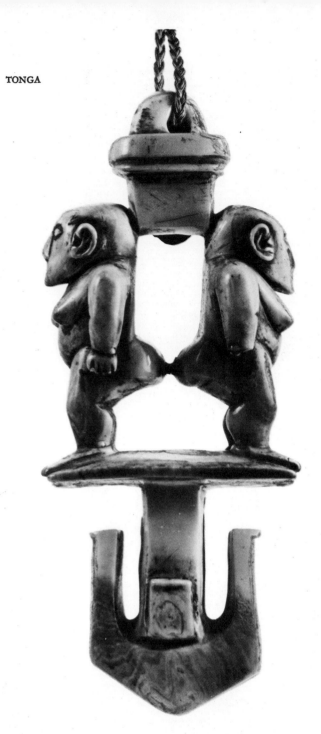

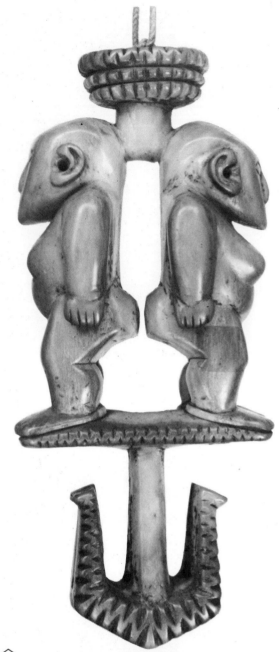

101 ⌂

Suspension hook god symbol incorporating two female images. Collected in the Nandi District, Viti Levu, Fiji (attributable to the Ha'apai Group, Tonga on the basis of style). Sperm whale (cachalot) tooth ivory. *Height*: 7″ (17.8 cm). *Collection*: Cambridge University Museum of Archaeology and Ethnology, England. *Photo*: author.

A similar small hook in the Cambridge collection (see Barrow, 1956) was given to Sir Arthur Gordon (later Lord Stanmore) about 1875 by a Fijian named Tavita. Tavita assured Sir Arthur that it was what was called "Nadi Devil" (that is, god of Nandi), and that the figures represented the "double wife" of the god. Tavita claimed also that in former times, before the coming of the *Lotu* (church), he had heard the hook speak with "a thin squeaky voice", and that in those early days the hook had the power to stand upright unaided.

102 ⌂

Suspension hook god symbol incorporating two female figures. Collected at Namosi, Viti Levu, Fiji (attributable to the Ha'apai Group, Tonga, on the basis of style). Sperm whale (cachalot) tooth ivory. *Height*: 5⅞″ (14.8 cm). *Collection*: Marischal College Anthropological Museum, Aberdeen, Scotland. *Photo*: Carl Schuster.

The museum catalogue records that this ivory hanger was used "by eight generations of a family in Namosi"; also that it was collected by Dr McGregor in the 1870s. Hook suspenders with incorporated figures, or masks, were used in parts of Melanesia, notably in New Guinea. In Polynesia they are found only in Fiji and Tonga. Fijian hangers are made of strong wood and with rat baffle discs fitted on the top. They are made for hard usage (138). The small Tongan suspension hooks are of light weight and of such delicate manufacture that they are unsuitable for practical use. All accounts indicate that they served as ritualistic symbols of the gods.

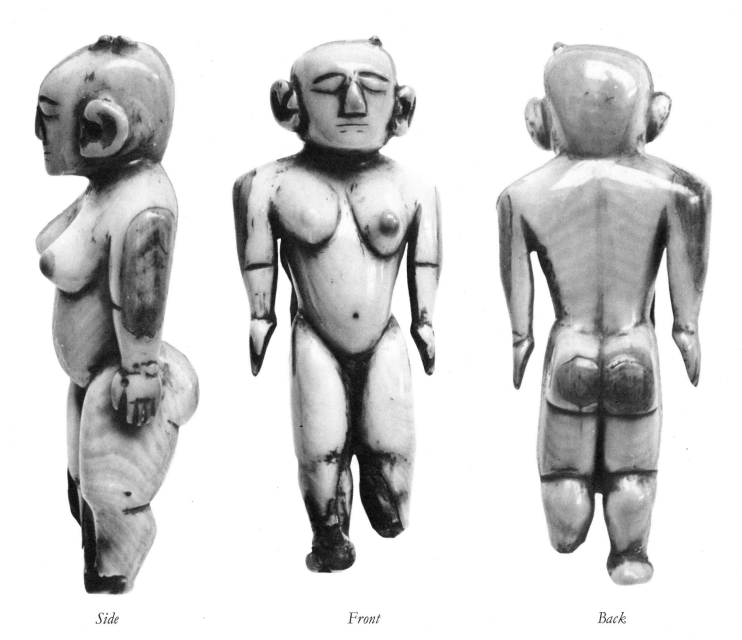

Side *Front* *Back*

⇧ 103 ⇧ 104 105 ⇧

Three views of a female pendant image. Collected on Viti Levu, Fiji (attributable to Tonga on the basis of technique, style, and the known Ha'apai Group ivory-carving tradition). Sperm whale (cachalot) tooth ivory. *Height*: 4¼″ (10.8 cm). *Collection*: Cambridge University Museum of Archaeology and Ethnology, England. *Photo*: author.

This specimen was collected in Fiji before 1900. A small suspension hole is visible on the crown of the head, indicating that it was worn suspended singly, or in an assemblage of images on a necklace, in the manner of one illustrated from Fiji (125). Although the feet are damaged, the figure is in fair condition and in general is a good example of Tongan ivory sculpture. (Compare 106–7.)

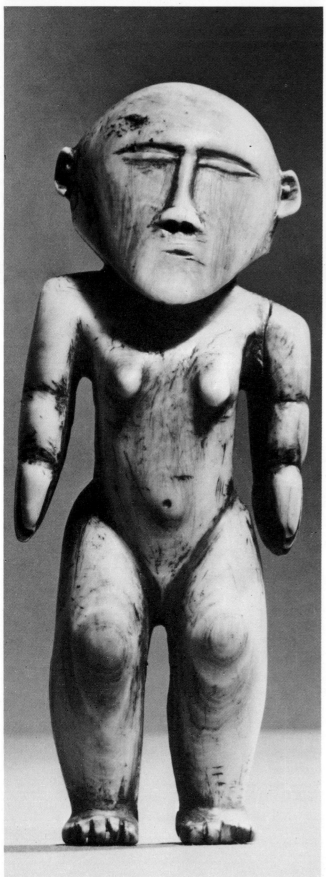

106 ◊

Female pendant figure. Tongan Islands. Collected on Viti Levu, Fiji (attributable to the Ha'apai Group, Tonga on the basis of style). Sperm whale (cachalot) tooth ivory. *Height*: 5¼″ (13.2 cm). *Collection*: Museum of Primitive Art, New York. *Photo*: museum archives.

This remarkable small image is said to have been collected in Fiji by a Cyril Hawdon in 1868. The author first examined it before it was offered for sale in 1957 in Sotheby's auction rooms, London, later in New York, in 1969. When the auctioneer at Sotheby's raised the price to about 800 English pounds in quick bids, there was something of a sensation. However, in just over a decade Polynesian artifacts have appreciated several times over in monetary value. This trend must continue because of big demand and small supply.

A suspension lug at the back of the head indicates that the figure was worn as a pendant singly, or in a necklace assemblage. Whether goddess or ancestor spirit is represented must remain undecided, as is often the case with images without recorded identification.

◊ **107**

Female pendant figure. Tonga (probably Ha'apai Group). Sperm whale (cachalot) tooth ivory. *Height*: 5″ (12.7 cm). *Collection*: Mr and Mrs Raymond Wielgus, Chicago. *Photo*: Art Institute of Chicago, USA.

The colour of this small Tongan ivory is typical of the warm brown that develops with handling and aging. The colour is easily lost if a specimen is exposed to strong daylight. This Wielgus Collection item is carefully preserved, and it represents Tongan ivory carving of best condition and quality. A suspension hole at the back of the head (now worn out or broken away) was formed by the usual Polynesian method of drilling two holes, each angled at about 45 degrees so that they met below the surface to form a flush suspension lug. This figurine was worn either singly or as part of a necklace assemblage. (Compare 125.)

TONGA

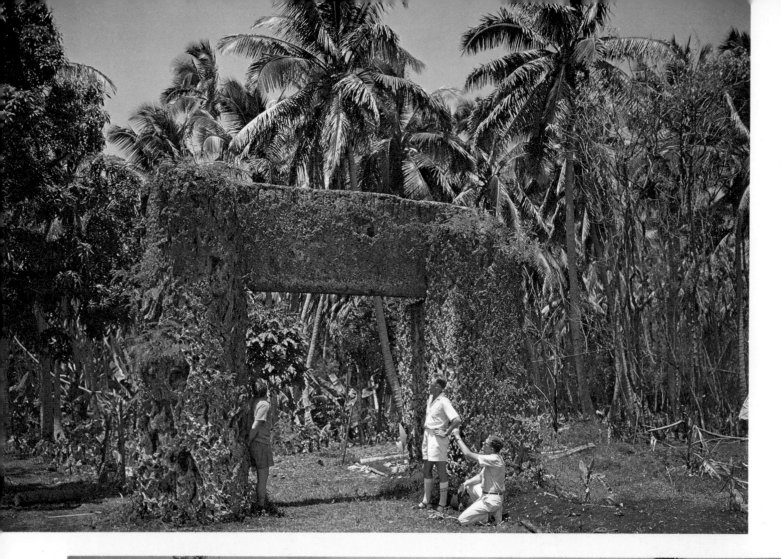
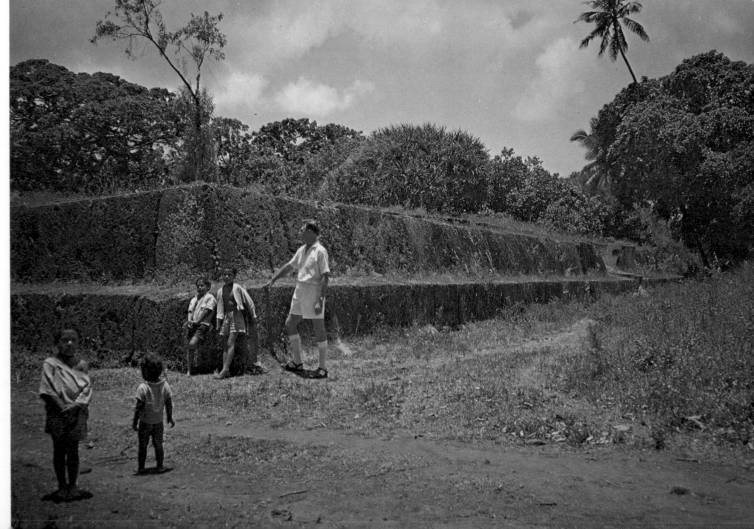

108 ◁

A trilithon of coral rock, Tongatapu, Tongan Islands. This structure, which bears the name of Ha'amonga-a-Maui (Burden-of-Maui), stands about sixteen feet high and is composed of giant slabs weighing thirty to forty tons each. Their placement is readily explained by the use of massive manpower, and inclined causeways formed from loose coral rock which were subsequently removed. Tongan tradition claims that this structure was erected by Tuitatui, the eleventh *Tui Tonga*, or ruler, as a monument to his two sons. An estimate of age based on generations since the eleventh *Tui Tonga* places the date of construction at about 1200 AD. *Photo*: S. D. Scott.

109 ◁

Tombs faced with dressed coral slabs, Tongatapu, Tongan Islands. *Photo*: S. D. Scott.

At the place called Mua two great *lagis* (terraced mounds) rise at some points to twenty feet. They are tombs, associated with the burial of generations of sacred kings of Tonga. Terraced structures related to religious ceremony and burial are found in many parts of Polynesia. The high, multi-terraced temple of Mahaiatea of Tahiti, although known to have been built in the eighteenth century, encouraged false notions of a direct relationship between Polynesian and ancient Egyptian culture.

110
111 ▷

Club with surface ideographs. Crayon rubbing of surface detail (111). Tonga. Hardwood. *Length*: 34¼" (87 cm). *Collection*: Bernice P. Bishop Museum, Honolulu. *Photo*: George Bacon, museum archives.

The distinctive *intaglio* of this club is typical of a number collected on the two visits to Tonga by the ships of Captain James Cook. The rubbing shows characteristic working of ideographs within compartments. The two pairs of dogs, two men, a turtle, an octopus, two crescents, and three dots occur just above the grip of the club. The surface carving is un-

110

finished on the lower part of the handle, where interesting process cuts are to be seen. Unfinished work usually indicates either the death of the owner (when no one would dare continue his work or alternatively, the trade of an item before it was finished. The various creatures probably relate to the totem of the club's owner. (See page 52–5 for further discussion on totems; also refer to 112–14.)

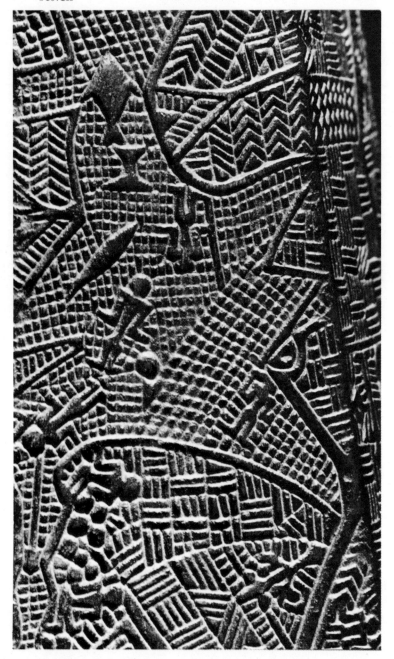

112 ⬈

A photographic enlargement of the surface of a Tongan club in the collection of the Tropical Institute, Amsterdam, Holland. *Photo*: R. L. Mellema, museum archives.

The club from which this detail is taken is extremely unusual, firstly in the manner of surface *intaglio*, and secondly in subject, which is a connected landscape of a kind not observed in any other Polynesian carving. On this club a scene appears within which is found a lagoon (or bay), trees, fish, men, and birds. It was mentioned to the author when studying the club at the Tropical Institute that it was possible the club dates from the visit of Abel Tasman to Tonga in 1643. This is feasible, as the club is evidently of an older style than those collected by Captain Cook and his men in the late eighteenth century, and certainly much older than the common run of figured clubs collected in the nineteenth century.

113 ⬈ **114** ⬊

A selection of zoomorphs from Tongan clubs which were made available to the author for study and crayon rubbing in the London home of Captain and Mrs Fuller in 1956. The Fuller Collection has since been acquired by the Field Museum of Natural History, Chicago. The subjects of the small pictures are clear: men with carrying poles, warriors fighting (one of them has lost his head), turtles, a warrior with headdress, European sailing vessels, and old-type anchors. The two sets of eyes at one end of a club indicate, along with other features, its basic animal form. (See page 54.) General reference to totems in Polynesian art is provided on page 52.

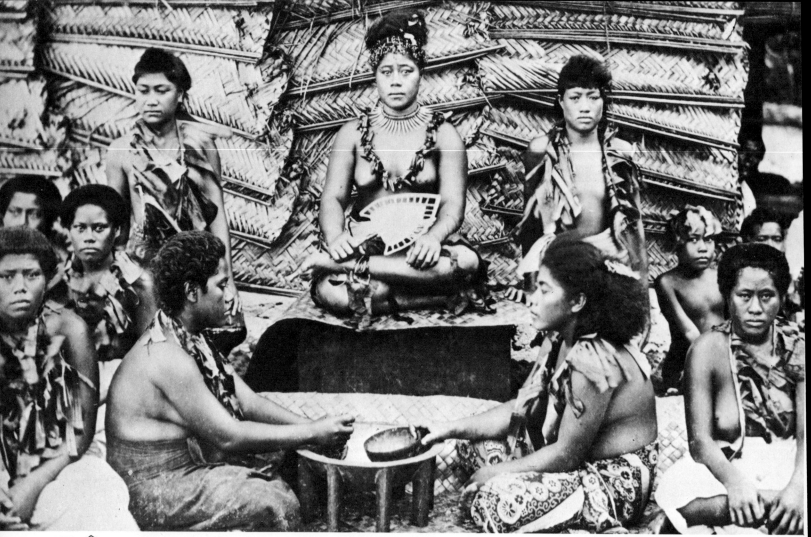

115 ⌂

The serving of *kava* from large wooden bowls in separate coconut cups requires the highest etiquette and a knowledge of the rank of the guests. *Collection*: author. *Photo*: Burton Brothers, Dunedin, New Zealand, 1890.

The custom had an important place in the social life of many Polynesian islands, but it is now used only in Samoa, Tonga, and Fiji. The girl seated high in the centre of this Samoan group is a high chief's daughter (*taupou*), who must assume the ritual task of making *kava* and serving it from the bowl. A cup carrier took the *kava* to the guest.

SAMOA, WESTERN POLYNESIA

Today the Samoan group of islands is divided into two parts: Western Samoa, an independent sovereign state, the principal islands of Upolu and Savai'i totalling 1,133 square miles, and Eastern Samoa, an unincorporated territory of the United States of America, comprising seven small islands including Tutuila, Ta'u and those of the Manua Group. The major islands are mountainous, well-watered and wooded, with the concentration of populations in coastal villages. The Samoan islands are not distinguished by a spectacular decorative or sculptural art; however, they are an undoubted centre of Polynesian cultural formation. Regardless of any art that may have existed formerly, the Samoans of classical times devoted their energies to the sponsorship of representative chiefly orators and sacred virgins. They seem to have had little time for the embellishment of material culture. Natural forms of animals replaced man-made symbols as abiding places for spirits. The ornamentation of chiefly persons by tattoo, elaborate headdresses and fine ceremonial mats (which were exchanged on all important occasions), and house-building, represent the art of Samoa.

76

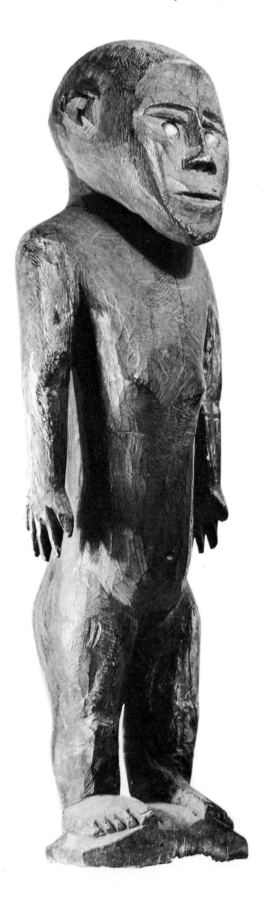

116 ⬦

Free standing image. Upolu, Western Samoa. Wood. Opercula eye insets. *Height*: 27⅛″ (69 cm). *Collection*: British Museum, London. *Photo*: author.

According to museum records this figure was presented to Queen Victoria by King Malietoa in 1841. As the Samoans were not known to be makers of anthropomorphic images as vehicles of gods and spirits, the existence of this figure, definitely localised to Samoa, is often explained away as having actual origin in Tonga, or as being made in Samoa by a Tongan. In the author's opinion, features of style of this image are sufficiently unlike the Tongan style to allow of a Samoan maker. In fact, it incorporates both Tongan and Fijian image features. It may well be an indigenous product, as its history suggests, and the sole survivor of a minor image-making tradition which conceivably existed in the Samoan group before European contact.

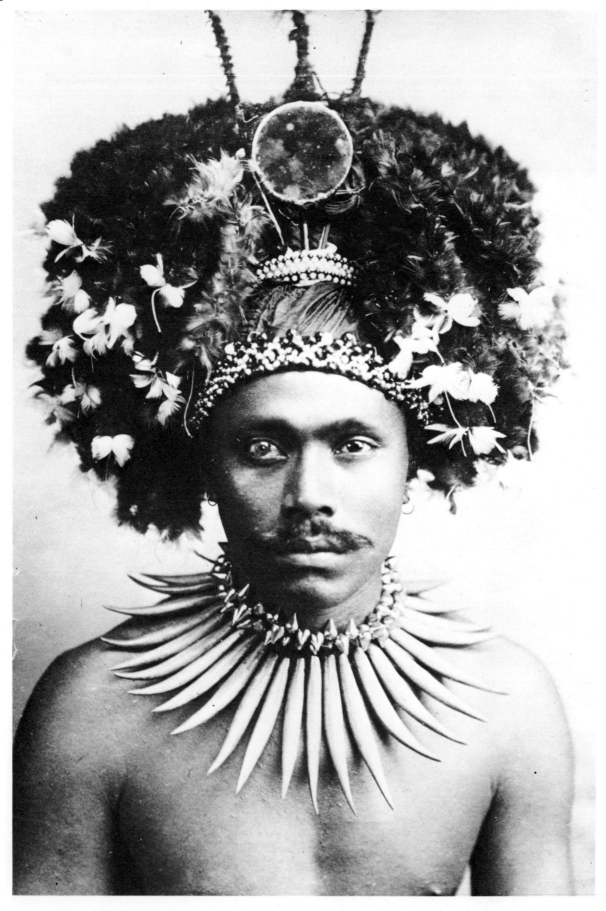

117 ⇑

A high chief of Western Samoa resplendent in elaborate headdress (*tuinga*) made from bleached human hair, red feathers, and shells. *Collection*: author.

The heavy necklace worn by this man is made of sperm whale (cachalot) teeth sawn into sections, then shaped and polished. Headdress and necklace were allowed those of highest rank. Today the old necklaces are in public museums or private collections. The headdresses have changed form; for example, mirrors replace the pearlshell plates of former times.

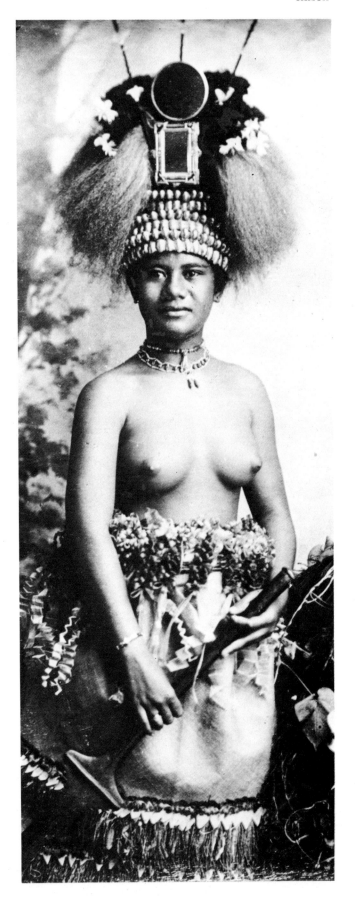

118 ⇗

A chief's daughter of Western Samoa of *taupou* rank, in whom the prestige of a village was centred. This handsome girl is wearing the elaborate *tuinga* headdress (which was worn by both men and women) and a fine plaited mat trimmed with red feathers. The Tongan club in her hand was probably provided as a studio "prop", following the custom of the early photographers who established themselves in various port towns of the Pacific late in the nineteenth century. They usually kept an assortment of "curios" on hand.

119 ⌂

Tattoo artists at work in Western Samoa late in the nine-
teenth century. From an original in the archives of the Bishop
Museum, Honolulu. Western Samoa is the last place in
Polynesia where the tradition of body tattoo survives. It
remains the mark of the man of good family and manly
virtues. Customarily, two friends shared this ordeal over
several painful days. Tattoo artisans were highly paid for
their work, with food, mats, and other goods.

120 ⇨

A group of seated young men of Eastern Samoa during a
communal flag-raising ceremony. Whereas the European
practice is to stand in respect, the Polynesian custom is to sit.
Their disciplined attention and muscular backs shining with
coconut oil express the mode of the Polynesians of old times.
The virility of the warrior and discipline were qualities highly
regarded. The author took this photograph at Honolulu in
1968 during a gathering of Samoans. Many of these young
men have bodily tattoo, just visible despite the dress of modern
times.

SAMOA

121 ⬦
Dish in human form. Fiji Islands. Wood. *Length*: 14½″ (37 cm). *Width*: 8½″ (21.5 cm). *Collection*: Auckland War Memorial Museum (W. O. Oldman Collection), New Zealand. *Photo*: author.

A dozen or more of these anthropomorphic bowls are identified as oil dishes used by priests when anointing their bodies with refined and scented coconut oil. Temples were numerous in old Fiji. Plain types of oil dish (compare examples 130–33) are relatively common. Bowls in human form are classified as "rare".

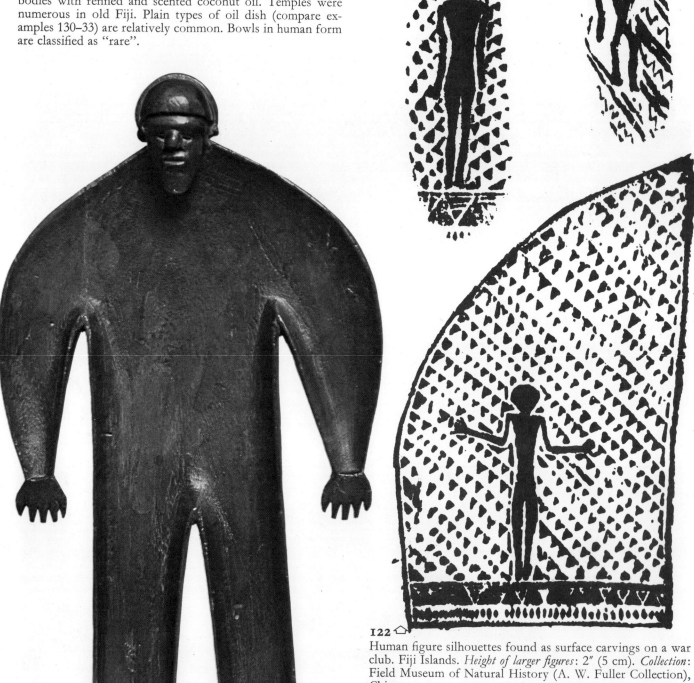

122 ⬦
Human figure silhouettes found as surface carvings on a war club. Fiji Islands. *Height of larger figures*: 2″ (5 cm). *Collection*: Field Museum of Natural History (A. W. Fuller Collection), Chicago.

These surface patterns were recorded by the author by the rubbing technique. They appear on the blade of a paddle-form club (compare 30), and serve to illustrate the heavy style of Fijian club zoomorphs compared with the Tongan style. (See 110–14; also refer to the general note on surface decoration, page 58.)

The Fiji group is composed of Viti Levu, with its numerous small islands (totalling 4,053 square miles), and Vanua Levu (2,137 square miles). There are numerous other islands and fifty-seven islets of the Lau Group to the east of the mountainous islands of Viti Levu and Vanua Levu. Atolls and raised coral islands occur within the group of Fijian culture, and coral reefs fringe some shores of the major high islands. Rivers, coasts, and forests provided abundant resources for exploitation. The traditional Fijians exhibit Melanesian elements in the racial make-up, yet they are classifiable as Polynesians for several reasons, including that of their material culture. Earthenware, superb domestic utensils, and impressive oceangoing canoes are the most notable products of this culture. The political status of the group was until very recently that of a British Crown Colony; however, Fiji became independent in October 1970.

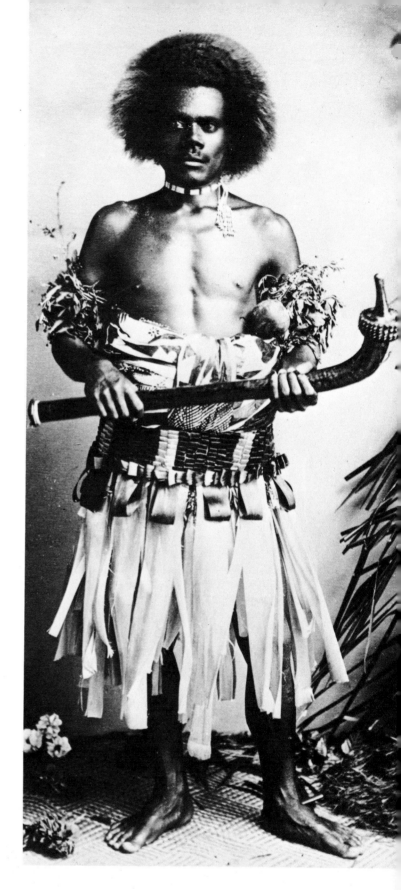

123 ⬦

A warrior of the Fiji Islands holding a war club made from a sapling which had been tied down to grow in a curved form. The dress he is wearing consists of a heavy wrap of printed *tapa* overtied with strips of bark. The knobbed end of a belt club may be seen projecting above the garment at the man's left side. *Photo*: Unidentified photographer working in the late nineteenth century. From an old print secured by the author in London.

FIJI

83

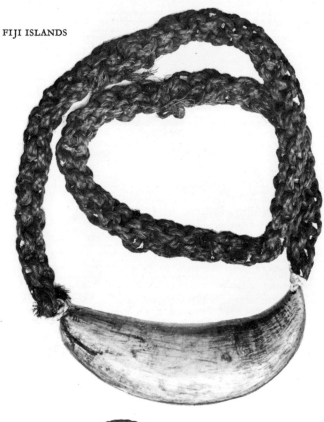

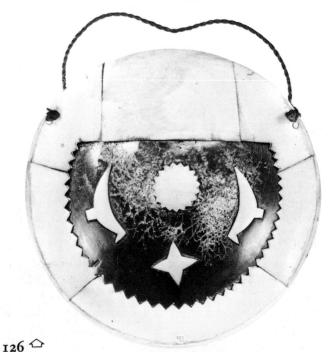

124 ⬦

Amulet of *tambua* type. Fiji Islands. Sperm whale (cachalot) tooth ivory and sennit cord. *Width of tooth*: 7¼″ (18.5 cm). *Collection*: Mr and Mrs L. Fortess, Kaneohe, Oahu, Hawaii. *Photo*: author.

The *tambua* of Fiji is one of the most famous of Polynesian artifacts. Its use as an obligatory gift is explained on page 38.

⬦**125**

Necklace with human images and "tooth" elements. Fiji Islands. Whale (cachalot) tooth ivory and sennit suspension cord. *Height of images*: from 2⅞″ (7.4 cm) to 3¾″ (9.6 cm). *Collection*: Cambridge University Museum of Archaeology and Ethnology, England. *Photo*: author.

The eight female figures and nine tooth elements are hung on a suspension cord composed of seven strands. There is no precise history for this unique necklace; however, it is believed to have been presented to Lady Gordon (wife of Governor Gordon) about 1884. The style of the images is not of the Ha'apai type (103–7), but indigenous Fijian. (Compare the wooden figures 138–43.)

126 ⬠

Breast ornament. Fiji Islands. Pearlshell and sperm whale (cachalot) tooth ivory. *Width*: 10¼″ (26 cm). *Collection*: Auckland War Memorial Museum (W. O. Oldman Collection), New Zealand. *Photo*: Dominion Museum, Wellington, New Zealand.

Warriors' breastplates are among the most impressive products of Fijian craftsmanship. This item has inlaid birds rendered in the Tongan convention, often seen in Tongan club surface carving. (Compare the club zoomorphs 112–14.) It is conceivable that this breastplate is of Tongan workmanship.

127 ⬠

Breast ornament. Fiji Islands. Whalebone and sennit suspension cord. *Width*: 7½″ (19 cm). *Collection*: Dominion Museum, Wellington, New Zealand. *Photo*: museum archives.

This rare whalebone breast ornament is in the form of a pearlshell, as is the ivory and shell specimen 126. The serrated rim, with its numerous "teeth", is characteristic of the edge treatment of artifacts in several parts of Polynesia. The substitution of materials, in this case whalebone, for the original shell, is a Polynesian practice of great interest.

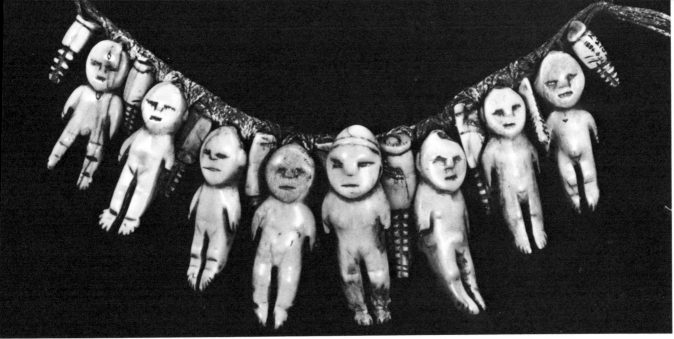

125

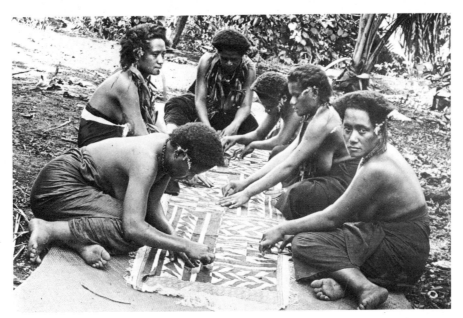

128 ▷
Fijian women busy at work marking a long waist wrap of barkcloth. *Photo*: Bernice P. Bishop Museum archives, Honolulu.

Barkcloth was widely used throughout Polynesia (with the exception of New Zealand) as clothing, bedding, ornament, wrapping material for ritual objects, and in numerous other applications. Fiji developed its own variant of cloth with distinctive patterns, as did most other Polynesian groups. In Fiji and Tonga sheets of impressive length were made for ceremonial occasions, when the nobles literally walked along paths of barkcloth.

Detail from a barkcloth sheet of Fiji, illustrating a local stencil method of decorative marking. *Collection*: Cambridge University Museum of Archaeology and Ethnology, England. *Photo*: author. ▷ 129

The patterns of Fijian *tapa* decoration are strongly rectilinear; in this instance a rare zoomorphic motif in the form of a swimming turtle is added. Fijian *tapa* is commonly lightweight bleached cloth with deep black patterns stencilled or block-printed over most of the surface. Some sheets have an ochrous red added as a third colour. Generally the greatest restraint is in the oldest work.

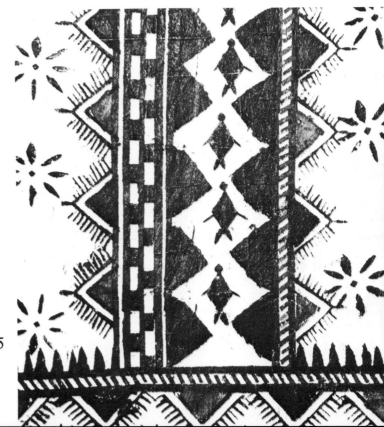

85

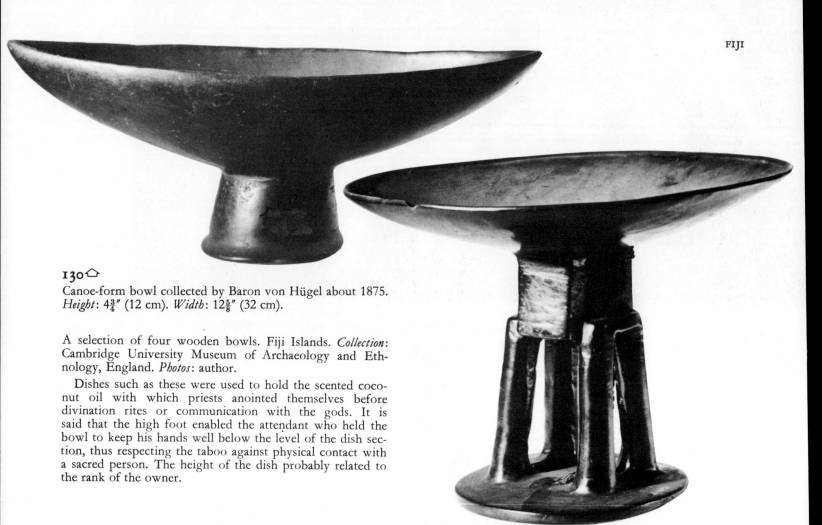

130

Canoe-form bowl collected by Baron von Hügel about 1875.
Height: 4¾″ (12 cm). *Width*: 12⅝″ (32 cm).

A selection of four wooden bowls. Fiji Islands. *Collection*: Cambridge University Museum of Archaeology and Ethnology, England. *Photos*: author.

Dishes such as these were used to hold the scented coconut oil with which priests anointed themselves before divination rites or communication with the gods. It is said that the high foot enabled the attendant who held the bowl to keep his hands well below the level of the dish section, thus respecting the taboo against physical contact with a sacred person. The height of the dish probably related to the rank of the owner.

132

Shallow dish on legs. *Height*: about 8″ (about 20 cm). *Width*: about 12″ (about 30 cm).

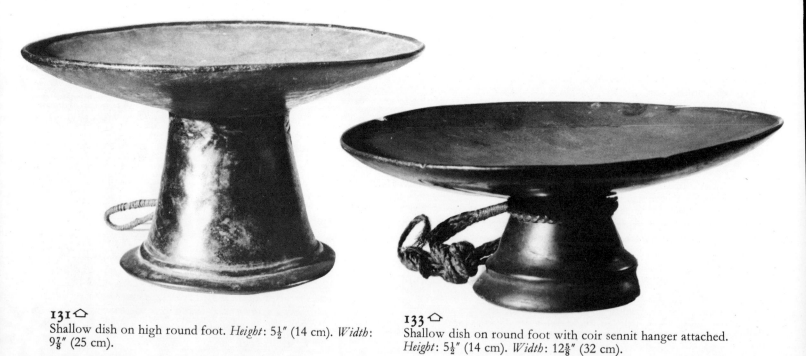

131

Shallow dish on high round foot. *Height*: 5½″ (14 cm). *Width*: 9⅞″ (25 cm).

133

Shallow dish on round foot with coir sennit hanger attached. *Height*: 5½″ (14 cm). *Width*: 12⅝″ (32 cm).

134 △
Open bowl with resin glaze and incised stipple pattern. *Height*: 5⅛″ (13 cm). *Diameter*: 7⅛″ (18 cm).

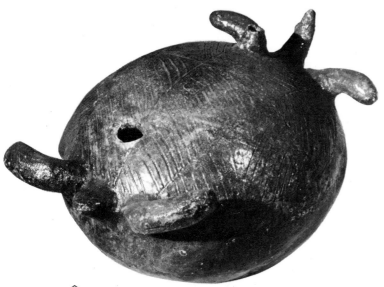

136 △
Wide-mouthed jar with uneven resin glaze and notched lip. *Height*: 9⅜″ (25 cm). *Diameter*: 7⅞″ (20 cm).

135 △
Turtle form water bottle with resin glaze and lightly-incised decoration. *Length*: 12¼″ (31 cm).

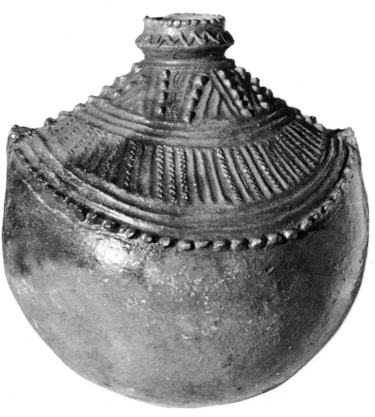

137 ⬦
Water bottle with mottled orange-green resin glaze with applied and incised surface decoration. *Height*: 11″ (28 cm). *Width*: 10¼″ (26 cm).

This selection of four pots represents typical styles of Fijian earthenware. *Collection*: Cambridge University Museum of Archaeology and Ethnology, England. *Photos*: author.

Fijian potters, traditionally women, fired the raw wares in open wood fires, then glazed or partially-glazed them when still hot by rubbing gum from indigenous pine over the surface.

87

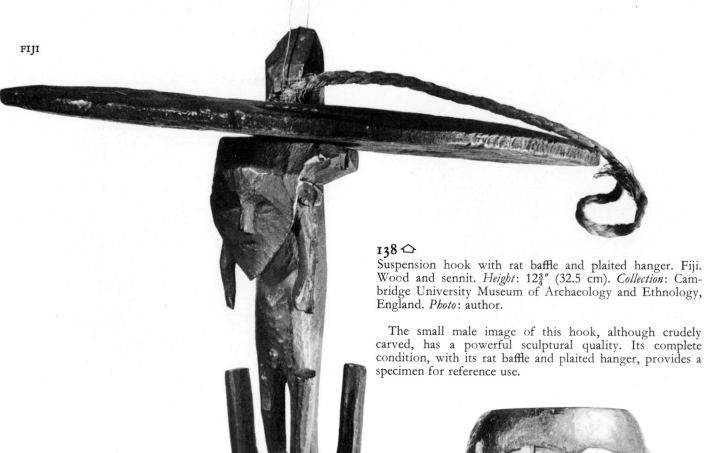

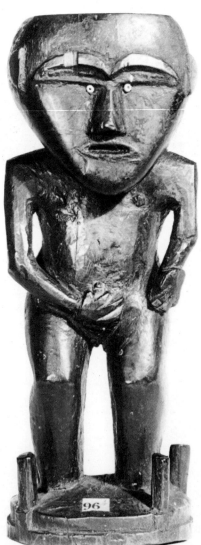

138 ⬆

Suspension hook with rat baffle and plaited hanger. Fiji. Wood and sennit. *Height*: 12¾″ (32.5 cm). *Collection*: Cambridge University Museum of Archaeology and Ethnology, England. *Photo*: author.

The small male image of this hook, although crudely carved, has a powerful sculptural quality. Its complete condition, with its rat baffle and plaited hanger, provides a specimen for reference use.

Wooden hooks suspended from convenient high points provided one of the few safe means of storage in and about houses. Cupboards were absent from Polynesian life, and predacious rats were abundant and ever ready to eat anything edible. Most suspension hooks are simply double hooks without decoration. A few have human images incorporated into their design. Round rat baffles were used in conjunction with most hooks, although they are rarely preserved with the hook.

139 ⬇

Suspension hook. Fiji. Wood. Trade-bead eyes. *Height*: 24″ (61 cm). *Collection*: Marischal College Anthropological Museum, Aberdeen, Scotland. *Photo*: author.

Some previous owner of this artifact has mutilated it beyond ready recognition as a hook. The top projection, used to hold a rat baffle and to receive the suspension hole, has been sawn off. Also the base has been trimmed to provide a flat standing surface. The figure is nevertheless a very good example of Fijian wood sculpture.

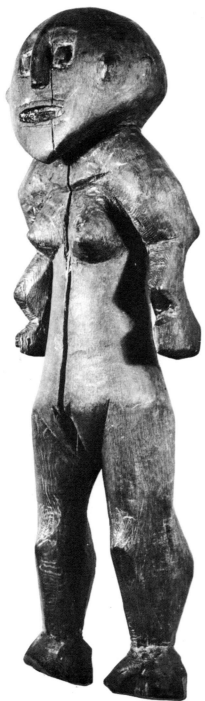

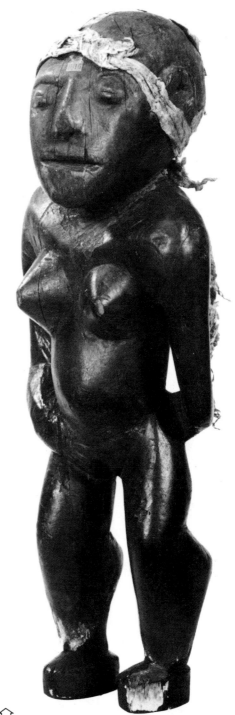

140 ⌂
Female image. Rewa River, Fiji. Wood. *Height*: 20½″ (52 cm). *Collection*: Cambridge University Museum of Archaeology and Ethnology, England. *Photo*: author.

This unusual figure was collected about the year 1875 by Baron von Hügel, who noted that it was thought to be the portrait of a "half-cast girl" of Mbau. The significance of this identification was not clarified by Baron von Hügel. The style is a variant of Fijian work and is in some features related to the images of New Caledonia. The heavy crack running down the centre of the body suggests that green wood was used in the carving of this figure. This condition usually indicates a relatively late period of manufacture, when craftsmen became less careful in their selection of materials.

141 ⌂
Female image with *tapa* headband. Sandlewood Bay, Vanua Levu, Fiji. Brown wood stained black. *Height*: 17″ (43 cm). *Collection*: Smithsonian Institution, United States National Museum, Museum of Natural History, Washington, DC. *Photo*: museum archives.

Museum records indicate that this figure was collected by the famous United States Exploring Expedition, which visited Fiji in 1840 under the leadership of Commodore Charles Wilkes. Its identification remains unknown; probably a local goddess is represented. One of the hands is placed behind the back, while the other rests on the vulva. Mobile disposition of arms may be seen in other Fijian images (for example 139); however, the standard position is for the arms to be pendant at the sides (140).

142 ◊

This old figure was collected in 1840 by the United States Exploring Expedition under the command of Commodore Wilkes. The preceding figure, 141, has the same expedition association. The museum catalogue includes an old description of this board image as an "idol" from the "chief spirit place of the Fijians at Rawa (sic.), Island of Viti Levu". The head 143 is remarkable for the "alive" expression of the face and for an overall sculptural power.

143 ◊

Image on board. Head detail, 142. Viti Levu, Fiji, Wood. *Height overall*: 41½″ (105.5 cm). *Height of image*: 37″ (94 cm). *Collection*: Smithsonian Institution, United States National Museum, Museum of Natural History, Washington, D.C.

Photos: museum archives (black and white plate); author (colour plate).

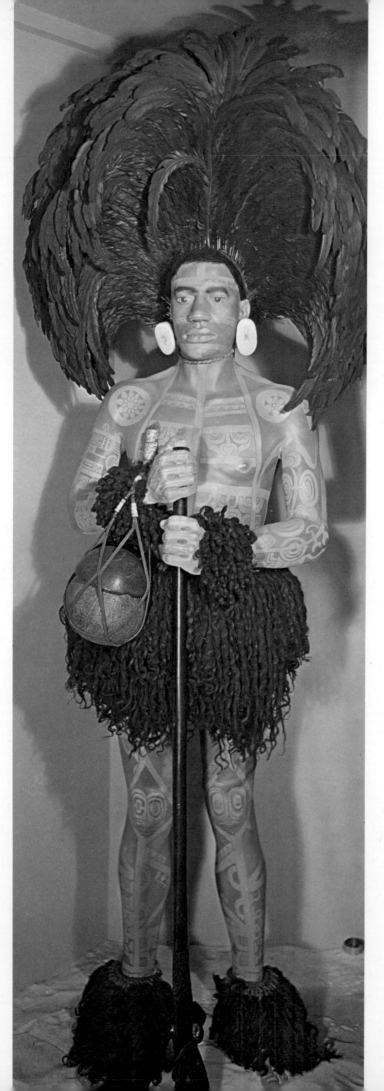

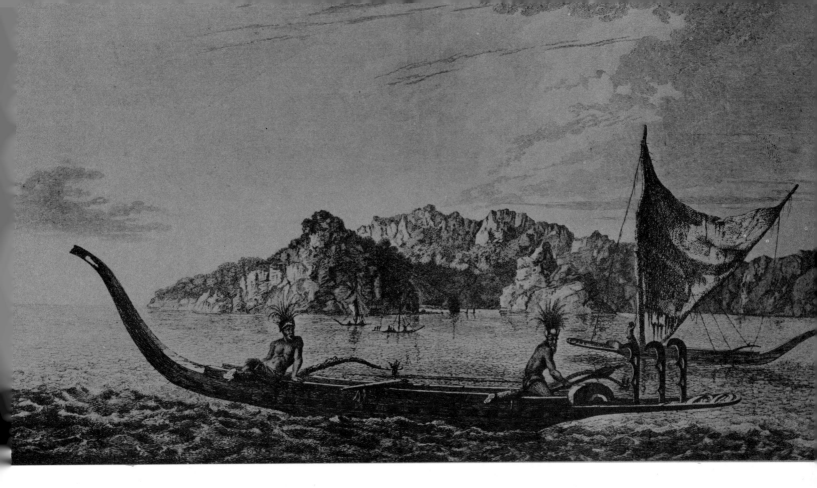

145 ⬦
This engraving, entitled "Resolution Bay in the Marquesas", is from a drawing by W. Hodges, artist on Captain James Cook's second voyage of discovery in the Pacific (1772–75). *Collection*: Alexander Turnbull Library, Wellington, New Zealand. *Photo*: author.

The volume in which this illustration appears, *A Voyage towards the South Pole and round the world. ... 1772-1775*, was published in London, 1777. In the foreground is a small Marquesan outrigger canoe of an all-purpose inter-island type. A similar canoe is shown with sail set in the background.

MARQUESAS ISLANDS, FRENCH OCEANIA

The archipelago of the Marquesas Islands consists of the south-eastern group (principally Fatu-Hiva, Tahuata, Hiva-oa) and the north-west group (Ua-Pou, Nukuhiva, Ua-Huka, and others). The islands of this group are typically mountainous, with high ridges radiating to the sea from central highlands. Sometimes intervening valleys that were drowned by the sea are now deep inlets of a kind very convenient to Polynesian settlement. In the last decade the Marquesas have become important in theories of Polynesian dispersal. It seems certain

that both Hawaii and Easter Island had migrants directly from this group, and highly probable that New Zealand shares in Eastern Polynesian culture of this origin also. Marquesan decorative art is varied and vigorous with extensive surface decoration. In many respects it is comparable only with the rich art of the New Zealand Maori. The isolation of village groups in valleys formed by mountain ramparts, with outlets only to the sea, strengthened feelings of tribal exclusiveness and no doubt contributed to the perennial state of warfare that existed between local tribes.

144 ⬦
Life-size model of a Marquesan warrior in full regalia, including cockfeather headdress, human hair ornaments (at waist, ankles and wrists), and massive sperm whale (cachalot) tooth-ivory earplugs. *Photo*: W. R. Neill.

This muscular figure of a chief, modelled over a department store dummy core by Mr Gordon White, head of display at the Dominion Museum, Wellington, New Zealand, was

developed in collaboration with the author, who was at the time staff ethnologist of the museum. The tattoo patterns were selected from the illustrations in the classic work on Marquesan art by Karl von den Steinen (1925–8). The artifacts were selected from the W. O. Oldman Collection, the Marquesan part of which is rich in such materials. The strong Polynesian face was cast from life, by Mr White, from a Samoan youth.

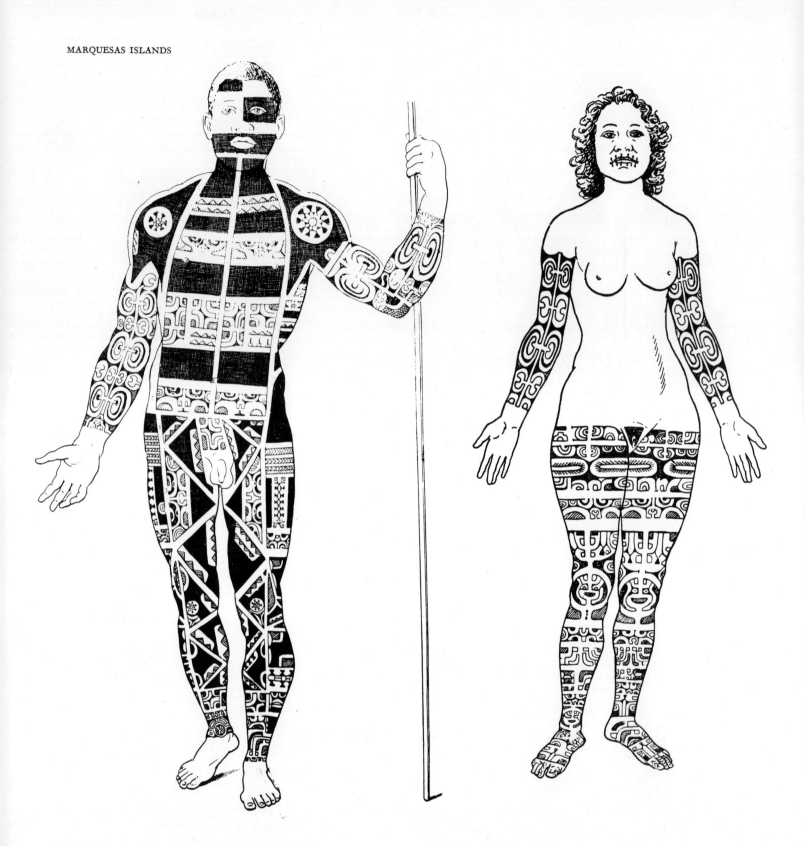

146 ⬦

147 ⬦

These two illustrations—of a man with tattooed body, arms, legs and face, and a woman with tattooed legs, arms and lips—provide examples of the highly-developed body tattoo of these islands. (See also the studio photograph of a tattooed Marquesan, 21.) Both drawings are from Karl von den Steinen's classic three-volume work on Marquesan art, published in Berlin. General comments on tattoo are provided on pages 42 and 58.

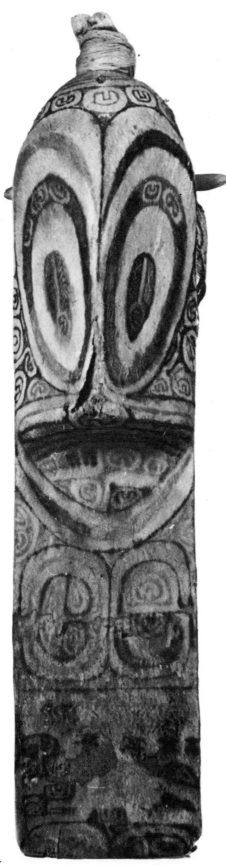

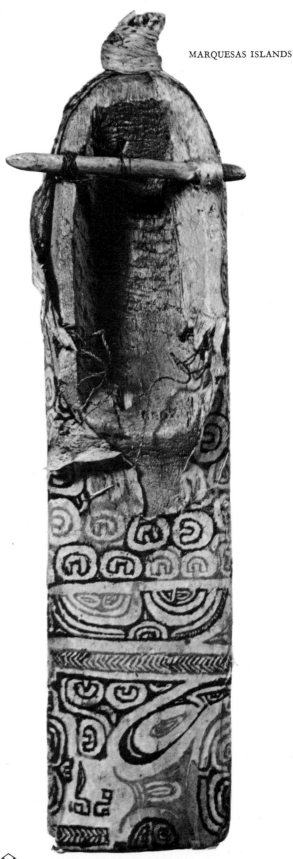

148 ⌂
Two views of a deity. Marquesas Islands. Barkcloth over a core of soft wood. Red and black painted patterns on back and front. *Height*: 23¼″ (59 cm). *Width*: 5¼″ (13.5 cm). *Collection*: Bernice P. Bishop Museum, Honolulu. *Photo*: George Bacon, museum archives.

Although of rare occurrence, spirit symbols of this type

149 ⌂
exist in several collections. The freely-painted designs on the *tapa* are usually of a lively kind. The facial pattern appears to relate directly to the tattoo patterns that occur on the knee and shin. This artifact must have been brought to Hawaii at an early time, as it was in Lahainaluna School in 1853, long before its transfer to the collection of the Bishop Museum.

95

150 ▽
Poi pounder. Marquesas Islands. Basalt. *Height*: 7⅞″ (20 cm). *Diameter*: 5⅛″ (13 cm). *Collection*: Bernice P. Bishop Museum, Honolulu. *Photo*: George Bacon, museum archives.

In parts of Polynesia, namely the Cook, Society, Hawaiian, and Marquesas Islands, pounders were in regular domestic use (basic pounder types are illustrated, 57). *Poi*, a mash made from breadfuit and *taro* or other fruit, was matured by fermentation and served as an important food staple. (See page 38.) In the Marquesas vast quantities of breadfuit *poi* were stored in submerged and stone-lined pits to meet daily domestic requirements and to safeguard against famine. The best Marquesan *poi* pounders, with outward-facing heads, are rivalled for beauty of form only by those of the Society Islands (179–80). Sexual symbolism is evident in Marquesan pounders as the grip and head clearly represent a phallus. (See page 57 and compare the shape of the New Zealand pounder 39.)

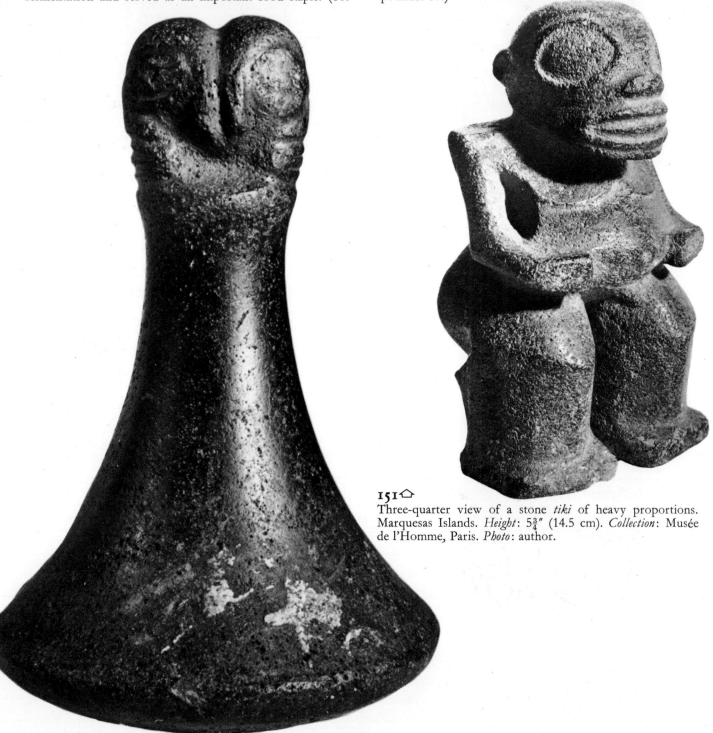

151 △
Three-quarter view of a stone *tiki* of heavy proportions. Marquesas Islands. *Height*: 5¾″ (14.5 cm). *Collection*: Musée de l'Homme, Paris. *Photo*: author.

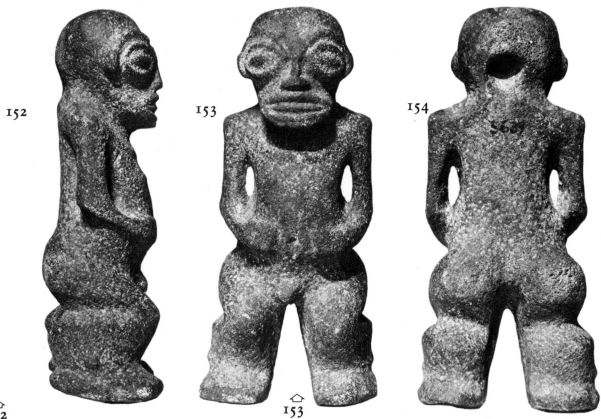

⇧
152
A stone *tiki* with suspension hole (viewed on three planes). Marquesas Islands. *Height*: 7⅝″ (19.5 cm). *Collection*: Bernice P. Bishop Museum, Honolulu. *Photos*: author.

155 ⇩ **156** ⇩
Double stone *tiki* joined at head and buttocks (viewed on two planes). Marquesas Islands. *Height*: 7⅛″ (18 cm). *Collection*: Bernice P. Bishop Museum, Honolulu. *Photos*: author.

Small pendants of human form, representing ancestral spirits or minor gods, are found in many parts of Polynesia.

⇧
153

⇧
154
The Marquesan variant of these small *tiki* are made from basaltic rock which is worked by pecking and bruising with a small hammer stone. Some have final grinding, others not. A suspension hole commonly appears behind the head, or, in the case of double images, between the figures joined back to back. According to Linton (1923), an authority on Marquesan art, small stone images were used in healing the sick or in votive offerings. He notes also that they were made and carried by priests to be invoked for aid in the success of one enterprise or another.

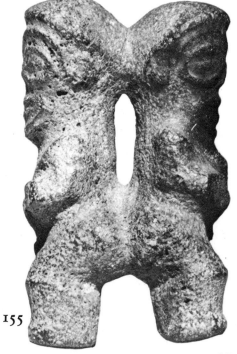

155

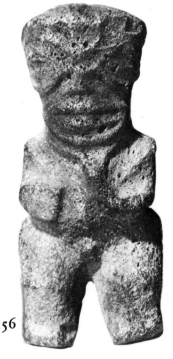

156

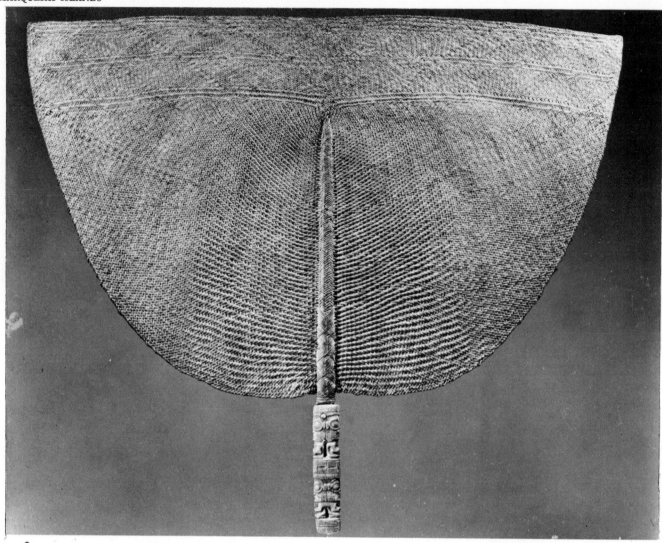

157 ⌂
Fan. Marquesas Islands. Pandanus leaf and whale ivory. *Height*: 18¼″ (46.4 cm). *Collection*: Mr and Mrs Raymond Wielgus, Chicago. *Photo*: Raymond Wielgus.

In Polynesia fans served in ordinary use for personal comfort, and as symbols of chiefly rank. The latter are usually distinguished by the best craftsmanship in weaving and carving. Decorated handles of exquisite craftsmanship are much sought after as collectors' items. This large and impressive specimen of the fanmakers' art shows particularly the ingenuity of the plaiter in varying the strength of the flap from a rigid centre to flexible edges.

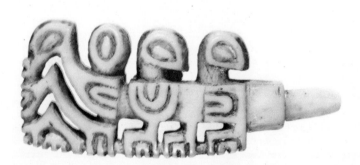

158 ◊
Ear ornament. Marquesas Islands. Sperm whale (cachalot) tooth ivory. *Length*: 2″ (5 cm). *Collection*: Peabody Museum, Salem, Massachusetts. *Photo*: museum archives.

The projection at the right is usually fitted with a shell plug which passes through the pierced lobe of the ear of the wearer. Such delicate carvings are highly variable in pattern and are reminiscent of the Rarotongan staff gods image arrangement 209. Ear ornaments worn by Marquesan warriors were heavy plugs (such as worn by the model 144), while those of this light and delicate form were worn by women of chiefly rank. Ivory ornaments were always highly prized and regarded as heirlooms to pass from generation to generation.

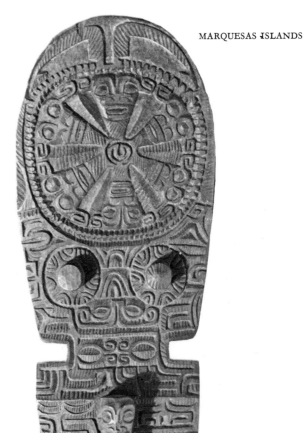

159 △
Head detail of a war club. Marquesas Islands. Hardwood. *Overall length of club*: 63″ (160 cm). *Collection*: Peabody Museum, Salem, Massachusetts. *Photo*: author.

The mask shown in this photograph is repeated on the reverse side of the club. Both sides share one curious formula for faces, namely, small masks form eye pupils and the nose of the principal mask, while another shallow-cut face is set at the top. On the lower part, where a mouth should appear, there is a second set of eyes, with a nose. Shallow-relief surface patterns appear in this area on most old clubs; however, there are marked individual differences in each club. The possible explanation is that these patterns served to distinguish personal ownership and could have related to the individual tattoo patterns of the owner. The glossy black surfaced finish was obtained by long immersion in *taro*-swamp mud, with subsequent rubbing with coconut oil and polishing after the wood had dried out. The type, which may be seen in various stages of decadence, has persisted as an item of trade. (Compare 160.)

160 △
Head detail of a trade club. Marquesas Islands. Wood. *Overall length of club*: 36⅝″ (93 cm). *Collection*: Mr and Mrs L. Fortess, Kaneohe, Oahu, Hawaii. *Photo*: author.

This late club, probably made before the turn of this century, imitates the traditional club form, but it has lost all usefulness as a fighting weapon, as well as the advanced technical skill of the old ironwood weapons (159). The original concept of design has persisted, but the mandala-like circle above the principal eyes is derived from a pattern used on the base of bowls of relatively late date. It was this carving of the mid-to-late nineteenth century that influenced the painter Paul Gauguin, as may be seen from rubbings from clubs and bowls in the artist's *Noa Noa* manuscript (1954, facsimile), and in his use of elements of this art in woodblocks and paintings. In the studio study (21) the tattooed Marquesan holds a club of the same vintage. Good collectors and open-minded museum curators realise the value of securing examples of late work that show a change in art forms. Inevitably these examples illustrate a decadence which was in some areas preceded by a brief flowering of traditional forms. (See page 60.)

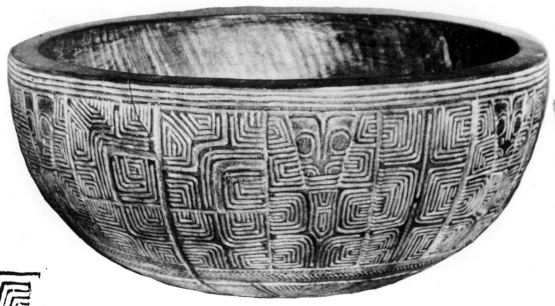

161 ⬠

Wooden bowl. Side view, and (162–3) two rubbings from bowl surface. Marquesas Islands. *Height*: 4⅜″ (11 cm). *Diameter*: 9½″ (24 cm). *Collection*: Bernice P. Bishop Museum, Honolulu. *Photo and rubbings*: author.

⬠ **162**

This bowl, although of no great age, is of good craftsmanship, with its surface patterns clearly defined. The two rubbings from the outer face of the bowl show the compartmental treatment of the forms. The upper rubbing represents a highly conventionalised human form of the usual Marquesan surface treatment, with hands and feet fitting round a small central torso. The lower rubbing represents a long insect with a forklike rendering of the head, and a fretted, spiral treatment of the legs. (For discussion of surface patterns in Polynesian art see page 58.)

⬠ **163**

⬠ **165**

Paddle-blade with surface carving. Marquesas Islands. Wood. *Height of blade section illustrated*: 17″ (43 cm). *Collection*: Bernice P. Bishop Museum, Honolulu. *Photo*: author.

This paddle, like the bowl 161, is of recent manufacture and probably is not more than seventy years old. It is a useful illustration of Marquesan surface patterns, partly because of the interesting enlargement of motifs that took place after the introduction of steel tools. Some post-contact work represents a flowering before the subsequent slide to decadence. (For the discussion of decadence in Polynesian art see page 60.)

100

164 ▽

Surface rubbing by the author from a wooden trumpet. Fatu-Hiva, Marquesas Islands. *Width of inner bands*: 2″ (5 cm). *Collection*: Cambridge University Museum of Archaeology and Ethnology, England.

The study value of this pattern is in the appearance of curvilinear elements modifying the usual fretted spirals of Marquesan art. The theoretical significance of spirals is discussed on page 58.

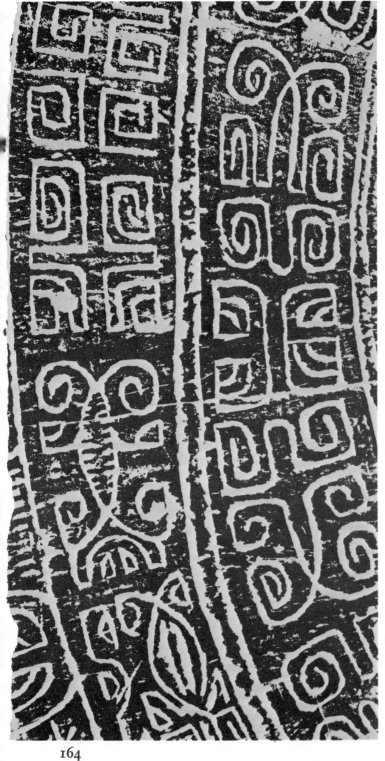

164

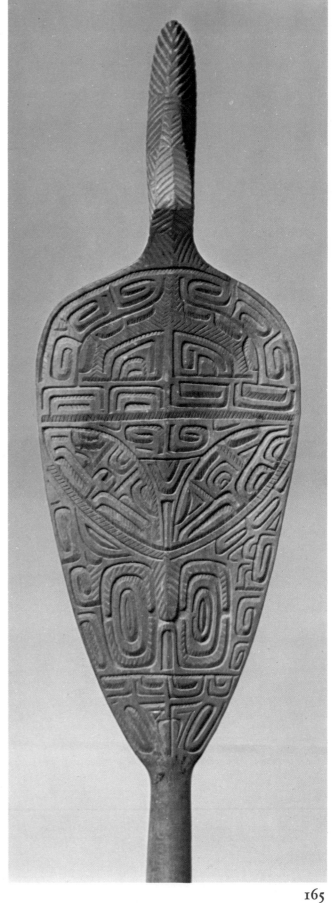

165

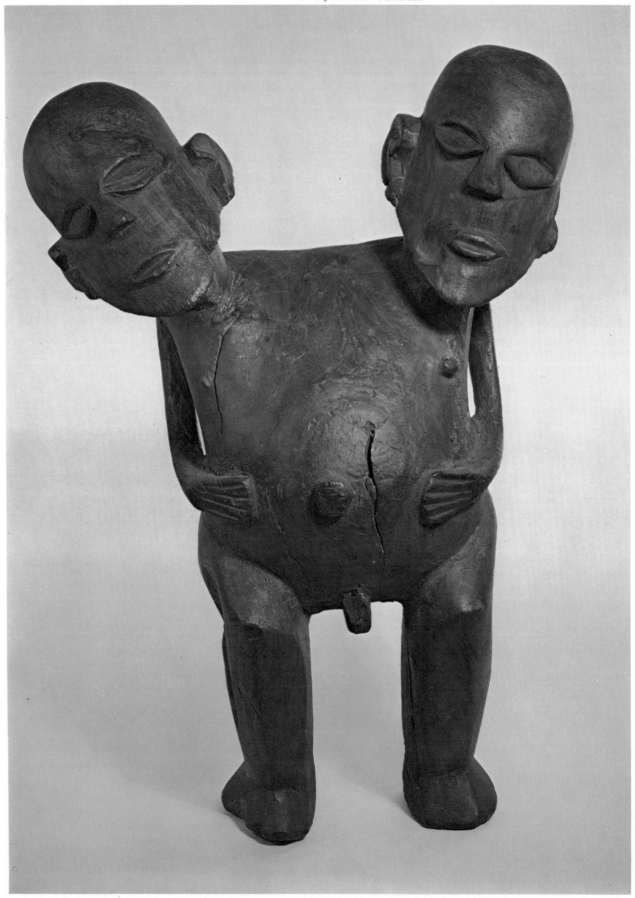

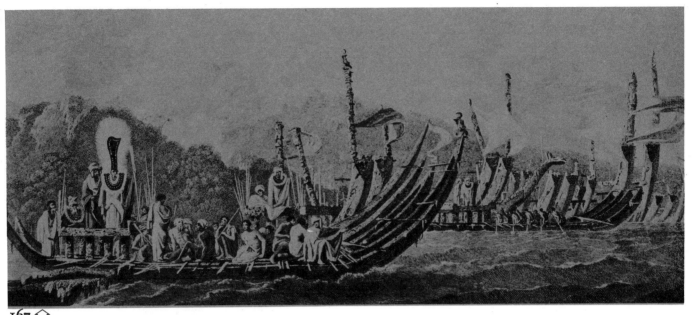

167 ⌂

A fleet of war canoes at Pirae, to the east of Pape'ete, Tahiti, Society Islands, April 1774, as seen during Captain James Cook's second voyage of Pacific discovery (1772–75). Entitled "The Fleet of Otaheite assembled at Oparee," and dated London, 1777, this engraving is from an oil painting by W. Hodges, now in the collection of the National Maritime Museum, Greenwich, London. A priest in full regalia is standing at the bow end of the canoes.

SOCIETY ISLANDS, FRENCH OCEANIA

The Society Islands, located at the centre of Eastern Polynesia, comprise two groups: the Windwards (principally Tahiti, Mo'orea, Mehetia, Tetiaroa, Maiao), and the Leewards (principally Huahine, Tahaa, Ra'iatea, Bora Bora). Tahiti and the other Society Islands are by tradition at the romantic heart of Polynesia, and were much favoured by Captain Cook and other great Pacific explorers. Ra'iatea, not Tahiti, was the ancient religious and political centre of the Society Islands. High mountains, wooded valleys, and coral reefs enclosing deep lagoons are typical of the group. Its material culture produced an impressive array of images (particularly for use in sorcery), magnificently decorated canoes, and graceful domestic utensils.

However dance, poetry, oratory, religious activities, and concern with rank absorbed the energies of this people. One must suppose that the art had greater complexity in ancient times; however, the classical culture found by early visitors was relatively simple and without elaborate decorative styles.

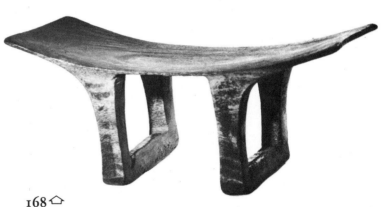

168 ⌂

Headrest. Tahiti, Society Islands. Wood. *Length*: 12¼" (31 cm). *Collection*: Cambridge University Museum of Archaeology and Ethnology, England. *Photo*: author.

Wooden pillows, commonly called headrests, are found in Western and Eastern Polynesia. They were used by chiefs. This graceful example was collected on the first voyage of Captain Cook (1768–71).

166 ◁

A rare two-headed wooden figure. Tahiti, Society Islands. *Height*: 23" (58.5 cm). *Collection*: British Museum, London. *Photo*: museum studio photograph prepared for this publication.

This unusual figure, possibly a sorcerer's image, was acquired by the British Museum in 1955 from Ireland, where it had rested in a family home for many years. Skilful research by B. A. L. Cranstone (1963) revealed that the figure had been collected by a Captain Sampson Jervois, RN, of HMS *Dauntless*, January 1822, in all probability at Matavai Bay, Tahiti. Although double-faced Janus-style heads are relatively common in parts of Polynesia, double-headed images are exceedingly rare, totalling only a few examples.

103

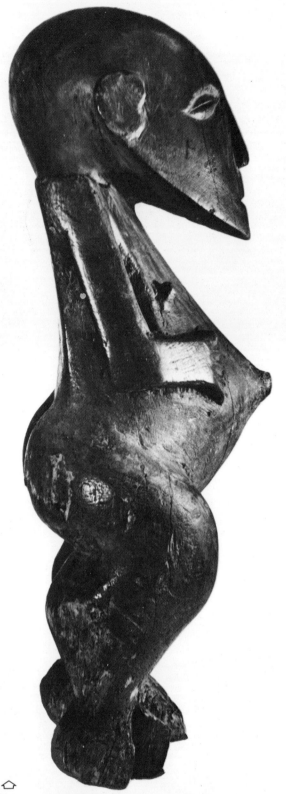

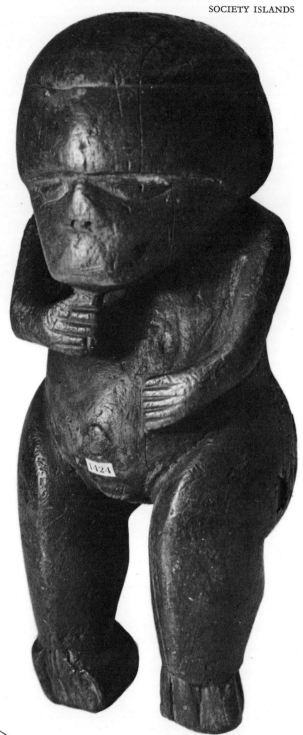

169 ⌂
Profile view of a male image. Society Islands. Wood. *Height*: 20⅞″ (53 cm). *Collection*: British Museum, London. *Photo*: author.

Before reception by the British Museum in 1871, this image was in the possession of the Sheffield Literary and Philosophical Society. It is evidently of early manufacture. This side view illustrates well the distinctive characteristics of the old wood figure style of the Society Islands. The forward thrust of ridged lower jaw, large stomach with projecting umbilicus, strong buttocks, and incurved back, are all typical features.

170 ⌂
Female image. Tahiti, Society Islands. Wood. *Height*: 12¼″ (31 cm). *Collection*: Pitt Rivers Museum, Oxford, England. *Photo*: author.

This small *tiki*, collected by John Reinhold Forster, who with his son, George, shipped as naturalist on Captain Cook's second voyage (1772–75), has less appeal to the eye than many Society Islands images; yet its credentials are of the best, as it appears as an illustration in an official account of Cook's voyages. There is no personal identification for the figure; however, the sex, although somewhat concealed, is indicated by a vulva. One hand is raised to the mouth in a gesture seen in images from several parts of Polynesia.

171 ▷

Male image. Tahiti, Society Islands. Wood. *Height*: 22½″ (57 cm). *Collection*: Bernice P. Bishop Museum, Honolulu. *Photo*: George Bacon, museum archives.

The specimen was found in a cave with barkcloth, in association with a female image and another small *tiki*. Certain features of the carving style suggest that it was cut with steel rather than stone tools. It is difficult to determine whether certain carvings were cut with stone or early iron tools; however, in many cases comparison of known old specimens with known post-contact pieces yields information on differences between early and late work. The eye learns to detect subtle differences that cannot be defined precisely in words.

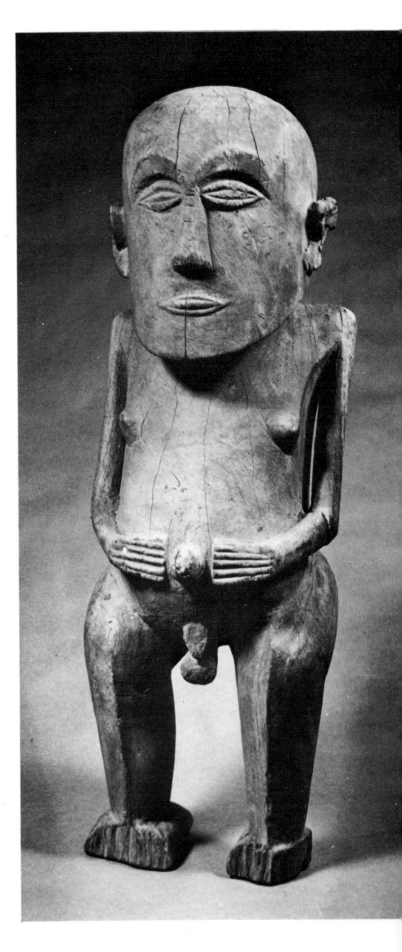

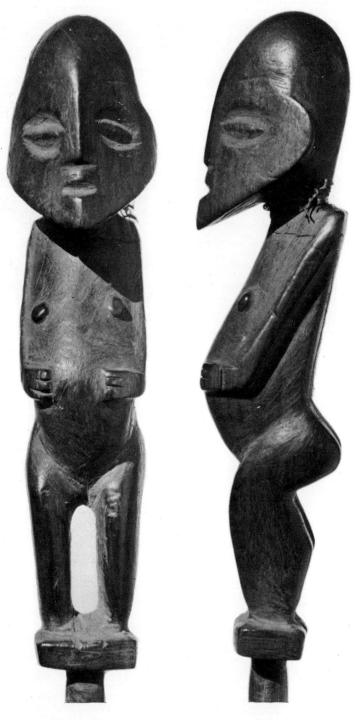

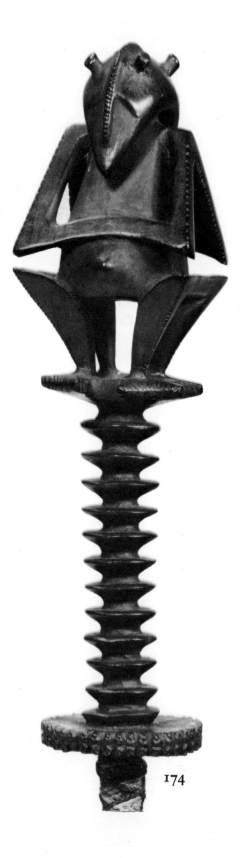

172 ⌂　　　　　　**173** ⌂

Two views of a whisk-handle image. Society Islands. Wood. *Overall length of handle*: 13½″ (34.3 cm). *Height of figure*: 5″ (12.7 cm). *Collection*: Dominion Museum (W. O. Oldman Collection), Wellington, New Zealand.

　This handle, with the *tiki*, was taken to England by G. Bennet in 1823. W. O. Oldman secured it from the Duke of Leeds Collection about a century later. Ceremonial whisks were important in old Polynesian society, as they served as symbols of rank and as places for the spirits to enter. Their original, practical use as fly flaps is evident in the form; however, the ceremonial use of fly flaps is ancient in the Pacific and traceable to a similar use in ancient Asian cultures. Carved handles developed from ritualistic use.

174

106

175 ◊ 176 ◊

Two views of a ceremonial fly whisk-handle. Tahiti, Society Islands. Sperm whale (cachalot) tooth ivory, sennit and wood. *Length*: 12¼″ (31.3 cm). *Collection*: Mr and Mrs Raymond Wielgus, Chicago, Illinois. *Photo*: Art Institute of Chicago.

This whisk-handle, one of the most remarkable Tahitian artifacts in existence, was secured from Pomare II of the Royal House by the Rev. Thomas Haweis in 1818. It is a most delicate composition of parts fastened together by finely-plaited coir sennit. The lower end is fitted with a wooden terminal of a form that related to some stone pounders (179–80), while the upper end is in the form of an acrobatic figure bent back to form the last hole through which the sennit flap passed, or by which it was attached. The worn surfaces of this last hole support this assumption; however, it must be noted that the handle itself may have been used as a baton of rank without a sennit whisk. Individual artifacts of sufficient mana are given personal names, and in Polynesian eyes are treated as living things. (See page 38.)

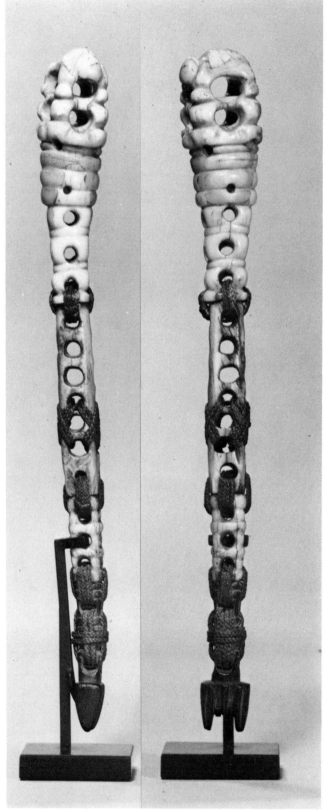

◊ 174

Double image on a whisk-handle. Society Islands. The whole whisk is composed of a wooden handle, sennit flap, and sennit and human hair plaited binding. *Overall length*: 15½″ (39.4 cm). *Carved section with image*: 8⅝″ (21.9 cm). *Collection*: Mr and Mrs Raymond Wielgus, Chicago. *Photo*: Art Institute of Chicago.

The apparent modern style of Tahitian images of this form gives an impression of present-day sculpture of the *avant-garde*. Analysis of parts may be readily made. The knobs on the head of the figure represent topknots of hair, not eyes. The eyes are represented by down-slanting cuts well below these hair knobs. The large disc at the base of the handle has many small, conventionalised images cut on its rim.

175 *Front* *Side* 176

107

177 ▽
Phallic image. Society Islands. Stone. *Height*: 41" (104 cm). *Collection*: Otago Museum, Dunedin, New Zealand. *Photo*: museum archives.

The Society Islands present a wide range of anthropomorphic stone *tiki* which seem at first to be amorphous. Close examination, however, reveals underlying themes and parts that are identifiable. This image is a good general example. The shape is human, with head, torso, legs, fingered hands on the stomach, and sex (represented by a vulva). The entire image has an important single basic theme, namely that of an erect phallus (the head representing the glans). The same concept is seen in other images (e.g., 196). (For a general discussion of phallicism in Polynesian art see page 57.)

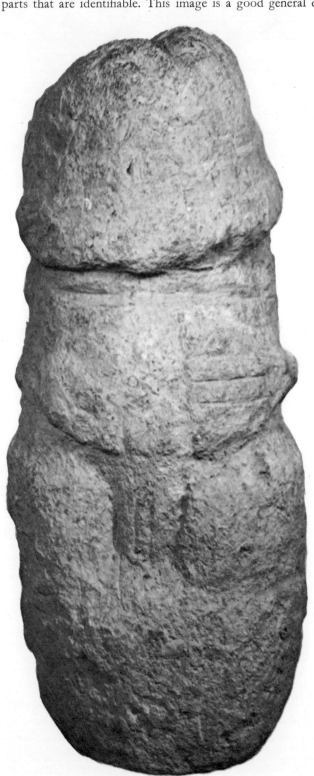

178 ◊
An elaborate petroglyph *in situ*. Tipaerui Valley, Tahiti, Society Islands. *Height of design*: about 72" (about 183 cm). *Photo*: Bernice P. Bishop Museum, Honolulu Museum archives.

The subject of this rock engraving is a pair of outward-turned human images with upraised hands. One image has a dancing figure poised on its head. A phallus is represented, but it is not clear whether the forked appendage indicates a male or a female. The incised channels that form the images have been bruised into the basaltic rock. The surrounding white lines are chalk marks drawn in by the photographer to outline the incised design. Petroglyphs are found in most parts of Polynesia.

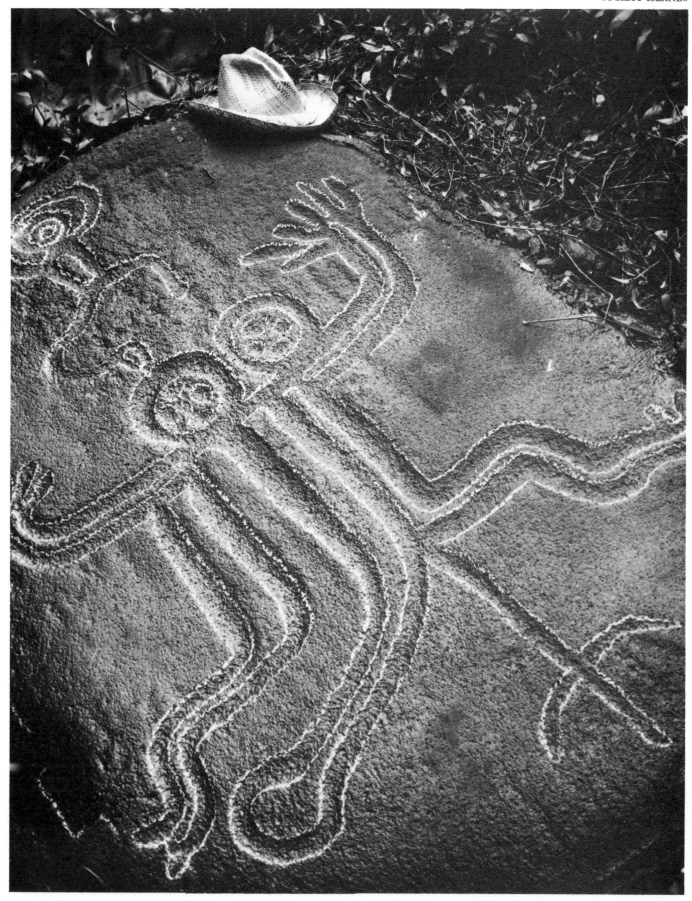

The Society islanders produced domestic items of highly-skilled craftsmanship. Among such implements are found stone *poi* pounders of several forms (57). The two illustrated here are in the Collection of the Cambridge University Museum of Archaeology and Ethnology, England. Both are believed to have been collected on Captain Cook's first Pacific voyage (1768–71), and they were later placed in Trinity College, Cambridge, with other Cook items, in the collection of the Earl of Denbigh.

◊ **179**
Pounder with two vertical flanges on the pommel. Tahiti, Society Islands. *Height*: 6¾″ (17 cm). *Photo*: author.

181 ◊
A section of a painted barkcloth sheet. Tahiti, Society Islands. The detail illustrated is part of a *tapa* page from an album made from clippings of barkcloth collected on the voyages of Captain James Cook. A limited number of these books was published under the title *A Catalogue of the Different Specimens of Cloth, collected on the three Voyages of Captain Cook to the Southern Hemisphere* (Alexander Shaw, London, 1787). The page here reproduced is from a book in the collection of the Peabody Museum, Salem, Massachusetts.

◊ **180**
Pounder with faceted pommel. Tahiti, Society Islands. *Height*: 5⅞″ (15 cm). *Photo*: author.

182 ◊
A decorated wooden house board. Tubuai, Austral Islands. *Length*: 14″ (35.5 cm). *Width*: 7″ (18 cm). *Collection*: Bernice P. Bishop Museum, Honolulu. *Photo*: author.

The chevron design, which is cut deeply into the surface of this plank, is a motif widely used in Polynesian carving. A zigzag line is almost universally regarded as a water symbol; however, there is no positive evidence that the Polynesians regarded it as such. The chevron theme in Polynesian art is related closely to certain stylised human figures. (See the series 191, and refer to the motif on page 59.)

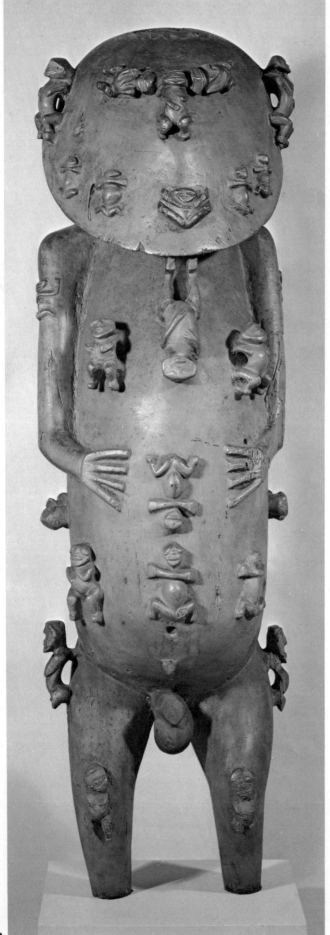

183

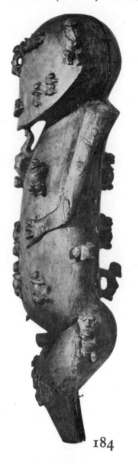

184

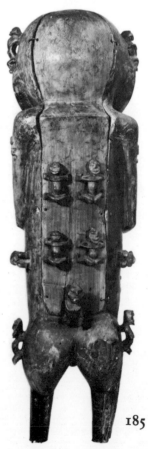

185

The principal islands of the Austral Group are: Tubuai, Rurutu, Rimatara, and Raivavae. The island of Rapa Iti is usually regarded as belonging to the Austral Islands, but it lies well to the south east of the main cluster. High elevations prevail in these islands. The artifactual material from this area is now sparse; however, that which exists is accomplished in craftsmanship and notable in style. Raivavae is famous for large stone images and the finely-decorated paddles traded to passing ships. Rurutu has a fascinating iconography, while Rapa Iti has its terraced hill forts. The material culture of the area relates principally to the Society Islands from where, it would appear, this group was settled.

◊ ◊ ◊
183 184 185
Three views of an image representing Tangaroa, Rurutu, Austral Islands. Wood. *Height*: 44″ (112 cm). *Collection*: British Museum, London. *Photos*: museum photographic department (colour plate); author (other views).

One of the most remarkable of all Polynesian sculptures is this figure of Tangaroa Upao Vahu, the great Polynesian sea god. This primary god of the Polynesian pantheon is giving birth to other gods and to mankind; some thirty small images occur on the body, including five on the removable back cover 185. The hollow interior formerly contained separate small images, but these have been long since lost.

The island of Rurutu was converted to Christianity *en masse* in 1821, when the high chiefs became convinced that the new religion was acceptable. Total conversion was then declared, and the villagers followed a chiefly decree of acceptance in a pattern of action well-known in Polynesia.

This notable image was first sent home by missionaries as evidence of a fallen heathenism. It has made many appearances illustrating the missionaries' literature, sometimes with an added loincloth (213). Today such magnificent sculpture is understood as expressive of a particular culture and not as evidence of a benighted way of life and of "devil worship". (See page 56.)

186 ◊
Detachable spear point. Rurutu, Austral Islands. Wood. *Length*: 15¾″ (40 cm). *Collection*: Bernice P. Bishop Museum, Honolulu. *Photo*: George Bacon, museum archives.

This object has a curious history. It was described as a Hawaiian dagger by Matthew H. Bloxam, brother of the diarist Andrew Bloxam of HMS *Blonde* (Bloxam, 1825), in the *Mirror*, 7 October 1826, at Rugby, England. Matthew Bloxam claimed that it was one of the daggers that had stabbed Captain Cook. However, it is not a Hawaiian dagger but an Austral Island spear point which has had the tang cut off and has been grooved for use as a fly whisk-handle. The pigs resemble those of the phallic necklace 192.

113

187

◊ **187**
Ritual drum. Raivavae, Austral Islands. Wood, sennit, shark-skin. *Height*: 54″ (137 cm). *Collection*: Mr and Mrs Raymond Wielgus, Chicago, Illinois. *Photos*: Raymond Wielgus.

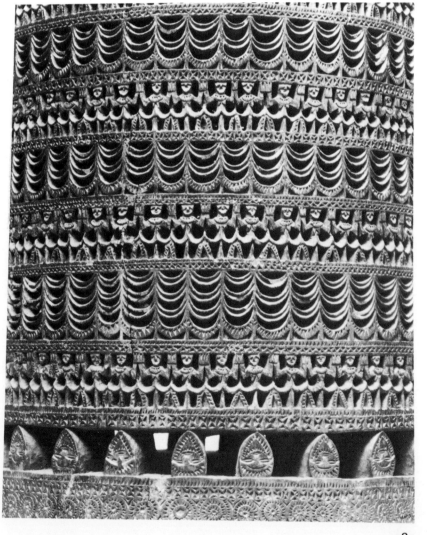

189

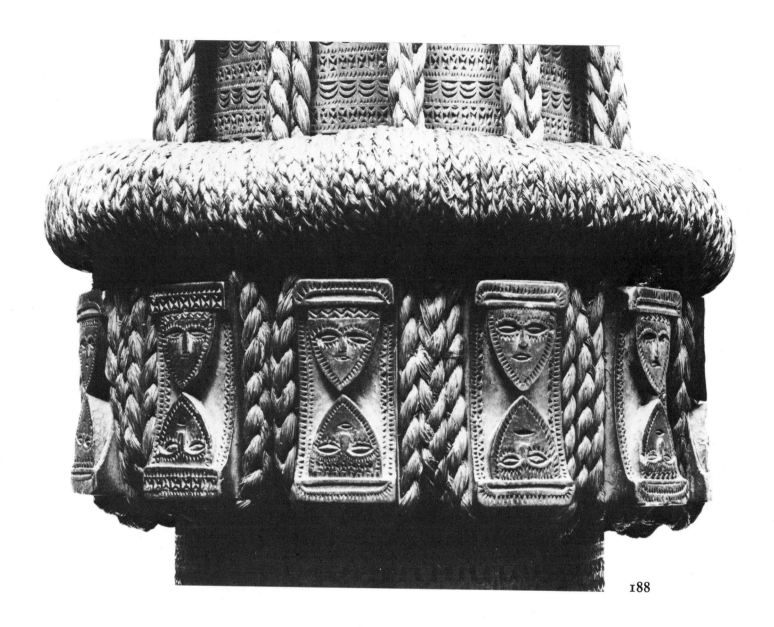

188

◊ 189 188 ◇

This magnificent example of a tall Raivavaean drum has the usual hollow base with pierced decorative carving, demonstrating remarkable technical skill. The concept of a drum base incorporating human images is regular in Polynesia. However, Raivavaean drums surpass all others in both detail of workmanship and height. The regular arrangement of rows of figures on drum bases is seen in Hawaiian art (275). By contrast, in Raivavae the figures are rendered very small and in numerous rows (189). A rare Austral Islands paddle 193 (detail), repeats the general surface pattern, which suggests inspiration from a drum base similar to this one. (Compare detail 189 with detail 193.)

115

Free-standing figures from the Austral Islands are rarely found today. This example was acquired by the British Museum in 1854 from Sir George Grey, who was twice Governor-General of New Zealand. How the image came into the hands of Sir George Grey is unknown, but he was a keen collector, in touch with ships and sailors visiting New Zealand. An old label describes it as the "front of house — — Feejee Isles", which, of course, it is not. Its provenience is no doubt in the Austral Islands and almost certainly Raivavae. The image style relates directly to those rendered on drum bases. (Compare facial and body treatment in the detail studies of the Wielgus drum 188–89.) "Sun" motifs decorate the cheeks, torso, and knees. The female sex is clearly indicated by vulva and breasts. Unfortunately, one arm and an ear have been broken off.

190 ⬦

Female figure. Austral Islands. Wood. *Height*: 24⅜″ (62 cm). *Collection*: British Museum, London. *Photo*: author.

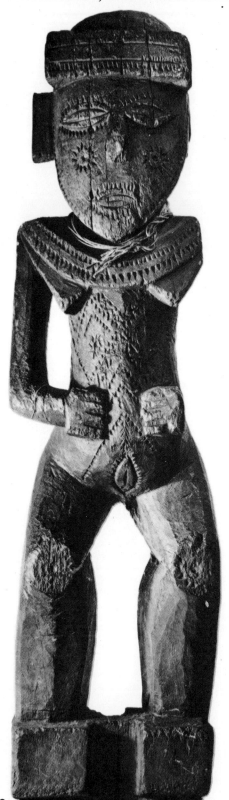

190

191 ⬧

Rubbings by the author from lug cleats of a Raivavaean drum similar in form to the Wielgus Collection drum 187. *Width*: 2⅜″ (6 cm). *Collection*: Hancock Museum, Newcastle, England.

Discussion of this type of stylisation of the human figure is on page 59.

116

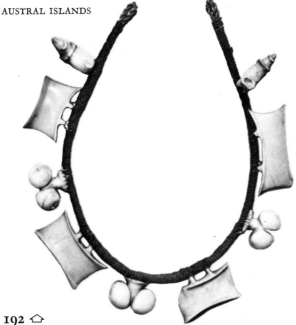

192 △

Phallic necklace. Austral Islands. Whale (cachalot) tooth ivory, sennit cord, and human hair braid. *Collection*: Peabody Museum, Salem, Massachusetts. *Photo*: author.

Necklaces of this type have been conventionally attributed to Mangaia in the Cook Islands. Buck (1944), who noted ten such ivory necklaces with descriptions of the intricate techniques of attachment, contemplated the possibility of diffusion of the type from the nearby Austral Islands. Duff (1969) illustrates two such phallic necklaces that bear positive Austral Island provenience (Tubuai [Tupua'i] and Rurutu), and provides significant reasons for changing the conventional attribution. The author has long suspected that many of the so-called Mangaian phallic necklaces must have originated in the Austral Islands, but until Duff's references he had no knowledge of specimens documented to them.

The attached amulets have significance as symbols of chiefly status. The phallic element represents the virility of the chief, the seats his rank, and the pigs his wealth and food. Pigs and seats were present in traditional Austral culture but absent in Mangaia. The small pigs (commonly but incorrectly referred to as "dogs") that occur on these necklaces are sometimes rendered in the form of a phallus, thus complementing the sexual symbolism. Small pigs of similar type, but lacking particular phallic form, are to be seen on the converted spear point 186.

193 △

Detail from the surface of a wooden paddle-blade. Raivavae, Austral Islands. *Height of figures*: about $\frac{1}{2}''$ (about 1.3 cm). *Collection*: Cambridge University Museum of Archaeology and Ethnology, England. *Photo*: author.

Eight rows of small images are on the left side of the back face of the paddle-blade, and a single row appears on the right half in company with forty-five renderings of the "sun" motif seen on the figure 190. Crescents below the figures indicate that the theme is derived from the base pattern of local drums (189), and is here merely adapted to the flattish surface of a paddle-blade, presumably to enhance its value as a trade-paddle. Paddles were exchanged in large quantities when ships called at the island.

194 ▽

Chief's seat. Austral Islands. Wood and sennit. *Length*: $19\frac{1}{4}''$ (49 cm). *Collection*: Peabody Museum, Harvard University, Cambridge, Massachusetts. *Photo*: museum archives.

In Polynesia, seats are associated with chiefs, height and size being adjusted to rank (some seats are five or six feet in length). Domestic furniture was virtually non-existent in an ordinary Polynesian household. Mats and headrests served most needs. However, Austral Islands collections present a number of fine seats, some of which are rimmed with small abstract human images, as shown here. A sennit cord tied diagonally between two legs probably served as a hanger when the seat was not in use. Also, it is likely that the presence of sennit cord added to the prestige of the seat. Although similar seats are found in the Society Islands, those of the Austral Islands remain unsurpassed for gracefulness of form.

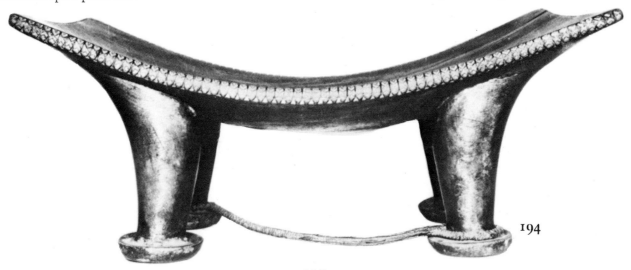

194

117

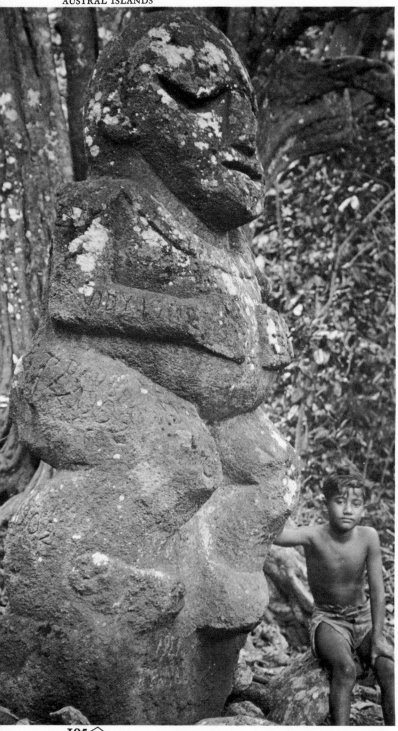

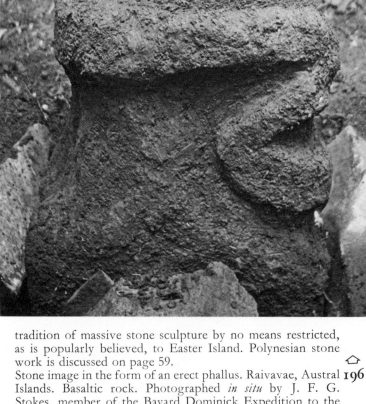

195 ⇧

Female statue. Raivavae, Austral Islands. Soft basaltic rock. *Collection*: Musée de Pape'ete, Tahiti, Society Islands. *Photo*: J. F. G. Stokes, Bernice P. Bishop Museum archives. (See 196.)

The Raivavaean boy sitting at the right of the image provides a scale of size, while the initials cut by vandals gives an idea of the relative softness of the rock material. This photograph was taken with the image *in situ*; it has since been removed, with a companion, to Tahiti. Sir Peter Buck (Te Rangi Hiroa), in his classic book on Polynesians entitled *Vikings of the Sunrise* (1938), portrayed himself standing by this image outside the old Pape'ete Museum. Polynesia has a tradition of massive stone sculpture by no means restricted, as is popularly believed, to Easter Island. Polynesian stone work is discussed on page 59.

Stone image in the form of an erect phallus. Raivavae, Austral **196** ⇧ Islands. Basaltic rock. Photographed *in situ* by J. F. G. Stokes, member of the Bayard Dominick Expedition to the Austral Islands, 1920. Raivavae is the only island in the Austral group with an impressive tradition of stone image manufacture. Some of these images, more ingeniously than elsewhere in Polynesia, combine the phallus with the human features of torso, arms, and head (the head corresponding to the glans) as a symbol of ancestral virility.

The principal islands of the Gambier group are: Mangareva, Taravai, Aukena and Akamaru. Mangareva, after which the whole group is sometimes named, is a high volcanic island enclosed by a barrier reef. During the whaling era it was much visited, but in modern times it has been relatively isolated. The art styles of this group, which is situated at the south eastern end of the Tuamotu Archipelago, are best represented by the magnificent sculpture of Mangareva. Little wood carving remains to tell us of the past art of these islands, but the few extant Mangarevan images are evidence of a vigorous sculptural tradition which experimented with naturalism and extreme abstraction of natural forms.

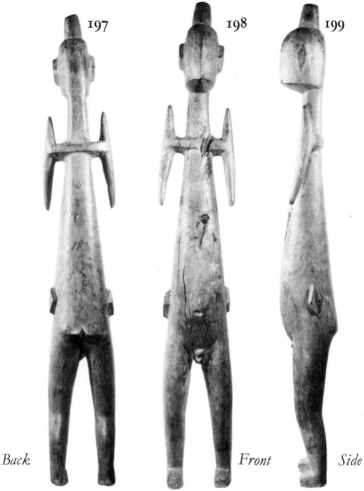

197 198 199

Back *Front* *Side*

197 ▷ 198 ▷ 199 ▷
Male deity. Mangareva, Gambier Islands. Wood. Vestiges of a polished surface are to be seen. *Height*: 41⅜″ (105 cm). *Collection*: Musée des Antiquités au St-Germain, France. *Photo*: museum archives.

The unique style of Mangarevan sculpture is known from a mere handful of survivors of an "idol"-burning spree overseen by Roman Catholic fathers in 1835. Désiré Louis Maigret, a Picpus father, notes in an unpublished journal (the author is indebted to Professor Jean Charlot for this reference) that a chief brought a god and invited him and a fellow priest to "knock it on the head" after mistreating it before them himself. Father Maigret adds: "At this very moment, the stake is being made ready where all the gods will be burned together." At the time he was writing he noted one image was still smouldering outside his hut, as it had been all night.

One type of Mangarevan image is of more or less naturalistic form (200–2), while another type is realistic only in torso and legs, as illustrated here. This figure has its arms represented by curved cylinders with pointed ends set out on stumpy projections. The face is featureless, apart from its central division by a ridge into two distinct planes. Diamond-shaped knobs serve as ears, and similar knobs are repeated, somewhat illogically it would seem, at the hips.
The preceding example of Mangarevan sculpture (197–99) represents a unique style of a highly-conventionalised kind. The second Mangarevan wood sculpture tradition, which may have predominated in prehistoric times, is much more naturalistic in style, as may be seen by the two examples illustrated (200–2). It is painful to think of the wholesale burning of the figures of Mangareva, but deliberate and massive destruction of images is a fact of island history in many parts of Polynesia. (See page 56.)

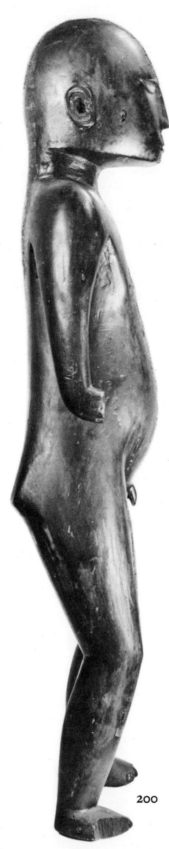

200

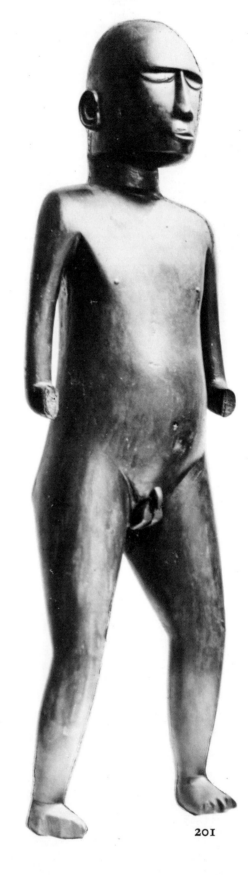

201

Male figure, in side and frontal views. Mangareva, Gambier Islands. Wood. *Height*: 46¼″ (118 cm). *Collection*: British Museum, London. *Photo*: author.

202 ⬦
Male figure, full view. Mangareva, Gambier Islands. Wood with remnant areas of polished surface. *Height*: 38¾″ (98.4 cm). *Collection*: Museum of Primitive Art, New York. *Photo*: Charles Uht, New York.

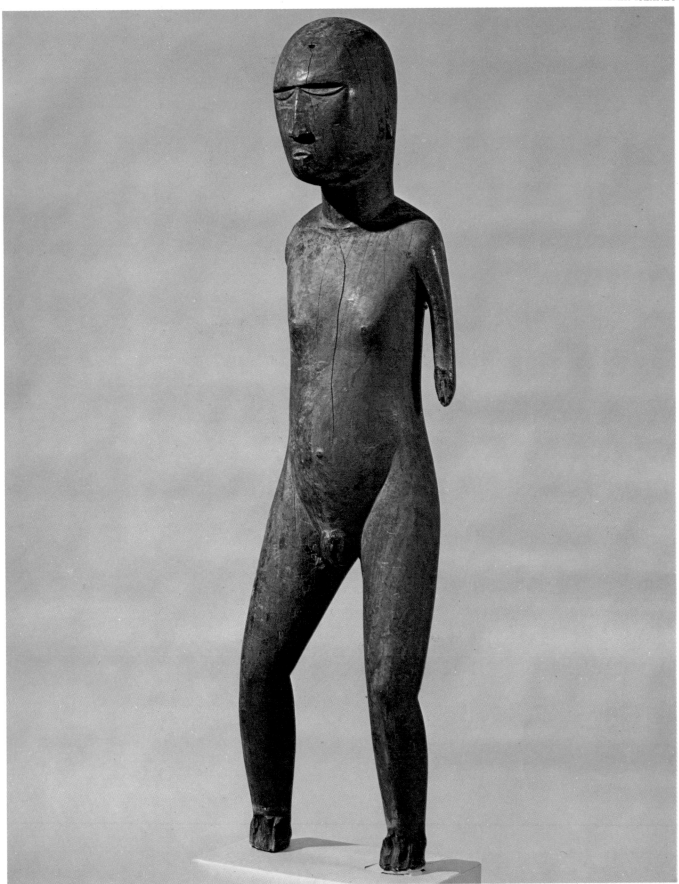

202

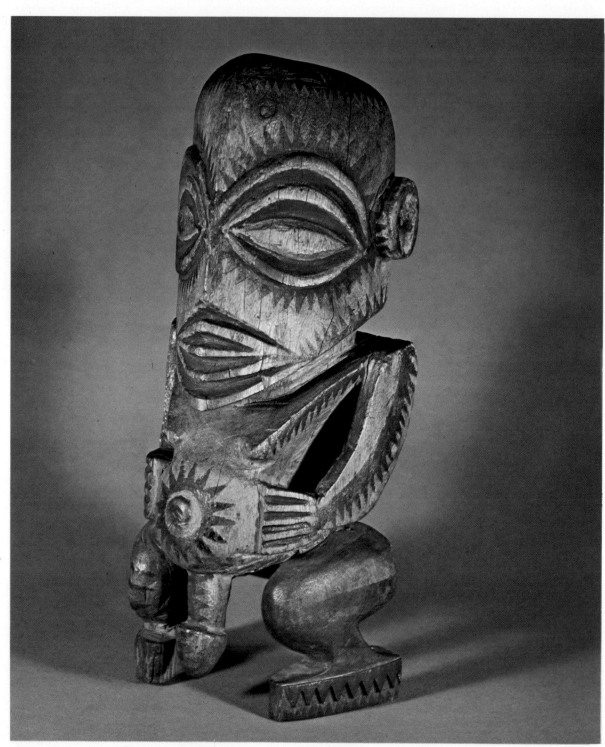

203 ⌂

Fisherman's canoe god. Rarotonga, Cook Islands. Wood with black painted patterns. *Height*: 16¾″ (42.5 cm). *Collection*: Peabody Museum, Harvard, Cambridge, Massachusetts. *Photo*: author. The line drawing is from Buck (1944).

This god, acquired by the museum in 1899, was probably collected early in the nineteenth century. The use of canoe gods ended when Christianity was established in Rarotonga. *Tiki* of this type were used by fishermen as talisman to ensure successful catches and good fortune in facing the dangers of the sea. Their use was discouraged by missionaries. The

204 ◇ **205** ◇ **206** ◇

gods' feet were inturned so that they would fit the canoe prow on which they were placed.

Similar images appear in plates 208 and 212; however, these have suffered emasculation at the hands of early collectors. Images of this fishermen's god type usually have the provenience of Rarotonga, which is the principal island of the Cook Islands. The painted patterns on the *tiki* follow features of a notched decorative carving found on certain unpainted images. Also, tattoo patterns appear to be represented by some of the painted patterns.

The Cook Islands, formerly known as the Hervey Islands, are divided into a southern group (Rarotonga, Mangaia, Atiu, Takutea, Mauke, Mitiaro, Aitutaki) and a northern group (Palmerston, Suwarrow, Manihiki, Rakahanga, Pukapuka, Penrhyn). With the exception of the high island of Rarotonga, some twenty miles in circumference, the islands are of either elevated coral or the atoll type. The rich wood, water and food resources of the mountainous Rarotonga gave it pre-eminence over nearby islands. Mangaia, some 110 miles to the south east of Rarotonga, developed a remarkable cult of the ceremonial adze. The Cook Islands are self-governing but are linked to New Zealand by a common head of state, HM Queen Elizabeth II. The group is dependent on New Zealand for subsidy, and for external affairs policy and defence. The people are New Zealand citizens.

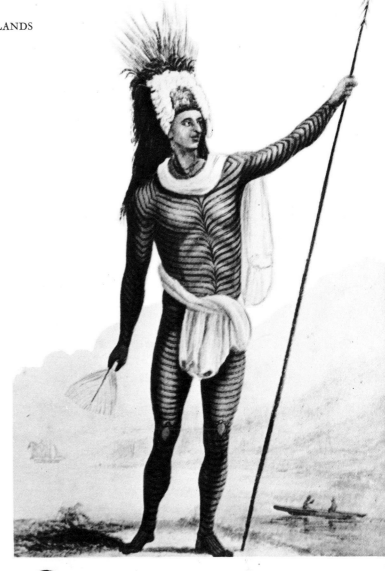

207 ▷

Te Po, a chief of Rarotonga, Cook Islands. From a print in oil colour by G. Baxter, after the original painting by J. Williams, Jnr. Published in London, 1837. Te Po (The Night) is depicted with feather headdress, fan, and spear. His curious linear tattoo disappeared early from the Polynesian scene. *Photo*: Alexander Turnbull Library, Wellington, New Zealand.

204

205

206

208 ▽
Fisherman's canoe god. Rarotonga, Cook Islands. Wood. *Height*: 16⅛" (41 cm). *Collection*: Royal Scottish Museum, Edinburgh, Scotland. *Photo*: author.

The Rarotongan fishermen's canoe gods, carried for protection and to aid good catches, follow a distinctive form also seen in the two other examples illustrated, 203 and 212. Seen in profile the head of this image style relates directly to the uppermost figures of staff gods 209–10.

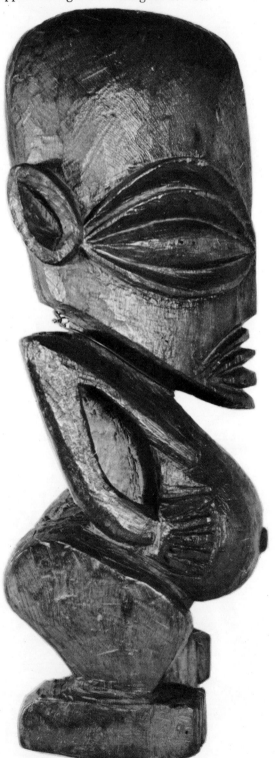

209 ▷
Staff god fragment. Rarotonga, Cook Islands. Wood. *Height*: 30¼" (77 cm). The portion illustrated is the decorative upper part of a staff god which was formerly six or seven feet overall. The part shown here can be compared with the complete staff god 210. *Collection*: Otago Museum (W. O. Oldman Collection), Dunedin, New Zealand.

This fragment of a large staff god illustrates well the accomplished craftsmanship of the Cook Islands carvers. Pierced work, technically difficult when stone tools alone are used, helps to divide forward-facing figures, which have heads set full face from the profile renderings arranged alternately below the dominant top figure, the head and upper arms of which alone are represented. The secondary figures are sometimes referred to as "bats"; however, the resemblance is probably unintended. A curious yet undoubted feature is the small penis projection at the throat of each profile head. This is not seen elsewhere in Polynesia except in the instance of a single New Zealand pendant which was illustrated in the *Wairarapa Times-Age*, Masterton, New Zealand, 23 January 1964.

210 ▷
Staff god, Rarotonga, Cook Islands. Wood, barkcloth, sennit. *Length*: 45⅜" (115 cm). *Collection*: Otago Museum (W. O. Oldman Collection), Dunedin, New Zealand. *Photo*: author.

Although of a quality inferior to that of the preceding god staff fragment 209, this specimen has the virtue of completeness. It is formed of a central wooden staff with end terminations of a head and a penis respectively. Between the terminations and the associated secondary figures there is a central roll formed by three layers of barkcloth: inner white, central light brown, and an outer cover of white cloth decorated with black zigzag patterns. The *tapa* sheets were folded, then rolled around the wooden shaft and tied into place by sennit cordage, which no doubt was regarded as having symbolic importance. (For discussion relating to the religious use of coir sennit and other materials see page 55).

209

210

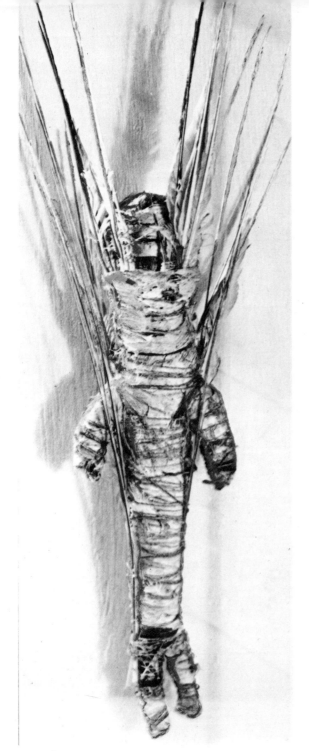

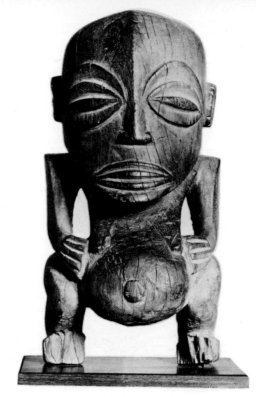

212 ⌂

Fisherman's canoe god. Rarotonga, Cook Islands. Wood. *Height*: 16″ (40.5 cm). *Collection*: Sir Robert and Lady Sainsbury, London. *Photo*: Art Institute of Chicago, USA.

The use of images of this kind is noted elsewhere (caption 203), and its form may be compared to images 203 and 208. It is possible that this figure originally had painted patterns on it, similar to 203, which have been obliterated by weathering. The cracked surface certainly indicates a long exposure to sun and water at some time in the past.

211 ⌂

God emblem. Mangaia, Cook Islands. Barkcloth, sennit, and feathers. *Length overall*: 17¼″ (44 cm). *Collection*: Cambridge University Museum of Archaeology and Ethnology, England. *Photo*: author.

The body is formed of lengths of coconut fibre sennit wrapped with white barkcloth. A fine thread binds on the long red tail-feathers of the tropic bird. Several types of feathers are attached, but these tail-feathers are the most conspicuous. An old label informs us that the image is "Tangua a mighty god from Mangaia said to be the progenitor of the present inhabitants and deities", and that human sacrifices were offered to it. The god mentioned may be Tangiia, or the identity may have been confused with Tangiia, an ancestor of Rarotonga. The collector was John Williams (1796–1839) of the London Missionary Society.

213

214

Fan. Society Islands. Wood handle with coconut-leaflet flap. *Length*: 18⅛″ (46 cm). *Collection*: Otago Museum (W. O. Oldman Collection), Dunedin, New Zealand. *Photo*: author.

This fan is placed slightly out of context for comparison with 215. Fans served two purposes in Polynesian society, as explained in relation to the Marquesan fan 157. Firstly, there were ordinary fans to cool the body in hot weather, and secondly, there were extraordinary fans that served as status symbols. Generally, the fineness of plaiting and the degree of elaboration of the handle in this example indicate the latter use, but there is no invariable rule of classification for any Polynesian artifact. Fans were used by nobles as graceful symbols of prestige in some Polynesian areas, notably in the Society and Cook Islands, the Marquesas, and in Hawaii (47). In other areas they tended to have common use only. Extreme stylisation of human forms is in the double and outward-turned figures on the handle of this fan. A similarly-shaped fan is carried by the Rarotongan chief Te Po, 207.

215

Detail of a fan handle. Rarotonga, Cook Islands. Wood. Coconut-leaflet flap. *Collection*: James Hooper, Sussex, England. Photographed by the author in 1957 at Mr James Hooper's Totems Museum, Arundel, England. (The museum has since closed.)

Although only about three inches high, these two outward-turned images relate in detail to large-scale Rarotongan images, several of which are illustrated in 203–10, 212 and 223. (Compare the Society Islands fan and handle 214).

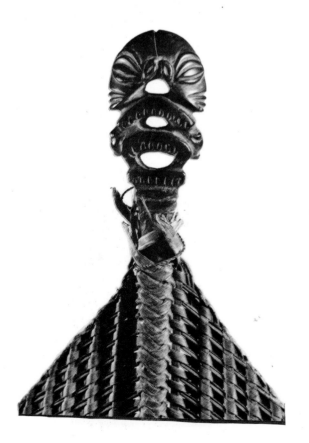

213

An assemblage of images, mainly Cook Islands', seen as a pen drawing in *The Story of the South Seas Written for Young People,* published by the London Missionary Society, 1894. This illustration demonstrates a nineteenth-century attitude towards Polynesian sculpture, namely, the persistent belief that these figures were the idols of heathenism and vehicles of an actual devil spirit that was then firmly held as a reality by Christian believers in Lucifer. The figure of Tangaroa (183) representing the Austral Islands, is seen here wearing a loincloth in one of its several early appearances in the literature. The two "demons" in the upper part of the plate are Rarotongan fishermen's gods. (Compare 203, 208, and 212.)

127

216 ◊

Central section of the shaft of a toothed and bladed spear-club. Cook Islands. Wood. *Overall length of weapon*: 94½″ (240 cm). *Collection*: Bernice P. Bishop Museum, Honolulu. *Photo*: George Bacon, museum archives.

The illustration shows the centre section of a typical Cook Islands spear-club, composed of grip shaft, penis pommel, and broad blade. "Eyes" are carved below the toothed blade. Skinner has provided a fascinating explanation for the appearance of "eyes" and "teeth" on clubs found in many parts of the Pacific. In 1964 he revealed a remarkable supporting demonstration of his thesis that images relating to crocodiles are expressed in certain Polynesian art forms (see page 54), though crocodiles are not present in the fauna of Polynesia.

◊ ◊
217 218

Post with human figures. Cook Islands. Wood with black painted patterns. *Height*: 15⅜″ (39 cm). *Collection*: Hunterian Museum, Glasgow, Scotland. *Photo*: author.

This unusual carving was presented to the museum by G. Turner in 1860. No record exists of former function; however, it appears to have been cut from a house or canoe. The appearance of similar figures on the doorposts of New Zealand carved houses favours the suggestion that this carving was cut either from the house of a chiefly person or from a temple structure. Chevron patterns are painted over the bodies of both figures.

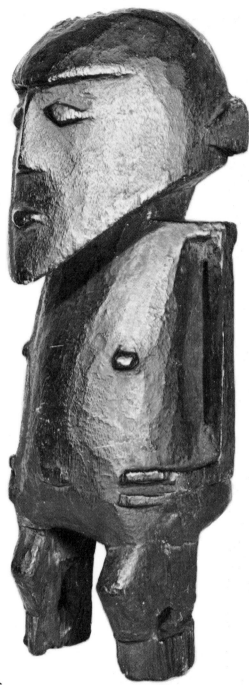

219 ⬦

Human image. Aitutaki, Cook Islands. Wood, with black painted surface. Right arm broken off. *Height*: 15¾″ (40 cm.) *Collection*: Hunterian Museum, Glasgow, Scotland. *Photo*: author.

Museum records suggest that this figure, secured by William Hunter, was originally collected by Captain Cook. As Aitutaki was not discovered until 1789 by Captain Bligh, a decade after the death of Cook, this recorded history is in error, or the island provenience is misreported. This image differs from the typical Rarotongan image, as may be seen by comparing the fisherman's god 203. The style appears intermediate between the style of Cook Island images and images of the Society Islands. It resembles, in a general way, known images from Aitutaki. The hands are conventionalised to two fingers, which form simple forks.

217

218

129

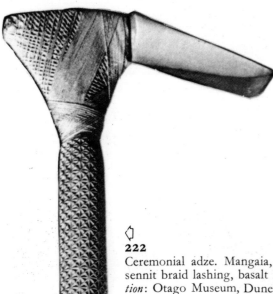

223 ▷

Freestanding male image. Rarotonga, Cook Islands. Wood with lashings of sennit on the arms. *Height*: 27⅛" (69 cm). *Collection*: British Museum, London. *Photo*: museum photographic department, for the present work.

An early collection date for this remarkable figure is indicated by its presence in the London Missionary Society collection and its several appearances in nineteenth-century literature. The head of the figure is of distinctly Rarotongan form, comparable with the heads of fishermen's god figures 203, 208, and 212. The three images on its chest resemble in style the staff-god secondary images (compare 209), but the concept of images sprouting from the body of a god is more thoroughly carried out on the Rurutu image 183. Highly-polished surfaces such as on this specimen are possible only when close-grained hardwoods are used as a raw material. (See the discussion on woods used by Polynesians, page 59.)

◁

222

Ceremonial adze. Mangaia, Cook Islands. Wooden handle, sennit braid lashing, basalt head. *Length*: 24". (61 cm). *Collection*: Otago Museum, Dunedin, New Zealand. *Photo*: author.

Adzes of this type are symbols of gods and of ceremonial rather than practical use. Their form relates to the high status of craftsmen and of the carving art. This adze has a history that associates it directly with Captain Cook, who discovered Mangaia in March 1777. After Cook's death in Hawaii in 1779, his two successors, Clerke and Gore, died in turn before the *Resolution* reached England. Lieutenant King, who assumed final command on the last stage of the voyage, appears to have assumed that all the "curiosities" in the captain's cabin belonged to his immediate predecessor, as they were sent to Gore's relatives in Northern Ireland. This beautiful adze was originally in this group of material, most of which has found its way into the collections of the National Museum of Ireland and Trinity College, Dublin. The collections are described by Freeman in the *Journal of the Polynesian Society* (1949). ◁**220** **221** ▽

Shark hook. Mangaia, Cook Islands. Line drawing of shark hook with detailed pattern projected on a flat plane (after Buck, 1944). *Height*: 11½" (29 cm). *Collection*: British Museum, London.

Beasley (1928), in his classic work on fish-hooks, regarded this old specimen, which was originally part of the London Missionary Society Collection, as one of the finest in existence. The surface pattern is derived from the human form in the manner typical of Mangaian and Raivavaean surface patterns. (See page 58-9; note also the surface treatment of the Mangaian ceremonial adze 222.) No record exists as to the use of this hook. However, we can be reasonably sure that it was made for ritualistic rather than ordinary purposes. Elaborated fish-hooks of no practical use were sometimes retained as talisman by chiefs and head fishermen. (See the New Zealand ornament 65.)

222

220

221

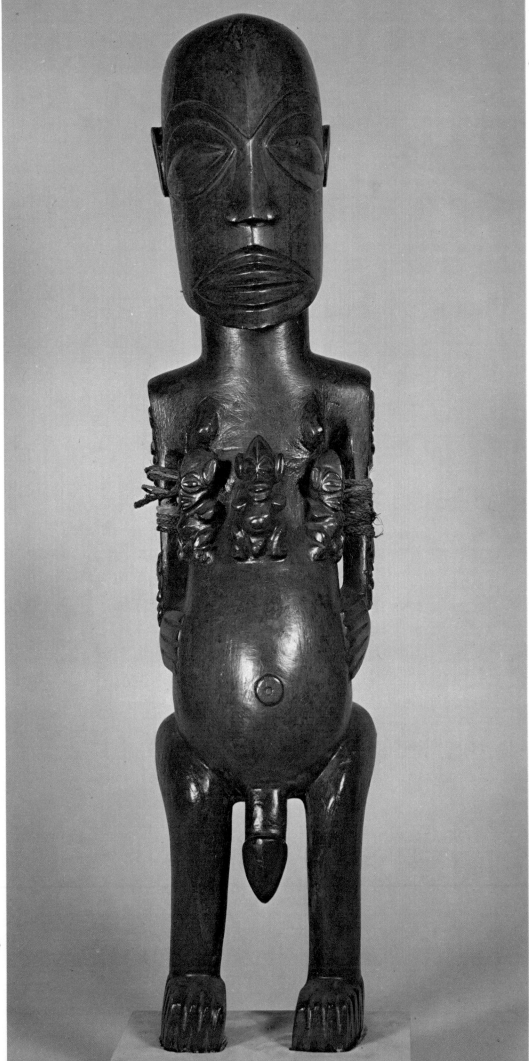

223

A scene of 1789 at Easter Island from an engraved illustration by Godefroy in the *Atlas du voyage La Pérouse* (Paris, 1797). In this romantic setting some of the ship's gentlemen are seen fraternising with the local people, while others are engaged in measuring in a rough-and-ready manner one of the massive stone images. Two thieves are skilfully relieving the unsuspecting visitors of their personal possessions. Thievery was an admired art in Polynesia and had its own patron deity. However, an unsuccessful thief was obliged to submit to punishment without resistance or plea for mercy. This attribute of Polynesian character was neither understood nor tolerated by Europeans and it became a frequent cause of bloodshed when European met Polynesian. Regarding the fallen images, it is believed they were toppled when the two clans called the Short-ears and the Long-ears were engaged in a long and bitter feud. With the headlong collision of the two groups, possibly brought about by the impact of foreign ships whose existence planted the seeds of unrest, image-making ceased. Mid-nineteenth-century slavers from Peru terminated local squabbles and put a virtual end to traditional Easter Island culture by carrying off the chiefs and learned men of the island.

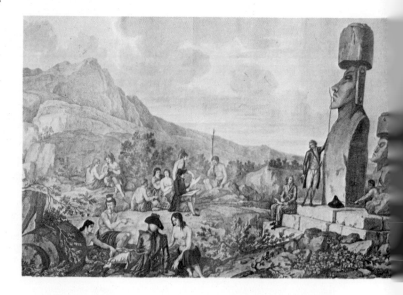

Easter Island, a dependency of Chile, is, by popular fancy aided by pseudo-scientific writing, shrouded in mystery. This eastern outpost of Polynesia, thirty-four miles in circumference, is a dry island surrounded by a vast ocean. It is one of the most inaccessible inhabited islands of the earth, although it has been opened recently to a jet air service, which has ended an isolation of centuries. Tourists may now see for themselves the massive stone images, but the famous talking boards and old wooden images are now far from Easter Island, in distant museums.

There is no mystery about Easter Island or its arts. The first settlers were typical Polynesian sea voyagers who somehow discovered this new land. They named it Te Pito te Henua (the Navel of the Earth), regardless of its barren and inhospitable appearance to a people from lush tropical islands. No coconut palms or large trees grew here, and rainfall was minimal. However, the relatively harsh environment conditioned a culture that became one of the most interesting in all Polynesia.

Two Easter Island products have capitvated the imaginations of Europeans for centuries. The first is the massive stone work (11–12 and 224), and the second is a group of small flat tablets with "writing" in "hieroglyphic" characters incised in rows on them (256–58). After numerous attempts had been made at translating the so-called "script" of Easter Island, a German scholar named Barthel (1958) established the principal use of the symbols seen on these boards.

The simple fact is that the Easter Island inscriptions are not true writing but a system of pictorial mnemonics of a picto-ideographic kind. The boards were used by priestly bards to help them recite events and genealogies in the traditional Polynesian manner. Since each line is upside down to the line above it, the user must have rotated the tablet at the end of each line to read the succeeding line upside-down. This is by no means impossible, as in missionary times Polynesian learners using a single book are reported as sitting around it and of necessity learning to use it from whatever viewing angle they happened to take. Many tablets were burnt at the orders of missionaries, as they thought they helped to keep alive the paganism they were determined to eradicate. However, it was the Peruvian slave raids between 1858–70 that swept away most of the learned men of Easter Island and their full knowledge of the talking boards.

225 **226**

Stone slab with a flying bird painted in red ochre on a white clay ground, and a photograph taken at the recovery site, Orongo, Easter Island. *Length of slab*: 48″ (122 cm). *Width*: 24″ (61 cm). *Collection*: Department of Anthropology, Smithsonian Institution, Washington, DC.

This painted slab is one of several removed from the interior of one of the numerous stone dwellings at Orongo by members (226) of USS *Mohican* in a visit to Easter Island (1886). Paymaster Tompson wrote an informative account (1891) of the explorations and investigations made during this expedition and described the artifacts recovered, including the painted paddle in 247–49. This was associated with the extraordinary birdman cult of the island. (See page 54.)

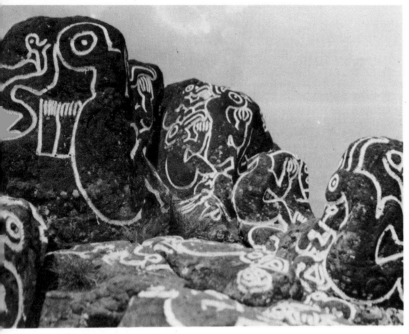

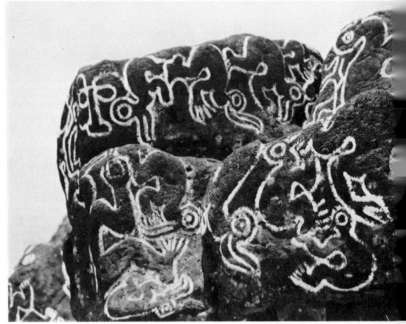

227 ⬦ **228** ⬦
Rock outcrops at Orongo, Easter Island, extensively marked
with birdman petroglyphs. These photographs of birdman
rocks *in situ* were taken by Alfred Métraux, a member of the
Franco-Belgian Expedition to Easter Island (1934–35).
Photos: Bishop Museum archives, Honolulu.

A very limited number of wooden birdman figures is pre-
served in museum collections. Compared with the standard
image type (242), which occurs in considerable numbers,
birdmen figures are exceedingly rare. The author has des-
cribed material representations of birdmen in Polynesia
(Barrow, 1967), including the three figures illustrated here.

230 ▷

A birdman depicted as a masked figure, with arms and hands
rendered as wings, and added tail (not visible in the illus-
tration). Easter Island. Wood. *Height*: $10\frac{1}{2}''$ (26.6 cm).
Collection: British Museum, London. *Photo*: author.

231 ▷

A birdman formed by the combination of a human body with
a bird head. The arms are formed as wings, and a tail is
present. A nose is situated on the upper mandible of the beak.
Easter Island. Wood. *Height*: 17″ (43 cm). *Collection*: American
Museum of Natural History, New York. *Photo*: museum
archives.

232 ▷

A birdman formed by the placement of a human head on a
bird body. Easter Island. Wood. *Length*: $13\frac{1}{4}''$ (33.5 cm).
Collection: British Museum, London. *Photo*: author.

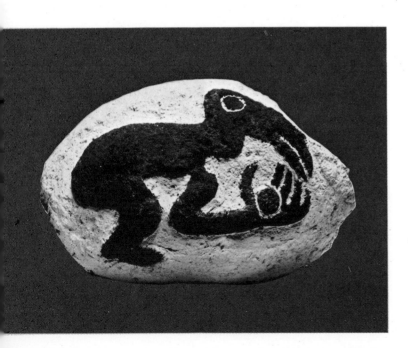

◁ **229**
Petroglyph depicting a birdman holding an egg. Easter
Island. *Collection*: British Museum, London. *Photo*: museum
archives.

This distinctive birdman figure is, with other birdmen
illustrated, associated with the cult of the sooty tern which
prevailed on Easter Island.

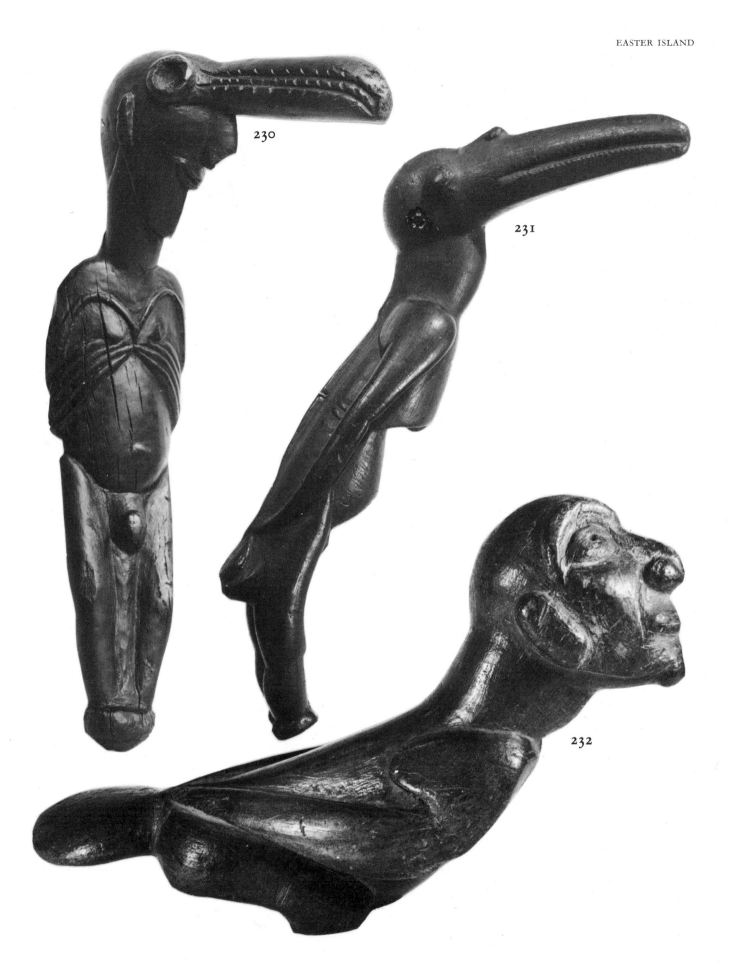

230

231

232

135

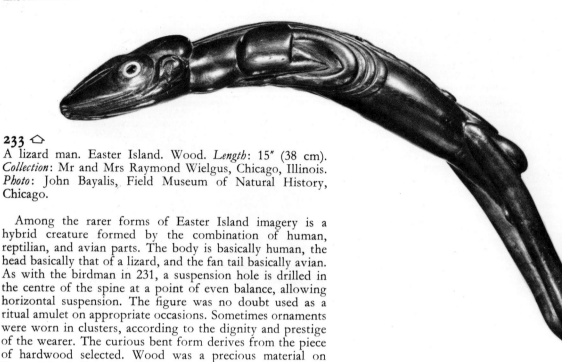

233 ⌂

A lizard man. Easter Island. Wood. *Length*: 15″ (38 cm).
Collection: Mr and Mrs Raymond Wielgus, Chicago, Illinois.
Photo: John Bayalis, Field Museum of Natural History,
Chicago.

Among the rarer forms of Easter Island imagery is a
hybrid creature formed by the combination of human,
reptilian, and avian parts. The body is basically human, the
head basically that of a lizard, and the fan tail basically avian.
As with the birdman in 231, a suspension hole is drilled in
the centre of the spine at a point of even balance, allowing
horizontal suspension. The figure was no doubt used as a
ritual amulet on appropriate occasions. Sometimes ornaments
were worn in clusters, according to the dignity and prestige
of the wearer. The curious bent form derives from the piece
of hardwood selected. Wood was a precious material on
Easter Island. (See page 59.)

234 ▷

Male figure. Easter Island. Wood. Eye inlay of bird wing
bone circlets with obsidian centres. *Height*: $8\frac{1}{4}$″ (21 cm).
Collection: Canterbury Museum (W. O. Oldman Collection),
Christchurch, New Zealand. *Photo*: author.

235 ▷

Male figure with its head turned to the left and glyph on
cranium. (Compare 234.) Easter Island. Wood. Eye inlay of
bird wing bone circlets, obsidian centres lost. *Height*: $7\frac{7}{8}$″
(20 cm). *Collection*: Canterbury Museum (W. O. Oldman
Collection), Christchurch, New Zealand. *Photo*: author.

236 ▷ **237** ▷

Squatting male figure. Easter Island. Wood. Eye inlay of
bird wing bone circlets with obsidian centres. *Height*: $6\frac{7}{8}$″
(17.5 cm). *Collection*: British Museum, London. *Photo*: author.

Small human images of infantile rather than adult form are
present in a few Easter Island collections. These are in a
standing or squatting position. They appear to belong to a
class of small figurines worn as ancestral pendants, comparable
to the New Zealand *hei tiki* (307 and 309); the ivory figurines of
Tonga (103–7); and the small stone images of the Marquesas
(151–56). They share the essential features of small size and a
suspension hole on the crown, at the back of the head, or
behind the neck. Three examples from Easter Island are
illustrated here.

This small image has heavy eyebrows and beard, and large
ears. The impish expression of this figure is comical to
Western eyes, but it is doubtful if humour was intended.
Humour seems absent from Polynesian art, although a good
sense of it is a notable Polynesian characteristic. This small
image, which has a suspension hole at the neck, appears to
relate to certain Maori *hei tiki*. (For example, 307.) A unique
wooden specimen described by the author elsewhere (Barrow,
1969) supplies us with a parallel form of a small anthropo-
morphic amulet in wood from New Zealand.

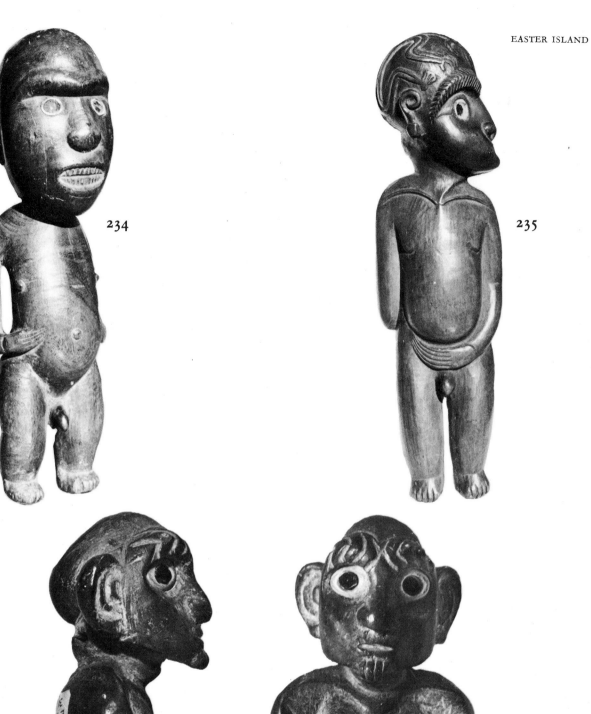

234

235

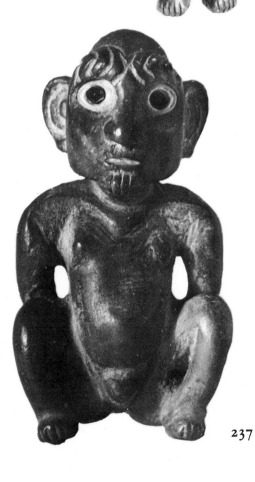

236

237

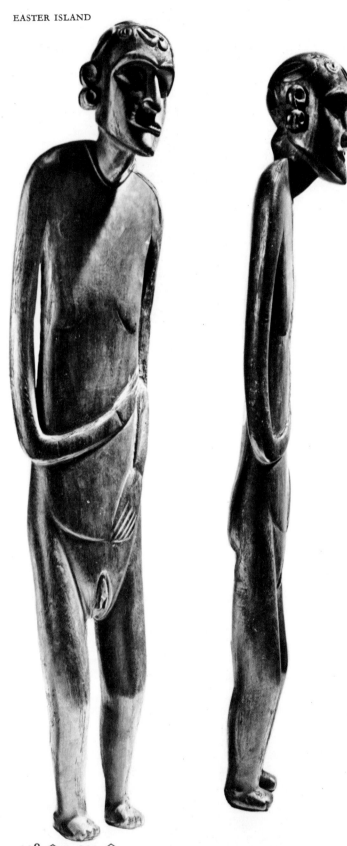

Easter Island wooden images are usually of the male sex and of emaciated appearance (242). There is, however, a class of female image, somewhat larger than the male image and of flattish form, which exhibits pendant breasts and vulva. One hand typically rests on the pubes. While female images appear to be of post-contact manufacture and generally of craftsmanship inferior to the best male images, the type is probably quite old and not merely a late innovation for trade or other purposes. George Forster of Captain Cook's second voyage noted (1777) the presence on Easter Island of both male and female wooden images.

240 ⬠

The cranial glyph (*length of glyph*: 4½″ 11.5 cm) is drawn by the author from his rubbing. It must be remembered that this design is on a rounded surface and that when it is rendered on a flat surface it spreads as a kind of Mercator's projection. In the original design the beaks of the two birds touch, as can be seen in 238.

241 ⬠

Cranial glyph with forehead spirals. Easter Island. Drawn by the author from his rubbing from an image in the Cambridge University Museum of Archaeology and Ethnology, England. *Length of glyph*: 4½″ (11.5 cm).

The subject matter of glyphs ranges widely but is always of symmetrical arrangement. Birds with touching beaks (240), human figures with outspread limbs (243), and octopuses with decoratively placed tentacles, as well as other subjects, are commonly found. Distortions caused when rendering designs from rounded to flat surfaces must be kept in mind when viewing 240, 241, and 243.

238 ⬠ **239** ⬠

Standing female figure with cranial glyph. Easter Island. Wood. Eye of bird wing bone circlet, obsidian centres missing. *Height*: 18⅛″ (46 cm). *Collection*: British Museum, London. *Photos*: author.

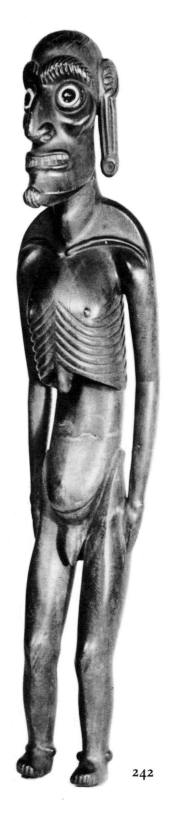

242 ⇕ ⇧ 243

Standing male figure with detail of cranial glyph 243 (*Length*: about 3½"—about 9 cm.) Easter Island. Wood. Eye inlay of bird wing bone circlets with obsidian centres. Traces of red ochre paint. *Height*: 18⅛" (46 cm). *Collection*: Ipswich Museum, England. *Photo*: author.

This fine old specimen of a male image was secured by the museum from a private estate. The physical form of these *moai kavakava* images appears to be derived from the artists' observation of the bodies of the dead mummified by art or desiccated by the dry atmosphere of burial caves. At some ancient time it was decided that wooden images of departed ancestors should take on this emaciated appearance. According to Easter Islanders, when the spirits of the dead appear as ghostly apparitions they are of this form and facial expression.

Images of this type were first mentioned in George Forster's account (London, 1777) of Cook's second voyage to the Pacific, 1772–75. Since then they have been collected regularly by visitors to Easter Island. For over a century there was observable a progressive decline in standards of craftsmanship which reflected local cultural loss, the introduction of steel tools, the use of imported woods, and the stimulus of foreign trade. No class of Polynesian artifact more readily reveals progressive decadence and loss of restraint and discerning taste. The oldest carvings are among the finest in Polynesian art; the most recent are among the worst survivals of a traditional art form.

242

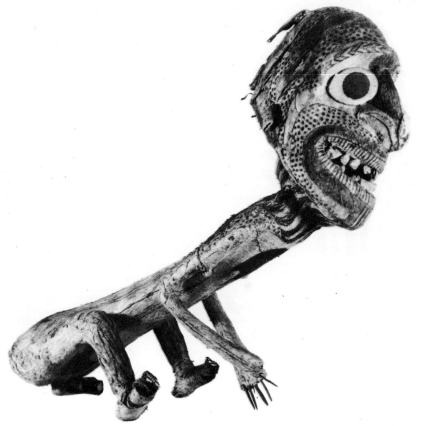

244 ◁

Tepano, a chief of Easter Island, from an engraving illustrating Stolpe (1890). *Photo*: Bishop Museum archives, Honolulu.
Tepano's powerful profile illustrates a strong Caucasoid racial element, which was evidently dominant in some groups and individuals. His tattoo patterns may be related in a general way to those of the barkcloth images 245–46, and the painted paddle 247–49. The racial composition of Polynesians is discussed on page 20.

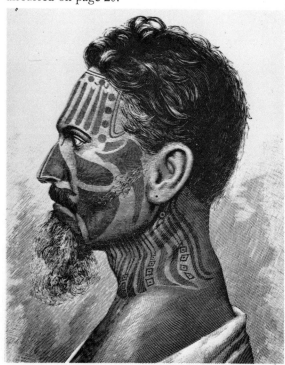

245 ◁

Seated figure. Easter Island. Pithwood, barkcloth, and pigments. *Height*: 12″ (30.5 cm). *Collection*: Peabody Museum, Harvard University, Cambridge, Massachusetts. *Photo*: museum archives.

This rarity of Polynesian sculpture was secured in 1899 by the Peabody Museum from the Boston Museum, where it had been presented along with a second *tapa* image (246) by the heirs of David Kimball. The proportionately large head in relation to the small stick-like body is a convention of Polynesian art based on the religious importance of the head in Polynesian culture. (For discussion of this, see page 50.) The use of these figures has passed unrecorded, but it seems likely that they served as ancestral guardians rather than as tattooers' models or other minor functions in Easter Island society.

246 ▷

Seated figure. Easter Island. Bulrush pithwood, barkcloth, and pigments. *Height*: 15″ (38 cm). *Collection*: Peabody Museum, Harvard University, Cambridge, Massachusetts. *Photo*: author.

The scant history of this notable figure is shared with its preceding companion piece 245, as it, too, was acquired by the Peabody Museum seventy-odd years ago from the Boston Museum, which in turn had received it from the heirs of David Kimball. Of three extant figures of this type (a third is in the Ulster Museum, Belfast), this is the most accomplished and has the most elaborate decoration. As the Marquesas Islands is a homeland of Easter Island culture, resemblances are to be expected. One form of Easter Island tattoo shared with the Marquesas is that of placing broad bands on the face. (For examples see the Marquesan 146, and the paddle designs 247–48.) The marks on this figure (246) evidently represent tattoo designs.

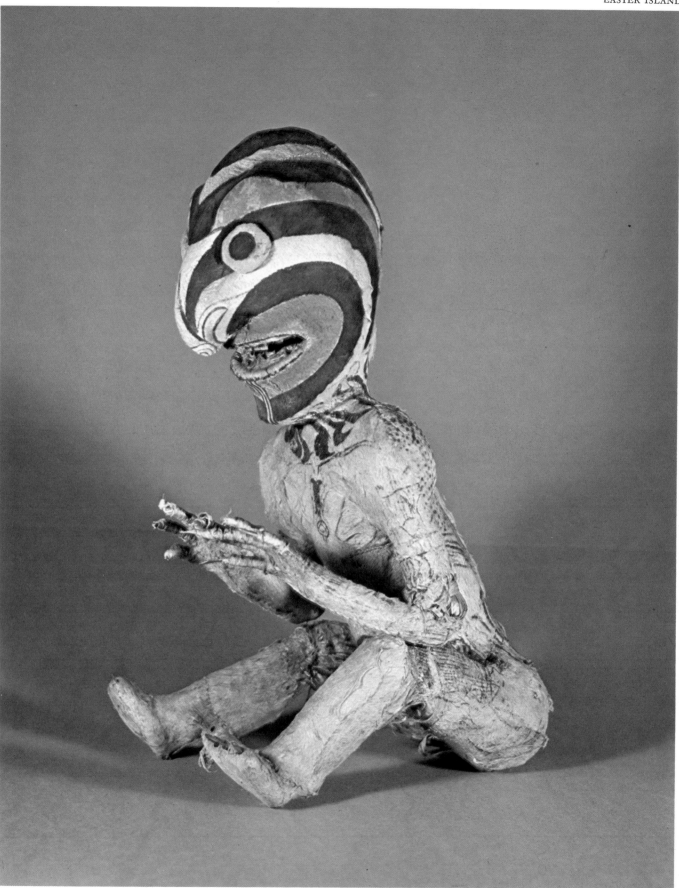

247 ◇

◇ **248**

Dance paddle with carved and painted face. Head details as they appear on each side. Easter Island. Wood with eye inlay of bird wing bone and obsidian. Pigments on surface. *Length overall*: 88″ (223 cm). *Height of head*: 22″ (56 cm). *Collection*: Department of Anthropology, Smithsonian Institution, Washington, DC. *Photos*: museum archives (black and white); author (colour).

Dance paddles were used in many Polynesian islands. They are usually of conventionalised paddle form but of a wood which does not serve for working paddles. In Easter Island such paddles were used in ceremonial dances to

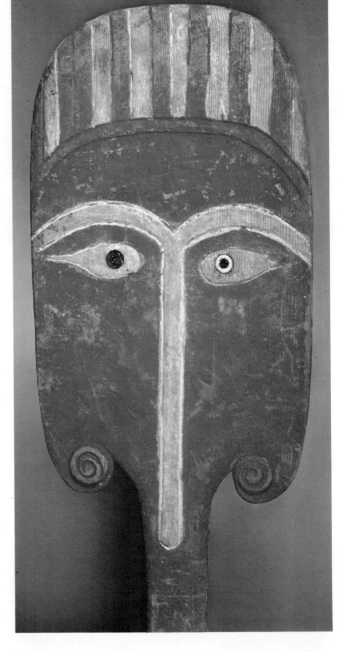

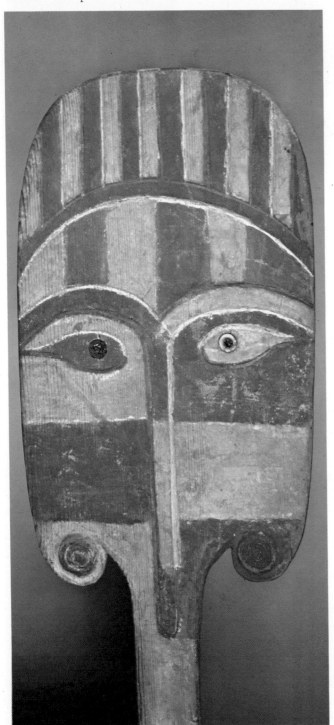

248

propitiate spirits, ward off crop failure, avoid drought, and secure advantage. This specimen, collected by Paymaster Tompson during the visit of USS *Mohican* in 1886, is evidently made from a ship's plank or imported board of some kind.

Old paddles are smaller and of superior form, and are made from hardwood. However, this post-contact paddle with its clear rendering of a human face provides a valuable comparative piece useful in interpreting the old paddles (of which 250 is a good example). The high-curved brow ridges, nose bar, and ears with plugs through the lobes, are typical features in this area of carving. The stylised brow ridges link these forms closely to certain rare southern New Zealand forms and with Chatham Islands carvings (318 and 320–21).

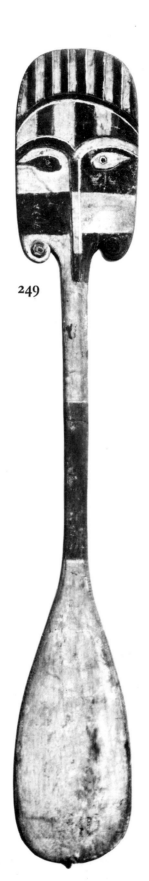

249

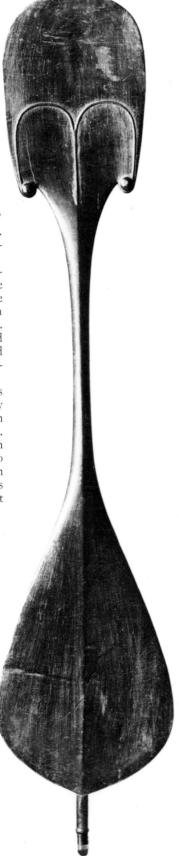

250 ◊

Dance paddle representing a human head. Easter Island. Wood. *Length*: 32⅞″ (83.5 cm). *Collection*: Museum of Primitive Art, New York. *Photo*: museum archives.

The parts of the abstract face of this paddle are best identified by reference to the head parts of the post-contact paddle 247–49. It seems likely that the lower blade represents the out thrust tongue of the head of the upper blade. A note on the symbolism of the tongue is provided (on page 55). This relationship of upper and lower parts recently occurred to the author after handling and looking at Easter Island dance paddles for many years. The obvious is often overlooked.

Paddles of this type are among the most beautiful products of Polynesian art. Although highly valued by collectors, they are not extremely rare. Seven are illustrated by W. O. Oldman (1943), and they are also regularly seen in museum collections. The Oldman specimen sizes range from 64⅝″ (164 cm) in length down to 35″ (89 cm). This provides a good reference to the length of pre-contact Easter Island dance paddles in general. In post-contact Polynesia, quality decreases as general size increases especially when it goes beyond the limit of the largest classical specimens.

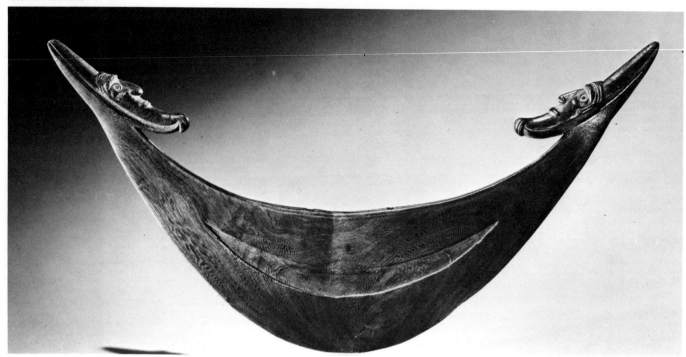

251 ⬦

Gorget. Easter Island. Wood. Eye inlay of bird wing bone circlet and obsidian centres. *Width*: 15″ (38 cm). *Collection*: Mr and Mrs Raymond Wielgus, Chicago. *Photo*: Field Museum of National History, Chicago.

This crescent-form breast ornament with human masks carved at each end is of extremely sensitive craftsmanship. Drilled holes at the back of the upper rim indicate where it was suspended when worn. The heads at each end follow the classical Easter Island art convention; however, in some gorgets the end heads become bird heads. The latter arrangement is probably traditional, but it has not been encountered by the author in the collections of old specimens he has studied.

The shape of these ornaments is unquestionably derived from the natural form of the pearlshell breast ornaments that were widely worn on islands where large pearlshells were available from either harvest or trade. The copying of the pearlshell form using other materials is seen elsewhere, notably in Fiji (126–27). The Easter Islanders also reproduced in wood the loved but lost coconut (252).

⬦ **252**

Amulet. Easter Island. Wood. *Height*: 6¼″ (16 cm). *Collection*: Bernice P. Bishop Museum, Honolulu. *Photo*: George Bacon, museum archives.

The shape of this ornament is that of a coconut, with superimposed stylised human features similar to those seen on dance paddles (250). The climate of Easter Island was sufficiently warm to allow the coconut palm to grow, if not flourish, but it seems that the first Easter Islanders did not succeed in establishing the palm in their new home. It is probable that the first settlers carried viable nuts along with other valuable plants. The absence of the coconut must have been lamented and the memory of the tree affectionately perpetuated. As with the pearlshell-form gorget 251, the Easter Islanders produce replicas of the coconut in wood, with superimposed brows and nose.

253 ◁ ▷ **254**

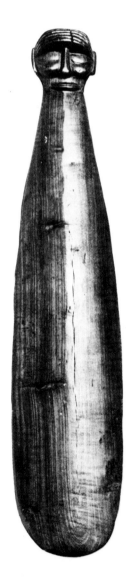

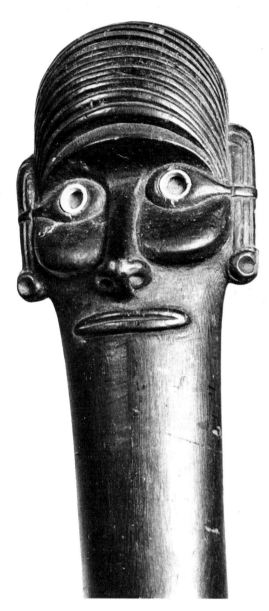

Spatulate club, with head detail 254. Easter Island. Wood. Eye inlay of bird wing bone, obsidian centres missing. *Length*: 62¼″ (158 cm). *Collection*: Bernice P. Bishop Museum, Honolulu. *Photo*: George Bacon, museum archives.

Clubs of this type, which average about this size, have at one end a flattish striking part and at the other an ornamental pair of faces in the manner of the Janus (254). Such bladed clubs are paralleled in New Zealand by the long spatulate *taiaha*, just as the short hand club of Easter Island has its counterpart in a Maori short club. The hand grip and method of attack and parry of this type of Polynesian weapon (which the author has elsewhere called a sword-club) may be compared in many respects with those of the sword of old Japan.

The club shown here has its head upright, but in use the striking blade is uppermost, while the part above the inverted heads is grasped with both hands in the manner of the New Zealand *taiaha*. Thompson (1891) states that Easter Island long clubs were chiefly batons not for use in hand-to-hand encounters. This is probably true of their late use, but clubs of this type are deadly, and there need be little doubt that they were used as weapons in ancient times.

255 ◁
Short club. Easter Island. Wood. *Length*: 20⅝″ (52.5 cm). *Collection*: Bernice P. Bishop Museum, Honolulu. *Photo*: author.

The short fighting clubs of Easter Island compare with certain New Zealand *patu* (301). The parallel form of New Zealand long clubs has been noted in the caption to 253–54.

145

256 ⌂
Section of a talking board illustrating the delicately-incised
ideographs. Easter Island. *Collection and photo:* Musée de
l'Homme, Paris.

257 ◇ **258** ◇
Two plaster casts of talking boards. Easter Island. *Collection:*
Smithsonian Institution, United States National Museum,
Museum of Natural History, Washington, DC. *Photos:* author.

These casts with inked-over inscriptions clearly show the
individual characters inscribed on the original boards.
Careful examination of the rows will confirm that alternate
lines are inverted: after scanning one row, the viewer would
have to turn the tablet around while still viewing the same
side in order to scan the next row, and so on. With practice,
the viewer could no doubt read the lines without having to
turn the tablet. Another example of the script can be seen
on the endpapers.)

257

258

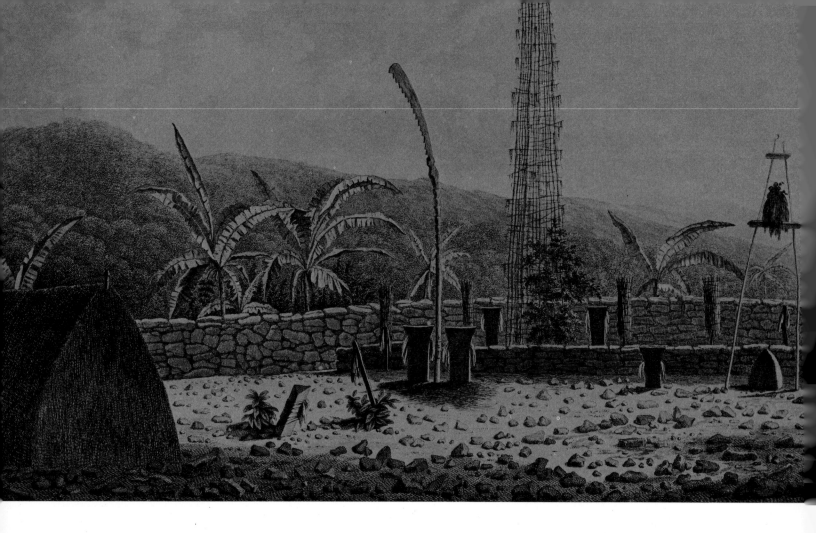

259

A temple drawn by John Webber (17), artist with Captain Cook on the third great Pacific voyage (1776–80), offers one of the best early views of a substantial Hawaiian temple. This one was drawn at Waimea on the island of Kauai in 1778. This engraving, from an original drawing, first appeared as an illustration in *A voyage to the Pacific Ocean . . . performed under the direction of Captain Cook, Clerke and Gore . . .* (London, 1784). *Collection*: Alexander Turnbull Library, Wellington, New Zealand. *Photo*: author.

Hawaiian temples, locally known as *heiau*, are found in various shapes and sizes throughout the Hawaiian chain of islands, from Necker Island in the north west to Hawaii in the south east. An organised priesthood used temples for elaborate ceremonies which were not attended by commoners within temple precincts. Commoners sometimes served as sacrificial offerings. (See page 54.) The impressive stone piles one sees in Hawaii appear to the untrained eye as amorphous masses of rock, but on many sites base structures for temple houses and other buildings may be detected. The restoration of the temple at Honaunau (13,14) allows the visitor to get a good impression of the site as it appeared about the time of European contact (15). The engraving (18) of Captain Cook being honoured as a god gives an idea of a temple interior in the eighteenth century.

HAWAIIAN ISLANDS

The Hawaiian archipelago stretches in a north west to south east direction with a cluster of high and habitable islands at the southern end (Hawaii, Maui, Kahoolawe, Lanai, Molokai, Oahu, Kauai, and Niihau). Except for Necker and Nihoa the islets and reefs that stretch to the north west of the principal islands are of minor interest in Polynesian settlement. The Hawaiians, whose traditional homelands are in Marquesas and Society Islands, developed a rich material culture which included a spectacular featherwork craft. The rigid caste system of classical Hawaii appears to have become increasingly burdensome as the centuries passed. Whereas nobles were given every privilege, commoners were oppressed. The social gap between aristocrat and commoner was always evident in Polynesia, but in Hawaii this extreme division of society had a marked effect on the arts of the islands. In 1959 Hawaii became the fiftieth state of the United States of America. Necker Island is one of the smallest of the dozen or so islands of the Hawaiian group usually named in atlas maps. It lies to the north west of the principal habitable islands.

▷**260**

This lithograph by the artist Jacques Arago, who visited Hawaii with an expedition commanded by Louis de Freycinet, shows a Hawaiian chief attired in feather cloak, helmet, and loincloth (*maro*). From de Freycinet's *Voyage autour de monde* . . . 1817–20 (published in Paris 1827–39).

Successive rows of triangle motifs on the left leg and a chequered pattern on the chest illustrate two of several styles of Hawaiian tattoo. The English language legend tattooed on the right arm reads: "Tamaahmah (Kamehameha I, 1758–1819) died May 8 1819". After the missionaries introduced books, reading and writing became widespread in many parts of Polynesia. The custom of tattooing in affectionate commemoration of the name of a deceased notable person or family relative was widely adopted. Quite naturally the tattooed letters imitated the form of the letterpress of prayer books and Bibles. The pole-spear that this warrior carries was one of the principal weapons of old Hawaii before the introduction of firearms.

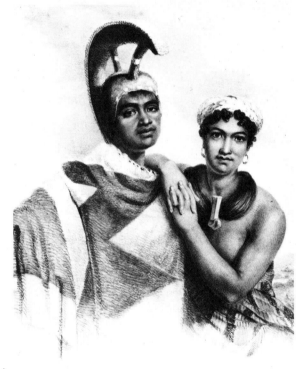

261 ▷

The Hawaiian high-chief Boki, Governor of the island of Oahu, and his wife Liliha. They sailed to England in 1823 with Kamehameha II and his consort, Queen Kamamalu, to hold audience with King George IV of Great Britian, but before the meetings of kings could take place Kamehameha and his young wife died of measles. Boki and Liliha returned to Hawaii in HMS *Blonde* which was dispatched by the British Government to return the royal bodies to Oahu. This lithograph after the artist John Hayter was published in London, 1824. *Collection*: Honolulu Academy of Arts, Hawaii. *Photo*: museum archives.

Boki is depicted wearing a magnificent feather cloak and helmet, while his wife Liliha is wearing a feather *lei* as a head coronet, a necklace of braided human hair with carved sperm whale tooth, and a skirt of fine printed barkcloth. The handsome pair are fair representatives of Hawaiian nobility in the early nineteenth century.

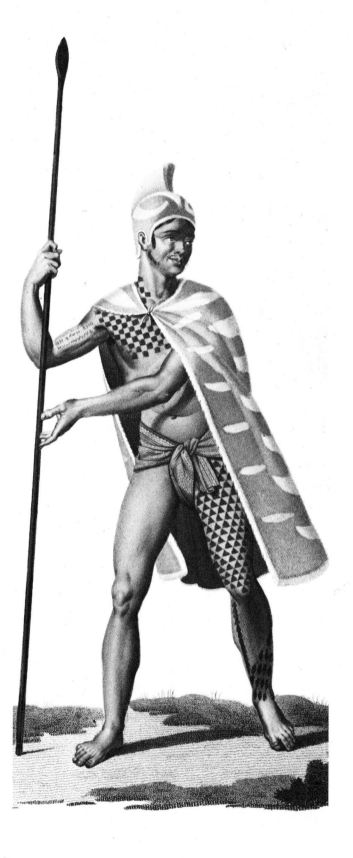

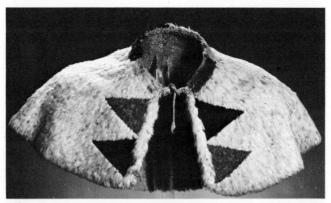

262

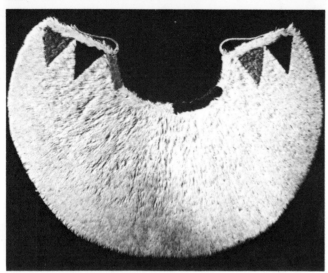

262 ⬦ 263 ⬦ 263

A feather cape displayed in both worn and flattened positions.
Composed of black, red, and yellow feathers attached to a
fibre netted base. Hawaiian Islands. *Width*: 26″ (66 cm).
Collection and photos: American Museum of Natural History,
New York.

This cloak formerly belonged to King Kamehameha III,
who gave it to Stephen D. Mackentosh in 1836. Although the
cloaks and capes of Hawaii are usually viewed flat, as is most
necessary for their conservation in museum cases or in com-
prehending the overall pattern, the relationship of front hem
patterns is revealed when a cape is draped as worn (262).
The cloak designer arranged his pattern to the best effect
when a cloak was in use, as can be confirmed by studying the
two views of this cape.

⬦ 266

The Princess Nahienaena. Hawaiian Islands. This engraving,
from an original portrait in oils by Robert Dampier, was
first published in Captain George Anson Byron's *Voyage of the
HMS Blonde to the Sandwich Islands* (London, 1826).
Photo: Honolulu Academy of Arts, Hawaii.

The young Princess died in 1836 at the age of twenty-one, a
victim, it is said, of the conflict between the irreconcilable
Calvinist missionary doctrines and the ideals of her native
Hawaiian culture. Princess Nahienaena wears a feather head
circlet, a cape, and a sacred feather wand termed *kahili*. The
original painting is in the Honolulu Academy of Arts.

⬦ 264

Feather cape. Hawaiian Islands. Composed of red, yellow,
and black feathers attached to a fibre netted base. *Width*:
27″ (68.5 cm). *Depth*: 13½″ (34 cm). *Collection*: Bernice P.
Bishop Museum, Honolulu. *Photo*: author.

This spectacular small cape formerly belonged to Queen
Kapiolani (1834–99), consort of King David Kalakaua.
Its deep red feather base encloses narrow crescents of black
and yellow. The half-crescents of yellow are designed to
meet at the frontal hems, as demonstrated by the New York
cape in 262–63.

⬦ 265

Feather cape. Hawaiian Islands. Yellow, red, and black
feathers attached to a fibre netted base. *Width*: 32″ (81 cm).
Depth: 14½″ (37 cm). *Collection*: Bernice P. Bishop Museum,
Honolulu. *Photo*: author.

The design of this cloak uses yellow as the base colour, and
for this reason it presents a striking contrast to the Kapiolani
cape 264. The base yellow has a large red crescent inset,
black feathers being limited to parts of the neckline.
This fine cape formerly belonged to Kaumualii, King of
Kauai, who received it as a gift from Kamehameha I when
he ceded his island kingdom to the latter in 1810.

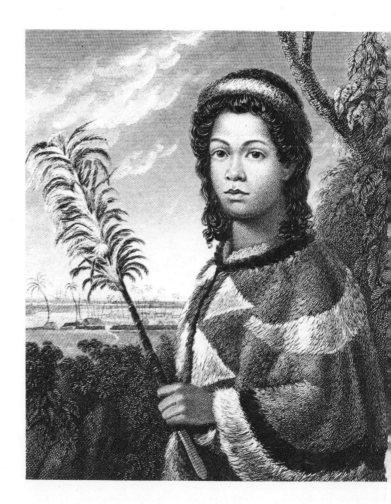

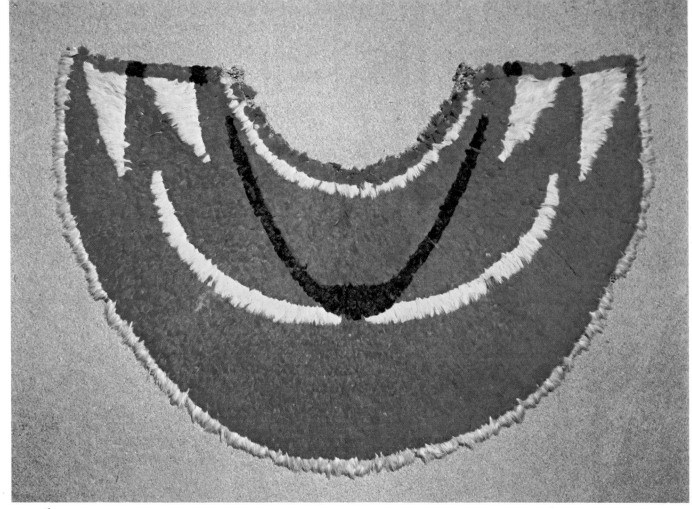

264

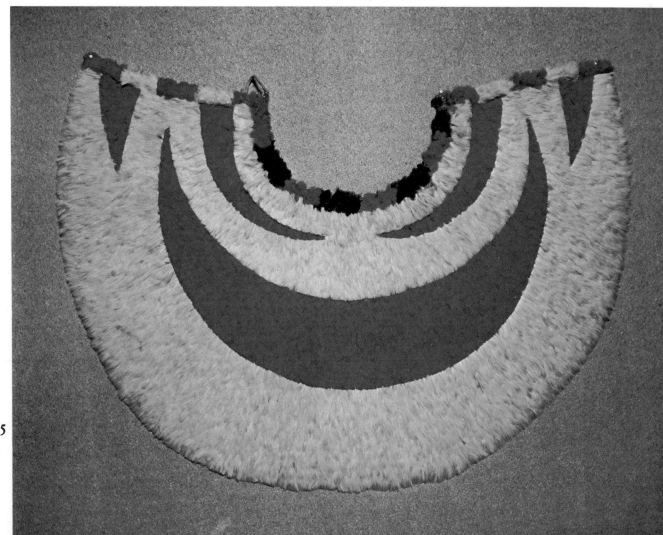

265

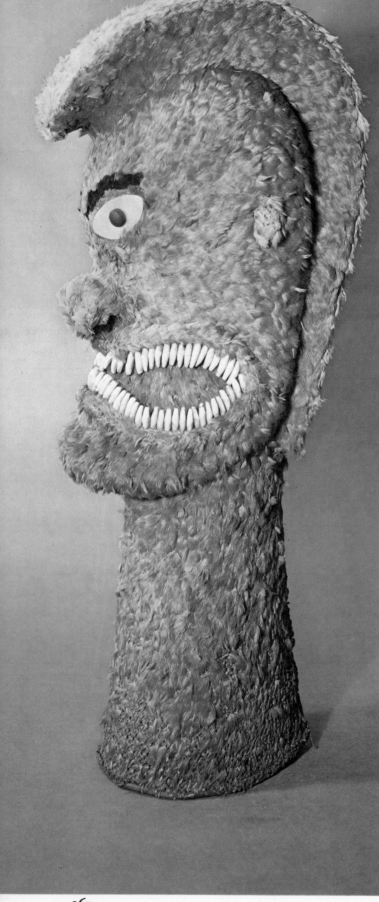

267

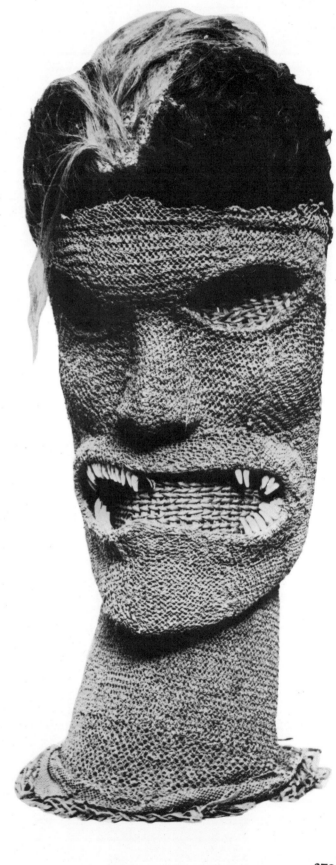

270

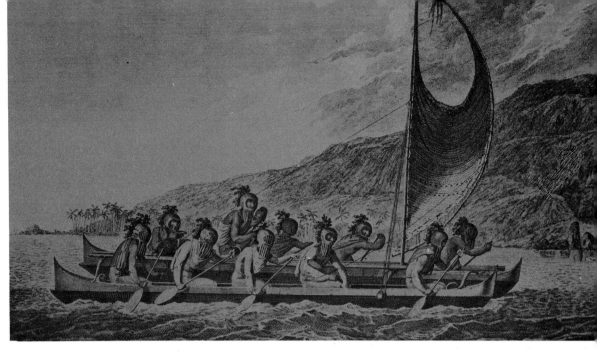

267

Feather god. Kealakekua Bay, Hawaii. Basketwork frame of split aerial roots of the *'ie'ie* with fibre net cover and attached feathers, pearlshell eyes with wood centres, and dog incisor teeth. *Height*: 32½″ (82.5 cm). *Collection*: Dominion Museum (Lord St Oswald Collection), Wellington, New Zealand. *Photo*: author.

The head was presented to Captain James Cook, with other featherwork, in 1779, as a mark of great respect. The event is illustrated 268 in part by the canoe carrying a feather god, which could be the same god. The Bishop Museum in Honolulu has two feather gods of this type, while archival records total about twenty in existence. Five are in the British Museum, London. All date to an early period of contact, before images were forsaken by the Hawaiians. (See page 56.) This type of image is believed to represent the war god Kukailimoku, an identification that is confirmed by the personal history of some specimens.

268

Engraved illustrations from the account of Captain Cook's third Pacific voyage (1776–80), from paintings by Webber (17), of a small double-hulled canoe propelled by sail and masked Hawaiian paddlers. *Collection and photos*: author.

Each man wears a gourd helmet, fringed with white bark-cloth strips and crowned with twigs of greenery thrust into holes in the top (269). Although these helmets are usually termed masks, they are not true masks, as most of the face is visible. Some helmets of this type, known only from Webber's drawings, are masks, since the wearer's face is hidden, and viewing is by means of small holes. Closely-spaced barkcloth ribbons fringe the base of these gourd helmets. The canoe is on a mission delivering featherwork to Captain Cook at Kealakekua Bay in 1779. It is likely that the feather god held by the man half-standing in the far hull is the one now in the collection of the Dominion Museum, Wellington, New Zealand (267). It was on the shoreline running behind the canoe that Captain Cook was killed by the Hawaiians in the same year.

269

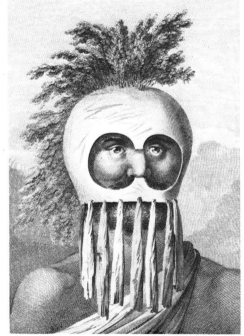

270

Feather god. Hawaiian Islands. Basketwork frame of split aerial roots of the *'ie'ie* overlaid with fibre netting to which feathers were formerly attached. Attached dog incisor teeth and human hair (both natural hue and bleached). *Height*: 24″ (61 cm). *Collection*: Peabody Museum, Harvard University, Cambridge, Massachusetts. *Photo*: Art Institute of Chicago.

This powerful image portrays the ferocity and disdain of the Hawaiian war god Kukailimoku. Loss of feathers from insect ravages, fallen teeth, and loss of pearlshell eyes have not removed the scornful expression from this head.

It was collected by a missionary, the Rev. William Richards, before 1833, then was given to the Androver Theological Seminary in New England, USA, whence it passed to the Peabody Museum in 1937. It has an old label which reads: "God of Kekuaokalani. To this idol two human sacrifices were offered at the commencement of the battle (1819) which decided the fate of idolatry in the Sandwich Islands. Presented by Mr Richards". The label refers to the reactionary chief Kekuaokalani and the battle against Kamehameha I, decisive in Hawaiian history, in which Kekuaokalani and many other chiefs died.

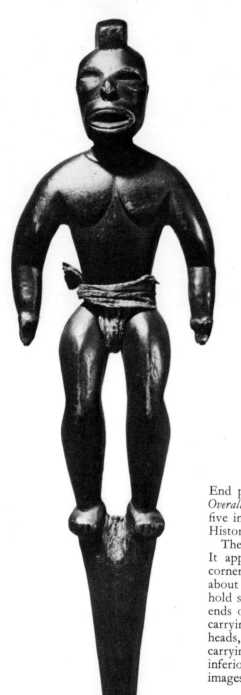

as patrons of his crafts, social status, and tribal welfare. Most other Polynesians appear less concerned with their gods. The material representatives of the Hawaiian gods are dynamic sculptures either of a free-standing type (34–36 and 276–286), or with a peg or prop at the base, such as is illustrated by this specimen. This stick god form, which may well have pre-dated the settlement of Polynesia, seems very old and presumably is from a form evolved in the island world of South East Asia. Immediate parallels to Hawaiian stick gods are best seen in New Zealand specimens. (See Barrow 1959, 1961.)

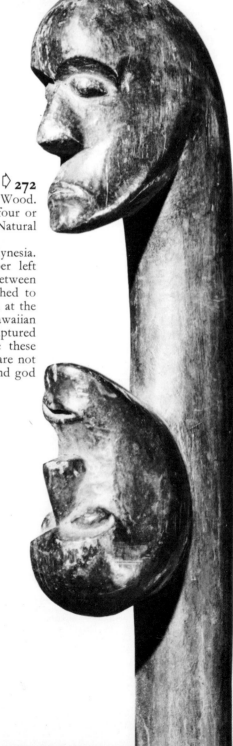

⟩ 272

End portion of a carrying pole. Hawaiian Islands. Wood. *Overall length of pole*: 64″ (163 cm), this detail being four or five inches of one end. *Collection*: Field Museum of Natural History, Chicago, Illinois. *Photo*: museum archives.

The carrying pole is a device widely used in Polynesia. It appears in the pictographic art of Tonga (upper left corner, 114). Hawaiian carrying poles range in size between about three-and-a-half to eight feet, with ends notched to hold sling cords which suspend the burdens balanced at the ends of the pole. The end notches (or knobs) of Hawaiian carrying poles are sometimes elaborated with sculptured heads, as shown here. Because of their small size these carrying-pole heads tend to be overlooked, but they are not inferior to more formal sculpture, such as ancestral and god images.

271 △
Stick god. Hawaiian Islands. Wood. Barkcloth *maro* and black pigment. *Height overall*: 16⅛″ (41 cm); *figure*: 11¼″ (28.5 cm). *Collection*: Royal Scottish Museum, Edinburgh, Scotland. *Photo*: Art Institute of Chicago.

This fine stick god, or "godstick" (as the New Zealand counterparts are called; compare 297), was collected by the Beechey Expedition in 1827. The Hawaiians were much devoted to their gods and each person held particular deities

(continued top of page).

154

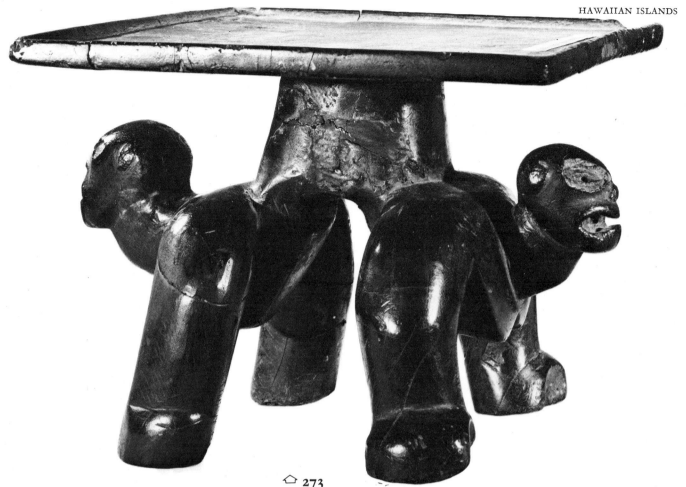

△ 273

Gaming board mounted on two figures. Kawaihae, Kohala, Hawaii. Wood. (Shell eye inlay lost.) *Length*: 12″ (30.5 cm). *Height of human figures*: 8″ (20.5 cm). *Collection*: Hawaii Volcanoes National Park (David McHattie Forbes Collection), Hawaii. *Photo*: Honolulu Academy of Arts, Hawaii.

In 1905 several old carvings were found in a burial cave which came to be known as the Forbes Cave (described by Brigham, 1906). This remarkable site, situated at the western end of the island of Hawaii. yielded a group of remarkable treasures, including this playing board, two magnificent female images (one of which is 277–78), and the bowl 274. The Hawaiians used the board in a game called *konane*, resembling the Western game of draughts, in which black and white pebbles were moved according to rules. This particular board has 156 small playing holes cut into its surface.

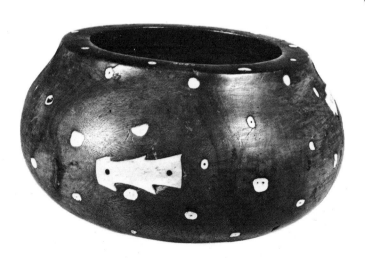

△274
Chief's scrap bowl. Kawaihae, Kohala, Hawaii. Wood. Whale tooth ivory and human teeth inlaid. *Collection*: Bernice P. Bishop Museum, Honolulu. *Photo*: George Bacon, museum archives.

The careful retention of food fragments, sputa, nail parings, hair clippings, and other personal waste, was necessary because of the possible use of such matter in black magic against those from whose person the things originated. It was believed that everything that was of the body or that had touched the body of a chief retained some of his life force (mana) and could be used by malignant sorcerers to bring illness and death. For this reason spittoon and scrap bowls were used by any Hawaiian of a rank sufficient to stir envy in either friends or enemies. Keepers were appointed by the highest chiefs to guard their bowls and to dispose of the contents secretly in appropriate places. The inlaid teeth on this bowl may be those of some slain enemy, so used to insult to the utmost the dead man as well as his living relatives. In Polynesia, revenge and insult were obligatory in certain circumstances. (See page 43.)

155

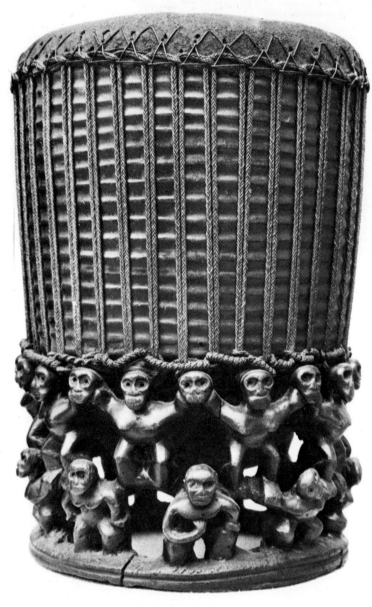

Ⓓ **275**
Drum. Hawaiian Islands. Wooden base, sharkskin drumhead with coir sennit and *olona* cord strainers. *Height*: 18½″ (47 cm). *Top diameter*: 13¼″ (33.6 cm). *Collection*: Canterbury Museum (W. O. Oldman Collection), Christchurch, New Zealand. *Photo*: author.

The dark wood of the base of this drum is finished on the outside with shallow horizontal flutings and is well polished. The resonance chamber is hollowed out in the manner of other wooden drums with diaphragms, and in addition the base stand is hollowed out also. The pierced walls of the base are sculptured into two rows of nine images set in dynamic postures. Nine additional heads appear in the upper row. This drum is a masterly demonstration of Polynesian skill with the stone adze and chisel, and of the fertile Hawaiian imagination. The Raivavaean drum 187 may be compared as a different treatment of the same traditional idea of incorporating human figures in drum stand decoration.

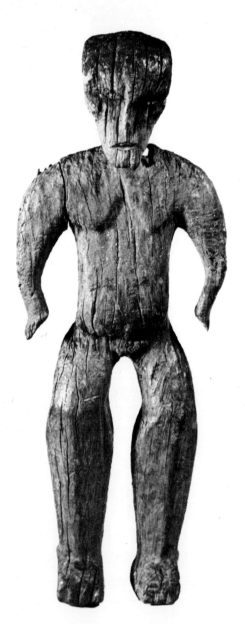

276 Ⓓ

A small image. Hawaiian Islands. Wood. *Height*: 16½″ (42 cm). *Collection*: Bernice P. Bishop Museum, Honolulu. *Photo*: George Bacon, museum archives.

This image is one of a number of figures identified as representing Kalaipahoa, the poison god of Hawaii. The reason for this identification, which may or may not be correct, is the presence of a cavity in the back said to have been used to receive the materials of sorcery. The best-known of all the so-called Kalaipahoa images, which has black lizards painted on its face (34, 35), is now in the Bishop Museum collection. (The back cavity and the lizards present a sinister combination.) The threatening and malignant expression on this small image, and its back cavity, support its identification as a Kalaipahoa.

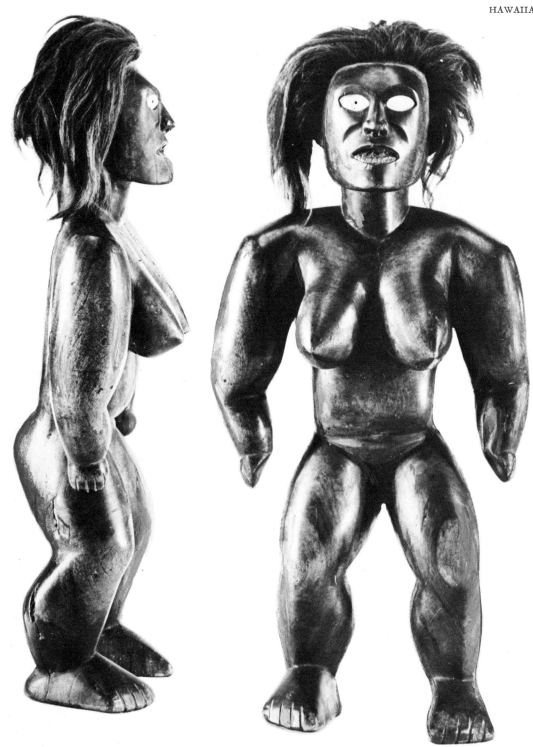

277 △

Two views of a goddess. Kawaihae, Kohala, Hawaii. Wood, shell, human hair and bone. *Height*: 28½″ (72.5 cm). *Collection*: Bernice P. Bishop Museum, Honolulu. *Photo*: author.

The discovery of Forbes Cave, described in the literature by Brigham (1906), yielded a number of treasures of sculpture, including this image and another like it which is now in the Hawaii Volcanoes National Park Museum. The gaming board 273 and scrap bowl 274 are from the same cave. Forbes Cave had been used as a burial place, and also, it would appear,

278 △

to dispose of things tabooed by missionaries. Most items were found wrapped carefully in barkcloth, as was the custom. Brigham (1906) called this image and the second "household deities". However, their exact identity and function are not known. The modern fashion is to identify them with Pele, the fearsome goddess of fire and volcanoes, for no other reason than that they are female and that Pele is popular. This wooden image has the added features of human hair, attached in tufts to the scalp with the usual device of closely-spaced small pegs, and a bone plate inset into the mouth and grooved to imitate the lower incisor teeth.

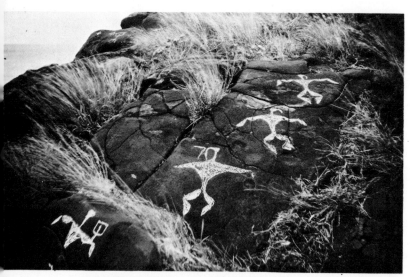

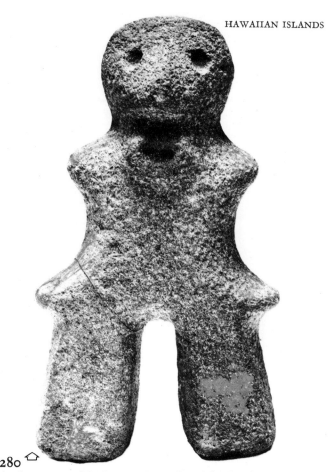

279 ⬦

Petroglyphs depicting birdmen (*in situ*) at Kaunolu, Lanai, Hawaiian Islands. *Photo*: Kenneth P. Emory, Bernice P. Bishop Museum archives, Honolulu.

The individual figures on this engraved rock were marked by white chalk for photographic clarity. Rock engravings, formed by bruising the surfaces of vesicular lava rock with hammer stones, are found throughout the Hawaiian Islands. The subject matter of petroglyphs is diverse, including men in various acts, birds, birdmen, dogs, lizards, turtles, canoes, canoe sails, human feet, and abstract patterns which may or may not have had representational meaning to the Hawaiians who created them. As sailing ships, horses, goats, guns, and European letters make their appearance, we have confirmation that petroglyphic art persisted into the historic period of the Hawaiian Islands.

Petroglyph "fields" occur in greatest concentration at resting or camping places on trails; however, they appear sporadically also. Some pictographs are said to represent local spirits or godlets, as is believed the case with these dancing birdmen of Kaunolu, while some (especially circles) are thought to relate to the ritual disposal of the umbilical cord. As Hawaiian traditional life was immersed in the occult, we may assume that many petroglyphs had magical uses while others were mere personal *graffiti*.

280 ⬦

Anthropomorphic image. Hawaiian Islands. Stone. *Height*: about 11″ (28 cm). *Collection*: Bernice P. Bishop Museum, Honolulu. *Photo*: author.

This small image, probably the material vehicle of a god, has sculptural values similar to the fish god 281, and represents Polynesian stone forms having tremendous appeal to the modern eye. There are several traditions of Polynesian stone sculpture (for example, that of Necker Island 283–85), in which elements of the old Pacific artistic styles are echoed. Similar images, concepts and taste are found in South East Asia.

281 ⬦

Fish god. Hawaiian Islands. Stone. *Height*: 5¼″ (13.3 cm). *Collection*: Bernice P. Bishop Museum, Honolulu. *Photo*: author.

Stone fish gods are thought to represent Kuula, the Hawaiian fish god. The simple form of this example, comprising only a body with knobs for fins and tail, is to modern eyes a most satisfactory piece of abstract sculpture in its own right. To the ancient fisherman, however, it served not as an object of art but as a place to accommodate a helpful spirit. Fishing was a vital activity in the Polynesian economy and was thought to require the protection and aid of magic.

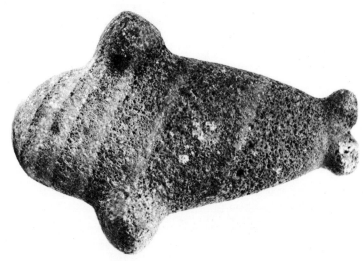

282 ⬦

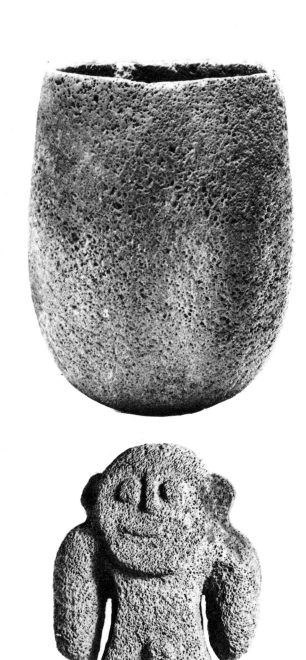

Bowl. Necker Island, Hawaiian Islands. Vesicular basalt. *Height*: 9″ (23 cm). *Collection*: Bernice P. Bishop Museum, Honolulu. *Photo*: author.

The technical skill required to make this thin-walled bowl from a small basaltic boulder and the patience needed to endure long hours pecking away with a small hammer stone can hardly be comprehended by wage-earning workers in an industrial society. We can, however, be reasonably sure that the craftsman chose stone instead of wood as a bowl material because suitable wood was not available on Necker Island. This remarkable bowl was collected by the Tanager Expedition, 1923–24. Like the stone images of Easter Island it is a product of the environmental restriction of available raw material rather than of complete freedom of selection of material on the part of the craftsman.

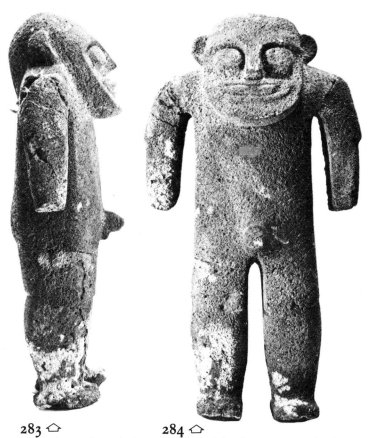

283 △ **284** △

Two views of a male image. Necker Island, Hawaiian Islands. Vesicular basalt. *Height*: 14½″ (37 cm). *Collection*: Bernice P. Bishop Museum, Honolulu. *Photo*: author.

This image was collected in 1923 when a US Navy minesweeper visited the island on survey work (Emory, 1928). Necker stone images were made by the usual stone hammer-pecking technique, followed by the surface grinding of some types. Two complete specimens in the Bishop Museum collection have the surfaces ground, while the other two complete specimens, in the British Museum, have rough surfaces. All known images are of male sex. Their remarkable formal abstraction of limbs, torso, and head is reminiscent of ancient Japanese art styles of Jomon or Haniwa (compare the stone figure 280), and it is proposed elsewhere (page 60) that such resemblances emerge from relationships in ancient Asia.

285 △

Male image. Necker Island, Hawaiian Islands. Vesicular basalt. *Height*: 11¾″ (30 cm). *Collection*: British Museum, London. *Photo*: author.

This image was collected by officers of HMS *Champion*, which called at the island in 1894. The image style of Necker Island, distinctive in its own right, appears to have two basic types of figure: one that is of slim form with ground surfaces and thus sharper features (283–84), and a second with surfaces unfinished and of a broad flat form resembling a gingerbread man (285). All images collected appear to be associated with a temple and would seem to represent gods rather than ancestors.

 286

Temple image. Honaunau Bay, Hawaii. Wood. *Overall height*: 52½″ (133 cm). *Collection*: Field Museum of Natural History (A. W. F. Fuller Collection), Chicago. *Photo*: museum archives.

This image and a twin figure commonly known as the Bloxam image in the Bishop Museum, differ from conventional Hawaiian images in having the arms extended outwards rather than hanging pendant. Also, the style of head is unusual. Both images are believed to have been collected from the temple and royal mausoleum of Hale-o-Keawe (shown in its early nineteenth-century condition 15, and in modern restoration 13) during the visit of Captain George Anson Byron in HMS *Blonde* in 1825. The association of this image with Hale-o-Keawe is a reasonable assumption, and Buck (1957) suggests it is the second of a pair known to have been seen on the visit of Captain Byron to Hale-o-Keawe. Although Polynesians were never inclined to "matching pairs", these carvings seem to present the exception to the rule. The Fuller image has on its surfaces crisp adze marks, while some of the more protected parts that have not been stained by human handling, for example under the arms, have a fresh-cut appearance which aroused the author's quiet suspicions when he first viewed the image in the London home of Captain Fuller in 1956. However the image is undoubtedly authentic, and its association with Hale-o-Keawe is a safe assumption. The provenience is here accepted as Honaunau Bay.

287

Detail of a barkcloth sheet stamped with the sea-urchin motif. Hawaiian Islands. *Collection*: Bernice P. Bishop Museum, Honolulu. *Photo*: museum archives.

The abstract patterns of Hawaiian barkcloth are occasionally named from real or fanciful association with natural forms. Few designs show such clear derivation as this sea-urchin pattern. The motif itself is stamped on the cloth in a manner comparable with 48, and in contrast to the impressing of pattern 288.

288

Detail of a barkcloth sheet of rectilinear design. Hawaiian Islands. *Collection*: Bernice P. Bishop Museum, Honolulu. *Photo*: author.

The design of this sheet was stamped on to the plain base cloth, using stamps and a red-brown pigment. It is not a drawn pattern. Some bamboo markers have multiple nib-like ends, which suggests that they are used as pens; in practice, however, their tips are dipped repeatedly into pigment then impressed on the cloth, thus extending a linear pattern little by little.

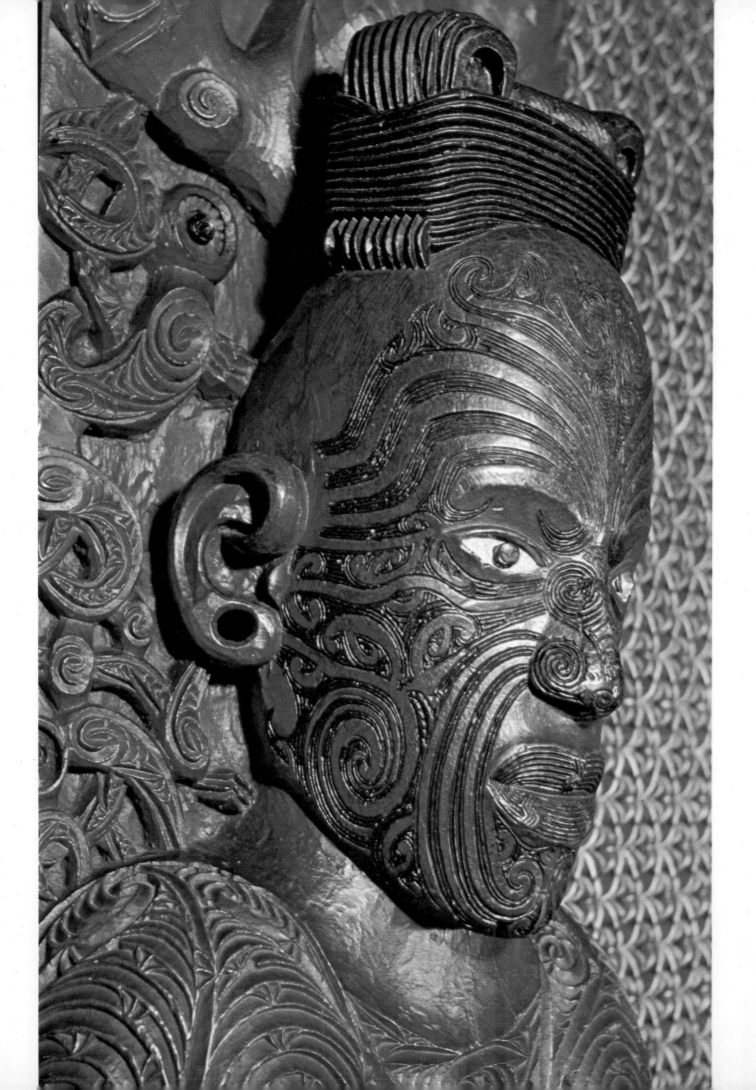

New Zealand has a unique place in Polynesia for several reasons. Its land area of over 100,000 square miles is vast by Oceanic standards, and all other Polynesian islands could be contained within its three main islands (North Island, South Island, and Stewart Island). Offshore islands are numerous. The geology is diversified, with rich resources of stone suitable for implements. A forest well-stocked with birds and bush, and foods and seafoods from extensive coastal reaches presented an abundance of a kind not before encountered by Polynesians. For over a thousand years descendants of the early settlers experimented with the new environment,

with impressive results. The adaptation of a Polynesian culture to the New Zealand environment is one of the most remarkable achievements of the Polynesian saga. Ornamented houses, massive canoes, carved storehouses, exquisite ornaments, and beautiful garments are among the remarkable products of the Maori people. The southernmost outpost of Polynesia, New Zealand lies within temperate latitudes where cold winters are normal, and this seems to have an invigorating effect on the migrants from tropical latitudes. Climate, land mass, and rich resources especially wood, were the determinating factors of New Zealand's old-time Maori life.

◊ **289** **290** ◊

A portrait figure. Manutuke, Gisborne, New Zealand. Wood with shell inlay. Red and black paint. *Overall height of image*: 44″ (112 cm). *Collection*: Dominion Museum, Wellington, New Zealand. *Photo*: museum archives. *Colour detail*: author.

This image, one of the best known of Maori carvings, is situated on the left immediately inside the entrance door of the ceremonial house Te Hau-ki-Turanga, which is now located in the Dominion Museum, Wellington. A history of this house is available as a Museum guide (Barrow, 1965). The figure portrays the carving master Raharuhi Rukupo, who built Te Hau-ki-Turanga with a team of about eighteen carvers. The house was erected after about eighteen months' work early in the 1840s. Raharuhi Rukupo belonged to a group of early nineteenth-century carvers who looked back to apprenticeship with old masters who had been soundly trained to work with stone tools. (It must be kept in mind that the ceremonial house as we know it today is a post-European innovation.)

The restraints of old traditions are carried over in Te Hau-ki-Turanga. Much of the carved work of the time expresses this same spirit of old ideas combined with the technical advantage of steel tools and the new enthusiasms.

The head of Raharuhi Rukupo is rendered large because of the importance of the head in Maori belief. (See page 50.) Precise tattoo is marked in the face, and we may assume that it is the individual tattoo of the man. The Maori regarded tattoo patterns as a ready means of identification, and someone being sought was sometimes described in terms of the details of his facial tattoo. The adze of authority held in the hand may be compared with 296. The squared arrangement on the crown represents long hair tied into the customary topknot.

291 ▷

A scene in a Maori village of the 1840s. Wanganui, New Zealand. The illustration is a lithograph from an oil painting by the settler-artist John Alexander Gilfillan. Storehouses on posts, dwelling houses, and defensive stockade surround this busy scene of communal domestic life. *Photo*: Alexander Turnbull Library archives, Wellington, New Zealand.

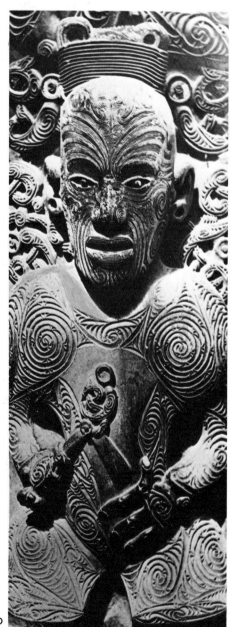

290

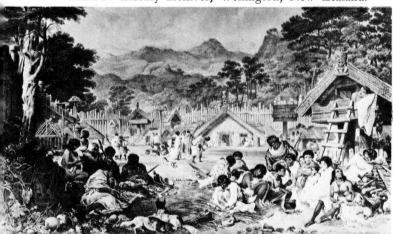

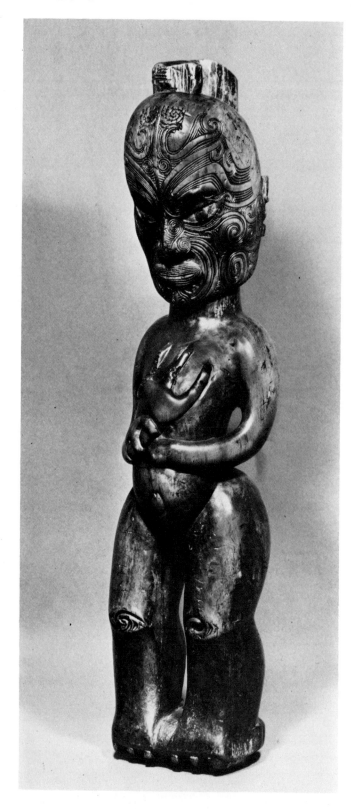

Ancestral image from the base of a ridge support post. Gisborne district, New Zealand. Wood. *Height*: 25½" (65 cm). *Collection*: Royal Scottish Museum, Edinburgh, Scotland. *Photo*: Tom Scott, museum archives.

Museum records indicate that this small yet powerful figure was received from the Society of Antiquaries of Scotland, to which it had been presented by Walter Lorne Campbell in 1873. European culture was introduced into New Zealand via seamen, missionaries, soldiers, and settlers; thereafter, towns, timbermills, new tools and architectural ideas stimulated Maori communities to build large meeting-houses on their own account. Support figures, traditionally incorporated into the base part of ridge support posts, increased in size. Post images of the contact period range in size from about eighteen inches to about three feet. By the mid-to-late nineteenth century post images set in the largest houses had in some instances reached a height of about six feet.

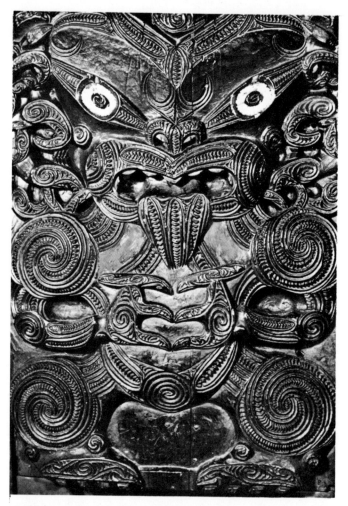

293 ⬠

Interior house panel. Manutuke, Gisborne, New Zealand. *Height*: 27" (68.6 cm). *Collection*: Dominion Museum, Wellington, New Zealand. *Photo*: author.

This panel, which illustrates the Maori craftsmen's skill in adapting human form to a panel, is from the house Te Hau-ki-Turanga. (Compare 289-90). It provides a striking contrast with the portrait image of Raharuhi Rukupo. The differing treatment of the images within the same house illustrates the extremes of the naturalism and formalism of Maori wood sculpture of the period.

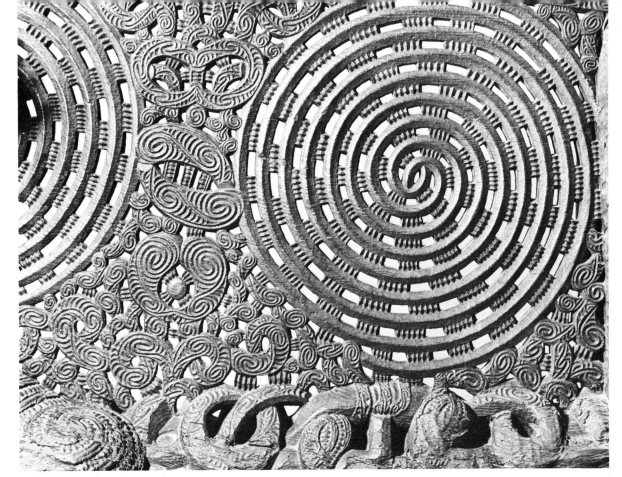

294 ⬆

Detail from a canoe prow. New Zealand. Wood. *Diameter of large spiral*: 15″ (38 cm). *Collection*: Taranaki Museum, New Plymouth, New Zealand. *Photo*: author.

The prow from which this detail was photographed is from a canoe which was active in raids and warfare on the west coast of the North Island of New Zealand around the 1840s. The carving precision seen here is a product of metal tools, but the arrangement of figures is traditional. Between the spirals there is a highly conventionalised human image, above and below which are located beaked *manaia* figures. (See page 54.) The entire vertical composition of the prow surmounts an image lying on its back. The separation of motifs in Maori wood carving is aided by eliminating from consideration the connecting chocks, which are used to strengthen pierced work. These chocks are not an intrinsic part of the associated motifs, although they sometimes enhance the general design. Here the chocks are clearly to be seen holding apart the two elements of the large double spiral.

295 ⬇

Treasure box (for view of the lid see 37). Wood. *Length*: 39″ (99 cm). *Collection*: Peabody Museum, Salem, Massachusetts. *Photo*: author.

This splendid box, of a type termed *wakahuia*, was designed for the storage of precious ornaments of feather or jade and is of sufficient size to accommodate large objects such as jadeite weapons. There is no class of artifact in Polynesian wood carving that presents for study a greater diversity of local style and of individual variation than do these treasure boxes of New Zealand. Fortunately, they have been preserved in considerable numbers. An unusual feature of such boxes is that they are well-decorated on the underside, which may be explained by the simple fact that they were usually suspended from rafters and thus commonly viewed from below.

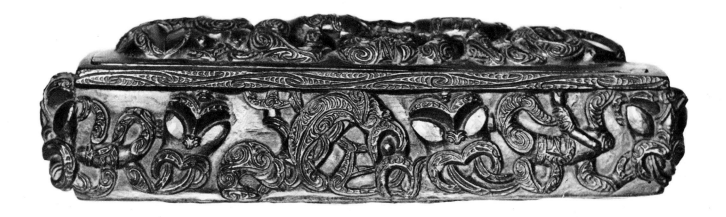

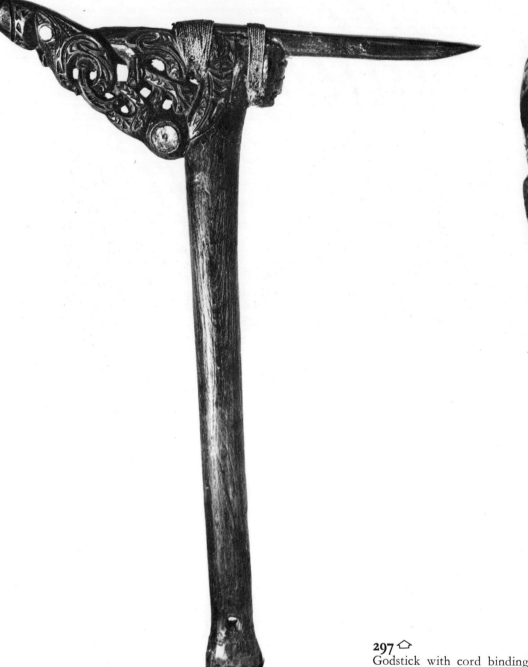

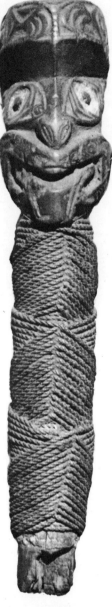

296 ⌂
Adze of chiefly power. New Zealand. Wood, nephrite blade, flax fibre lashings. *Length from heel to pommel*: 16⅛″ (41 cm). *Collection*: Ethnographical Museum, Basel, Switzerland. *Photo*: author.

Batons of this type, termed *toki-pou-tangata*, were used by Maori chiefs when delivering orations and when exercising authority, such as directing attack or defence. They are reported to have been used at times to kill prisoners of rank deemed sufficient to deserve such an honour. Ceremonial adzes that were carried as symbols of prestige and of the gods are known from several parts of Polynesia, notably in the Cook Islands. (Compare 222, and refer to page 58-9.) It should be remembered that the adze of Polynesia was not, as is commonly held by popular fancy, a battleaxe. An adze was an implement of work and was the basic tool of the Polynesian craftsman.

297 ⌂
Godstick with cord binding on the shaft. Waimate Plain, Taranaki, New Zealand. Wood, flax fibre, shell inlay. *Height*: 9⅝″ (24.5 cm). *Collection*: Auckland War Memorial Museum, New Zealand. *Photo*: author.

This godstick was collected in the 1840s by the catechist William Hough, who recorded it as representing the war god Maru. New Zealand godsticks are rare in collections, for they were disposed of when their owners embraced Christianity. They were "offensive", in contrast to the inoffensive ancestral images that form the bulk of Maori carved images, because they represented Maori gods. After long search the author was able to locate twenty-seven, which he described (Barrow, 1959, 1961). The Maori godstick has interesting comparative forms in Hawaii (271) and the Cook Islands (210). Maori godsticks were not regarded as effectual until they were painted with ochre, bound with cordage, and dressed with red feathers. The absence of the coconut palm in cool New Zealand required the substitution of the coir sennit, and this was found in the leaf fibre of the indigenous flax plant (*Phormium tenax*).

166

298 △

A female crop god. Taranaki, New Zealand. Volcanic rock. *Height*: 20″ (51 cm). *Collection*: Taranaki Museum, New Plymouth, New Zealand. *Photo*: author.

The form of this image was influenced by a number of factors: the size and shape of the raw boulder selected, local traditions of stone working, the style of Taranaki wood-carving art (the head and hands of this god reflect local carving conventions), and the technique of manufacture by pecking and bruising with hammer stones. Such images were placed in or near cultivation patches to protect growing plants against calamity and to promote fertility. (See page 40.)

299 ◁

Crop god. Taranaki, New Zealand. Stone. *Height:* 24″ (61 cm). *Collection:* Taranaki Museum, New Plymouth, New Zealand. *Photo:* museum archives.

Double-faced guardians of gateways are found in many parts of the Pacific. They seem to belong to an ancient Oceanic tradition of art, but in Polynesia they are encountered only sporadically, namely in the Society Islands, Marquesas, Easter Island and New Zealand. They are of course unlike the double-headed images (e.g. Tahiti, 166), which are exceedingly rare.

300 ▷

Crop god. Maketu, Bay of Plenty, New Zealand. Pumice. *Height*: 5⅞″ (15 cm). *Collection*: Bernice P. Bishop Museum, Honolulu. *Photo*: author.

The museum record with this specimen says that it was dug up with a mass of bones which it suggests were those of slaves sacrificed in the cause of crop fertility. This small image is certainly of the crop god class, indicating that it was placed with crops to protect them from harm. (Compare 298–99.) The pumice material used is soft and friable but durable if left undisturbed and dry. Generally pumice images tend to lack a fixed form. They are often suspect, because the ease with which pumice can be cut and the amorphous nature of genuine pumice specimens have frequently tempted forgers to use this material.

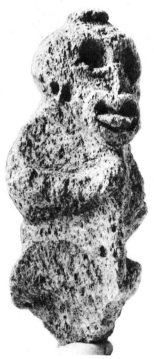

167

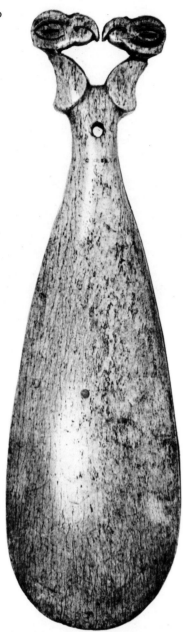

301 ⬡

Short club. New Zealand. Whalebone. *Length*: 19¾″ (50 cm). *Width of blade*: 5¾″ (14.5 cm). *Collection*: Cambridge University Museum of Archaeology and Ethnology, England. *Photo*: author.

Whalebone was a much-favoured material for making several types of short fighting clubs. This magnificent example, with opposed birds at the butt end, has on it an old label which reads: "Bone meri (*mere*) with bird heads. Deposited by the Master and Fellows of Jesus College, Cambridge, 1887." No exact early history has been established for this specimen, but there is a good probability, in view of its qualities and the rich Cook collections in Cambridge, that this hand club was collected on one of the voyages of Captain Cook. Clubs of this type were not bludgeons but "knife-clubs," if the term may be coined. The most effective part of this weapon is the sharp end of the spatulate blade, which was used in jabbing and slicing. A firm wrist thong, made from a strip of dogskin which passed through the hole in the grip section, was used to help prevent the weapon from sliding back in the hand when a thrust hit home.

302 ⬡

Short club. Hokio Beach, Wellington Province, New Zealand. Wood. *Length*: 16¼″ (41.2 cm). *Collection*: Dominion Museum, Wellington, New Zealand. *Photo*: author.

The author has previously described this fascinating hand club (Barrow, 1963 and 1969). The circumstances of its collection is typical of the kind of chance recovery often associated with rare old carvings. In 1963 a local schoolboy came to the author's office at the Dominion Museum in Wellington with this club wrapped in brown paper. He had discovered it while hunting rabbits along beaches where small streams emerge from swampy areas behind sandhills. One of these streams drains Lake Horowhenua, which has over the years yielded many prehistoric artifacts from its muddy bottom. This club appears to have been washed out of the lake and come to rest on the beach sand where it was found. The relationship of old New Zealand style to that of Easter Island sculpture is made clear by comparison.

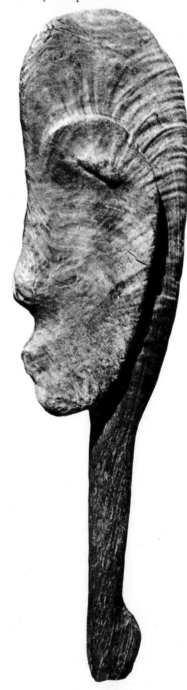

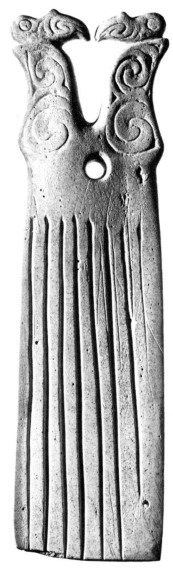

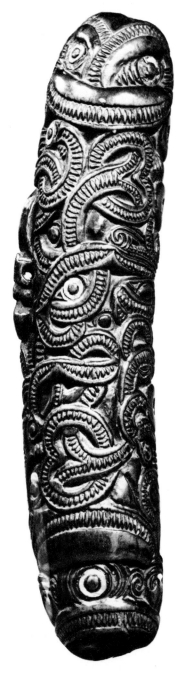

304 ▽

Short flute. New Zealand. Wood with shell inlay. *Length*: 7½″ (19 cm). *Collection*: Mr and Mrs Raymond Wielgus, Chicago, Illinois. *Photo*: Raymond Wielgus.

Flutes of the *koauau* type, of which this is a good example, are simply hollow tubes drilled with three stops on one side. They are usually equipped with a central suspension hole drilled through a small lug so that they could be worn around the neck as personal adornment and be on hand for ready use. Both upper and lower ends are decorated with a type of Janus double-mask (as with 41), the openings of the flute forming the mouth parts of respective heads. The rounded body and slight curve and the treatment of the ends indicate that the maker gave this flute phallic form. The chance to add an overtone of the virile symbolism, whether to flute bailer, or pounder (39), appears to have been welcomed by the old time Maori craftsmen. (See page 57.)

303 ⬠

Amulet in form of a comb. Otara, New Zealand. Whalebone. *Length*: 6¼″ (15.8 cm). *Collection*: Dominion Museum (Bollons Collection), Wellington, New Zealand. *Photo*: museum archives.

The ornament is recorded as having been collected at Otara, a coastal site that has yet to be identified. Polynesian artifacts often exhibit features not readily paralleled by other specimens of the region concerned. This does not mean the particular artifact is unique, but it may indicate that it is the only survivor of a kind. This object is in this class. It is conventionally regarded as an unfinished comb. The author agrees that it is in the form of a comb but believes it is an amulet for the following reasons: the grooves cut into the surface are uneven and would appear merely to represent teeth; there is a drilled hole below the birds, designed to take a neck suspension cord; and there is a significant small hole at the lower right corner. This may at first appear to be a natural nerve channel in the bone; however, close examination reveals it to be drilled and probably intended for the attachment of a small bundle of feathers. Bundles of feathers were commonly attached as ornamentation to many things. The style of the work is archaic and reminiscent of the art styles of ancient Asian cultures. (See page 60 and compare the various illustrations 79–89.)

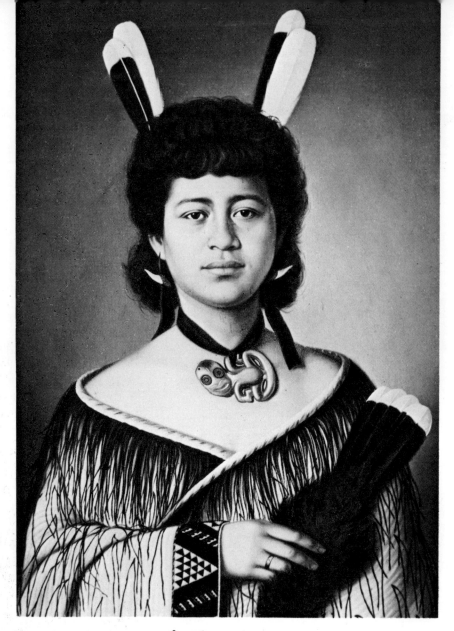

⇧ 305

306 ⇩

An oil portrait of Ruruhira Ngakuira by Gottfried Lindauer. *Collection*: Wanganui Public Museum, New Zealand. *Photo*: museum archives.

Lindauer, an immigrant into New Zealand from Bohemia, painted numerous Maori portraits from the mid-1870s on into the twentieth century. His precise painting of dress, ornament, and tattoo gives his Maori portraits value as ethnographical records quite apart from their distinct merit as works of art. A fine selection from the Partridge Collection of Lindauer paintings, Auckland, was recently published (Graham, 1965). This noble young woman wears a flax fibre coak with *taniko* border (compare 306), nephrite *hei-tiki* (see 307–9), and shark-tooth ear ornaments. In her hair she wears tail feathers of the now extinct *huia*, an unmounted skin of which she holds in her hand. The place of this bird in Maori culture and the sad story of its extinction is told by Phillipps (1963).

Section of a flax fibre garment showing part of a *taniko* border pattern and a small area of the undyed body of a cape. *Collection*: Dominion Museum, Wellington, New Zealand. *Photo*: New Zealand Tourist and Publicity Department, New Zealand.

The borders of certain Maori cloaks are decorated with narrow to wide bands of weaving, termed *taniko* (sometimes spelt *taaniko*, after a form of modern spelling of Maori which indicates long vowel sounds by a doubling of a letter of the vowel concerned). *Taniko* is not made by a true weaving of the warp and woof method. It is more correctly a technique of making cloth by a multiplicity of turns and knots according to the formulas worked out for various simple or complex geometric patterns. The fibre used for *taniko* and for the body of capes is secured from the leaf of the indigenous flax (*Phormium tenax*), and coloured dyes are made from vegetable materials. Black is secured by the immersion of fibre hanks in swamp mud. This beautiful textile art may be studied from classical beginnings to present-day use, as it is a living Maori art. *Taniko* has been subject to change with the passage of time. Early post-contact modifications arose through the overworking of old patterns with imported coloured threads, using imported steel needles (Barrow, 1962). *Taniko* technique, ancient and modern, has been described with detailed practical instructions (Mead, 1968).

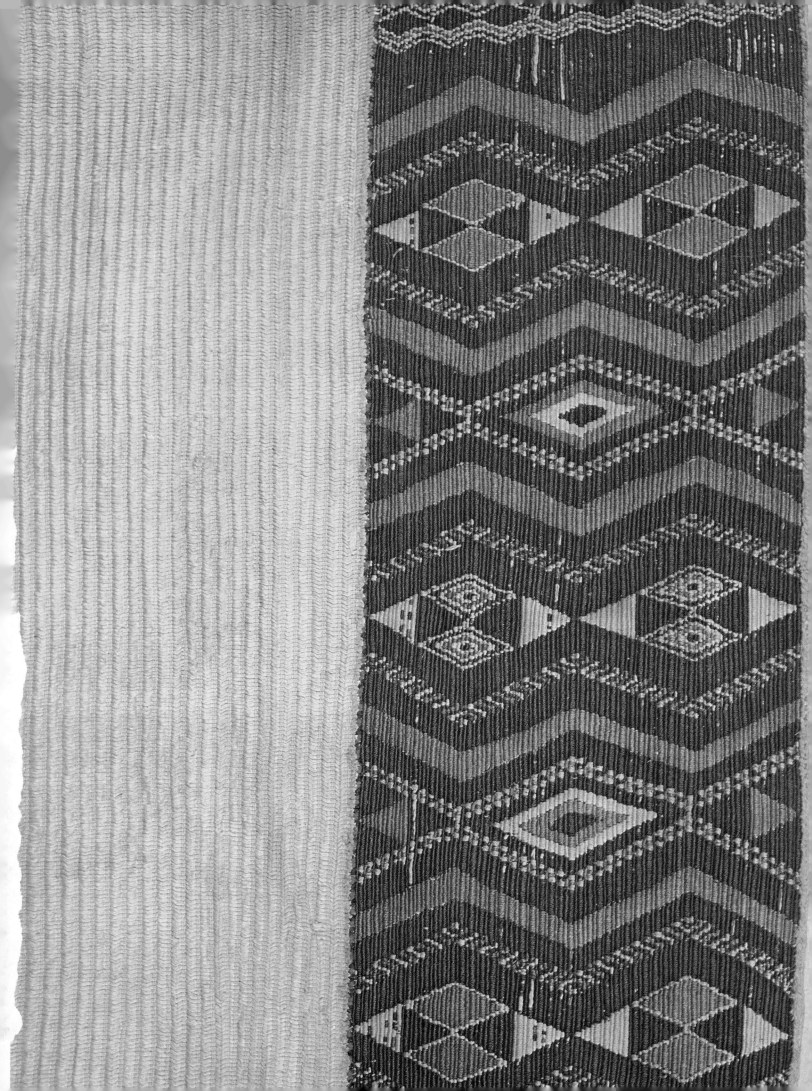

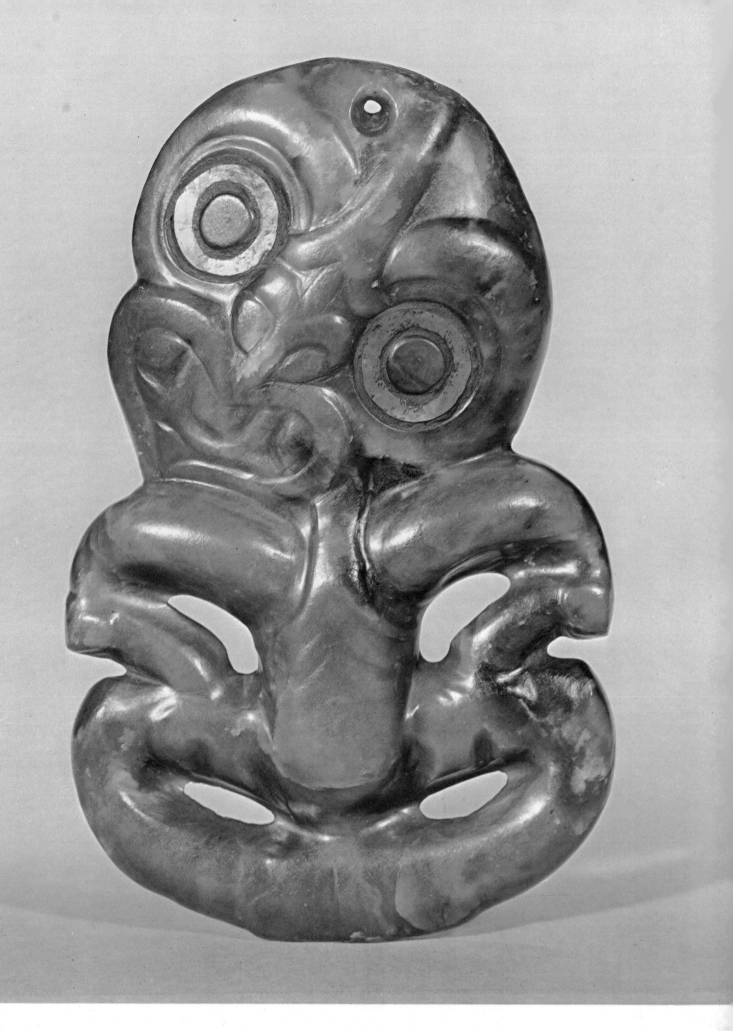

307

Ancestral pendant of *hei-tiki* type. New Zealand. Nephrite, shell inlay, traces of red ochre. *Height*: 9″ (23 cm). Reproduced life-size. *Collection*: Mr and Mrs Raymond Wielgus, Chicago, Illinois. *Photo*: Art Institute of Chicago.

This magnificent *hei-tiki*, one of the largest in existence, was shown to the author in London in 1956 by the sculptor Sir Jacob Epstein, who regarded it as a principal item in his distinguished collection. The author next had the pleasure of handling it in 1969 in the Chicago home of the present owners. *Hei-tiki* have many fallacies surrounding them; for example, they are often said to represent the human embryo and they are generally regarded as exclusively an ornament of women. In fact, they first represented ancestors and contained the mana of former owners. They were given personal names and were regarded as family heirlooms. The form is usually related to wood-carving conventions adapted to the intractable nature of the extremely hard material.

Nephrite was worked only by abrasion, with water, sand, and sandstone. A single average-size *hei-tiki* required many hundreds of hours of hand labour, although the time involved has been exaggerated in modern times. Colour in *hei-tiki* and other jadeite ornaments varies from a dark greenish-black through a range of leaf-green hues to a milky-white celadon. Adzes were often converted into *hei-tiki* in post-contact times after steel tools made stone obsolete and when the demand for trade curios became intense. Many *hei-tiki* reveal by their shape that they were made from an adze.

309

Ancestral pendant of *hei-tiki* type. New Zealand. Nephrite, shell inlay. *Height*: 6⅝″ (16.8 cm). Reproduced life-size. *Collection*: Cambridge University Museum of Archaeology and Ethnology, England. *Photo*: author.

This *hei-tiki* is comparable with 307 in terms of its big size. Regarding comparison of style, it has clearly delineated details, whereas the Wielgus item has a more modelled sculptural quality. Both *hei-tiki*, however, are superb and beyond comparison as to superiority or inferiority. One figure has its head resting on the left shoulder (307), while the other has its head resting on the right (309). An examination of eighty-five finished *hei-tiki* in the catalogue (Webster, 1948) of the K. A. Webster Collection (now scattered) shows that twenty-four have the head on the left shoulder, while fifty-eight have the head on the right shoulder. This gives an idea of relative proportions. There seems to be no reason why one position is favoured over another. Three Webster *hei-tiki* have a face on both sides, so the head is on the right shoulder on one side and on the left shoulder on the other.

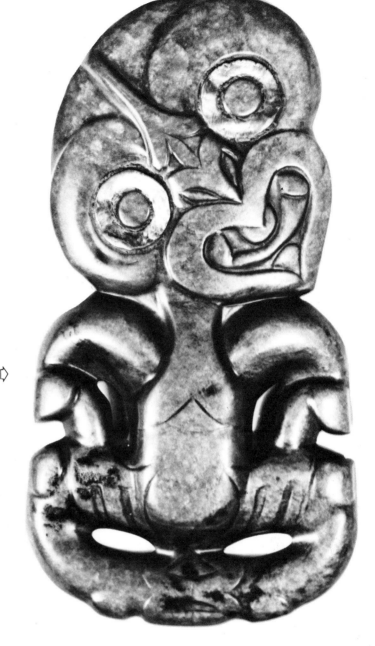

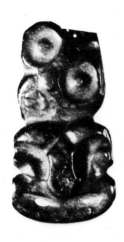

308

Small ancestral pendant (*hei-tiki*). New Zealand. Nephrite. *Height*: 2⅛″ (5.4 cm). *Collection*: Dominion Museum, Wellington, New Zealand. *Photo*: author.

This small *hei-tiki* of dark green hue is introduced here to illustrate one of the smallest representatives of this type of amulet for comparison with two of the largest (307 and 309). To give an impression of the small size the author placed a New Zealand half-crown next to the specimen. (The photograph was taken in 1961, before the conversion in New Zealand to dollar currency.)

173

The Chatham Islands (chiefly comprising Chatham and Pitt Islands) lie about 470 miles due east of Banks Peninsula, South Island, New Zealand, and are part of New Zealand territory. The original Polynesian settlers, termed Moriori, are extinct as a distinctive group; survivors of the original stock have inbred with the mainland Maori invaders who in 1835 overran the local population, causing bloodshed and slaughter. Chatham Island and the adjacent Pitt Island range within fifty miles of longitude, and are generally exposed to the strong western winds encountered in these latitudes of the South Pacific. The climate is described as "windy, damp and cool", with a mean annual air temperature of about 50 degrees. This is below the

comfortable level for Polynesian conditions of life. Until definition of Chatham Island culture by the researches of Skinner (1923), the Moriori were regarded as a people more Melanesian than Polynesian. The Moriori were indeed descendants of tropical Polynesian ancestors who had found and settled these islands, probably by way of New Zealand, and who made the best of an uninviting environment. The presence of a schist rock provided material for heavy weapons of fascinating forms, while the abundant groves of *kopi* trees (*Corynocarpus laevigatus*) yielded berries and wood. The slow-growing bark of the *kopi* trees provided a "canvas" for a dendroglyphic art unique in Polynesia.

310 ⬦

Male image. Chatham Islands. Pumice. *Height*: 7¼″ (18.5 cm). *Collection*: Cambridge University Museum of Archaeology and Ethnology, England. *Photo*: author.

This pumice image, which resembles certain Maori crop gods and Tahitian stone images, was presented to the museum by Lord Stanmore in 1893. The arms appear to emerge from or enter into the mouth as a divided tongue (a divided tongue is seen in Maori wooden masks), brow ridges are typically arched (compare 318), and the umbilicus is indicated by a knob. The use of pumice as an image material was customary in New Zealand but is recorded from the Chatham Islands by only a few rare specimens. (Compare 311.)

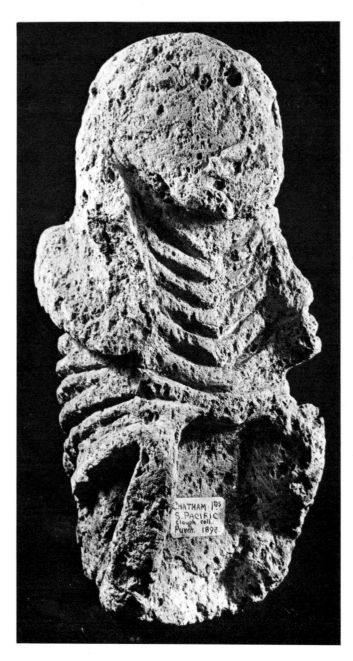

311 ⬦.
Squatting figure. Chatham Islands. Pumice. *Height*: 10¾″ (27.3 cm). *Collection*: Pitt Rivers Museum, Oxford, England. *Photo*: author.

The style of this figure relates immediately to the sole surviving Chatham Island free-standing wooden figure (313–15). Its squatting position represents a rare but basic posture of Polynesian iconography. (See page 55.) The strongly-defined ribs appear as a distinctive Chatham Islands convention in rendering the figure. (Compare the wooden figure, and 317.)

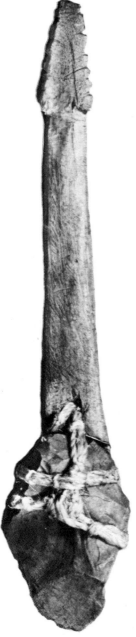

312 ⬦
Flint blade and haft. Chatham Islands. Chert, wood, flax fibre. *Length*: 11″ (28 cm). *Collection*: Dominion Museum, Wellington, New Zealand. *Photo*: author.

Roughly-flaked stone blades of a consistent form are found in many parts of Polynesia. One basic type is conventionally termed *mataa* and is found in considerable numbers in the Chatham Islands, southern New Zealand, and Easter Island, where obsidian is the favoured material. The form is typical. Above the cutting edges the blade has a tang (which may amount to nothing more than a rough projection), which facilitates the lashing of the blade to the wooden handle. This Chatham Island specimen illustrates one method of doing this.

Front
313 *Back*
314 *Side*
315

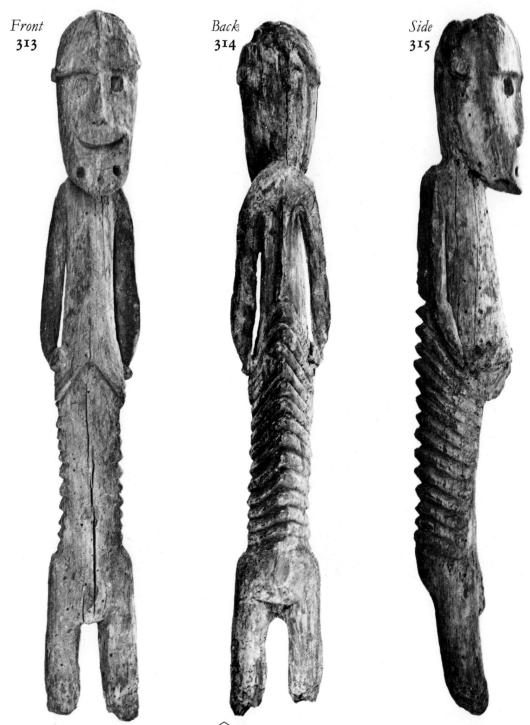

313 ⬆ ⬆ **314** ⬆ **315**

Three views of a male figure, Chatham Islands. Wood. *Height*: 41¾″ (106 cm). *Collection*: Auckland War Memorial Museum, New Zealand. *Photo*: author.

Skinner (1923) provides the interesting history of this image. It appears that the collector was T. Ritchie, who, after hearing the local people say that there were *atua* (gods or spirits) in the bush, prevailed on the Maori husband of a Moriori woman to show him where these *atua* were to be found. In consideration of some pounds of tobacco the Maori guided Ritchie to a Moriori burial ground, pointed out a figure, then ran away. The figure is the one here illustrated. Apparently it had stood upright in the earth until the feet had rotted away. Fortunately when it fell it had come to rest against a nearby tree, saving it from full earth contact. The figure had a name, but Ritchie could not secure it. Presumably an ancestor is represented. The figure resembles the highly-finished images of Easter Island (compare 242) and thus provides yet another link between these two areas.

316 ⬡
Dendroglyph motifs. Chatham Islands. *Left*: A group of three anthropomorphic stick-figures, one of which is in profile and headless. *Overall height of cluster*: 44″ (112 cm). *Right*: A single figure with heart-shaped face and clearly defined ribs. *Height*: about 36″ (about 91 cm). *Drawing:* author.

Both of these illustrations are from Christina Jefferson's intensive study of Chatham Islands tree carvings, published in the *Journal of the Polynesian Society* (Jefferson, 1955). The term dendroglyph is derived from the Greek (*dendron*, tree; *gluphe*, carving), and means, simply, carvings on trees. In the impoverished environment of the Chatham Islands the most remarkable art form to emerge was that of the scraping and

317 ⬡
cutting designs on the living bark of the slow-growing *karaka* (*Corynocarpus laevigatus*), a tree known locally as *kopi*. As the only large tree in the island it was of special importance in several respects, especially for its abundant yield of berries in due season. The dendroglyphs are usually concentrated in thick groves of trees with the human form predominating as a subject. The skeletal figures suggest death and ancestral spirits rather than gods. The Moriori referred to these carvings as "birds". As birds and spirals were intimately associated in Chatham Islands culture the expression is understandable. (For the general relationship of birds and spirits in the Pacific, see page 54.)

318 ⌂
Short club. Chatham Islands. Schist rock. *Length*: 13″ (33 cm). *Collection*: Canterbury Museum, Christchurch, New Zealand. *Photo*: author.

The brow ridges and vertical bar representing a nose that are present on this club signify a Chatham Islands artistic convention of rendering the face that is exactly paralleled in Easter Island. (Compare 247–52). The bone specimens of the Chatham Islands (320–21) have, in addition to brow ridges , tongue and teeth. The *patu* blade itself can represent the tongue, as noted in relation to 319.

319 ⌂
Short club. Chatham Islands. Schist rock. *Length*: 13″ (33 cm). *Collection*: Hawke's Bay Museum, Napier, New Zealand. *Photo*: author.

Without corroborative evidence it would be unreasonable to regard the form of this club as basically anthropomorphic. The identification of the form with 318, which has nose, eyebrows, and teeth, suggests that this club represents a human face also. The blade of this type represents, in the author's opinion, an out-thrust tongue. (For the significance of this, see page 55.)

178

The concealed presence of anthropomorphic and reptilian forms in Pacific weapons has been perceptively revealed by the researches of Skinner (1964). This short club comprises a human face (brows, lips, teeth, and tongue), while the grip and pommel represent a penis. Tongue and phallus were believed to have special magical powers, as noted elsewhere. (See page 55.)

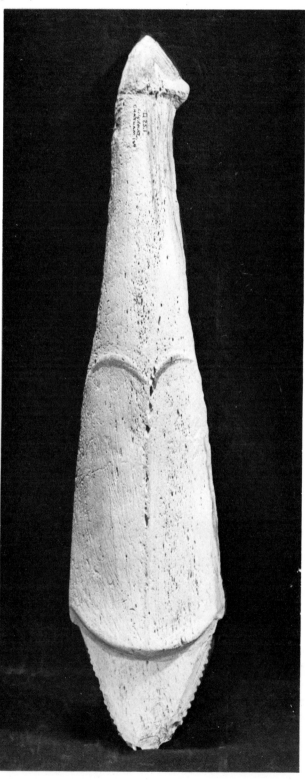

320 ⬆

Short club. Chatham Islands. Whalebone. *Length*: 13¾″ (35 cm). *Collection*: Hawke's Bay Museum, Napier, New Zealand. *Photo*: author.

This group of four Chatham Islands short clubs (318–21) has useful application in comparative study. (Compare the Easter Island dance paddles, 247 and 250.) The clubs illustrate well a Polynesian tendency to fragment forms and to use parts symbolically. The valuable place of Moriori material culture in the study of Polynesian culture in general, and particularly that of the New Zealand Maori, is due to the revealing simplicity of its art forms.

⬇ **321**

Short club. Chatham Islands. Whalebone. *Length*: 14¼″ (36 cm). *Collection*: Otago Museum, Dunedin, New Zealand. *Photo*: Chalmers Watson, Dunedin.

▽ **322**

Short club in the form of a bird with human head. Chatham Islands. Schist rock. *Length*: 15″ (38 cm). *Collection and photo*: Otago Museum, Dunedin, New Zealand.

The idea of placing a human head on a bird body is present also in the Easter Island carving 232. This symbiosis of human and avian features results in a distinctive bird-man. The Moriori of the Chatham Islands, like most Polynesians, held birds in reverence and regarded them as vehicles of spirits. Recognition of the curious relationship of birds and men in Oceanic belief is one of the keys to a better understanding of Polynesian art.

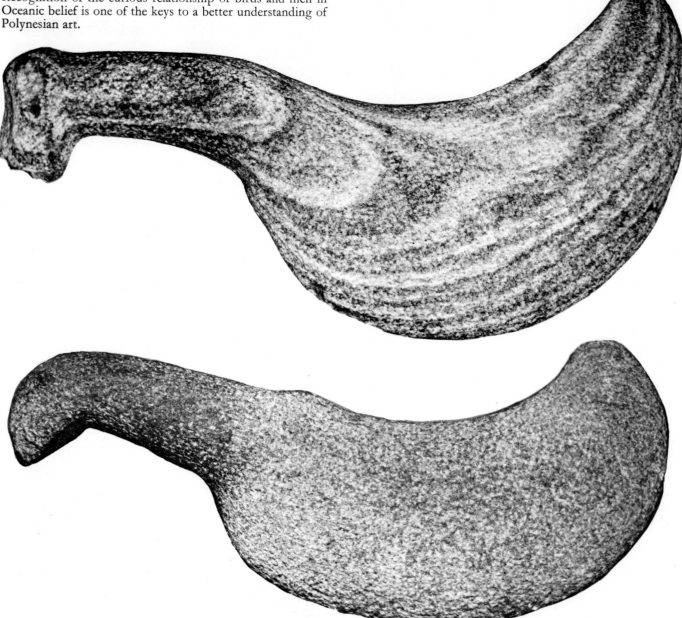

△ **323**

Short club in the form of a bird. Chatham Islands. Schist rock. *Length*: 14″ (35.5 cm). *Collection*: Dominion Museum, Wellington, New Zealand. *Photo*: author.

This club and a second of similar form (322) illustrate a widespread Polynesian tendency to use bird symbols and to give birds human features. The author has described the material symbols of birdmen of Polynesia in another work (Barrow, 1967).

Publications referred to in the making of this book are here recommended as a substantial working bibliography. The written materials for Polynesia are however so extensive that particular bibliographies and specialised library catalogues must be referred to for the further study of any one island group, custom, or class of artifact. C. R. H. Taylor's *A Pacific Bibliography* (2nd edition, Clarendon Press, Oxford, 1965) and the *Journal of the Polynesian Society Index* (Vol. 1–75, years 1892–1966) provide thousands of classified entries. Many of the books listed below incorporate specialised bibliographies and provide guidance to general reading: for example Jean Guiart's *The Arts of the South Pacific* (1963) has an extensive annotated book list. Works in print, or those out of print yet readily available in any large library, have been favoured for inclusion in this short bibliography. The great atlases and journals that served as sources for illustration are noted in captions to each print, but book titles of these early reference works are not included here.

Akerblom, K.
1968, *Astronomy and Navigation in Polynesia and Micronesia,* Monograph Series—Publication No. 14, The Ethnographical Museum, Stockholm.

Anderson, J. C.
1969, *Myths and Legends of the Polynesians,* Charles E. Tuttle, Rutland, Vermont and Tokyo (first published 1928).

Archey, G.
1949, *Handbook of Maori and Oceanic Ethnology: South Sea Folk,* Auckland War Memorial Museum, Auckland (2nd edition).
1955, *Sculpture and Design: An Outline of Maori Art,* Handbook of the Auckland War Memorial Museum, Auckland.
1965, *The Art Forms of Polynesia,* Bulletin No. 4, Auckland Institute and Museum, Auckland.

Armstrong, E. A.
1958, *The Folklore of Birds: An Enquiry into the Origin and Distribution of some Magico-Religious Traditions,* Collins, London.

Badner, M.
1966, "The Protruding Tongue and Related Motifs in the Art Styles of the American Northwest Coast, New Zealand and China", *Two Studies of Art in the Pacific Area, Wiener Beitrfige zur Kulturgeschichte und Linguistik*—Vol. 15, Vienna.

Balfour, H.
1917, "Ethnological Suggestions in regard to Easter Island or Rapanui", *Folk-Lore,* pp. 355–81, December.

Barrow, T.
1956, "Human Figures in Wood and Ivory from Western Polynesia", *Man,* Article 192, pp. 165–68, London.
1959, "Maori Godsticks collected by the Rev. Richard Taylor", *Dominion Museum Records in Ethnology,* Vol. 1, pp. 183–211, Wellington.
1959, "Free-Standing Maori Images", *Anthropology in the South Seas: Essays presented to H. D. Skinner,* editors Freeman, J. D. and Geddes, W. R., New Plymouth.
1961, "Maori Godsticks in Various Collections", *Dominion Museum Records in Ethnology,* Vol. 1, No. 6, Wellington.
1961, "Two hei tiki-matau Amulets", *Journal of the Polynesian Society,* Vol. 70, No. 3, p. 353.
1964, *The Decorative Arts of the New Zealand Maori,* A. H. & A. W. Reed, Wellington.
1965, *A Guide to the Maori Meeting House Te Hau-ki-Turanga,* Dominion Museum, Wellington.
1967, "Material Evidence of the Bird-Man Concept in Polynesia", *Polynesian Culture History: Essays in Honor of Kenneth P. Emory,* editors Highland, G. A.; Force, R. W.; *et al.,* Special Publication 56, Bernice P. Bishop Museum, Honolulu.
1969, *Maori Wood Sculpture of New Zealand,* A. H. & A. W. Reed, Wellington.

Barthel, T. S.
1958, "The 'Talking Boards' of Easter Island", *Scientific American,* Vol. 198, pp. 61–68, June.

Beaglehole, J. C. (Editor)
The Journals of Captain James Cook:
1955, Vol. 1, *Voyage of the Endeavour, 1768–1771;*
1961, Vol. 2, *Voyage of the Resolution and Adventure, 1772–1775;*
1967, Vol. 3, *Voyage of the Resolution and Discovery, 1776–1780;* Hakluyt Society, Cambridge;
1966, *The Exploration of the Pacific* (3rd edition), Stanford University Press, California.

Beckwith, M.
1970, *Hawaiian Mythology,* University of Hawaii Press, Honolulu (first published 1940).

Best, E.
1924, *The Maori,* Memoirs of the Polynesian Society, Vol. 5, H. H. Tombs, Wellington.

Bishop Museum Press
1967, *Polynesian Culture History: Essays in Honor of Kenneth P. Emory,* editors Highland, G. A.; Force, R. W.; *et al.,* Special Publication 56, Bernice P. Bishop Museum, Honolulu.
1968, *Prehistoric Culture in Oceania: A Symposium,* editors Yawata, I. and Sinoto, Y. H. (papers presented at the 11th Pacific Science Congress of the Pacific Science Association, Tokyo, 1966), Honolulu.

Blavatsky, H. P.
1963, *The Secret Doctrine: The Synthesis of Science, Religion, and Philosophy,* Theosophical University Press, Pasadena (first published 1888).

Bloxam, A.
1925, *Diary of Andrew Bloxam, Naturalist of the "Blonde" On Her Trip From England to the Hawaiian Islands 1824–25,* Special Publication No. 10, Bernice P. Bishop Museum, Honolulu.

Brigham, W. T.
1899, *Hawaiian Feather Work,* Memoirs Vol. 1, No. 1;
1903, *Additional Notes on Hawaiian Feather Work,* Memoirs, Vol 1, No. 5;
1906, *Old Hawaiian Carvings,* Memoirs Vol. 2, No. 2;
1911, *Ka Hana Kapa,* Memoirs Vol. 3;
1918, *Additional Notes on Hawaiian Feather Work—Second Supplement,* Memoirs, Vol. 7, No. 1; Bernice P. Bishop Museum, Honolulu.

British Museum
1910, *Handbook to the Ethnographical Collections,* University Press, Oxford.

Buck, P. H. (Te Rangi Hiroa)
1930, *Samoan Material Culture,* Bulletin 75, Bernice P. Bishop Museum, Honolulu.
1935, "Material Representations of Tongan and Samoan Gods", *Journal of the Polynesian Society,* Vol. 44, pp. 48–53, 85–96, 153–62, New Plymouth.
1937, "Additional Wooden Images from Tonga", *Journal of the Polynesian Society,* Vol. 46, pp. 74–82, New Plymouth.
1938, *Ethnology of Mangareva,* Bulletin 157, Bernice P. Bishop Museum, Honolulu.
1938, *Vikings of the Sunrise,* Lippincott Co., New York.
1939, "Mangarevan Images", *Ethnologia Cranmorensis,* No. 4, pp. 13–19, Chislehurst.
1944, *Arts and Crafts of the Cook Islands,* Bulletin 179, Bernice P. Bishop Museum, Honolulu.
1945, *An Introduction to Polynesian Anthropology,* Bulletin 187, Bernice P. Bishop Museum, Honolulu.
1950, *The Coming of the Maori* (2nd edition), Maori Purposes Fund Board and Whitcombe and Tombs Ltd, Wellington.
1953, *Explorers of the Pacific: European and American Discoveries in Polynesia,* Special Publication 43, Bernice P. Bishop Museum, Honolulu.
1957, *Arts and Crafts of Hawaii,* Special Publication 45, Bernice P. Bishop Museum, Honolulu.

Bühler, A.; Barrow, T.; Mountford, C. P.
1962, *Oceania and Australia: The Art of the South Seas,* Art of the World—a series of regional histories of the visual arts, Vol. 8, Methuen, London; Crown Publishers, New York (English-language editions). First published (German-language edition) Baden-Baden, 1961.

Burrows, E. G.
1938, "Western Polynesia, A Study in Cultural Differentiation", *Etnologiska Studier,* No. 7, Ethnographical Museum, Göteborg.

Churchill, W.
1917, *Club Types of Nuclear Polynesia,* Publication No. 255, Carnegie Institution of Washington, Washington, DC.

Clark, G.
1969, *World Prehistory: A New Outline,* University Press, Cambridge.

Cousins, G.
1894, *The Story of the South Seas—Written for Young People,* London Missionary Society, London.

Cox, J. H.
1967, "The Lei Niho Palaoa", *Polynesian Culture History: Essays in Honor of Kenneth P. Emory,* editors Highland, G. A.; Force, R. W.; *et al.,* Special Publication 56, Bernice P. Bishop Museum, Honolulu.

Cox, J. H., with Stasack, E.
1970, *Hawaiian Petroglyphs,* Special Publication 60, Bernice P. Bishop Museum, Honolulu.

Cranstone, B. A. L.
1955, "An Easter Island Bird Figure", *The British Museum Quarterly,* Vol. 20, No. 1, London, March.
1963, "A Unique Tahitian Figure", *The British Museum Quarterly,* Vol. 27, Nos. 1–2, London.

Danielsson, B.
1969, "They sailed with Captain Cook: Essay on Swedish Naturalists, Daniel Solander and Anders Sparrman", *No Sort of Iron: Culture of Cook's Polynesians,* editor Duff, R., Christchurch.

Davidson, D. S.
1947, *Oceania,* The Oceanic Collections of the University Museum, *University Museum Bulletin,* Vol. 12, University of Pennsylvania, Philadelphia, June.

Davidson, J. M.
1968, "A wooden Image from Nukuoro in the Auckland Museum", *Journal of the Polynesian Society,* Vol. 77, No. 1, pp. 77–79, Wellington, March.

Dodd, E.
1967, *The Ring of Fire: A Pictorial Peregrination Through the Shapely and Harmonious Often Enigmatical Sometimes Shocking Realms of Polynesian Art,* Vol. 1, Dodd, Mead and Company, New York.

Dodge, E. S.
1937, *The Hervey Island Adzes in the Peabody Museum of Salem,* Peabody Museum, Salem.
1939, *The Marquesas Islands Collection in the Peabody Museum of Salem,* Peabody Museum, Salem.
1941, *The New Zealand Maori Collection in the Peabody Museum of Salem,* Peabody Museum, Salem.
1969, "The Cook Ethnographical Collections", *No Sort of Iron: Culture of Cook's Polynesians,* editor Duff, R., Christchurch.

Duff, R.
1950, *The Moa-hunter Period of Maori Culture,* Bulletin 1, Canterbury Museum, and Department of Internal Affairs, Wellington; 2nd edition: Department of Internal Affairs, Wellington, 1956.
1959, "Neolithic Adzes of Eastern Polynesia", *Anthropology in the South Seas: Essays Presented to H. D. Skinner,* editors Freeman, F. D. and Geddes, W. R., New Plymouth.
1969, *No Sort of Iron: Culture of Cook's Polynesians* (A Cook Bicentenary Exhibition organised by the Art Galleries and Museums' Association of New Zealand, 9 October 1969 to 30 June 1970), Christchurch.
1970, *Stone Adzes of Southeast Asia: An Illustrated Typology,* Bulletin No. 3, Canterbury Museum, Christchurch.

Edge-Partington, J. and Heape, C.
1890, *Album of Weapons, Tools, Ornaments, Articles of Dress of Natives*
1895, *of the Pacific Islands,* 3 vols, privately printed, Manchester.
1898

Ellis, W.
1969, *Polynesian Researches,* 4 vols; first published in 2 vols in 1829, Charles E. Tuttle, Rutland, Vermont and Tokyo.

Emory, K. P.
1928, *Archaeology of Nihoa and Necker Islands,* Tanager Expedition Publication 5, Bulletin 53, Bernice P. Bishop Museum, Honolulu.
1938, "Hawaii: God Sticks", *Ethnologia Cranmorensis,* Vol. 3, Chislehurst.

Englert, Father S.
1970, *Island at the Center of the World: New Light on Easter Island* (translated and edited by Mulloy, W.), New York.

Fairservis, W. A.
1959, *The Origins of Oriental Civilization,* Mentor Books, New York.

Finney, B. R.
1967, "New Perspectives on Polynesian Voyaging", *Polynesian Culture History: Essays in Honor of Kenneth P. Emory,* editors Highland, G. A.; Force, R. W.; *et al,* Special Publication 56, Bernice P. Bishop Museum, Honolulu.

Firth, R. W.
1925, "The Maori Carver", *Journal of the Polynesian Society,* Vol. 34, pp. 277–91, New Plymouth.

Force, R. W. and Force, M.
1968, *Art and Artifacts of the 18th Century,* Bishop Museum Press, Honolulu.

Fraser, D.
1962, *Primitive Art,* Thames and Hudson, London.
1966, "The Heraldic Woman: A Study in Diffusion", *The Many Faces of Primitive Art: A Critical Anthology,* editor Fraser, D., Prentice-Hall, New Jersey.
1968, *Early Chinese Art and the Pacific Basin: A Photographic Exhibition,* editor, Fraser, D. (a catalogue printed for the 1967–68 exhibition organised as part of the Program of Advanced Studies at the Graduate Faculties, Columbia University, New York), Intercultural Arts Press, New York.

Freeman, J. D.
1949, "The Polynesian Collection of Trinity College, Dublin; and the National Museum of Ireland", *Journal of the Polynesian Society,* Vol. 58, No. 1, pp. 1–18, New Plymouth.

Freeman, J. D. and Geddes, W. R. (Editors)
1959, *Anthropology in the South Seas: Essays presented to H. D. Skinner,* editors Freeman, J. D. and Geddes, W. R., New Plymouth.

Friis, H. R. (Editor)
1967, *The Pacific Basin: A History of Its Geographical Exploration,* American Geographical Society, New York.

Gatty, H.
1958, *Nature is Your Guide: How to Find your Way on Land and Sea,* Collins, London.

Gauguin, P.
1954, *Noa Noa,* fascimile of manuscript by Sagot-Le Garrec, Paris; also by Reynal and Co., New York.

Goldman, I.
1970, *Ancient Polynesian Society,* University of Chicago Press, Chicago.

Golson, J. (Editor)
1962, *Polynesian Navigation: A Symposium on Andrew Sharp's Theory of Accidental Voyages,* Memoir No. 34, *Supplement to the Journal of the Polynesian Society,* Wellington.

Graham, J. C. (Editor)
1965, *Maori Paintings: Pictures from the Partridge Collection of Paintings by Gottfried Lindauer,* A. H. & A. W. Reed, Wellington.

Green, R. C.
1967, "The Immediate Origins of the Polynesians", *Polynesian Culture History: Essays in Honor of Kenneth P. Emory,* editors Highland, G. A.; Force, R. W.; *et al,* Special Publication 56, Bernice P. Bishop Museum, Honolulu.

Green, R. C. and Kelly, M. (Editors)
1970, *Studies in Oceanic Culture History,* Vol. 1, Pacific Anthropological Records No. 11, Bernice P. Bishop Museum, Honolulu.

Greiner, R. H.
1923, *Polynesian Decorative Designs,* Bulletin No. 7, Bernice P. Bishop Museum, Honolulu.

Guiart, J.
1963, *The Arts of the South Pacific* (translated from the French by Christie, A.), Thames and Hudson, London.

Haddon, A. C. and Hornell, J.
1936, *Canoes of Oceania,* Vol. 1, *The Canoes of Polynesia, Fiji and Micronesia,* Special Publication 27, Bernice P. Bishop Museum, Honolulu.

Hale, H.
1846, *United States Exploring Expedition, 1838–42,* Philadelphia.

Hamilton, A.
1896, *The Art Workmanship of the Maori Race in New Zealand,* New Zealand Institute, Dunedin.

Handy, E. S. C.
1923, *Tattooing in the Marquesas,* Bulletin 1, Bernice P. Bishop Museum, Honolulu.

Heine-Geldern, R.
1966, "Some Tribal Art Styles of Southeast Asia: An Experiment in Art History" (based on a paper published in *Revue des Arts Asiatiques,* 1937), *The Many Faces of Primitive Art: A Critical Anthology,* editor, Fraser, D., Prentice-Hall, New Jersey.
1966, "A Note on Relations between the Art Styles of the Maori and Ancient China", *Two Studies of Art in the Pacific Area, Wiener Beiträge zur Kulturgeschichte und Linguistik,* Vol. 15, Vienna.

Henry, T.
1928, *Ancient Tahiti,* Bulletin 48, Bernice P. Bishop Museum, Honolulu.

Heyerdahl, T.
1959, *The Kon-Tiki Expedition: By Raft Across the South Seas* (translated from the Norwegian edition, published 1948, by Lyon, F. H.), Allen and Unwin, London (23rd impression).
1968, *Sea Routes to Polynesia,* Allen and Unwin, London.

Heyerdahl, T. and Ferdon, E. N.
1965, *Reports of the Norwegian Archaeological Expedition to Easter Island and the East Pacific,* Vol. 2, *Miscellaneous Papers,* 16 contributors, Forum Publishing House, Stockholm.

Honolulu Academy of Arts handbook
1967, *An Exhibition of Oceanic Arts from Collections in Hawaii,* Honolulu

Howard, A.
1967, "Polynesian Origins and Migrations: A Review of Two Centuries of Speculation and Theory", *Polynesian Culture History: Essays in Honor of Kenneth P. Emory,* editors Highland, G. A.; Force, R. W.; *et al,* Special Publication 56, Bernice P. Bishop Museum, Honolulu.

Jefferson, C.
1955, "The Dendroglyphs of the Chatham Islands", *Journal of the Polynesian Society,* Vol. 64, No. 4, pp. 367–441, New Plymouth, December.

Krämer, A.
1902- *Samoan-Inseln,* 2 vols, Stuttgart.
1903

Krieger, H. W.
1932, *Design Areas in Oceania Based on Specimens in the United States National Museum,* Smithsonian Institution, Washington, DC.

Larsson, K. E.
1960, *Fijian Studies, Etnologiska Studier* No. 25, Ethnographical Museum, Göteborg.

Lavondès, A.
1968, *Traditional Art of Tahiti,* Dossier 1, Société des Océanistes, Paris.

Lewis, D. H.
1964, "Ara Moana: Stars of the Sea Road", *Journal of the Institute of Navigation,* Vol. 17, No. 3, pp. 278–88, London, July.

Linton, R.
1923, *Material Culture of the Marquesas Islands,* Memoirs Vol. 8, No. 5, Bernice P. Bishop Museum, Honolulu.
1926, *Ethnology of Polynesia and Micronesia,* Guide 6, Field Museum of Natural History, Chicago.

Linton, R. and Wingert, P. S.
1946, *Arts of the South Seas,* The Museum of Modern Art, New York.

Luomala, K.
1949, *Maui-of-a-Thousand-Tricks: His Oceanic and European Biographers,* Bulletin 198, Bernice P. Bishop Museum, Honolulu.

Marshall, D. S.
1961, *Ra'ivavae,* Doubleday.

McEwen, J. M.
1966, "Maori Art", *An Encyclopaedia of New Zealand,* Vol. 2, pp. 408–29, Government Printer, Wellington.

Mead, S. M.
1961, *The Art of Maori Carving,* A. H. & A. W. Reed, Wellington.
1968, *The Art of Taaniko Weaving,* A. H. & A. W. Reed, Wellington.

Metraux, A.
1940, *Ethnology of Easter Island,* Bulletin 160, Bernice P. Bishop Museum, Honolulu.

Moschner, I.
1955, *Die Wiener Cook-Sammlung: Südsee-Teil, Archiv für Völkerkunde,* Vol. 10, Vienna.
1959, *Katalog der Neuseeland-Sammlung (A. Reischek), Archiv für Völkerkunde,* Vol. 13, Vienna.

Museum of Primitive Art handbooks:
1960, *Raymond Wielgus Collection;*
1963, *Sculpture from the South Seas;*
1963, *Robert and Lisa Sainsbury Collection,* Chicago.

Newton, D.
1964, *Seafarers of the Pacific,* World Publishing Company, Cleveland and New York.

Oldman, W. O.
1943, *The Oldman Collection of Polynesian Artifacts,* Memoirs of the Polynesian Society, Vol. 15, New Plymouth.
1946, *Skilled Handwork of the Maori: Being the Oldman Collection of Maori Artifacts Illustrated and Described,* Memoirs of the Polynesian Society, Vol. 14, New Plymouth.

Oliver, D. L.
1961, *The Pacific Islands* (revised edition), The American Museum of Natural History and Doubleday, New York.

Otago Museum
1963, *Craftsmanship in Polynesia,* a handbook to the Polynesian collections of the Museum (text Simmons, D. R.; photographs, Forster, R. R.), Dunedin.

Pacific Islands Year Book and Who's Who
1968, Tenth Edition, editor Tudor, J., Pacific Publications, Sydney.

Phillipps, W. J.
1948- "Breast Plates of Fiji", *Transactions and Proceedings of the Fiji*
1950, *Society,* Vol. 4.

Routledge, C. S.
1919, *The Mystery of Easter Island,* London.

Rydén, S.
1965, *The Banks Collection*: *An Episode in 18th-Century Anglo-Swedish Relations,* Monograph Series—Publication No. 8, The Ethnographical Museum of Sweden, Göteborg (reprinted edition).

Schuster, C.
1951, *Joint-Marks: A Possible Index of Cultural Contact Between America, Oceania and the Far East, Afdeling Culturele en Physische Anthropologie* No. 39, Royal Tropical Institute, Amsterdam.
1952, "V-Shaped Chest-Markings: Distribution of a Design-Motive in and around the Pacific", *Anthropos,* Vol. 47, Fribourg.

Sharp, A.
1957, *Ancient Voyagers in the Pacific,* Penguin Books, Middlesex and Baltimore. First published by the Polynesian Society, New Plymouth, 1956.
1964, *Ancient Voyagers in Polynesia,* University of California Press, Berkeley and Los Angeles.

Shawcross, W.
1964, An Archaeological Assemblage of Maori Combs, *Journal of the Polynesian Society,* Vol. 73, pp. 382–98, New Plymouth.

Simmons, D. R.—See Otago Museum—1963, and Skinner, H. D.—1966.

Sinoto, Y. H.
1968, "Position of the Marquesas Islands in East Polynesian Prehistory", *Prehistoric Culture in Oceania—A Symposium* (11th Pacific Science Congress, Tokyo, 1966), Bernice P. Bishop Museum, Honolulu.

Skinner, H. D.
1923, *The Morioris of Chatham Islands,* Memoirs Vol. 9, No. 1, Bernice P. Bishop Museum, Honolulu.
1924, "The Origin and Relationship of Maori Material Culture and Decorative Art", *Journal of the Polynesian Society,* Vol. 33, pp. 229–43, New Plymouth.
1933, "Three Polynesian Drums", *Journal of the Polynesian Society,* Vol. 42, No. 4, pp. 308–9, New Plymouth.
1964, *Crocodile and Lizard in New Zealand Myth and Material Culture,* Records of the Otago Museum—Anthropology, No. 1, Dunedin.
1966, *The Maori Hei-Tiki* (2nd edition with appendix by Simmons, D. R.), Otago Museum, Dunedin.
1967, "Cylindrical Headdress in the Pacific Region", *Polynesian Culture History: Essays in Honor of Kenneth P. Emory,* editors Highland, G. A.; Force, R. W.; *et al,* Special Publication 56, Bernice P. Bishop Museum, Honolulu.

Smith, B.
1960, *European Vision and the South Pacific 1768–1850: A Study in the History of Art and Ideas,* Clarendon Press, Oxford.

Söderström, J.
1939, *A Sparrman's Ethnographical Collection from James Cook's 2nd Expedition (1772–1775),* New Series Publication No. 6, The Ethnographical Museum of Sweden, Stockholm.

Solheim, W. G. II
1970, *Reworking Southeast Asian Prehistory,* Social Sciences Research Institute Reprint No. 34, University of Hawaii, Honolulu.

Speiser, F.
1966, "Art Styles in the Pacific" (originally printed as a handbook, 1941, Museum für Völkerkunde, Basel), *The Many Faces of Primitive Art: A Critical Anthology,* editor Fraser, D., Prentice-Hall, New Jersey.

Steinen, Karl von den
1925 & 1928 *Die Marquesaner und ihre Kunst, Primitiver Südseeornamentik,* Vol. 1, *Tautauierung,* Berlin; Vol. 2, *Die Sammlungen,* Berlin.

Stolpe, H.
1891- *Evolution in the Ornamental Art of Savage Peoples* (translated by
1892, March, G. C.), *Transactions of the Rochdale Literary and Scientific Society* (reprint), Clegg, Rochdale.

Suggs, R. C.
1960, *The Island Civilizations of Polynesia,* Mentor Books, New York.

Te Rangi Hiroa—See Buck, P. H.

Thomson, W. J.
1891, "Te Pito te Henua or Easter Island", *U.S. National Museum Annual Report for 1889,* pp. 447–552, Washington, DC.

Tippett, A. R.
1968, *Fijian Material Culture: A Study of Cultural Context, Function, and Change,* Bulletin 232, Bernice P. Bishop Museum, Honolulu.

Tischner, H. (photographs by Hewicker, F.)
1954, *Oceanic Art,* Thames and Hudson, London.

Tokyo National Museum
1964, *Exhibition of Japanese Old Art Treasures in Tokyo Olympic Games,* Tokyo.

Vayda, A. P. (Editor)
1968, *Peoples and Cultures of the Pacific: An Anthropological Reader,* The American Museum of Natural History, New York.

Wardwell, A.
1967, *The Sculpture of Polynesia* (being a catalogue of an exhibition held at the Art Institute of Chicago and at the Museum of Primitive Art, New York), the Art Institute of Chicago, Chicago.

Watson, W.
1961, *China before the Han Dynasty,* Thames and Hudson, London.
1966, *Early Civilization in China,* Thames and Hudson, London.

Webster, K. A.
1948, *The Armytage Collection of Maori Jade,* Cable Press, London.

Wielgus, R. (Introduction) and Goldwater, R. (Foreword)
1960, *The Raymond Wielgus Collection* (catalogue of an exhibition held at the Museum of Primitive Art), New York.

Willetts, W.
1965, *Foundations of Chinese Art from Neolithic Pottery to Modern Architecture,* McGraw Hill, New York.

Williams, J.
1837, *A Narrative of Missionary Enterprises in the South Sea Islands,* Snow, London.

Wingert, P. S.
1953, *Art of the South Pacific Islands,* Thames and Hudson, London.
1962, *Primitive Art: Its Traditions and Styles,* Oxford University Press, New York.

LIST OF ILLUSTRATIONS

GLOSSARY

A Concise Glossary of Artifact Names with a Note on the Polynesian Language

THE POLYNESIAN LANGUAGE belongs to the Malayo-Polynesian (Austronesian) family of languages which are found from Madagascar to Easter Island. It is divided into two major branches: West Polynesian, and East Polynesian (including the sub-marginal and marginal island groups). Dialectical subdivisions of both West and East Polynesia occur by island groups, individual islands, or even in relation to regions within islands. The Polynesian language, however euphonious and rich in vocabulary, is classified as a minor branch of the Malayo-Polynesian tongue (which has over a hundred million modern speakers). The fluent speakers of Polynesian unfortunately constitute a small minority within Polynesia and represent a small fraction of today's Malayo-Polynesian speakers.

To the Western reader unfamiliar with the Polynesian language words that are basically the same often look quite different because of (i): the occurrence of the glottal closure (indicated by a hamza); and (ii) dialectical variation in the use of consonants. For example *whare* or "house" in New Zealand becomes *'are* in the Cook Islands, *fare* in the Society and Marquesas Islands, *fale* in Samoa and *hale* in Hawaii (vowels remain constant). Variations in Polynesian artifact names follow similar patterns in changing consonants and glottals.

Artifact terms have not been well preserved in Polynesia (with the possible exceptions of Hawaii and New Zealand); also there is sometimes doubt as to which names are old authentic ones and which are merely late descriptive names or modern coinings. Until some energetic scholar compiles a comparative dictionary of Polynesian artifact names, and assesses these in current usage, we must seek our artifact terms for one Polynesian culture or another as best we can from language dictionaries, ethnographical bulletins, monographs and catalogues. The world list provided below makes no claim to being more than a short glossary more or less related to the artifacts illustrated. Some terms are found in the same form in several islands but they are associated with only one group for the practical purposes of listing.

ahu	altar	Tahiti
ahu	stone temple	Easter Is
'ahu 'ula	feather cloak or cape	Hawaii
'au-amo	carrying pole	Hawaii
'aumakua	protective guardian	Hawaii
'aumakua-hulu-manu	feather god image	Hawaii
fare-no-atua	god house	Tahiti
ha'akai	men's ear ornament	Marquesas
heiau	ritual temple	Hawaii
hei-matau	fish-hook form pendant	New Zealand
hei-tiki	anthropomorphic pendant	New Zealand
heru	comb	New Zealand
hoe	paddle	Hawaii
hue	gourd	Hawaii
i'e	barkcloth beater	Tahiti
ipu-k'ui	mortar	Hawaii
kapa	barkcloth	Hawaii
kahili	feathered staff	Hawaii
ki'i	anthropomorphic image	Hawaii
kilo pohaku	stone mirror	Hawaii
koauau	short flute	New Zealand
kohau-rongorongo	script board	Easter Is
ko'i	adze	Hawaii
konane papa	gaming board	Hawaii
kotaha	whip-sling	New Zealand
kotiate	fiddle-form short club	New Zealand
kuka ili moku	feather image of war god	Hawaii
kumete	food bowl	New Zealand
lei	necklace or garland	Hawaii
lei niho palaoa	whale-tooth necklace	Hawaii
mahiole	feathered helmet	Hawaii
manaia	bird-like carving motif	New Zealand
manu-uru	seated figure	Easter Is
marae	village meeting area	New Zealand
mataa	flaked and tanged blade	New Zealand
matau	fish-hook	New Zealand
moai-kavakava	male image	Easter Is
moai-miro	general for images in wood	Easter Is
moai-moko	lizard man image	Easter Is
moai-paapaa	female ancestor image	Easter Is
moena	mat	Hawaii
moko	tattoo or lizard	New Zealand
nguru	whistle-flute	New Zealand
niho	tooth	Hawaii
no'oanga	low seat	Cook Islands
'ohe-kapalapala	bamboo marking stamps	Hawaii
olona	fibre from this tree	Hawaii
pa	fortified village	New Zealand
paekaha	head ornament	Marquesas
paepae	base or threshold	New Zealand
pahoa	hardwood dagger	Hawaii
pahu-ra	drum	Raivavae
pahu-hula	dance drum	Hawaii
paki	light dance paddle	Tonga
paoa	stabbing club	Easter Is
pare	lintel	New Zealand
pataka	storehouse	New Zealand
patu	short club	New Zealand
penu	starch pounder	Tahiti
pololu	thrusting lance	Hawaii
pounamu	nephrite	New Zealand
poupou	wall post or panel	New Zealand
pou-toko-manawa	ridge support post	New Zealand
putorino	long flute	New Zealand
rapa	dance paddle	Easter Is
rei	pendant ornament	New Zealand
rei-miro	wooden gorget	Easter Is
tahi	fan	Marquesas
taiona	woman's ear ornament	Marquesas
taiaha	long club	New Zealand
tambua	whaletooth pendant	Fiji
tangata-manu	birdman figure	Easter Is
tapa	bark cloth	Tahiti
tata	canoe bailer	New Zealand
ta-tatau	tattooing mallet	Tahiti
tau-ihu	canoe prow	New Zealand
ta'umi	warrior's gorget	Tahiti
tau-rapa	canoe stern post	New Zealand
teka	digging stick foot rest	New Zealand
tekoteko	gable pinnacle figure	New Zealand
tiki	anthropomorphic image	New Zealand
tiki-wananga	godstick	New Zealand
toki	adze	New Zealand
toki-pou-tanagata	ceremonial adze	New Zealand
toko	staff	New Zealand
to'o	staff	Samoa
turuturu	weaving stick	New Zealand
ua	staff club	Easter Is
uhikana	headband	Marquesas
umeke la'au	wooden bowl	Hawaii
uru'a	wooden pillow	Tahiti
u'u	hardwood club	Marquesas
wahaika	sickle-form short club	New Zealand
whare	house	New Zealand
whare-runanga	meeting house	New Zealand
waka	canoe	New Zealand
wa'a	canoe	Hawaii
waka-huia	treasure box	New Zealand

INDEX

ART AREAS OF POLYNESIA

This map indicates the geographical relationship of the major Polynesian groups and the position of islands of special significance. The plates in this book are presented under the headings of principle island clusters, and Easter Island.

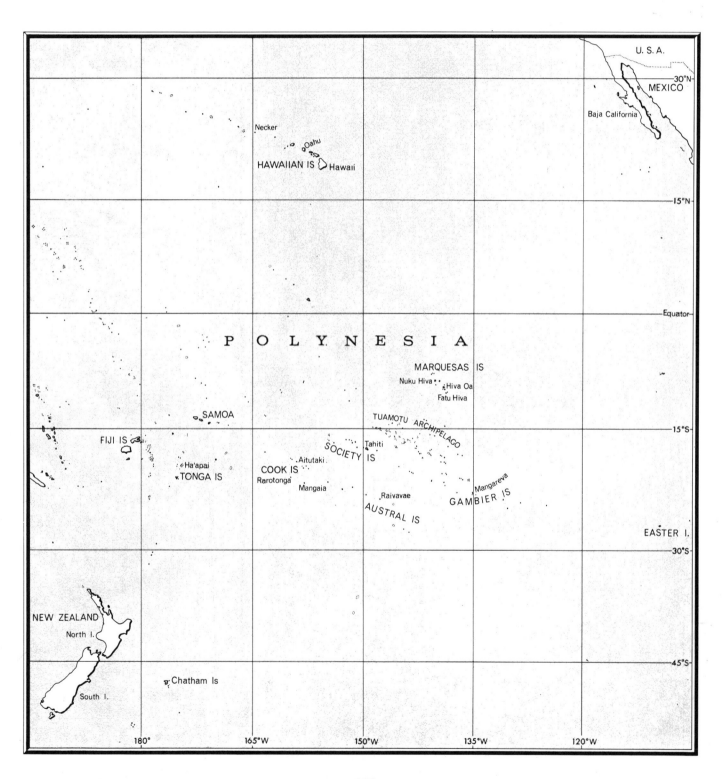